Max J. Friedländer

FROM VAN EYCK
TO BRUEGEL

EDITED AND ANNOTATED BY
F. GROSSMANN

D0910683

A Phaidon Book

Cornell University Press

ITHACA, NEW YORK

First published by Phaidon Press Ltd. 1956
First published, Cornell Paperbacks, 1981

International Standard Book Number 0-8014-9220-3
Library of Congress Catalog Card Number 80-69740

Translated from the German by Marguerite Kay

Printed in the United States of America

CONTENTS

Foreword vii

Introduction ix

The Geography of Netherlandish Art 1

Jan van Eyck 6

Petrus Christus 14

Rogier van der Weyden 16

Dieric Bouts 26

Hugo van der Goes 32

Hans Memlinc 41

Gerard David 48

Geertgen tot Sint Jans 53

Jerome Bosch 56

General Remarks on the Sixteenth Century 65

Quentin Massys 70

Joachim de Patenier 78

Joos van Cleve 87

Jan Provost 93

Jan Gossaert 97

Jan Joest 107

Jan Mostaert 113

Lucas van Leyden 121

Jan van Scorel 128

Pieter Bruegel 135

THE PLATES 145

List of Plates 403

Index of Places 407

Acknowledgements 410

PUBLISHER'S NOTE

Friedländer's *Von Eyck bis Bruegel* was first published in German in 1916 and a second, enlarged edition appeared in 1921. The first English edition was published by Phaidon Press in 1956 and reprinted with corrections in 1964 and 1969. This Cornell Paperbacks edition has been photographically reprinted from the 1969 edition. The nine colour plates in the first edition are here reproduced in black and white although they are referred to as 'colour plates' in the list of illustrations on page 406; for production reasons their blank verso pages have been retained.

The locations of some of the works reproduced have changed during the past twenty years. Plates 32 and 121 are now in the Metropolitan Museum (The Robert Lehman Collection), New York; Plate 96 is now in the Wildenstein Gallery, New York; Plate 173 is now in the National Gallery of Scotland, Edinburgh; and some other pictures listed as belonging to private owners have also changed hands.

FOREWORD

Written some forty years ago, Friedländer's *Von Eyck bis Bruegel* is one of the few art-historical books of its period which have lost nothing of their impact since they were first published. We value it as the mature work of the unrivalled connoisseur and historian of early Netherlandish painting who, in his fiftieth year, here presented a series of artists' portraits, the fruits, without the labour, of his continuous detailed studies and intuitive insight. What is summed up here in concise, often epigrammatic form in a single tome was later expanded by the author in the fourteen volumes of his magnum opus, *Die Altniederländische Malerei*, published 1924–1937. In this later publication he was able to devote more space to the discussion also of minor artists and to the elaboration of detail which he had avoided in *Von Eyck bis Bruegel*, and, of course, his continuous searching study of the subject, as well as the appearance of hitherto unknown material—paintings and documents—necessarily led to some new results. It is a measure of the earlier work's high quality that in spite of subsequent writings and Friedländer's still continuing work it has in no way become obsolete. The reasons are obvious: in 1916, when he was writing it, his notion of early Netherlandish art was fully developed and formed, and he was complete master of a unique style of expressive characterization which in its elegance and precision and absence of art-historical jargon has few equals in German academic writing.

The first German edition appeared in 1916, a second enlarged one in 1921. It is on the latter that this first English edition, published in the author's ninetieth year, is based.

In the republication of a book of this order any interference with the text is out of the question and the editor's task is a very limited one. In annotating the volume I have tried to enhance its usefulness for the present-day reader mainly in three ways: by indicating changes in the ownership of works discussed, by drawing attention to later relevant discoveries, in particular those of Friedländer himself, and by pointing out, wherever necessary, his most recent views. In order to leave the text completely unchanged, all this matter appears in footnotes which are marked with an asterisk to distinguish them from the author's own. The lists of paintings to be found in the original German edition have been omitted, as Friedländer has provided more extensive ones in *Die Altniederländische Malerei*.

As regards the illustrations, the publishers have generously accepted many of my suggestions and have greatly expanded the original number. Here our aim has been a threefold one: to show the paintings on which Friedländer's main arguments are based, to add to these some typical examples of each artist's work (including some pictures which, discovered later and mostly published by Friedländer

himself, have confirmed his original ideas) and finally to provide a supplement which in itself may serve as a pictorial survey of early Netherlandish art.

I have to thank all those who have helped by supplying the photographs and permitting their reproduction and by providing information about the present whereabouts of a number of paintings. While my greatest debt here is to Dr. H. Gerson and the Rijksbureau voor kunsthistorische Documentatie at The Hague and to Mr. Peter Murray and the Witt Library in London, I am no less grateful for the replies to my inquiries received from Mr. E. Haverkamp Begemann, Professor J. G. van Gelder, Dr. Hans Konrad Röthel, Dr. Alfred Scharf, Dr. A. B. de Vries and Professor Ellis K. Waterhouse.

London, 1956 F. GROSSMANN

NOTE TO THE SECOND EDITION

The 1956 edition of this book was to be the last publication of a major work of Max J. Friedländer in his life-time. He died in Amsterdam on October 11, 1958, in his 92nd year. Almost to the end he remained active, and among the papers he left there ·was a book, practically completed, on Lucas van Leyden (his third detailed study of the artist), to which Friedrich Winkler had very little to add when he edited it for posthumous publication in 1963. The style and the method of approach to the artist's work are the same, and of the same vigour, in this late book as in his early classic opus *From van Eyck to Bruegel*, which, with very slight changes only, is here reprinted from the 1956 edition.

In the present edition Friedländer's text has, of course, again remained un-altered. The notes, too, have been left unchanged though in a few cases they have been expanded by references to facts which have come to light in the last years. In addition recent changes of ownership have been indicated. Finally, it is my pleasant duty to thank Professor Egbert Haverkamp Begemann for further valuable information and Dr. Michael Kauffmann for help in checking some dates.

Manchester, 1964 F. G.

NOTE TO THE THIRD EDITION

On the whole the principles of annotation and revision have remained the same as in the previous edition. The annotation has, however, been somewhat expanded in order to add to a classic text the usefulness of a reference book.

University of Washington, Seattle, 1969 F. G.

INTRODUCTION

What the reader will find in my essays is an endeavour to put into words the characteristic qualities of various painters. At the same time he will be given the fragmentary results of a student's experience of attribution problems which, though often ridiculed, nevertheless seems to me if not the purpose at least the basis for any serious art research, and in which those gentlemen who look haughtily down on it also participate—though generally with little talent.

I must warn the reader against the mistaken notion that it is possible to recognize the work of a particular painter through implicit faith in a formulated characterization. Failure to do so does not necessarily discredit or refute the characterization. I myself never use fixed ideas of my impressions as a means of attribution and harbour grave misgivings against all persons who use quotations to establish, attack or defend attributions.

Correct attributions generally appear spontaneously and 'prima vista'. We recognize a friend without ever having determined wherein his particular qualities lie and that with a certainty that not even the most detailed description can give.

Such unthinking recognition may be regarded as unscientific whilst the 'method' that Giovanni Morelli imagined, or asserted, that he had found may be admired as scientific. I am convinced that Morelli for all his method would have achieved nothing had he not been a talented connoisseur, more, I am convinced that he never used his method but that he shrouded the results of intuitive connoisseurship in a mantle of false erudition to make them appear unassailable to the naive mind.

Attributions cannot be proved or disproved. And mistakes are only recognized as mistakes when they wither and die. Here the only criterion for truth is that it should prove fruitful. A correct attribution evokes further attributions, a false one, even if it is armed to the teeth with powerful arguments, cannot endure and in due course will prove null and void.

Scientifically speaking, we can regard every discovery of style analysis as a hypothesis and erect airy structures with the intuitively discovered data, confident that documents and signatures, to which we aspire with the help of the provisional structure, will later give a greater solidity to the whole.

Unlike the copper-plate in engraving, the creative personality does not produce commensurably equal works. Therefore it is the problematic task of the connoisseur to perceive in the one production the productive power as a whole with all its potentialities, so that any further work will be recognized as a result of this particular power.

Various things can be deduced from such a concept. There is little advantage in

recording and learning by heart all the characteristics of a work of art, because it is not in the least likely that all of them will recur in a second work. We must distinguish between what is necessary for the author and what is accidental—and only effective in the one case—such as size and subject-matter. It is not advisable to scrutinize too intently. It is a good thing to examine in rapid sequence as many works by a master as are accessible, and then to gather and assimilate the impressions away from the monuments. This is the best way to harmonize the versatility of the critic with the potential abilities of the creative personality.

My essays cannot serve directly as a guide to connoisseurship, and could not do so even if they were more successful and detailed in the characterization. Indirectly—and this is the extent of the modest hope that sustains me—they may facilitate and intensify the study and the enjoyment of the originals. The ability to attribute and check attributions will then follow automatically from study and enjoyment. Yes, from enjoyment!

Many art historians, it is true, make it their ambition to exclude pleasure from art, in which, for obvious reasons, some of them succeed all too well. They are embarrassed and afraid that representatives of the more strictly disciplined sister sciences will not regard them as equals but will suspect them of an entertaining or frivolous occupation. Reasoning based on calculations and measurements is presented as the true method. A dry approach stands high in favour. Abstruseness, involved terminology, which makes the reading of art-historical books such torture, derives from that very ambition. Sometimes there are depths, but so obscure as to be worthless for the reader, generally all is shallow but cunningly troubled so as to suggest depths.

It can never be the aim of a science to ignore the specific and essential quality of its subject—and the specific and essential quality of art is the impression it makes. I do not know what organs would remain with which to apprehend a work of art once enjoyment had been sacrificed to the ideal of ascetic, scientific method.

Aphoristic remarks, put together unsystematically, are best suited to transmit pictorial impressions, to spotlight particular characteristics. I do not believe that a more detailed and fuller description, which would be full of wearying repetitions, could serve the purpose better. Strictest economy of words seems advisable since the receptive power of the reader must be regarded as limited. No reader is able to retain endless descriptions of form and colour.

THE GEOGRAPHY

OF NETHERLANDISH ART

WHEN we speak of Flemish and Dutch painting we mean the entire area—so rich in art during the fifteenth and seventeenth centuries—lying within the political boundaries of Belgium and the Kingdom of the Netherlands. The contrast between Dutch and Flemish is especially clear in the painting of the seventeenth century and a comparison between the personalities of Rubens and Rembrandt imprints it firmly on our minds.

In the fifteenth century the dividing line is not equally clear. The political and religious differences were formed, or at least intensified, by the long wars of independence against the clerical and feudal domination of Spain. As a final result of these wars the Northern states, that is substantially the modern Kingdom of the Netherlands, became a self-contained Protestant community whilst the Southern provinces, that is substantially modern Belgium, remained orthodox and under Habsburg rule. In the South the doors were wide open to the influx of Latin culture; the North shut itself off with puritanical strictness and preserved its Germanic culture intact. In the fifteenth century the Netherlands were more of an entity with a uniform culture and the Germanic essence, blended it is true with Latin elements from France and Burgundy, flowed through the entire land. In their critical study of painting scholars have attempted, with some success, to discern even in the fifteenth century the contrast that was later to become so evident, but the scarcity of monuments in present-day Holland—a result of the iconoclasm of the sixteenth century—is a serious handicap.

To apply the term 'Flemish' to the Habsburg states in the South is not correct and posits a part for the whole. Strictly speaking this geographical concept embraces only the two counties of Flanders but leaves out Hainaut, Liège, Brabant and other parts which had a greater share in the art life of the non-Dutch Netherlands than had Flanders. It would be better to expand the concept Flemish, not incorrectly, and speak of the

Southern Netherlands, modern Belgium, as opposed to the Northern Netherlands, modern Holland.

The artistic predominance of the Flemish provinces is a mere illusion. Bruges and Ghent in the fifteenth, Antwerp in the sixteenth century were flourishing commercial centres with an international prosperous mercantile society which attracted artistic talent. In addition to the Burgundian princes, who were of real importance as patrons of artists and introduced the exacting demands of the French court, we note with some surprise a comparatively large number of Italian merchants as patrons (Tommaso Portinari, Jacopo Tani, Giovanni Arnolfini and others). In the sixteenth century the export of art works to Spain assumed vast dimensions and Spanish demands determined the work in the Antwerp workshops. A study of Dürer's Netherlandish diary gives a good idea of the international character of the upper strata of the Antwerp population.

If then what we might call the consumers were by no means pure Flemish, the producers were still less so. Of the masters who set the course for Bruges art hardly one was of Flemish origin. Jan van Eyck came from Maaseyck, a place on the Meuse north of Maestricht, where the political boundaries of Belgium, Germany and Holland meet. The area around Maaseyck should be kept in mind as a central source for Netherlandish art. Hans Memlinc came from Germany, presumably from Mömlingen on the Middle Rhine,[1] Gerard David from Oudewater, which lies in Holland between Gouda and Utrecht. Jan Provost was a native of Mons, that is to say from Hainaut in the South, Ambrosius Benson from Milan. With the exception of Hugo van der Goes and Justus van Gent who may have come from the Flemish city of Ghent, no important painter of the fifteenth century, and very few of the sixteenth, can with any probability be traced to Flanders.

Round about 1500 Antwerp became the artistic reservoir and melting pot. Painters gathered there from every province in the Netherlands. Of the celebrities who determined the character of the art of Antwerp with its flourishing export, Quentin Massys had immigrated from Louvain (Brabant), Jan Gossaert from Maubeuge (Hainaut), the Master of the Death of the Virgin is probably identical with Joos who came from Cleves. Large numbers of unknown artists are entered in the surviving Antwerp guild lists and in many cases the names, though they tell us nothing else, at least show the place of origin. The North (Holland) and

*[1] Cf. p. 41 note 1.

the East (Northern Brabant and Limburg) seem to have been particularly rich in artistic talent. Roughly speaking the situation may be summed up as follows: the flourishing commercial cities, Bruges in the fifteenth century, later Antwerp, were comparatively poor in artistic talent but attracted artists from all parts of the Netherlands, particularly from the East. If we draw a circle with Antwerp as centre and Antwerp-Maaseyck as radius the circumference line runs roughly through the places of origin of the painters whose influence was decisive, namely Tournai (Rogier van der Weyden and Robert Campin, who is presumably identical with the Master of Flémalle), Mons (Provost), Maubeuge (Gossaert), Dinant (Patenier), Hertogenbosch (Jerome Bosch), Oudewater (Gerard David).

Any consideration of Netherlandish art from the racial angle must be largely determined by linguistic boundaries and, moreover, conclusions necessarily drawn from modern conditions are bound to be of doubtful validity for the fifteenth and sixteenth centuries. The Flemish cities which were presumably entirely Germanic in the fifteenth century can, according to my interpretation, be left entirely out of account.

Holland, the influence of which in the structure of South Netherlandish art was demonstrably strong, may be regarded as a Germanic area. The area of Northern Brabant (Hertogenbosch, Limburg, Maaseyck) must be described as predominantly German in the wider sense, so that not only Geertgen, Jan Mostaert, Lucas van Leyden, Jacob van Amsterdam but also Jerome Bosch and Pieter Bruegel of the later artists, and Pol de Limburg and his brother—outstanding book illuminators in the service of French princes at the end of the fourteenth century—and the brothers Hubert and Jan van Eyck may be accepted with some degree of probability as painters of Germanic extraction. On the other hand the racial origin of the artists who came to Brabant and Flanders from the South seems problematical, namely the painters who were born at Tournai, Mons, Maubeuge, Dinant.

How to classify the Master of Flémalle and Rogier van der Weyden is a particularly important question. According to recent research the Master of Flémalle seems rather older than Rogier, almost a contemporary of Jan van Eyck, and his genius is regarded as at least equal to that of Rogier, though, admittedly, in his types and compositional motifs Rogier obviously exerted a stronger and wider influence than any other painter of the fifteenth century. It is now assumed on very plausible grounds that the Master of Flémalle is identical with the Robert Campin who is documented as teacher of Rogier at Tournai. If this is correct then

the two masters represent an art that was native in Tournai, the peculiarities of which, especially in their contrast to Eyckian art, are more pronounced in Rogier than in the Master of Flémalle.

Tournai lies in the French-speaking zone. There is, I am afraid, no satisfactory scientific method of determining Rogier's racial derivation but it would be tempting to regard the contrast between Jan van Eyck, who came from the East, and Rogier, who came from the South, as a conflict between the German and the Latin temperament with the towns of Flanders providing the battleground. Round about 1450 the battle seems to be going in Rogier's favour.

It is not hard to recognize the far-reaching difference between Jan van Eyck and Rogier, but it would be imprudent to regard the two personalities as representative of their respective races. At any rate the utmost caution should be exercised. If we possessed a greater number of both French and Dutch, i.e. Germanic-Netherlandish, paintings of the fifteenth century, a careful check-up might prove fruitful. We could then contrast what the Dutch and the Van Eycks have in common on the one hand with what the masters of Tournai and the French have on the other. Unfortunately we possess very few purely Dutch and still fewer French paintings so that the examination of a rich and varied material becomes impossible.

The genius of Jan van Eyck certainly transcends purely racial qualities whilst the fanatically bitter spirituality of Rogier seems more individually than racially determined. But to a certain degree only. And it is in the estimation of this degree that the almost insoluble difficulty lies.

Essential for Jan van Eyck's art is the positive pleasure, the indiscriminate unprejudiced delight in the appearance of things. The illusion itself is the goal, reached in a blaze of triumph. He accepts the whole of the visible world without any preferences. Searching observation and a persistent study of the model suppress subjective invention and sweep tradition aside.

Compared with Jan van Eyck, Rogier seems immaterial and intellectual. The subject-matter dominates him from the outset and he works under the spell of traditional pattern but his mind is rich in imagery. He looks at nature with a selective eye and never follows her call down unknown paths to adventure. Pure in style, with a surely controlled austerity of expression that befits the devotional picture, his art appears poor and monotonous compared with Jan van Eyck's art, which finds constant renewal in the infinite richness of nature. Jan van Eyck is an explorer (Rogier is an inventor). He perceives air, light and chiaroscuro and how things

are related in space. Rogier composes like a sculptor, a carver in relief, by isolating the figure groups in his mind and adding the landscape backgrounds; he disposes the plastically conceived figures on the surface like a draughtsman by emphasizing the contours, Jan van Eyck conceives and represents as a painter. Beside Rogier's elaborately constructed compositions Eyck's works have the accidental charm of the picturesque, the pulsating warmth and individual richness of life itself. By the impetus of his thrust Jan van Eyck is carried further towards his own goal than any other painter of the fifteenth century. Taking the contrast between Eyck and Rogier as a touchstone for the evaluation of the other known Netherlandish painters, Geertgen tot Sint Jans of Haarlem, who represents the purely Dutch art, stands closer to Eyck than to Rogier.

Apart from personal genius that triumphantly transcends place and time, we may regard as Germanic heritage the impulse to observe nature that bears such fruit throughout Eyck's work and confers a universally acknowledged superiority on Netherlandish panel painting. Rogier's constructive form, and clear-cut pictorial ideas, which for two generations supplied Netherlandish workshops and painters far beyond the boundaries of the land with a formalized pattern of expression, can be regarded as half French. For is not the contrast between Claude and Ruysdael, between Watteau and Gainsborough, too, in some measure the contrast between the constructive draughtsman and the observant painter? France's supreme achievement in religious architecture and in the grand sculpture of the Middle Ages went far beyond what was achieved in the Germanic lands. An additional symptom of the innate French genius for architecture and sculpture.

The Southern Netherlands, especially the cities of Flanders and Brabant that flourished in the fifteenth and sixteenth centuries, draw their artistic talent from the half-French South and the Germanic East. The North Netherlandish, Dutch art may be regarded as purely Germanic, whereas in Flanders and Brabant Eyckian observation blends with the formalism of Rogier, the German with the Latin.

JAN VAN EYCK

HISTORY checks the flow of events and bestows a false importance on certain personalities by calling them founders and inaugurators. We do not do otherwise—even though our conscience may be more troubled—than did Carel van Mander, a Netherlandish painter who around 1600 zealously collected information from traditional sources on the painters of his country. This chronicler begins the history of Netherlandish painting, or at least his series of vitae, with the Van Eycks, just as we begin the history of the printed book with Gutenberg.

Naturally there were painters in the Netherlands before the van Eycks. Naturally the van Eycks were sons as well as fathers. Van Mander's idea was mistaken but it was a mistake in which was expressed a tradition that was widespread around 1600. The painters of the sixteenth century venerated the van Eycks as ancestors and founders of their craft. In the North they were the first to emerge with a personal achievement from the 'dark' Middle Ages with their anonymous craftsmanship. Only the creative power of genius could bequeath a memory that was woven into the Eyck legend, the Eyck cult.

We should argue along these lines even if nothing had survived of the brothers' work. But the vivid impression of the existing monuments blends with the venerable tradition. With the van Eycks a source of power seems to erupt from the ground. Nothing comes out of nothing. But what goes on underground is hidden from our eyes. Here if anywhere the mistaken idea of a beginning is excusable and is indispensable for the historian.

Jan van Eyck, the younger brother, is supposed to have invented something, namely oil painting—for the Netherlanders of the sixteenth century this meant quite simply painting. It was thought that quotations of old painter recipes, long before the van Eycks, in which oil is mentioned, could do away with this tradition. Jan van Eyck's painting technique differed from that of his predecessors. But the chronicler naively confuses cause and effect. The invention did not come first. Jan van Eyck—or Hubert van Eyck—was not able to paint as he painted after and because he had invented the technique of oil, rather is it true that he found new

media because the urge to paint as he painted could not be satisfied with the media hitherto in use. His search for new processes was stimulated and guided by observation, imagination and creative will.

Even though the age and the people had their share in this innovation, the inborn love of heroes could have found expression here had not two personalities instead of one laid claim to the honour of the one achievement, namely Hubert and Jan. If genius is rare then the law of averages makes us quite incredulous at the tidings that one pair of parents could produce two geniuses as sons. Wherever two brothers combine for one creative task we suspect from the very outset that one of them is a subordinate assistant. The happy collaboration of craftsmen is conceivable but the way of genius is to command or to repel. Again and again this persistent prejudice has urged historians to make a clean sweep once and for all of the legend of the two founders of Netherlandish painting.

The Ghent altarpiece bears an inscription which reads in English: 1–10 "The painter Hubert van Eyck who was surpassed by none (*maior quo nemo repertus*) began the work. Johannes, second in the art, completed it at the request of Jodocus Vyd in the year 1432 on the 16th of May." This text, which is not everywhere fully intact, poses almost as many problems as it answers.

Should the order of precedence of the brothers be simply accepted? Should it be regarded as a pious lie or a modest piece of self-deception on the part of the younger brother, who was responsible for the inscription? It remains probable that Hubert undertook the Ghent altarpiece which, about the year 1420, was designed to surpass all other altar decorations in the Netherlands in size and richness of content. If nothing had survived but the Ghent altarpiece we would accept without question the order of precedence of the inscription and regard Jan van Eyck as the collaborator, pupil and imitator of his elder brother. But apart from the Ghent altarpiece works by Jan have survived, done by him alone, after the death of Hubert (1426), works unequivocally signed with his name, devotional panels and portraits such as the van der Paele altar panel of 1436 and the *Arnolfini Couple* of 1434. In view of these works by Jan it 16, 20 becomes difficult to uphold the order of precedence of the Ghent inscription. There means and end seem in perfect harmony. The instrument is handled as only he can handle it who has made it for himself. Could such skill really be inherited and not acquired?

The scales are almost equally balanced. On Hubert's side in addition to his being the first-born is the superlative of the Ghent inscription; on Jan's side is the ever renewed impact of his pictures and, though this

carries less weight, his fame in olden times—Hubert's name was almost forgotten.

Critics approached the Ghent altarpiece confidently, convinced that stylistic analysis could solve all problems. The composite altarpiece, however, gave a different answer to each observer.

Every conceivable argument has been used to separate Hubert's share from that of Jan. It would be waste of time to compare the results. Dvořák's division[1] is the only solution which, if not correct, is at least satisfying in principle. The representatives of two generations, of two phases of art, are revealed in the Ghent altarpiece, or, if this aim is not achieved, at least the trend of the analysis is significant. Hubert's personality takes shape in the thoughtful and detailed study of the Vienna scholar as a master of the older generation who executed in what we can see today the three main figures of the upper row and some half of the central panel below. Dvořák attempts to show that these parts are conceived in a fundamentally different manner from the rest, that they had no part in the specifically Eyckian achievement. It was Jan who took the decisive step. Consistently, Dvořák claims all Eyckian paintings, even the unsigned ones, apart from the Ghent altarpiece, for Jan. In this interpretation Hubert's personality goes under, submerged in the general anonymity of pre-Eyckian craftsmanship.

Dvořák's interpretation has not been generally accepted. Over and again attempts have been made to place Hubert next to Jan as a personality of equal importance. Even the idea that Jan's art, like the moon, shines only with reflected light, the afterglow of Hubert's art, even this idea persists.

Jan's accredited works together with the information about him gleaned from archives give a tolerably well-defined picture. We first hear of him in the service of Count John of Holland (1422) and, immediately after that patron's death, of Philip of Burgundy. The warlike and splendour-loving rulers of those days restricted their luxury and their love of art to easily transportable things, to rich materials, jewels and books. For camp and tent life they favoured a maximum of art in a minimum of bulk and weight. The concentrated preciosity of Eyckian art was certainly calculated to satisfy this desire.

In a letter of the year 1524 we find the following revealing passage: *gran maestro Joannes che prima fe l'arte d' illuminare libri sive ut hodie loquimur miniare.* . . . According to this Jan began by doing book illuminations, had therefore probably been trained in a book illuminator's

[1] Vienna *Jahrbuch*, vol. XXIV.

workshop. Did the master's art evolve from older book illumination and is that the reason for its contrast to the panel painting of his own generation? The theory finds support from more than one side. Viewed in its relationship to the book illumination that had developed on French soil around 1400 (with, so it would seem, the decisive participation of Netherlandish artists) Jan's art, though it loses none of its brilliance, originality or historical importance, does lose some of its inexplicability.

Until 1902 Eyckian miniatures were only dreamed of. Then the un-expected that might have been expected actually happened: Eyckian miniatures came to light. Art criticism reacted as it always does on such 22, 23 occasions, turned a deaf ear, refused to accept the new. In 1902 Durrieux published *Les heures de Turin*, a fragment of a prayer book, on which quite obviously various hands had worked at different times, and in which several pages have an Eyckian flavour. Two years later this prayer book fell a victim to the flames. This, the most serious loss sustained in recent times in the world of art, is slightly mitigated by three circum-stances. In the first place, immediately before its destruction, the book attracted attention and was published in reasonably good collotype. Secondly Georges Hulin, the keenly discerning critic of early Nether-landish painting, examined the pages thoroughly, found in them the key to the solution of all Eyckian problems and set down the results of his examination. Finally a second fragment of the prayer book turned up at Milan in the Trivulziana[1] and in this part too there are pages of an Eyckian character.

One page of the Turin fragment represents Duke William of Bavaria on horseback with his retinue on the shores of the North Sea, offering up a prayer to heaven. The prayer book was owned by this duke sometime between 1414 and 1417, the year of his death. The miniature is thus dated, excitingly early, considerably earlier than any other known work by the van Eycks. Several more pages at Turin and Milan are certainly by the same hand of approximately the same date (the book contains in addition considerably older and appreciably younger work). That the Eyckian style should have been imitated by about 1417 in a book illuminator's workshop seems in itself highly improbable and in addition, the freshness, freedom and boldness of the illuminations (even in the poor reproductions) compel us to attribute them to the founder of Nether-landish painting. Particularly in the landscape painting, in the observa-tion of light and in the mood, the miniatures, limited as they are in size, surpass everything else we have of the van Eycks. The art revealed here

*[1] This part is now in the Museo Civico, Turin.

does not by any means differ from the art of the panel paintings in the sense that it is inferior or derived. Even those art critics who do reckon with the possibility of change generally forget to reckon with its necessity. Jan van Eyck must have painted otherwise in 1417 than in 1427.

The master of 1417, whoever he may have been, began the conquest of the visible world in landscape, rendering it with unparalleled illusion not only in the structure but also in the conditions of light, and endowing it with permanent validity. The local colours are adjusted to the dominant tone with inexplicable confidence. The gliding of shadows, the rippling of waves, the reflection in the water, cloud formations: all that is most evanescent and most delicate is expressed with easy mastery. A realism that the entire century failed to reach seems to have been achieved once by the impetus of the first attack.

The figures, in strange contrast to such freedom in the landscape, are closely linked to the Gothic tradition, little individualized, with flowing garments and of uncertain construction.

Hulin (in his publication *Les heures de Milan*) believed that he had discovered in the prayer book something more than the Eyckian style of 1417. It seemed to him, that the personalities of Hubert and Jan emerge here more distinctly than in the Ghent altarpiece.

In addition to the admirable pages in the *Turin-Milan prayer book* there are a few others, that deviate in style, which also have an Eyckian character, but Eyckian in a different sense, matter-of-fact in the landscape with no atmospheric charm and with stiff, straight drapery folds. Not a single page of this second group can be dated. If, as Hulin assumes, both groups originated around 1417 then the old problem is solved. Hubert— and this is Hulin's momentous conclusion—produced the miniatures of the first group, which appear archaic as a whole, Jan the superficially Eyckian but weaker pages of the second group. That is to say the order of precedence of the Ghent inscription would be confirmed. Hulin did not hesitate to draw the consequences from his division of the miniatures and attributed panels such as the wing panels in St. Petersburg[1] and the
13 Berlin *Madonna in the Church* to the elder brother.

I have never, unfortunately, seen the Turin fragment and hesitate to contradict the Belgian scholar, whose revolutionary proposal is the apparently inevitable result of a study of the miniatures. I cannot, how-ever, suppress some doubts. The weakest point in Hulin's argument is the impossibility of dating the second group. The wide divergence of style between the two brothers around 1417 seems remarkable. Surely at such

*[1] Now in the Metropolitan Museum of Art, New York.

an early date the difference in style should be slight. About 1425—in the Ghent altarpiece—the discrepancy is far smaller and so indistinct that even Hulin does not dare to attempt a separation between the two hands.

I am in complete agreement with Hulin's verdict on the first group and do not consider his praise of these pages in any way exaggerated. He who produced them was the founder of Netherlandish art. And if Hubert is the author then the inscription *maior quo nemo repertus* is true and Jan would be relegated to second place. My opinion of the second group differs from that of Hulin.

These pages are Eyckian but they lack the style characteristics of the early primitive. Their quality is by no means so exceptional that it could not have been attained by a follower of Van Eyck around 1440 (at this late date work was still being done on the prayer book). If by such a valuation the second group is set aside then the way becomes free— contrary to Hulin's view—to install Jan as the author of the first group. This change certainly has some advantages. In 1422 Jan was in the service of John of Bavaria; all the more probable that he had previously been associated with John's brother William of Bavaria, whereas there is no record of a connection between Hubert and any royal personage. In olden times Jan (not Hubert) was spoken of as a book illuminator.

The attempt to obtain an over-all picture of Jan's art, to trace a line of development with some degree of probability by including the miniatures in his *oeuvre* leads to a tolerably satisfying result. Those panel paintings that a few experts have always regarded as particularly early works by Jan, such as the *Crucifixion* in Berlin, the *Three Maries at the Sepulchre* in the Cook collection, Richmond,[1] and the wing panels in St. Petersburg, are closest to the miniatures, the panels produced after the Ghent altarpiece are furthest away. The line of development can be drawn through the Ghent altarpiece. If a corresponding attempt is made to draw a line from Hulin's second group to the late signed panels of Jan then the result, it seems to me, is less satisfying.

I am well aware that my reconstruction is one which, though it yields a full picture of Jan's art, has, in addition to other weaknesses, the disadvantage of leaving Hubert's personality in the obscurity to which Dvořák banished it.

In their colour effect Jan van Eyck's pictures show the same characteristics that first strike one in Rembrandt's paintings: they are dark without being black. They are brunette, warm, golden, a darkness that glows with colour. They have the inner brilliance of a precious jewel-like

*1 Now in the Museum Boymans-Van Beuningen, Rotterdam.

substance. Certain materials such as brittle, scaly, splintered rock, downy feathers, hair, and fur, creased silk or the shining gleam of armour, are set off with all the delight of a discoverer. The discerning drawing that searches out the detail never becomes laborious. A soft colour harmony encompasses and unites the steely sharpness of the formal design. The linear framework of the flesh is built up with folds, furrows and incisions full of brooding darkness. The internal drawing is rich in detail. The outer contour on the other hand is often lightly blurred with shimmering colour, whereas the painters of the fifteenth century normally define essentials in sharply etched outline.

Realism and illusion are all the more exciting at this stage because they are not consistently applied to the whole and to all the parts. Particularly in the works of Jan that I regard as early, but also, though less obviously, in his latest works, the basic conditions of realistic expression remain unfulfilled in the linear perspective and in the proportions of the figures to the surrounding space, conditions that in a later generation were fulfilled even by bunglers. The unity of lighting is an achievement of genius, centuries in advance of the time, but Jan never masters linear perspective. Conventions of form which derive from Gothic tradition, especially in the drapery and the female heads, are in sharp contrast to miracles of individual realism.

In the picture that bears the strange inscription *Johannes de Eyck fuit hic 1434*[1] one of the treasures of the National Gallery, London, a problem has been solved that no painter of the fifteenth century dared to set himself again—that of placing two people, in full-length figure, side by side in a richly appointed room, the Lucchese merchant Giovanni Arnolfini and his wife. A glorious example of the sovereign power of genius! The figures are a little too large but they stand freely in space and air in the shadowy room, for every nuance of colour has been seized with automatic dream-like assurance. The achievement lies in the ability to adapt the complex colour design to a single source of light, to conceive the figures and picture space as a whole, rather than in the careful fashioning of details.

The task was to paint the double portrait of a married couple but it would seem that the master was impelled not only beyond the limits of his theme but also further than the bounds of his own idea. The result surpasses the aim: certainly a sign of creative genius. Every sensitive observer is stimulated to wandering speculation and poetic phantasies.

[1] The meaning of this strange inscription has been elucidated by Prof. E. Panofsky (in *The Burlington Magazine*, vol. lxiv, 1934, pp. 117 ff.), who regards the painting as a marriage picture and interprets the inscription as "Jan van Eyck was here (as a witness to the marriage)".

We are tempted to interpret the solemn, stiff closeness of the man and the woman in a general, a symbolic way. The 'correct' explanation seems inadequate because it does not do justice to the mood into which the picture plunges us.

Only he who observes superficially is content to admire the amount of formal details and shades of colour that Jan van Eyck has conjured so minutely on to inch-sized surfaces. The more sensitive observer will not fail to note that this work was done in hot-blooded exaltation rather than patiently and with measured skill. Over and beyond this it becomes clear that this passion for appearance, this ferreting out of formal complexities, this respect for the material are born of a new feeling that can be regarded as the herald of a new conception of the world.

The human warmth, the perfect balance of sense and spirit were not transmitted to Jan's successors. As we leave him and turn to other painters of the fifteenth century we pass from the richness of a free, colourful, adventurous and seductive world into a monastery where in the cells hooded men, albeit each in a different way according to his temperament and talent, practise the painter's craft.

PETRUS CHRISTUS

JAN VAN EYCK died in 1441 at Bruges, where he had worked for the greater part of his last decade. In 1444 Petrus Christus became free master at Bruges. He was a native of Baerle, probably the place of that name that lies between Tilburg and Turnhout. As far as our scrappy knowledge goes, this Petrus represents Bruges painting for the period between 1444 and 1472, that is to say for the time between Jan van Eyck's death and the appearance of Memlinc. Bruges art in the second third of the century appears to us as the aftermath of the Eyck tradition, whether Christus was a pupil of Jan or not. Actually there is no lack of indications to suggest that several masters who worked in other parts of the Netherlands, such as the Master of Flémalle, Rogier van der Weyden or Dieric Bouts, intervened in some way in the art of the flourishing commercial city. They came and went but Petrus Christus remained. And his dependence on Jan borders on the parasitical.

A reflection of Eyckian art emanates from everything done by Petrus, endowing the poor achievements with prestige and glamour. His doll-like figures are generally of medium height, they have wide heads in which the temples, foreheads and cheeks seem broad and empty, whilst eyes, mouth and nose are close together. The figures are stuck in wide balloon-like garments with contours that are straight or round and everywhere of little mobility. The large high-set ear is often visible. The hands are short and plump. The sparse hair hangs down in strands.

Especially Eyckian is the small panel in the Berlin Museum with the 30 Virgin and St. Barbara, the so-called *Exeter Madonna*, presented by the same Carthusian friar who presented the Jan van Eyck *Madonna with Two* 15 *Female Saints* belonging to the heirs of Baron Gustave de Rothschild, Paris.[1] Petrus Christus borrowed as much as he needed from the richer composition. His holy women do not rise above the level of pleasant friendliness. It is instructive to compare the stiff outline which divides St. Barbara's hair from her face and the dreary contour that terminates the saint's gown with the expressive drawing of the Eyckian model. Most 31 nearly successful in the Eyckian sense is the portrait of a Monk (the halo is probably a later addition) privately owned at Valencia.[2]

*[1] Now in the Frick Collection, New York. *[2] Now Metropolitan Museum, New York.

The series of pictures correctly attributed to the master appears firmly defined. The few dates range from 1446 to 1452 (1457?); the undated pictures do not greatly, if at all, exceed these limits. To the generally known works I might add a small *Head of Christ* seen from the front (the signature indistinct) privately owned by Mr. F. Kleinberger, Paris,[1] as well as an *Annunciation* in a private collection, Paris.[2]

His biggest work, the *Lamentation over Christ* in the Brussels Museum, is 27 rather different from his other works and to some extent problematical. Renewed study of the form always confirms the attribution and I am in no doubt as to the authorship. But in order to explain the strange features, a few astonishingly expressive compositional motifs, the richness and the angularity of the drapery, the intervention of some outside source must be assumed which, in addition to Van Eyck's model, or replacing it, affected Petrus Christus.

One figure, the fainting Virgin, is taken from Rogier's *Descent from the* 53 *Cross* in the Escorial.[3] Other figures, such as the rather isolated one of the mourning Mary Magdalen on the left, are as little credible as inventions of the painter as is the obviously borrowed figure of the Virgin. A comparison between the *Lamentation* in Brussels and the one in New York, which lies well within the scope of Petrus Christus's ability and is little 28 more than a schematic version of Eyckian art, enables us to distinguish between the personal and the borrowed elements in the Brussels panel. The dead Christ is similarly placed in both. But his anatomy is much richer in the considerably larger Brussels panel and recalls Dieric Bouts, whose style is also suggested in several of the heads. Since Rogier's Escorial panel was at Louvain, where Bouts lived, a tempting hypothesis is suggested which could explain the turn in Petrus Christus's line of development: The Bruges master might have seen Rogier's altarpiece during a stay at Louvain and at the same time come under the influence of Dieric Bouts. Though, admittedly, the influx into the stagnant waters of Bruges art may have taken place in some other way.

*[1] Now in the collection of Mrs. W. R. Timken, New York.
*[2] The painting forms part of the Michael Friedsam Bequest to the Metropolitan Museum of Art, New York, where it is now ascribed to "Jan van Eyck and Helpers".
*[3] Now in the Prado, Madrid.

ROGIER VAN DER WEYDEN

ROGIER VAN DER WEYDEN and the Master of Flémalle stand very close to one another. How they stand to one another is a question to which various answers have been given. The Master of Flémalle was so to speak created out of a rib of Rogier's by art critics and as soon as he stood tolerably firmly on his own feet he was regarded as a descendant, as a follower of Rogier.

The only work by the Master of Flémalle which is inscribed with a
42-43 date, the Werle wings in Madrid, was done in the year 1438. We can scarcely with any certainty ascribe one work by Rogier to so early a date.[1] Judging his personality as a whole, the Flémalle Master seems more archaic than Rogier and like a contemporary of Jan van Eyck.

The youthful Rogier appears closer to the Flémalle Master than does the ageing Rogier. There would be less justification for the assertion: It is just the youthful Master of Flémalle who is close to Rogier. What he could have learnt from Rogier the Master of Flémalle does not possess.

It was tempting to experiment with the hypothesis that the Master of Flémalle was Rogier's teacher. As it happens, the name of this teacher is known. At least there is documentary evidence that a Rogelet de la Pasture was apprenticed to Robert Campin at Tournai in 1426. We know that in 1427 another pupil, Jaquelotte (Jaques) Daret, entered Campin's workshop. This fact provides unexpected support for the assumption that the Master of Flémalle was none other than Robert Campin. Fragments of a work executed in 1434 by Jaques Daret were discovered by George Hulin. Two panels of this altarpiece done for the Abbey St. Vaast at
44-45 Arras, the *Visitation* and the *Adoration of the Kings*, are in the Kaiser-Friedrich Museum, Berlin.[2] Jaques Daret, documented as a pupil of Campin and in the closest sense a fellow-pupil of Rogier's emerges from stylistic criticism as a not particularly firm character and dependent on the Flémalle Master.

We can regard as at least an intelligent working hypothesis the idea that Rogier was a pupil of the Flémalle Master at Tournai. The possibility

*[1] Friedländer later assigned a date earlier than 1438 to the following paintings by Rogier: Diptych with *Virgin and St. Catherine* in Vienna, the *Madonna* from the Northbrook Collection (now at Lugano), the *Portrait of a Woman* in Berlin.
*[2] Now in the Staatliche Museen, Berlin-Dahlem.

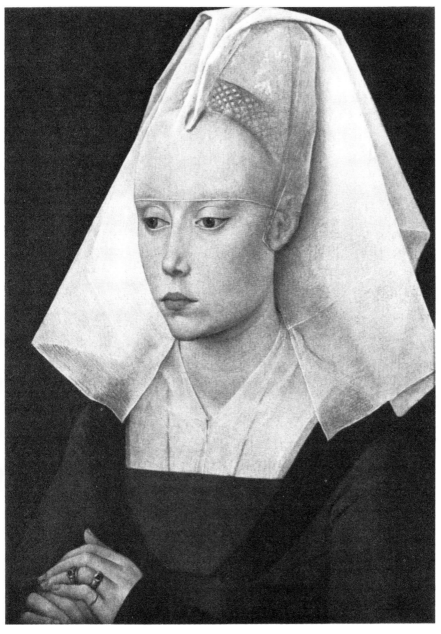

I. Rogier van der Weyden: *Portrait of a Lady*. London, National Gallery

that Rogier as associate and workshop companion also influenced his
teacher is the more plausible when we consider that he was not at the
customary apprentice age but a man of thirty when he worked with
Robert Campin, had possibly already been trained in the paternal sculp-
tor studio,[1] and was by nature strong-willed and dominating.

There is a motif that occurs both on the Werle altarpiece by the
Flémalle Master and in Rogier's altarpiece of the *Virgin* so that a
borrowing from one side must be assumed. The arm movement and
position of the hand of the Saviour appearing to His Mother, in that part
of the altarpiece at present owned by Messrs. Duveen,[2] are similar to the
arm movement and position of the hand of the Baptist in the donor wing
of the Werle altarpiece. As used by Rogier, the movement arises signifi-
cantly from the situation but not so in the Master of Flémalle's version.
The Baptist stands behind the kneeling donor commending and pre-
senting him—a customary motif that is varied here in an unaccustomed
way. Movement and gesture of the Baptist are not readily understood.
The inference that the Flémalle Master was the borrower has often been
drawn. It would be important to fix the terminus ante quem for the
altarpiece of the *Virgin*.[3]

There are other ways open to us for dating the altarpiece of the *Virgin*
but they are increasingly beset by difficulties. The Berlin gallery has an
exact replica of the Granada altarpiece the quality and condition of which
has been judged in curiously differing ways; sometimes it is hailed as an
original, sometimes rejected as a forgery or as over-painted. Since the
Granada version became known, the Berlin replica has been ignored as of
no importance. The Berlin altarpiece is unusually well-preserved, it is in
some respects inferior to the Granada work but can hardly be other than
an extremely careful and highly successful workshop replica.

At Miraflores near Burgos there was, as Ponz recorded in 1793, an
altarpiece of the *Virgin* allegedly presented in 1445, the description of
which, without a shadow of doubt, fits the work that has survived in two
versions. Martin V is said to have presented the altarpiece of Miraflores
to King John II. It remains probable that the Berlin altarpiece is identical
with the Miraflores one. But if we take the tradition of the presentation
seriously then we are forced to assume a suspiciously early date for its

50

42

49

*[1] Recent research has established that Rogier's father was not, as had long been believed, the
sculptor Henri van der Weyden, but the Tournai master cutler Henry de la Pasture. See also
Friedländer himself (in *Die Altniederländische Malerei*, XIV, 1937, p. 81).

*[2] Now in the Metropolitan Museum, New York.

*[3] Friedländer (in *Die Altniederländische Malerei*, XIV, 1937, p. 84) no longer considered the
gesture as of any help for the dating of the New York painting, which he then placed between
1440 and 1445. Cf. also Friedländer, *Die Altniederländische Malerei*, II, 1924, pp. 16 ff.

origin. Rogier was not made free master at Tournai until 1432. For the pope, who died in 1431, to have owned the altarpiece presupposes a reputation of the painter so early as to be hardly credible. At any rate that part of the Ponz report that refers to Martin V is untrustworthy.

Rogier and the Flémalle Master have the kind of relationship that one would expect from a studio association of several years but in character and talent they differ. Each possesses qualities that the other lacks. The Flémalle Master works less purposefully, less comprehensively, unevenly, unpredictable in success as in failure. With a more sensitive eye for the surface, the skin of things, for light, air and colour, he is less interested in construction than Rogier. He proceeds from observation, Rogier from the idea. He approaches us with human and sensuous qualities whereas Rogier's hard and relentless religiosity forbids any intimate approach.

The contrast is not everywhere equally sharp. Rogier's principal work, II, 53–55 the *Descent from the Cross*, now in the Escorial,[1] fortunately fairly well authenticated, is comparatively close to the work of the Flémalle Master. The emphasis on this close connection is one of the best passages in a book that is full of good passages: Friedrich Winkler's *Der Meister von Flémalle und Rogier* (Strassburg, Heitz, 1913). The *Descent from the Cross* is regarded by most people as a fairly early work. I am inclined to place it at the very beginning. Rogier's father was a sculptor[2] and he came from Louvain. The Escorial panel was painted for Louvain, possibly at Louvain.

The *Portrait of a Woman* that came a few years ago to the Kaiser- 68 Friedrich Museum, Berlin, from St. Petersburg has been added to rather than incorporated in Rogier's *oeuvre*, with some hesitation and not without vigorous protests being raised. Of the few voices worth listening to, Winkler's was notable as clearly affirmative, Hulin's, with less assurance, as negative. Hulin was tentatively in favour of an attribution to the Master of Flémalle.

Before the seated *Female Saint*, a fragment in the National Gallery, London, von Tschudi hesitated between the two masters. The head of this saint is close to the Berlin *Portrait of a Woman*.

As we see, the dividing line is not all too clear and the attempt made by Firmenich-Richartz to amalgamate the two masters though it cannot be approved is at least understandable.[3]

*1 Now in the Prado, Madrid. *2 See p. 17, note 1.
*3 While most scholars have remained opposed to this amalgamation, the arguments put forward in support of it by E. Renders (*La solution du problème van der Weyden—Flémalle—Campin*, 1931) were not unfavourably received by Friedländer himself in *Die Altniederländische Malerei*, XIV, 1937, pp. 81 ff. A new solution of the problem has been attempted by M. S. Frinta (*The Genius of Robert Campin*, The Hague, 1966), who suggests close collaboration between Campin and Rogier, especially in the Prado *Descent from the Cross*.

There was a Rogier art that flourished in contact with the art of the Flémalle Master before there was a Rogier mannerism. Rogier's early works, probably done soon after 1430, display more freshness, mobility and truth-to-nature than the tense and spiritualized compositions that we think of first when we hear his name.

The oft-copied *Descent from the Cross*, which made the deepest impression II, 53 on his contemporaries and in which the requirements of the Church are better satisfied than in any other Netherlandish altarpiece, seems to reproduce not life but an image. Where Rogier seeks to imitate living things, with insufficient truth-to-nature he does not get beyond the painted image. Here, where the image is his aim, with excessive truth-to-nature he achieves the uncanny effect of living and animated sculpture.

In a shrine that seems just deep enough to accommodate the life-size figures side by side, as long as their movements proceed parallel to the surface of the casing, are eight figures of equal bulk. The idea is that of a relief modeller, frustrating and almost unbearable for the painter. And yet under such compulsion, so restricted, Rogier produced his masterpiece.

The Passion is brought very close to the faithful, thrust before them so remorselessly that they have no possibility of evasion or escape. No distraction, no softening of the impact, no glimpse of any path that leads away from Golgotha. Isolated, remote, the drama of the Passion in the figure group transcends time and space, is eternalized and true to the doctrine of the Church.

In regarding the Escorial panel and the Berlin *Portrait of a Woman* as early works by Rogier I find myself in agreement with Winkler. But I disagree with him about certain other panels and consider myself justified in adding them here. The group, the entity of which is not disputed, is made up as follows—

Vienna, Kunsthistorisches Museum:
 The Madonna standing. 48
 St. Catherine.
 The panels, each only $7\frac{1}{2} \times 4\frac{3}{4}$ in., form a diptych.

London, Collection of Lord Northbrook:[1]
 The Virgin Enthroned, $5\frac{3}{4} \times 4$ in.

Turin, Galleria Sabauda:
 The Visitation. 46
 The Donor's Wing, each $35 \times 14\frac{1}{8}$ in.

*[1] Now in the Schloss Rohoncz Collection (Baron Thyssen), Lugano-Castagnola.

Of the wings, which belonged to the same altarpiece, the *Visitation* is perfectly preserved, the donor has been painted over but the landscape is untouched and most informative.

Luetzschena near Leipzig, Collection of Baron Speck v. Sternburg:[1]

47 *The Visitation*, 22½ × 14¼ in.

Louvre:
The Annunciation, 33⅞ × 36¼ in.

Antwerp, Royal Museum (Ertborn Collection):
The Annunciation, 7⅞ × 4¾ in.

With reference to the two *Visitations* at Turin and Luetzschena, Winkler expresses the—to me—untenable opinion that they are copies of a lost original by Rogier. If he were right the pictures would have to agree in composition but they could differ in the formal idiom and manner of painting. But the exact opposite is the case. The compositions differ from one another, differ as widely as the identity of the task could possibly permit, style and quality, however, agree throughout: two works, done at approximately the same time by one master, certainly by the same master who executed the small panels in Vienna and London. The two *Annunciations* are slightly weaker.

To begin with I should regard this artist rather as a pupil of the Flémalle Master than of Rogier. The *Annunciation* in the Louvre is reminiscent of the Werle wings by the Master of Flémalle in its spatial construction, in the play of light, in the cast shadow of the sconce. The 48 *Madonna* in Vienna shows surprising similarities to Jan van Eyck, in the movement of the Child and in the fall of the Madonna's mantle. Here the Rogier style does not appear as something adopted or learnt, further developed or modified, rather is it in bud or about to grow rigid.

Our next duty is to compare the group of pictures with the *Descent* II, 53 *from the Cross* in the Escorial. Winkler seems to have regarded the comparison as hopeless from the start. The delicacy of the former appeared to him so far removed from the 'monumentality' of the celebrated work by Rogier that he despaired of the possibility of bridging the gap. Here, as so often in critical considerations of style, too little account has been taken of the extent to which style is conditioned by size and subject-matter. Admittedly, the violent impact of the *Descent from the Cross* is in sharp contrast to the friendly effect of the *Visitations* and *Madonnas*. But if we compare individual details the results are astonishing. The clear-cut

*[1] Now in the Museum of Fine Arts in Leipzig.

head of St. Elizabeth in the *Visitations* at Turin and Luetzschena accords with the head of the weeping old woman on the extreme left of the Escorial panel. The drapery of Elizabeth's skirt, particularly in the Turin picture, corresponds to the drapery of the mourning woman on the extreme right in the *Descent from the Cross*. The quality—at times badly underestimated—of the *Visitations* is not inferior to that of the universally acclaimed Escorial picture. The hand so rich in detail of the Luetzschena St. Elizabeth is strikingly similar to the famous hand of St. John in the Escorial. The head of the small Vienna *Madonna* is shaped and rounded like the women's heads in the *Descent from the Cross*.

There is nothing in the Escorial picture to compare with the land-scapes—particularly rich is the background of the sadly neglected donor's wing at Turin. We must turn to other works by Rogier which I consider to be somewhat later in date, such as the Vienna triptych with the *Crucifixion*. There we find the same rocky, ascending ground, with over- 52 lapping mounds that offer no convenient foothold for the figures, and also similar cloud formations. In their feeling for landscape the *Visitations* stand higher than the Vienna altarpiece and higher than any other work by Rogier. The conception that the further he moved away from the Master of Flémalle the more meagre and arid his landscape became explains the superiority of the *Visitations* in my classification, whereas the assumption that these pictures are the work of a follower of Rogier—still less of a copyist—breaks down.

The moving *Descent from the Cross*, the soft and blooming *Portrait of a Woman* in Berlin and the outlined group of pictures give a richly varied idea of what the master was capable soon after 1432.

Several acknowledged works by Rogier may be dated with some certainty to around 1450. At that time the artist was in Italy, in Rome and Ferrara. It is certain that the portrait of Lionello d'Este, belonging to Mr. M. Friedsam, New York,[1] dates from this time. Probably the altar panels at Frankfurt and Florence are also of the same period.

The panel at Frankfurt seems Italian in its compositional motif. 57 There is at any rate no other *sacra conversazione* of this kind in the Nether-lands. Of the three escutcheons at the bottom two are empty, the third shows the Florentine fleur-de-lys. In view of the fact that on the right stand Cosmas and Damian, the saints of the Medici family, and on the left Peter and John the Baptist, who can be interpreted as the eponymous saints of Pietro and Giovanni de' Medici, and finally since the panel is

*[1] Now in the Metropolitan Museum, New York. The sitter has been identified as Francesco d'Este, an illegitimate son of Lionello d'Este, by E. Kantorowicz (in *The Journal of the Warburg and Courtauld Institutes*, III, 1940, pp. 165 ff.).

said to have come to Frankfort from Pisa, it is surely permissible to con-
nect the commission with the Italian journey and date it accordingly.

A similar argument can be applied to the picture of the *Entombment of*
56 *Christ* that has remained in Italy. This again is a composition apparently
not connected with Netherlandish tradition. Facius describes the central
panel of an altarpiece executed by Rogier at Ferrara in words that fit the
picture in Florence: *in media tabula Christus e cruce demissus, Maria mater,
Maria Magdalena, Josephus ita expresso dolore, ac lacrimis, ut a vero discrepare
non estimes.*

Rogier's art in its 1450 phase can be characterized from the Florentine
picture at Frankfort and from the Ferrarese picture in Florence. His
personal manner has emerged completely, his style is fully developed,
even slightly inflexible. The very fact that he endeavours to assimilate
the art of the Southern altarpiece whilst the types and the formal idiom
to which he was accustomed remain untouched by the breath of foreign
air reveals the firm self-assurance of his character. The figures are sharp
and pointed rather than large and monumental. We are unwilling to
touch them because everywhere corners protrude and because we are
scared of pushing them over. They stand insecurely on the ground.
Their limbs diverge. In spite of intensive modelling in the details they
have little physical substance and weight as a whole. They seem desiccated
and bloodless, with thin limbs narrowing to a point, with joyless careworn
heads. In the drapery are many small motifs but little feeling for the
material itself. In the colour scheme a primitive local colouring prevails
with no apparent interest in the unity of light or mutual accord. The
linear element is unusually conspicuous. Contour and inner lines are
incisively drawn. Looking back we realize that the further Rogier re-
treated from the Jan van Eyck and Master of Flémalle orbit the more his
types became remote from nature and the more he evolved what we might
call a graphic method.

For all that the altar panels executed around 1450 are dominated by
an ascetic gravity and an uncompromising stylistic purity which, from
an otherwise sensuously oriental art, singles out such distinctive produc-
tions as devout in a higher sense and assures them spiritual and intel-
lectual superiority.

I know no other work in which Rogier expresses himself with such
impressive eloquence as in the triptych acquired by the Louvre from Lady
Theodora Guest. Side by side in archaic, rigid symmetry are the half-
length figures of five holy persons: exactly in the centre, in full front view,
the threatening sombre form of Christ with wide-open eyes, to the right

and to the left in three-quarter profile turning to the centre, first John the
Evangelist and the Virgin, and on the wings Mary Magdalen and John 51
the Baptist. Purified and detached from earthly trivialities, here where
the task is conceived hieratically, the abstract stylization appears in-
evitable, the only solution, in no sense a defect or a limitation. The clear,
richly detailed landscape is merely a filling for the background. The
figures pushed close together conceal the middle ground. No one would
dream of asking where exactly in heaven or on earth these figures could
dwell.

Rogier's imagination is wholly absorbed by the images of sacred
personalities and therefore creative beyond any of his contemporaries in
inventing types; he visualizes his creations as a sculptor sees them com-
pletely isolated from their environment. The landscape, even though it is
constructed with understanding and accurately developed, is an adjunct.
Therefore the point where landscape or building on the one hand and
the figures on the other meet is a critical one. We would be hard put to
find in the master's work a single figure who stands, sits or kneels com-
fortably or naturally.

As Rogier worked with uniform care throughout and made use of his
stock of types untroubled by impressions of nature, it is not too difficult
to recognize the works of his mature and late periods. It reflects little
credit on art criticism that until quite recently so many of his works could
give rise to so much disagreement. It is to be hoped that Winkler's
sound and positive book has put an end once and for all to many
uncertainties.

The Beaune altarpiece to be sure has never been challenged—perhaps 62–64
only because so few critics have seen it—the triptych with the *Sacraments* 60–61
in the Antwerp museum, painted for Jean Chevrot, incomparably rich in
invention and apart from a few male heads perfectly preserved, has been
quite unreasonably doubted. A little weaker but nevertheless an original,
probably rather later in date, is the *Entombment* in The Hague, which even
Winkler criticizes with unjust sharpness.

A work that has seriously prejudiced our idea of Rogier's art must be
withdrawn from his *oeuvre*, namely the altarpiece in the Prado known,
though with insufficient justification, as the 'Cambrai altarpiece'. This
name crops up in all the Rogier literature and in view of the fact that
documents referring to an altarpiece commissioned from Rogier in
1452 for Cambrai are known the Madrid work has always received
prior, and serious, consideration. Even if—and this is by no means certain
—the altarpiece supplied by Rogier to Cambrai should turn out to be

the one in Madrid it would not be of much advantage for our under-
standing of Rogier's art. To all appearances the Madrid panels which
constitute the so-called Cambrai altarpiece were executed by a follower
of the master, at best then, provided the documents have been correctly
interpreted, in Rogier's workshop.[1]

Since Rogier's creative form was not constantly nourished and renewed
by direct observation, formulism and routine became an ever-growing
threat. The danger was that the master might become his own imitator.

Dated works of the late period authenticated by inscriptions, which
could confirm or refute the perhaps rather prejudiced opinions, do not
exist. If we feel that a work such as the *Columba* altarpiece in the
58 Pinakothek in Munich, with the crowded *Adoration of the Kings* on the
central panel, is a particularly late achievement we are guided by our
belief in the above conjectured law.

The relationship of Memlinc to Rogier offers a welcome though not
very extensive aid to the dating.

Memlinc takes over compositions and types from Rogier, modestly and
59 in good faith. He knew the Beaune altarpiece, as well as the *Bladelin* and
Columba altarpieces, or at any rate knew the compositions, from sketches,
drawings or copies of them. His style proceeds more from the *Columba*
altarpiece than from any other known work of his master. We are inclined
to believe that at the very moment when this altarpiece was being pro-
duced he was a pupil in Rogier's workshop and helped in its production.
It is impossible to determine with any certainty just how long Memlinc
remained under the spell of the Brussels master. The nearest one can say
is some time between 1455 and 1464, the year of Rogier's death.

The head of the Madonna, the centre of the *Columba* triptych, may be
regarded as the prototype of many of Memlinc's Madonnas. Among
Rogier's works the large and rather empty *Annunciation*, acquired by
Pierpont Morgan from the R. Kann Collection and previously in the Ash-
burnham Collection,[2] is related to the altarpiece at Munich.

Rogier's active, constructive and systematic mentality condensed the
achievements and observations of the Master of Flémalle into formulae.
His incisive characterization enabled the pictorial ideas to be trans-
mitted and disseminated abroad by various means and also with the aid
of prints. He, more than any other Netherlander of the fifteenth century,

[1] Vrancke van der Stockt, the successor of Rogier as official painter to the city of Brussels, has
been identified by Hulin de Loo (in *Biographie nationale de Belgique*, XXIV, 1926–29, col. 66) as
the author of the so-called Cambrai altarpiece. This identification has been fully accepted by
Friedländer (*Die Altniederländische Malerei*, XIV, 1937, pp. 86 ff.).

[2] Now in the Metropolitan Museum, New York.

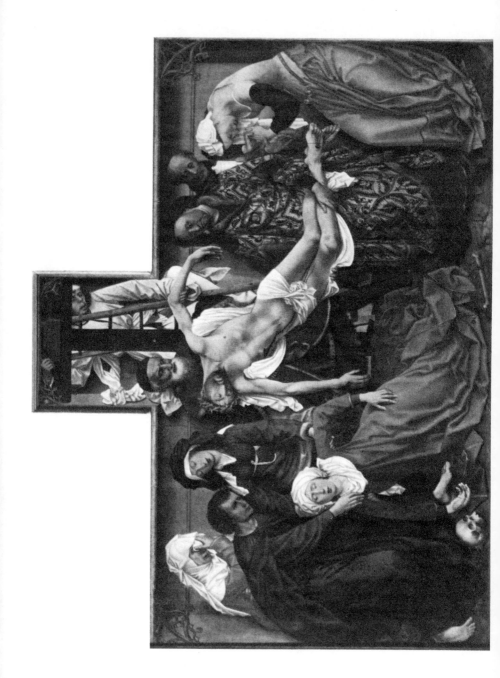

is the true progenitor. Many things derive from him, not only in the Netherlands, but also in France, in Spain and in Germany. His sermon, searching and inspiring even in faulty translations, reverberated far and wide.

A biassed, unjust but pertinent judgment was formulated by Fr. Knapp in an article on the Würzburg art collections.[1] He reproachfully calls the Brussels master the 'Man of Destiny' and holds him responsible for the reversion in Southern Germany to the 'over-stylized Gothic'. A reproach of this nature does more to honour Rogier's inflexible stylistic ideal than do all the tributes otherwise paid to his art.

[1] In the Munich *Jahrbuch*, 1914.

DIERIC BOUTS

VAN MANDER counts Dieric Bouts to the Dutch painters and mentions him together with Ouwater and Geertgen. He found a trace of him at Haarlem. There, in the Cruysstraet, not far from the orphanage, he was shown the house where Dieric Bouts was supposed to have lived. The only painting by the artist that he was able to see—at the house of Gerritsz Buytewegh at Leyden—bore an inscription saying that it had been painted at Louvain in 1462 by Dieric Bouts, a native of Haarlem. As a matter of fact we do find a Dieric Bouts at Louvain who worked for that city between 1450 (?) and 1475 and was twice married.

The documented and accredited work that he executed between 1464 and 1468 for the church of St. Peter at Louvain, the altarpiece of the
81 *Sacrament*, has survived and forms the basis for constructive stylistic criticism.

In view of the master's origin various qualities of his art have from time to time been singled out as national Dutch. The danger of getting caught in a vicious circle is obvious enough when we consider that, apart from Dieric Bouts, we know next to nothing about Dutch painting prior to 1450.

Dieric's style, as we know it in Louvain, is in some respects dependent on Rogier's model. Whether or not we go so far as to assume that Bouts came to Louvain from Haarlem via Brussels, spending some time in Rogier's workshop on the way, the Rogier formula is in any case an element that must be eliminated if we wish to appreciate the personal and the Dutch elements in his style.

The Louvre owns a *Lamentation* which from stylistic evidence can be
77 attributed to Bouts but which in its compositional motifs derives from Rogier. The stiff, rigid body of Christ lying diagonally on the Virgin's lap is—unnaturally—turned to the front, towards the picture surface, in a manner similar to that in Rogier's altarpiece of the *Virgin* at Granada.

In the altarpiece at Granada and in the altarpiece of *St. John* in Berlin, the Brussels master developed a particular type of altarpiece. The main scenes are enclosed in a Gothic portal framework and the painted sculpture, in the small groups of the intrados, contains a rich narrative material. I do not doubt that this mode of composition was very much in

(26)

the spirit of Rogier and even if he did not actually invent it he certainly developed and popularized it (around 1440). Bouts adopted this type of composition in his triptych at Valencia (replica at Granada)[1] and in four altar panels of the same size in the Prado. The figure of the Rising Christ 72–75 at Valencia is modelled on the small figure in the background in Rogier's altarpiece of the *Virgin*.

The connection with the Brussels master makes it probable that we have here relatively early works of the Louvain master, particularly as his chief work, executed in the 60's, is not so clearly reminiscent of the prototype.

A study of the four panels in the Prado enables us to define the relationship even more precisely. We note a connection with Rogier in superficialities, the following of a fashion. Perhaps the commission required portals and portal sculpture. The style, unaffected by Rogier, seems to be Dieric's personal style in an otherwise unknown, certainly early, Dutch phase.

I imagine that about 1440 Bouts, as a mature artist, left Haarlem for the West, that he was not trained in Rogier's studio but that he did succumb to the art dominating Brussels and radiating to Louvain at that time, gradually, however, freeing himself from the pressure.

The pictures in the Prado represent *The Annunciation, The Visitation, The* 72–75 *Nativity* and *The Adoration of the Kings*. Certain parts have been crudely retouched. The *Annunciation* is well preserved, except for the white robe of the Angel. In the *Visitation* wide areas have been worked over such as the red robe of St. Elizabeth and part of the blue one of the Virgin, part of the landscape, almost the entire ground. Notably the head of the Virgin is well preserved. In the *Nativity* the head of the Child has been touched up; ground, landscape, sky, heads are intact. The *Adoration of the Kings* is the best preserved.

The figures are short with massive heads, far removed from the leanness and the jagged, widespread contours of the Rogier forms, differing too from the rigidly taut figures that Bouts favoured in the 60's. The folds are simple, not nearly so conspicuous as Rogier's drapery lines. The observation penetrates lovingly to the details and in certain bits, such as the hands of the oldest king in the *Adoration*, comes startlingly close to nature. The texture—brocades, hair—is rendered with almost Eyckian passion. The panels as a whole are far more humane and warm-blooded than anything of Rogier's, more too than Bouts elsewhere. Though some

*[1] According to Friedländer's later view (as expressed in *Die Altniederländische Malerei*, XIV, 1937, p. 90) the Granada version is the original and the Valencia triptych a smaller, but very exact replica produced in the master's workshop.

general and familiar characteristics of the Bouts idiom emerge clearly
enough in his female types, such as the short noses, the small, apparently
blinking eyes, the strong reflecting lights, particularly striking in the head
of the Virgin Annunciate, yet the confidence, intimacy and archaism
dispel any idea of imitation. Everything accords with the theory that
Bouts developed this style in Holland. The impression of space is con-
vincing as is the uniform treatment of light with cast shadows and colour
perspective. At this stage Bouts is scarcely affected by the fatal emphasis
on line. The landscape—it is convenient to compare the *Visitation* with
73,46,47 the similarly composed *Visitations* by Rogier at Turin and Luetzschena—
is homely, inviting and exists in its own right. The happy atmosphere is
as much opposed to the resigned mood that Bouts subsequently revealed
as it is to the bitter pathos of Rogier.

Ouwater has been wrongly suggested as the author of the Madrid
panels but the mistake is instructive. The only known work by Ouwater
is not, in fact, so very different though admittedly far weaker and less
86 substantial.[1] If Ouwater, who worked at Haarlem, did stand in any
relationship to Bouts then the contact must have been with the early
Haarlem style of his compatriot and our idea of the Prado panels is
confirmed. I believe, incidentally, that Ouwater was stimulated by Bouts
and that one would not be justified in reversing the relationship.

It was quite wrong to uphold the attribution to Petrus Christus of the
Prado panels wherein at least their archaism and closeness to Van Eyck
were rightly perceived.

The centre panel of the Altarpiece of the *Sacrament* completed in 1468,
81 which has remained at Louvain and which is slightly higher than broad,
represents the *Last Supper*. The clear disposition of the interior allows
plenty of room for the gathering; it has natural height, is constructed
correctly in perspective and makes quite a convincing impression apart
from the fact that the vanishing point is rather high. In front, a fairly
broad strip of the richly patterned tiled floor remains empty which
increases the illusion of depth in the interior. The spacious hall is illumi-
nated in a uniform and consistent way from two windows on the left.

Christ is exactly in the centre and seen from the front. The Apostles,
who are distinguished from one another mainly by the shape of their
beards and their hair styles, are seated symmetrically on the right and
on the left but with some agreeable deviations in the symmetry. The

85 [1] Another painting considered by Friedländer (in *Die Altniederländische Malerei*, III, 1925, pp. 61 and 112) as a fragment of a work by Ouwater is the *Head of a Donor* in the Metropolitan Museum, New York.

Saviour as a type is not unlike Rogier's heads of Christ but with less intellectual power, less compelling, more a sufferer, used to suffering, with less strongly accentuated nostrils and a look which—instead of Rogier's threatening stare—seems to implore. The whole mood is subdued and elegiac, in no way dramatically tense, something in the nature of a conventicle of pious and well-behaved men, a memorial celebration that will be repeated from time to time.

The wings—those in Berlin well preserved, those in Munich ruined in parts by restoration[1]—provide a strong contrast to the central panel. The story tells how while Elijah sleeps an angel comes with food and bends over him, how Abraham and Melchisedek meet, how the Jews take the Passover meal standing, ready for the journey, and how they gather manna in the wilderness. The narrative is neither concise nor searching. The painter's aim to depict strange and remote events gives a particular charm to the scenes, even though each detail is fashioned after nature with patient objectivity and sincere humility. The tense and rather heavy atmosphere results less from certain peculiarities in the costumes than from the deep colouring and from the landscape. Bouts boldly attempted evening light and colourful sunsets. Transparent distances, shadowy masses of foliage, hills shutting out the light—all play their part.

The intermediate position of the Louvain master between Jan van Eyck and Rogier—and this is in no way meant to suggest a chronological order or a school relationship—becomes really clear the moment we compare the portraits. Bouts frequently and willingly introduced portraits into his compositions just as he loved to follow the model conscientiously and faithfully. The altarpiece of *The Last Supper* includes a series of portrait heads, though to the detriment of the picture as a whole insofar as the other heads appear over-stereotyped in comparison.[2] The *Judgment* panels 78–79 in the Brussels museum contain a whole gallery of portraits. Evidently the Governors of Louvain had themselves perpetuated here. There is no lack of donor portraits in the master's devotional pictures. Perhaps the finest is in the panel with Christ and John the Baptist, belonging to Prince Leuchtenberg at Schloss Seeon (Bavaria).[3] Single portraits are very rare. Apart from the generally accepted *Portrait of a Man* dated 1462 in the 83, 84 National Gallery, London, the *Portrait of a Man* in the Metropolitan

*[1] The wings are now again joined to the centre panel in the Church of S. Pierre at Louvain.

*[2] The altarpiece was commissioned by the Confraternity of the Holy Sacrament of St. Peter's Church on March 15, 1464, and, according to Professor J. G. van Gelder (in *Oud-Holland*, LXVI, 1951, p. 51), the portraits are those of the four masters of the Confraternity whose names appear in the contract of 1464.

*[3] Later in the collection of Prince Rupprecht of Bavaria (died 1955).

Museum, New York (formerly belonging to Baron A. Oppenheim and Mr. B. Altman) is especially characteristic in the cut of the head, the steepness of which is further accentuated by a high cap. To these I may add a small portrait belonging to Mr. E. Warneck, Paris[1] (Exposition Toison d'or in Bruges, Plate 37 of the exhibition publication) and— though with less confidence—the *Bust of an Elderly Man* exhibited by Mr. A. Brown at the Guildhall, London, in 1906 (No. 4, as by Van Eyck, reproduced in the exhibition catalogue).[2] How freely set in space and lightly detached from the background is the portrait of 1462! There is comparatively much that is individual in this portrait, also in the others, although the kind and rather depressed humanity, inherent in all the master's human beings, radiates through. The heads are angular, and long straight lines, contours and furrows give something careworn to the ex- pression. The line is emphasized, less in the early works, most strongly in the very late *Judgment* panels, but it has a different function from that in Rogier's art. Dieric's lines are ploughed shadows and reflecting strips but never merely graphic lines of demarcation such as Rogier, particularly in his late period, used so ruthlessly. Bouts would never, for instance, draw the far side of the face, that should recede into the depth, sharply silhouetted against the background.

Apart from the *Sacrament* altarpiece, so rich in content, only one other 78–79 work by Dieric is authenticated with any certainty, namely the two companion pieces now in the Brussels museum, which relate rather vaguely a forgotten error of justice and, in accordance with the custom of the time, were hung in the town hall of Louvain as a warning to the judges. We learn that towards the end of his life Bouts worked for the city and that after his death in 1475 Hugo van der Goes, of Ghent, was called to Louvain to give an expert opinion on how far the pictures had progressed and what should be paid for the finished parts. Therefore Dieric's death had interrupted the work. The condition of the pictures agrees with the documentary evidence once we examine the Brussels panels carefully.

The *Judgment* pictures have been sharply criticized and the blame laid (not without some justification) on the size that is too big, and on the subject that was not congenial to him, but the parts for which Bouts was not responsible have never been separated from the rest.

The first panel represents the unjust execution of the Count who has

*[1] Now in the Metropolitan Museum, New York. X-ray examination, which has revealed a hand (of a patron saint?) resting on the sitter's shoulder, has established the fact that this portrait is a fragment from a larger panel.

*[2] Now in the National Gallery of Art, Washington (Samuel H. Kress Collection).

been falsely accused by the Empress. The second panel shows the Countess with the red-hot iron in her hand testifying to the innocence of the executed man, with the Empress consumed by flames in the background. The second panel appears to have been completely finished by Bouts but the lower half of the first was apparently unfinished when Bouts died and was clumsily and crudely filled in. The ridiculous figure of the man standing at the edge of the picture on the extreme left and the drapery of the kneeling Countess are certainly not by Dieric.

Whereas the large panels seem empty and expose the painful nerveless-ness of the long figures as well as the weakness in their grouping, an unusually small size is advantageous for this art.

In the Munich Pinakothek a small altarpiece with the *Adoration of the Kings* in the centre, *St. John the Baptist* and *St. Christopher* on the wings, has 80 long been attributed to Dieric; for this work one is trying to retain the old-fashioned name 'Pearl of Brabant'. In recent art literature we find frequent attempts to remove the 'Pearl' from the Louvain masters' 'jewels'. Other small-size devotional pictures in the style of Bouts have been associated with the Munich triptych and a special master, a follower of Bouts, constructed. As far as I can see, this attempt to create an inde-pendent personality capable of existing next to Bouts has not been success-ful. The small size in itself conveys an impression of daintiness. The composition seems lighter and more pleasing, the figures move with greater freedom. The intensive and fiery local colours press closer together over smaller areas, which produces a vivid interplay of colour. For the rest, form, colour, conception, types and everything else are in complete accord with the accepted Bouts style which can best be verified in Munich itself where the triptych and the *Sacrament* altarpiece hang side by side.[1] I do not even believe that there is any considerable time interval between the *Sacrament* altarpiece and the 'Pearl of Brabant'.

Dieric's talent was not sufficiently robust and comprehensive to create out of his own resources an outstandingly impressive group, to make a movement flow through every limb of a body; but his devout and careful method of working could successfully fashion and animate a head or a hand. We sense the love of plant life and landscape as an essential and personal trait. Delight in his true perception of the colour and nature of the individual detail is blended with emotion at the touchingly awkward and halting co-ordination of the whole.

*[1] The wings of the *Sacrament* altarpiece are now again at Louvain, see p. 29 note 1.

HUGO VAN DER GOES

THE size of a picture and the scale of the figures have their share in determining method and style of the painter. Compelled by some commission probably every Netherlandish painter of the fifteenth century undertook small, medium and large-sized panels and, to a greater or lesser degree according to his nature, yielded to the dictates of the size on his style. In many cases art critics were unable to surmount the obstacle of a change of scale and, confused by the difference in style resulting from this change, failed to perceive the identity of the artists, as in the case of Dieric Bouts. A particular size is suitable and natural for every talent even though adaptability to a greater or lesser degree must be assumed and is apparent. Generally speaking a small size is appropriate for early Netherlandish panel painting, which is akin to miniature painting. And for the production of not a few Netherlandish painters the verdict stands: the quality rises and falls in 'inverse proportion' to the measurements of the picture. This certainly applies to Petrus Christus and to the Bruges painter whom we call Adriaen Ysenbrandt. Others, among them famous masters, do not pass unscathed beyond a medium size, as for instance Memlinc and Gerard David, whose religious works done for Spanish patrons (the organ panels from Najera in the Antwerp Museum and the altarpiece of *St. Anne* in the J. E. Widener Collection, Philadelphia[1]) are felt to be too big. Here as in many other cases the feeling intrudes that we are looking at enlarged rather than large figures, the uneasy feeling that execution and size are not suited to one another, that the knowledge of form, the observation and content do not suffice to fill out the enlarged boundaries.

Dieric Bouts seems to grow timid as soon as he approaches life-size. His, as it were, short-sighted piecemeal method of execution shies at extensive surfaces. As regards inventive power and conception, Memlinc and Gerard David seem more able to cope with large surfaces but not as regards the formal content. Finally there is a mysterious connection between intellectual power and picture size. Only if his talent is profound and deep-rooted has the artist the power to fill large surfaces of a canvas

*[1] Now in the National Gallery of Art, Washington.

(32)

in such a way that the proportions appear natural and that no disturbing contrast arises between content and form.

Hugo van der Goes gave wings to Eyckian painting and made it supple enough to cover wide spaces. Conception and execution, all creative forces are ample, they combine and radiate from the centre of his personality to produce a monumentality that is new in Netherlandish panel painting and of a different order from what we might describe as monumentality in certain productions by the Master of Flémalle and by Rogier.

A clear conception of the art of Hugo van der Goes was late in coming, a fine success for constructive stylistic criticism. For a long time the Portinari altarpiece in Florence, authenticated from Vasari's account as a work by the Ghent master, stood isolated amidst the Florentine altar panels, a strangely moving work in its harsh sincerity. Many art lovers returning to the North from Florence with the expected impressions, and this unexpected one, sought in vain for other works by the great Netherlandish artist. Scheibler was the first to make serious efforts to trace the style of the Portinari altarpiece. His was the hardest task. In his doctor thesis of 1880 he made the following claim, paradoxical at the time but valid today: "Hugo van der Goes is equal in quality to every one of Van Eyck's successors and as prolific as the majority of them."

The altarpiece which he made for Tommaso Portinari can be dated by 88–93 the number and ages of the children portrayed on the wings approximately to the years 1475–76. This large work must have been begun considerably earlier. Perhaps Goes, who is documented at Bruges in 1468, already at that time came in contact with Tommaso Portinari, who was living there as the agent of the Medici. He became free master at Ghent in 1467 and died in 1482. The Portinari altarpiece is a work of his middle period and therefore suitable as a crystallization point. The vast dimensions, to satisfy the Florentine demands, exceed what was usual in the North, but for the Ghent master they served as a stimulus, as an opportunity to give his powers full scope rather than as a compulsion or restraint. The central panel is some 10 ft. wide by 8 ft. 2 in. high. And not only are the panel boards long and wide, not only do the human beings attain life-size but the figures in themselves achieve a corresponding weight and cubic bulk and the three-dimensional space recedes in accordance with the surface extension of the picture plane. Atmospheric depth is captured by a compositional method of revolutionary audacity. The relief form has been dropped. The relationships between the figures and the groups do not develop along the picture plane, or parallel to it,

but pressing forward out of the depth and driving into the depth they intersect in the Christ child, whose feeble frame is the centre and goal of the adoration pouring in from all sides. The middle ground is no longer empty and dead. The gradual reduction in scale of the figures is supported by the gradation of the colour values. The solemnity, the significance of the event, the inner dignity and spiritual nobility of the figures seem to constitute the deeper content of the whole.

In general, the figures in fifteenth-century Netherlandish devotional panels are felt to be members of one family or society, and the donors, introduced by their patron saints, are admitted as equals into the holy circle. In the Portinari altarpiece a dualism is intensified to dramatic effect. The people, the 'third estate', represented in the shepherds, press
93 forward to salvation and their rough lowliness, inspired with zealous faith, blends with the dignity of the saints and the lean spirituality of the angels so that the ultimate and supreme conception unites a richly contrasted community. With the shepherds a new kind of piety, drawn from the congregation, is elevated to the altarpiece, a coarse and lumbering rapture that is ennobled by emotion and touching devotion.

In the large dimensions Goes, as a skilled craftsman, achieves a convincing illusion of solidity whilst as a painter, guided by his observation of light and colour values, he lets the form take shape.

The illusion of solidity, it is true, is everywhere evoked by contrasts of light. But we can construct a difference and distinguish between two methods of production—to take one extreme we might put it thus: from his imagination and experience a painter can successfully direct the light and allow it to flow in such a way that the form emerges, he can take just as much from his observation of light as he requires to represent form, that is to say with measured care and preconceived judgment he can exploit his power of observation for his work. At the other extreme we have the painter who has, or wishes to have, no preconceived idea of the form, but abandons himself completely to observation and lets the illusion take shape in colours, dabs of colour and light values. Naturally these extremes do not exist as such but it is possible to set up a scale between them and to allot a particular place to each painter. Let no one maintain that only the methods differ but that the results are the same. Light fulfils the task of making form visible in the same way that rain fulfils the task of watering the fields, it does not function for this purpose and only at times produces this result. Just as rain sometimes floods the fields, so light sometimes destroys, confuses or distorts the illusion of form capriciously, irrationally. Our established contrast is also of importance for the results.

.

If on the one hand pure and absolute observation leads to confused forms every limitation of observation on the other hand brings impoverishment and schematization.

On the whole, painting has tended to develop ever closer to the second extreme as its ideal, that is to say there has been an increasing tendency, come what may, to stick to the capricious illusion so that every more recent picture would give an impression of anarchy to a fifteenth-century eye whereas every picture of the fifteenth century seems schematic to the modern eye.

Van der Goes made a tremendous advance in the direction of the second extreme and, after the Van Eycks, he is the greatest pioneer in Netherlandish panel painting of the fifteenth century.

The master envelops wide areas in chiaroscuro. The light in his pictures picks out some forms, represses others, emphasizes, dissolves, loosens, divides and unites. He searches out reflexes that are hostile to form and draws more of the infinite wealth of nature into his picture than is observed by any other painter of his period.

Goes seems to have studied nature out of doors. His colour is strikingly cool. He avoids brownish shadows in the flesh tones. Grey, transparent tones generally produce the fleeting transient play of light on the flesh that gives the effect of material and is astonishingly varied in the local colouring of the complexion.

Nothing could better designate the avantgarde position of the master than the mistake made by one of our leading art critics who, when the *Nativity* came to Berlin, expressed the opinion that it was clearly a work 98 of the sixteenth century, and therefore could not be by Van der Goes.

The road that the master traversed before he reached the Portinari altarpiece (and he went still further) is not entirely hidden from us. Scheibler attributed to him the three small panels in Vienna. *Adam and Eve, The Lamentation over Christ* and *St. Genevieve*, which form a diptych. 94-95 This attribution can be accepted with the proviso that the date of origin must lie considerably before 1475. In the first place, however, the effect of the dimensions must be taken into account. The incisive and variegated colour effect of these panels is partly conditioned by their size. Penetrating to the depth, searching out bones and sinews, the draughtsman works with a conscientiousness that borders on self-torment. The contour lines are exceedingly nervous. Restricted by the size, Goes does not evolve the self-assured freedom of the Portinari altarpiece. But in my opinion the strenuous ascetic intensity of the Vienna pictures is in some measure due to the awkwardness and zeal of youth. If we compare them with the

triptych of the *Adoration of the Kings* in the collection of Prince Liechtenstein, Vienna,[1] which is no bigger, a considerable divergency in style is apparent. Here, too, we sense the pressure of the restricted size but the pressure works in a different direction. In the triptych the master seems to be confronted with an unexpected obstacle, constrained by the smallness of the panels he cannot organize the available space, but the drawing is nothing like so incisive, detailed and finical in style as it is in the diptych where the painter adapted composition and execution to suit the size. I do not regard the triptych in the Liechtenstein gallery at all as an early work.

Very close to the Vienna diptych is the small *Madonna* in Frankfurt
87 (the wings are obviously not by Van der Goes). I consider this picture to be one of the earliest known works of the master.

Apart from the Portinari altarpiece we know two other works by Goes the dates of which can be fairly accurately established without the aid of stylistic criticism. In all probability the Ghent master was commissioned to do the donor wing of the Bouts altarpiece at Bruges immediately after Dieric's death, that is directly after 1476. The altar wings at Holyrood with the portraits of James III of Scotland and his son were made about 1478 or at any rate not very much later. The prince, the future James IV, who is depicted as a boy, was born in 1473. Incidentally I do not believe that Goes completed the portraits of Scottish Royalty but that they were inserted by a weak hand, probably a painter in Scotland. I assume that Sir Edward Bonkil, whose portrait as donor is obviously by
100 Van der Goes, had commissioned the panel in the Netherlands and that the monarch to whom he dedicated them had his portrait and that of his wife added.

The wing panels in Scotland are not only related in style to the Portinari altarpiece, they are also of equal quality. But it is essential to distinguish what is genuine from what is not. In the panel with the king the dusky red tent is well preserved, as are the architecture and the wooden cross of St. Andrew. The head of the apostle is not quite intact, his green gown, his book and hands have been considerably overpainted. The king's head need not be considered here, as presumably even in its original condition it did not derive from Goes. The king's dress and book are passably well preserved but his hands are spoilt, as is also the vermilion gown of the young prince. The Trinity has been energetically 'restored' and only the greater part of the body of Christ, the loincloth

[1] The collection has been transferred from Vienna to Vaduz in Liechtenstein, but several paintings, amongst them the *Adoration* by Hugo van der Goes, have for several years been on loan to the National Gallery, London.

and the Dove still reveal the hand of the master. The wing with the Queen is better where St. George seems fully intact, and, finest of all, relatively well preserved, is the picture with the clerical donor and the organ-playing angels. The quality here is as fine as Goes achieved anywhere and it can be enjoyed unspoilt, especially in the hand and in the magnificent gown of the donor. ✓

The *Nativity* in Berlin differs so much from the Florentine altarpiece 98 that every critic feels that a time interval must separate the two. But strangely enough there seems to be no consensus of opinion as to which is the older. And the view I expressed in 1903 on the relative dates has not been accepted. I wrote, amongst other things, on the Berlin picture:[1]

"The *Nativity* with the Shepherds and the Angels, the same subject as in the central panel of the Portinari altarpiece, is depicted here. This makes the comparison easier. We are thus more quickly able to overcome our amazement and can reach a comparatively reliable, positive and negative verdict more easily. The Berlin panel is almost 8 ft. 2 in. wide and not quite 3 ft. 3 in. high. The dire necessity of spreading the familiar scene over such a wide area stimulated the artist to compositional ingenuities. The Florentine picture with its more convenient and natural proportions gives an incomparably greater effect of space but the grouping of the figures seems meagre, sparse and awkward whereas our picture is relief-like, devoid of air and overloaded but flowing and dynamic though less unified in composition than the Portinari panel. It is as if we were reading the narrative which is unfolded before us in epic sequence and the sections are filled with a variety of moods. Pathos alternates with noble calm. The limited space and the habitual arrangement of a triptych may have first suggested the striking and unique motif, may have given the master the significant idea, which is rooted in ancient typological conceptions, namely that of placing a chorus in front of the pictorial scene. On the right and on the left the representation is powerfully framed by the half-figure of a prophet whose approximately life-sized form looms in almost frightening contrast to the figures in the central scene who are only half as large. The prophets with deeply lined faces, visionary eyes and pointing gestures unveil the picture by drawing back a curtain. Dangerously theatrical devices have been used to endow the oft-repeated scene with a heightened meaning, to isolate it from the ordinary world.

"Two-fifths of the panel width are cleverly filled by the figures of the prophets but in spite of this the picture space seems rather low in comparison to its width. Beneath the low roof the figures kneel, bend and

[1] In the journal *Kunst und Künstler*.

incline towards the Christ Child. The compulsion of the form blends with
the demands of the subject. The shepherds approach from the left in
eager haste. An invisible barrier seems to separate the kneeling figure of
the Virgin mother from this passionate and needy throng of humanity.
Joseph is saying his prayers before the Christ Child with ritual solemnity.
A group of youthful angels, of somewhat uniform beauty, pressed together
head to head, fill the empty spaces.

"The colour is rich, on the whole rather cool and almost variegated, in
certain parts of exquisite harmony, everywhere pregnant with meaning,
like the musical accompaniment to the formal theme. To the right and
to the left near the edges heavy, warm colours predominate, a sumptuous
dusky red in the dress of one of the prophets and a brilliant scarlet in the
cloak of the other; the shepherds are clad in garments of less pure, broken
and iridescent hues, which relegates their importunate need to a subor-
dinate place. Joseph is dressed all in red, a rather sharp blueish dark red
in the outer garment and a dull brownish orange in the under-garment.
The main group in the centre, on the other hand, is entirely steeped in
the cool colours of the sky, white and blue with faint shades of violet.
The whitish rather chalky complexion, lightly shaded with grey, of the
Virgin, the Christ Child and the angels harmonizes with the dull ash
blond hair and heightens the effect of unearthliness and transfiguration.
The slight physical form of the new-born Child is drawn with relentless
realism and yet His divine nature is evoked with dark symbolism in
significant gestures and in the mature, spiritualized countenance. Perhaps
too the intensely thoughtful master, who ever sought to link the individual
and the earthly to the universal and the divine may have introduced the
sheaf of corn as something more than a *repoussoir*. In the drawing and
modelling, especially of the hands, Van der Goes shows an amazing
mastery, almost too much mastery. He is in full possession of his powers
on the downward rather than on the upward grade. Compared with the
robust vigour that seems amazed at its own strength in the Portinari
altarpiece, a weary confidence seems to lie over our picture. For this
reason I am inclined to place our panel and also the *Death of the Virgin* at
Bruges, which is if anything a degree more artificial, confident and
virtuoso, later, after the Portinari altarpiece. Though if Hugo van der
Goes died in 1482—and the Florentine altarpiece can hardly have been
done before 1475—there is admittedly not much margin to spare. These
dates, however, appear firmly fixed. Since in the Berlin altarpiece the
gentle and rather generalized beauty of the Virgin and the angels evoke
the age of Memlinc and Gerard David—by contrast the figures in the

Portinari altarpiece seem lean and ageing—whilst the bold unbroken flux of the composition even suggests Quentin Massys, we are certainly justified in dating the work as late as possible."

I see no reason to modify these observations of 1903. My task is rather to examine and defend the conclusions that I drew from them in the light of the Monforte panel, still unknown to me in 1903, which has appeared as a major work alongside the *Nativity* and which in its turn requires to 99 be inserted chronologically.

Unfortunately I am unable to welcome the new guest triumphantly as the missing link whose existence I had intuitively suspected. New difficulties arise but no clarification. The Monforte panel does not seem to fit into the constructed line of development.

In its spatial effect, in the rich free treatment of light the Monforte *Adoration of the Kings* is closer to the Portinari altarpiece than to the *Nativity*. The intellectual and formal harmony, the full, even opulent colour, the superb confidence of the modelling, the naturalness of the drapery, in which angular, rectilinear folds are done away with, all this makes me hesitate to date the Monforte panel before the Portinari altarpiece, as has been suggested by at least one scholar. The most likely position for the *Adoration* seems to lie between the Florentine panel and the *Nativity*. I must admit though that this order too is far from satisfactory and does not give at all a picture of organic growth.

The panel with the *Death of the Virgin*, owing to foolish judgment of its 101 state, has been fantastically misunderstood. Nowhere does the master express himself more clearly, at least as a draughtsman and in the psychology. The subject seems to determine the style and even more the colour. It is as though Van der Goes was led to make a new approach for each work, depending on the mood of the theme. Thus in the present case, cold and unsensuous as it is in the colour, all the expressive force is concentrated in the drawing of the heads and of the hands. To an even greater degree than in the Portinari altarpiece observation has been replaced by experience, not strongly enough to entitle us to speak of a mannerism but far enough for us to recognize his own particular handwriting in the even waviness of the contours. The Apostles with fully developed character heads have their share in a heightened sensitiveness that borders on monomania. Their piety is not pure and calm but rather the faith of penitents oppressed by memories. A dangerous passion is concealed in their agony, almost as though at the death-bed of the Virgin self-accusation and repentance mingled with their grief.

The *Death of the Virgin* and the Portinari altarpiece reveal the searching,

struggling soul of their author. Here more than in any other work of the fifteenth century is a personal avowal. Here the art critic must turn psychologist and eagerly grasp at the report of Hugo's mental disorder as offering some explanation and confirmation.

Goes left Ghent, where he had enjoyed honorary offices in the guild until 1473, and spent the last years of his life in the monastery of Roodende near Brussels. This step is in itself highly suggestive, and in addition intimate details are supplied in a chronicle written by a certain Gaspar Offhuys, who was a novice when the painter entered the monastery.[1] In this account Goes is depicted as a celebrity who enjoyed special privileges in the monastic life and who had by no means completely renounced either his work as a painter or the vanities of the world. Goes received visits from the high nobility, including Archduke Maximilian (the future Emperor Maximilian), was not averse to wine and was often a victim of fits of melancholy that sometimes mounted to delirium, to the manic idea that he was doomed to perdition.

Perhaps Goes placed himself under monastic discipline as a protection against his own passions, perhaps he was driven into the ecclesiastical stronghold by religious scruples. The excesses noted in the philistine report suggest if not a pathological then at least a problematic nature.

Were we to read that Petrus Christus had become mentally unbalanced there would be no reason to draw any conclusions from the circumstance. But in the art of Hugo van der Goes we sense such a tremendous tension that the break, the disorder of his mind, appears as the result of his creative work or else the productions of his genius are the result of an abnormal tendency.

Even an expert pathologist could probably not go much beyond these amateur phrases, particularly as the medical report of the fifteenth century though fairly wordy is crudely interspersed with superstitious prejudices and moralizing warnings.

*[1] He may have entered the monastery in 1478. In March 1478 he was still paying rent for his house at Ghent (A. de Schryver, in *Gentsche Bijdragen*, XVI, 1955/56, p. 193). As he died in 1482, this fact agrees with the statement of Offhuys that Van der Goes spent the last five or six years of his life in the monastery (see F. Winkler, *Das Werk des Hugo van der Goes*, Berlin 1964, p. 1).

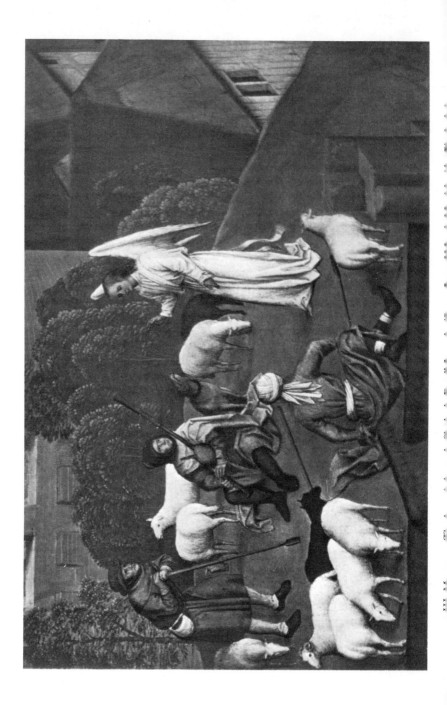

HANS MEMLINC

WE possess many works of Memlinc, more than of any other Netherlander of the fifteenth century. His art is conveniently accessible. Together at Bruges are undisputed works by his hand, some of which are signed. They make a deep impression there, like the fairest home-grown bloom—even though the master was not a native of the town—and their charm was felt even when the general understanding of Netherlandish painting was still in embryo.

The master's *oeuvre* has increased and has continued to increase year by year. Niggling criticism has had little success. The *oeuvre* remained close-knit, composed of similar parts with nowhere a gap into which the critical knife could be inserted.

Memlinc is documented at Bruges as early as 1466[1] where he worked until his death in 1494 apparently without any considerable interruptions. As he is almost always referred to as Hans not Jan we are justified in regarding him as of German origin. The diary of Rombout de Doppere, a notary of the church of St. Donatian, Bruges, contains under the year 1494 the following entry: *Die XI augusti, Brugis obiit magister Johannes Memmelinc, quem praedicabant peritissimum fuisse et excellentissimum pictorem totius tunc orbis christiani. Oriundus erat Mogunciaco* (Mainz), *sepultus Brugis ad aegidii.* Since there is a village Mömlingen in the Mainz area we can assume that the master, or at any rate his family, came from that place.[1]

To establish the year of his birth we have only the unreliable clue to his age contained in a self-portrait presumably painted in 1468. It is at least probable that the altarpiece which he painted for the Englishman 110–111 John Donne, owned by the Duke of Devonshire (now at Chatsworth),[2] originated in 1468, when the wedding of Charles the Bold and Margaret of York was being celebrated at Bruges, for which occasion distinguished Englishmen in close touch with the court came to Bruges, and I consider it certain that the man standing modestly behind the pillar on the left wing of the altarpiece, near his patron saint John the Baptist, is a self-portrait. If we note that Memlinc looks about thirty-five here, we can

[1] From an entry in the Bruges Burgesses' Book published by R. A. Parmentier (*Indices op de Brugsche Poorterboeken*, Bruges 1938, I, p. xxxvi) it is now known that Memlinc was born at Seligenstadt, a small town in the Mainz area, and became a burgess at Bruges on January 30, 1465.

[2] Now in the National Gallery, London.

infer from this that he was born about 1433 though admittedly the con-
clusion is rather doubtful. But we have no better means of establishing
the year of his birth.

Our only knowledge of the master's fortunes before he came to Bruges
and began his steady, prolific and well-rewarded activity, is deduced
from his style. Rogier's art is the foundation of Memlinc's art. Rogier
was Memlinc's teacher. This is as certain as any such relationship can be
certain when deduced only from stylistic criticism.[1] Rogier died in
Brussels in 1464, in 1466 Memlinc is first documented at Bruges.[2] Our
next assumption is that Memlinc, before he went to Bruges, worked for
some time at Brussels in the studio of the leading master there. This
assumption is rather weakened when we note that between 1470 and
1490 art at Bruges as a whole was under Rogier's sway, that the Eyckian
tradition which did not obviously influence Memlinc's style was every-
where pushed into the background at Bruges.

There are connecting links between the works of Rogier and Memlinc.
Memlinc adopted several of Rogier's compositions.

The masters are by no means similar in temperament. They were
certainly not kindred spirits. Memlinc's dependence is explained most
easily and naturally by the authority of the master and the community
of the studio.

As far as we can see, Memlinc knew and used Rogier's *Columba* altar-
58 piece, at that time at Cologne (now in Munich), both the central panel
with the *Adoration of the Kings* and the right wing with the *Presentation
of Christ in the Temple;* furthermore he knew the Middelburg Altarpiece
59 (Berlin), from which he borrowed at least the drapery motif of the
62 Madonna, and finally the altarpiece at Beaune. His *Crucifixion* (Vicenza)
was taken from the Brussels master but in this case it is not possible to
establish the particular model, seeing that Rogier often repeated the
subject with slight variations. These connections are easy to explain on
the assumption that Memlinc worked for a time in Rogier's studio,
without this assumption they become difficult. In Rogier's studio the
younger master could easily have copied preparatory drawings for altar-
pieces which had long since left the studio. As a matter of fact we are not
exclusively limited to observations of style if we wish to define the
relationship more precisely. In an inventory of the art treasures of
Margaret of Austria compiled in 1516 we find the following entry:
Ung petit tableau d'ung dieu de pityé estant ès bras de Nostre-Dame; ayant

*[1] For Friedländer's later views on this subject see his *Memling* (Amsterdam 1949), where he
gave further proofs of the relationship.
*[2] See p. 41, note 1.

deux feulletz, dans chascun desquelz y a ung ange es dessus lesdits feulletz y a une annunciade de blanc et de noir. Fait, le tableaul, de la main de Rogier, et lesdits feulletz, de celle de maistre Hans.

If this entry is to be believed then the triptych was produced in Rogier's workshop with the collaboration of Memlinc.

No picture like the one described here, the small central panel: *Christ as Man of Sorrows in the arms of the Virgin*, is known by Rogier but there is one by Memlinc. Two panels, one at Granada and one privately 108 owned in France (dated 1475),[1] would fit the description. In view of the Memlinc panels we might conclude that the inventory of 1516 was mistaken, not only the two wings but also the central panel were the work of Memlinc and identical with the picture privately owned in France. We can, however, and with more justification believe the inventory, regard the Rogier panel as lost and reconstruct its appearance from the Memlinc pictures.

In the small Sforza altarpiece in the Brussels gallery, which has recently been attributed to Bugati, an Italian painter who was apprenticed to Rogier, Memlinc characteristics have been rightly discerned within the strictly Rogierian workshop style. I consider it unlikely that Bugati could have completely effaced his national style. He cannot even be considered as the author. On the other hand I think it possible that Memlinc was in Rogier's workshop when this triptych was made for the Milan duke.

We must intensify our search for dated or at least datable works by Memlinc from his earliest period. Unfortunately the few inscribed dates do not go back further than 1475.

The Floreins altarpiece in the Bruges hospital dates from 1479. The 112 *Man of Sorrows*, privately owned in France,[2] a replica of a panel at Granada, is dated (genuinely I believe) 1475. The Danzig altarpiece was done before the year 1473. Painted, as A. Warburg has demonstrated, for Jacopo Tani, the altarpiece was to have been sent by sea route from Bruges to Florence but was seized in 1473 by the Danzigers. That is to say a *terminus ante quem* is firmly established. But I think that a simple consideration can help us to date the altarpiece even more precisely. If the Florentine donor had the large altarpiece shipped to Florence in 1473, then it was from the outset intended to be set up in Florence and it is unlikely that it remained many years at Bruges before being sent there. We are therefore justified in dating it shortly before or around 1470.

*[1] The version from the French private collection is now in the National Gallery of Victoria, Melbourne.
[2] Now in Melbourne, see previous note.

Two other recognized works by the master take us back still further.

1468 is probably the correct date for the portrait at Antwerp of Forzore
120 Spinelli, a Florentine medallist who in that year was in the service of
Charles the Bold.[1]

The altarpiece with the *Virgin and Saints* belonging to the Duke of
110 Devonshire,[2] which was donated by the Englishman John Donne, also
dates from 1468. The argument in favour of this dating has already been
indicated. Strictly speaking, however, none of these bring us early works.
In 1468 Memlinc's style was already fully developed. At that time he
was presumably in his thirties.

By nature Memlinc was an assured pictorial interpreter of quiet mood,
at his best when presenting the Virgin in a circle of female saints or as a
portraitist. In such tasks he seems, comparatively speaking, independent.
This already applies to the Devonshire triptych, the early style of which
is betrayed mainly by the thin, anaemic and dull treatment. Where
dramatic force, vigorous movement, complex composition or a richer
imaginative faculty are required the master remains until his late period
dependent on Rogier, falls back on memories of his apprentice days. We
note, not without some surprise, that the Christ in the *Last Judgment*, that
is the central figure in the Danzig altarpiece, is a painfully exact copy of
Rogier's figure in the Beaune altarpiece.

In his relationship to Memlinc, Hugo van der Goes was more a con-
temporary rival than a teacher. He was at Bruges for the wedding of
Charles the Bold in 1468 when he did decorative paintings. Perhaps it
was then that he came in contact with Tommaso Portinari, who was living
at Bruges. The Italian patron of the Ghent painter, who commissioned
the altarpiece in Florence, was at the same time a patron of Memlinc.
We possess three portraits of Portinari by Memlinc (the single portrait in
104 the Altman collection, now in the Metropolitan Museum, New York,
113 the donor portrait in the Passion panel at Turin and the portrait in the
Danzig altarpiece, where Tommaso appears as the man on St. Michael's
scales).

Memlinc painted a diptych in which, in half-length figures, the *Descent*
106–107 *from the Cross* is spread over both halves of the picture. The two parts are
in the Capilla Real at Granada. A copy or workshop replica of the right
half with the *Mourning Women and St. John* can be seen in the Munich

*[1] The earlier identification with Forzore Spinelli was proved to be wrong by G. Hulin de Loo
(in *Festschrift für Max J. Friedländer zum 60. Geburtstag*, 1927, pp. 103 ff.), who thought that the
sitter was the medallist Giovanni Candida. Friedländer himself (*Die Altniederländische Malerei*, VI,
1928, p. 42) pointed out that the portrait represents a collector of coins rather than a medallist.
*[2] Now in the National Gallery, London.

Pinakothek. The original disposition of the scene is shown in a feeble imitation at Genoa. Here a clumsy compiler has turned the diptych into a triptych and added donor figures.

In a private collection in St. Petersburg I found a replica by Memlinc's own hand of the left half,[1] showing the body of Christ supported by three men, unfortunately not in perfect condition. It gives a slight variation in composition which agrees even better than does the version in Granada with the Genoa copy. Naturally the St. Petersburg panel also had on the right the group of mourning women.

The dramatically concentrated composition of this double panel is not in keeping with Memlinc's manner. It so happens that there is in the Berlin gallery a painting on canvas, seemingly fragmentary, which is Goes-like in the formal treatment, a group of *Mourning Women* which corresponds in its main features to the right wing of the Memlinc diptych. Thanks to Grete Ring's happy idea we can now complete the Berlin fragment by a Goes-like *Descent from the Cross*, of which replicas have been found at Altenburg and in the Bargello, Florence.[2]

The relationship between the Goes and the Memlinc compositions is evident and it is certain that the Ghent master was the giver. This relationship may be conceived as a brief encounter and an episode.

When studying Memlinc compositions we occasionally come upon motifs which seem to derive from Rogier's workshop but cannot be traced in the now existing stock of works. In dramatically dynamic groupings the Bruges master uses certain motifs inconsistently and with all the hall marks of derivation. In the centre panel of the altarpiece (the wings of which were destroyed by fire) in the von Kaufmann Collection,[3] the left arm of the dead Christ is not convincing, not conditioned by its position. If we assume the existence of a model in which the Madonna, more closely, more passionately united with the dead Christ, had pushed her arm beneath His left arm, enfolding His body, then we can understand the position of the arm. The case shows that Memlinc modified the severity of Rogier's forms to suit his even, decorous manner whereby he became involved in dangerous half-measures.

[1] Now in the D. Sickels Collection, New York. A panel with the *Mourning Women* in the Museum of São Paulo, Brazil, is probably the right wing of this diptych.
[2] The Berlin canvas is now recognized by Friedländer as an original by Hugo van der Goes (see *Die Altniederländische Malerei*, IV, 1926, p. 39). The other part of the original canvas, with the *Descent from the Cross*, was discovered in a private collection in Paris and published by Friedländer 96–97 in *Oud Holland*, LXV, 1950, p. 150 ff.
[3] The centre panel, later in the Van Beuningen Collection, Vierhouten, was acquired in 1958 by the Museum Boymans-Van Beuningen, Rotterdam. In 1957 the damaged wings were in a private collection in Bruges.

Although Memlinc adopted thematic and compositional motifs, even such as were uncongenial to him, the form was consistently inspired by his personal feeling and regulated by an ever serene and unruffled sense of grace and moderation. We should expect a slow, undisturbed and organic development of his formal style and we can demonstrate this, though not without difficulty. Memlinc's attitude to nature is not that of a passionate wooer. He neither abandons himself to her nor does he tyrannize her. He observes and absorbs a certain amount—no more than Rogier—and moulds it with a gentle but firm hand.

The schematism, if there is any, of his formal idiom is unobtrusive. Certain constant characteristics, such as the rendering of the skin texture in the hands by means of fine parallel lines of light that proceed at right angles to the direction of the fingers, adapt themselves quietly to the whole.

Every attempt to formulate our impressions of Memlinc's compositional style leads to negative definitions. But it is just this lack of conspicuous qualities that is typical for his nature. Memlinc's portraits, of which an exceptionally large number survive, seem to have appealed to his contemporaries, especially the Italians living at Bruges. Memlinc was clearly the favoured portraitist of the wealthy business circles, he possessed something of the qualities that Van Dyck and Gainsborough, and society portrait painters of all ages, have used to increase their successes. Not that the intention of flattering his sitters influenced his art in any way, but his innate formal and intellectual sense toned down what was offensive and produced everywhere an agreeable likeness into which he infused something of his own pure and serene nature.

A searching examination reveals his portraits as more individual than a superficial inspection would suggest. The careful elucidating description of character is not obtrusive whilst habit and the professional practice of portrait painting envelop the personalities represented with a veil of uniformity. The main lines are selected and defined with flexible, pure and subtle draughtsmanship. The chance play of light is eliminated, abrupt and striking contrasts avoided. A gentle, slow, even and full projection of form is achieved more by wise manipulation of the line than by strong shadows. The hair, generally framing the head in luxuriant growth, is carefully portrayed in its material texture. Particularly near the edges, outside as well as inside, on the forehead and on the temples its loose and curly structure is richly and fully developed in sinuous strands and single threads.

Memlinc's faith is completely trusting, serenely confident, with no

trace of fanaticism, melancholy or sentimentality, no feelings of guilt, no
doubts, yearnings or driving ambition. His serene eye never penetrated to
the dark depths where primitive passions are unleashed. His *Martyrdoms* 114, 115
thus seem to contain more of beatitude than of pain, and evil-doers go
about their work without malice, even without real enthusiasm.

Of the famous Netherlanders of the fifteenth century Memlinc least
deserves the title of innovator or expander in the realm of art. Neither
through imagination nor through observation was he, like Goes or
Geertgen, carried forward along the highway or even down byways.
Compared with older masters he is imitative and his pictures seem faded
in their cool opaque colouring.

If his popularity surpassed even that of Van Eyck, this unjust preference
derived from a period that was sadly lacking in knowledge and under-
standing of early Netherlandish art. At that time, when the art of the
fifteenth century in general, and Netherlandish art in particular, was
felt as a contradiction to the norm of beauty, Memlinc was the first
Netherlander to get past the barrier of aesthetic prejudice. Today when
we use a different standard, Memlinc's position in the historical chain has
been shifted. But over and above all change of taste his lovable and
harmonious nature will ever continue to gain him friends.

GERARD DAVID

ERARD DAVID, who was the first in Bruges after Memlinc's death, has been rediscovered by recent research. He had been forgotten for centuries. Carel van Mander only says: "In olden times there was a certain Gerard of Bruges of whom I know no more than that Pieter Pourbus was heard to praise him highly as an excellent painter." The 'discovery' of this painter is a fine example of the successful collaboration between style criticism and documentary research, which marched independently but struck in unison. We owe the documentary evidence almost exclusively to James Weale, who since 1863 has been publishing material extracted from the Bruges archives. We owe its stylistic compilation to other experts. Finally, in his book published in 1905 (by Bruckmann in Munich), Von Bodenhausen successfully and with discerning insight combined the results. The master's *oeuvre* now comprises more than fifty items.

1460 (approx.)	Gerard, the son of Jan David, was born at Oudewater in Southern Holland. In the Rouen panel, painted in 1509, his self-portrait has been detected. He looks about fifty, which gives an approximate date for his birth.
1483	His name is first mentioned at Bruges.
1484	On January 14, Master in the St. Luke guild, Bruges.
1488–98	Commissions for the city of Bruges.
1488–1501	Honorary offices in the guild.
1496	Married Cornelia Cnoop, the daughter of a distinguished goldsmith.
1509	Altar panel for the Carmelite nuns, the picture that is now in the museum at Rouen.
1515	Stay at Antwerp (at least there is an entry referring to a Gerard of Bruges who is generally identified with David).
1523	Died on August 13.

127

(48)

The early and the late periods are problematical. David's compositions were widely copied at Bruges. The uninventive art of this town was long in shaking off the types he had invented. The painter whom we used to call Mostaert, and now call Adriaen Ysenbrandt, and Ambrosius Benson often seem to be imitators of David, whose influence on Bruges book illumination was immense. David's activity flows over into that of his pupils, the boundary lines are hard to define.

No less difficult is the task for the art critic attempting to clarify the growth of his style, its early origins and relationship to Dutch tradition. What did David bring with him when he came to the town of Jan van Eyck and Memlinc?

Four established major works give an all-round idea of the master's ability, temperament and sensibility. They date from his middle period (between 1498 and 1509).

1. The two Judgment panels with the *Verdict of Cambyses* and the *Flaying of Sisamnes* painted for the town hall at Bruges, now in the Communal Museum there. The first panel is dated 1498. That very year David received payment for a painting that he had completed for the jurors' room. 126

2. *Canon Bernardino de Salviatis and three Saints* now in the National Gallery, London, probably painted for the church of St. Donatian, Bruges, shortly after 1501. 125

3. The altarpiece with the *Baptism of Christ*, donated by Jan de Trompes, who is shown on the wings with his two wives, in the Communal Museum, Bruges. Since Elizabeth van der Meersch, the first wife, appears in the usual place on the inner wing opposite the donor, the altarpiece was probably commissioned before 1502 (the year of her death). In that case, however, the outer wings, where the second wife with her four-year-old daughter is represented in an unusual place, must have been added around 1508. 131

4. *The Virgin in a circle of female Saints*, now in the Rouen museum, painted for the Carmelite Convent of Sion at Bruges, donated by the painter, whose self-portrait can be seen on the extreme left. The date 1509 authenticated from documents. 127

To these a long series of stylistically related works in David's mature style can be added.

When the task requires no more than a grouping of holy and devout women, David's compositions make a solemn though monotonous impression. No urgency, no profane gestures upset the dignified attitudes of the well-formed but not coquettish women and maidens, in whom

soul and body, eye and figure are all similarly conceived and directed. The sumptuous splendour, the beautifully shaped hands with their solemn gestures, the heavy materials with the few simple drapery motifs, the symmetrical clarity of the groups, the gravity and calm collectedness, everything suggests a religious ceremony, a familiarity with church ritual. Through the conscientious leisureliness of the outline and modelling of the forms many things acquire statuesque-like isolation, everything is oppressed and rigidly banned. The compositions never even begin to flow. The *Judgment* panels give us the measure of his talent. The execution of the guilty judge is observed with pedantic accuracy like a surgical operation.

In the Louvre is a triptych of the *Virgin*, that came from the Garriga sale, which I claimed years ago for Gerard David. The attribution seems on the whole to have been favourably received and was accepted in von Bodenhausen's book, although in the Louvre it is still among the anonymous works.[1] The donor was Jan de Sedano, for whom, at least ten years later, David executed the *Marriage at Cana*, also in the Louvre. Whereas the *Marriage* reveals the fully mature familiar Davidian style, the style in the Triptych of the Virgin, on the wings of which the donor pair seem considerably younger, is a curious blend of tenderness, serenity, meagreness and constraint. The figures stand firmly, rise and take shape pillar-like in their sheer terseness. The modelling intent on sculptural, even statuesque forms remains characteristic for the master but the perceptive faculty grows heavier and duller. The age of the donor and in particular the date of his marriage would have supplied the best means of dating the work. But in default of these dates we can judge the period from the costume of the donatrix. This form of coif does not seem to have been worn after 1490. And the general stylistic effect confirms such a dating.

In the attitude of the Christ Child there is a connection with the famous *Paele Madonna* by Jan van Eyck. Two variants of the figure of the Virgin in the triptych are known from David's ˙ workshop, one at Darmstadt and one in the Johnson Collection, Philadelphia. Strangely enough from these replicas two threads, different threads, lead to Van Eyck. In Darmstadt, namely, angels making music have been added which are freely copied from the celebrated angels of the Ghent altarpiece whilst in the Philadelphia replica the carpet is exactly modelled on the Eyckian carpet in the *Paele Madonna*. The decorative motif of the nude children holding garlands links the Garriga triptych to Memlinc. As far as I know, Memlinc used this motif three times. David, who was

*1 Now catalogued in the Louvre as by Gerard David.

uninventive in such things, made use of this Renaissance motif, perhaps the first of its kind in Netherlandish painting, not only in the triptych of the Virgin but also in one of the *Judgment* panels of 1498, in the second, as I believe later case, however, he gave the children above a better and more secure place on a console. With Memlinc, and also in David's first use of the motif, the children are stuck uncomfortably on the arch.

A relationship to Rogier van der Weyden is shown in the half-figure of the suckling Madonna belonging to Mr. Traumann, Madrid.[1] Judging by the style, we have here a fine work by David of about 1495. The composition however is not by him. Nearly a dozen replicas of this composition are known, some by inferior hands, some more archaic than David's version. A few of these replicas are obviously copied from Rogier, who seems to have established the standard form, though Rogier's original version appears to be lost. The imprint of his manner, however, can still be felt even in David's work—apart from the landscape, which is purely Davidian. In an article in the *Jahrbuch der preussischen Kunstsammlungen*, 1906, and in an older article in the same periodical, I pointed out an even more interesting relationship between David and Hugo van der Goes.

There is in the Pinakothek in Munich an *Adoration of the Magi*, a horizontal picture with a many-figured composition, that has given rise to much speculation. To those who concentrated on the individual details, such as the hands of the eldest king, David's authorship seemed certain. Experts of the rank of Scheibler have long regarded this panel as a work by David. On the other hand all experts were agreed that the movement was too lively, the composition alien, too rich in invention, too involved, too dramatic. It so happens that in the Kaiser Friedrich Museum, Berlin, there is a far weaker version of almost the same composition, and this Berlin copy shows so clearly, though in slight distortion, the characteristics of Goes's art that the solution of the riddle is as follows: David copied the Munich picture from a work of the Ghent master now lost. Incidentally the head of the Virgin has been spoilt by a restorer. These pieces of evidence round off our idea of David's art. We note a quality of dependence. We see that the Bruges master copied, whom he copied and how he copied. And thereby his personal style emerges all the more clearly.

Unlike his contemporary and fellow countryman Geertgen of Haarlem, David left home early and at Bruges sought successfully to link up with the great tradition. What he lost in originality, through eclectic endeavour,

*[1] Now in the Museo Lázaro Galdiano, Madrid.

he gained in culture and understanding. The convention of the church picture supplied the framework for the successful development of gifts that from the outset were probably less potentially progressive than the talent of Geertgen.

It would be difficult to find a single early Netherlandish devotional picture of such sonorous accord, such gravity and such firm structure as
132 David's *Madonna with three female Saints and a donor* in the National Gallery, London (formerly Lyne Stephens Collection).

The simple composition is relatively loose, not tied symmetrically, the space clearly articulated. The horizontal aspect of the floor provides a solid foundation for the full and plastic figures rising up freely in space. The drapery lines are grand and stately. The uniform, almost sad expression knits the whole firmly together. Two hands, in masterly foreshortening, one reaching inwards, one forwards, heighten the spatial effect. In the detailed execution David almost attains Jan van Eyck's standard. Typical for the rather weary heads, so delicately individualized, are the low but firmly out-thrust chins, the high broad foreheads, the slanting eyes. Admittedly, this panel is a culminating point, perhaps even an exception, in the unity of the lighting, the warm colouring and the fully developed chiaroscuro. Generally David's panels seem more sober, attuned to a cooler key, the composition, with the heads adjusted to the same height, all too clear and all too regular.

David was no determined innovator but rather a guardian of tradition who represented at the eleventh hour the art of the fifteenth century in conservative Bruges, whilst in rising Antwerp Quentin Massys, probably an exact contemporary, was practising the differently oriented art of the new era.

GEERTGEN TOT SINT JANS

LMOST all the early altar painting in Holland has been destroyed so that, as far as our limited knowledge goes, Geertgen tot Sint Jans becomes the representative of the fifteenth century. He worked at Haarlem, and does not seem to have left Holland but apparently was not entirely unaffected by the art of the Flemish towns.[1] His very real originality must be regarded in the first place as a personal quality, then— though with caution—as national Dutch. Though the discovery of the one work by Ouwater, the *Raising of Lazarus* (Berlin) unfortunately bore 86 no further fruits it has been possible from our master's accredited chief work—the pictures in Vienna that formed the front and back of an 137–138 altarpiece wing clearly described by van Mander—to establish a considerable *oeuvre* for him and to gain a many-sided idea of his personality.

We have two *Madonnas*, one unusually large (Berlin, Kaiser-Friedrich Museum) one unusually small (Milàn, Ambrosiana), no less than three *Adorations* (Amsterdam, Prague, Dutch private collection),[2] the charming diptych in Brunswick,[3] the *Raising of Lazarus* in the Louvre, the *St. John* 136 *in the Wilderness*, Berlin, the symbolic representation of the *Holy Kindred* in 142 Amsterdam, the problematic *View of a Church* in Haarlem—that gets us nowhere—the *Man of Sorrows* in Utrecht, the night scene of the 143 *Nativity* in the v. Onnes Collection, Holland,[4] and finally a not fully 139 accredited portrait, formerly in the Leuchtenberg Collection, St. Petersburg[5], which represents the second wife of the Duke of Cleves. These

[1] Calling attention to the borrowings by Geertgen from the Monforte *Adoration* by Hugo van der Goes, Friedländer later did not exclude the possibility of Geertgen's stay in Ghent (*Die Altniederländische Malerei*, V, 1927, p. 18). If, as suggested by R. Koch (in *The Art Bulletin* XXXIII, 1951, p. 259) the "Gheerkin de Hollandere" mentioned as an apprentice in the accounts of the Guild of St. John and St. Luke at Bruges in 1474–75 is identical with Geertgen tot Sint Jans, the latter must have spent at least part of his apprentice years in Flanders.
[2] Now in the O. Reinhart Collection, Winterthur.
[3] The Brunswick diptych is now generally excluded from Geertgen's *oeuvre*. In a detailed study of Geertgen and his circle, Friedländer has given this diptych to a Geertgen follower, to whom he was also able to attribute several other paintings (*Die Altniederländische Malerei*, VI, 1927, pp. 51 ff.). For the Master of the Brunswick Dyptych, see also p. 113, note 4.
[4] Now in the National Gallery, London.
[5] *Trésors d'Art en Russie*, 1904. *Two important additions to Geertgen's oeuvre published by 140, 141 Friedländer (in *Maandblad voor beeldende Kunsten*, XXV, 1949, p. 187, and XXVI, 1950, p. 10) are the *Virgin and Child* in the Museum Boymans-Van Beuningen, Rotterdam, and the *Adoration of the Kings* in the Cleveland museum. To these should now be added a *St. Jerome* in the P. & N. de Boer Stichting, Amsterdam. The Rotterdam picture has been identified as the part of a diptych, the

thirteen works were done at approximately the same time. If van Mander is perhaps mistaken in allotting the master only twenty-eight years, he does in fact seem to have died young. None of the paintings listed here seems to have been done considerably before or appreciably after 1490. The differences between one or other of the links in the chain, however great they may appear to be, can be partly explained by the influence of the subject, the condition of the picture and the size.

Next to Hugo van der Goes, Geertgen is the Netherlandish artist in the second half of the fifteenth century with the greatest claim to creativeness and originality. The difficulty in assessing his achievement is all the greater because it is not easy to rid our minds of all that came later. Geertgen was probably born about the same time as Gerard David— 1465—and probably died about the same time as Memlinc—1495. Our immediate reaction to the Vienna panels, a feeling of excitement at their purposeful boldness, is increased rather than weakened by a more intensive study of all we possess of the master, for we become aware of the flexibility with which his perception of nature was ever adapted to the task before him.

138 In the *Lamentation over Christ* in Vienna, the mourners and the body of Christ in their plastic and spatial arrangement are resolutely adjusted to the seemingly horizontal surface of the ground. There is the illusion of a cubic bulk graduated to correspond with the recession, which convinces at every distance from the eye. The artistic means, without which this effect could never have been achieved, is the incisively sharp contrast of light and shade in the foreground figures, a contrast studied in the studio and not out-of-doors. The antithesis of the light values becomes less emphatic in proportion to the smallness of Geertgen's pictures. The small panels lack the tautness, lack the bursting rotundity or prismatic faceting, the deep rents and the jaggedness that is characteristic for the foreground shapes on the large Vienna panels.

The landscape is surprising in the soft succulent green of the vegetation. To grasp the significance of Geertgen's achievement we need only recall the position of landscape within the general run of early Netherlandish painting. The landscape setting is represented in natural relationship to the figures. Elements widely discrepant elsewhere here seem fused to organic unity.

The landscape cannot be ignored without destroying meaning and essence of the whole. The primitive device of the 'three grounds' is done

other wing of which, a *Crucifixion with St. Jerome*, is in the National Gallery of Scotland, Edinburgh, see I. Q. van Regteren Altena (in *Oud-Holland*, LXXXI, 1966, pp. 76 ff.). His doubts as to the autograph character of the diptych are certainly justified for the Edinburgh panel.

away with. Geertgen's contemporaries evoke the illusion of depth with masses like stage sets and stacked hills or trees parallel to the picture plane, the backgrounds alone being richly developed; they suggest distance in the landscape by the expedient of a division the inadequacy of which is generally betrayed in the middle ground. In Geertgen's pictures the grounds flow imperceptibly into one another. His landscape unfolds luxuriously in the middle ground. He achieves the illusion of distance without resorting to the 'prospect', the distant view, the wide horizon. The surrounding vegetation takes over the function of architecture and makes as important a contribution as the figures to the general effect. Geertgen's lyricism lies very largely in his landscape.

We like to feel that there is some deep-rooted cause underlying this blossoming of landscape representation at Haarlem, the town where Ruysdael worked, and eagerly seize on van Mander's passage: "Of the earliest painters it is affirmed and assured that it was Haarlem where in olden days the best and earliest manner of landscape representation arose."

Just as Geertgen with obstinate determination fashions figures that rise freely in space and stand firmly with their soles on the ground so he avoids strong protrusions and, like a sculptor in stone, binds the body masses together with austerely pure, sometimes almost mathematical outlines. His profiles are dull, the eyes shallow, the noses seem short, slightly arched and uptilted. The concrete observation leads the master unhesitatingly to introduce genre, even burlesque motifs and gives holy and profane alike an earthy solidity. Far removed from affectation and sentimentality he pursues the expression with naive objectivity to the verge of the comic. His composition is not painterly in as far as it is anything but surface decoration, and nowhere veils or blurs the form, and not graphic in as far as the boundaries never appear firmly stressed. Light is never sovereign but rather subsidiary, as is also the colour, which, at times exquisitely harmonious, at times glowing in splendour, always remains subordinate. He did not aspire to chiaroscuro in the sense of the later Dutch painters but with clear and consistent observation of the conditions of light, the inner and cast shadows, he created the basis on which the later art of Dutch painting could arise.

JEROME BOSCH

WHAT rather than how, content rather than form, these are the problems that absorb the art lover when first encountering the phenomenon of Jerome Bosch—to the extent that, generally speaking, no proper distinction is drawn between the original on the one hand and copies or imitations on the other. The invention is admired but little attention is paid to the manner of drawing and painting. The only serious attempt to comprehend Bosch's art, the article published by Dollmayr in 1898,[1] was as successful as a guide through an unfamiliar world of ideas as it was misguided in the stylistic criticism.

Bosch, whatever else he may have been, was certainly a great and original artist so that mind and matter form an entity in his work and in his imagination idea and image are conceived simultaneously. Therefore the study of form will give us just as much insight into his world of ideas as the understanding of his intellectual outlook will aid the work of stylistic criticism. We have not yet arrived at the deplorable period which suffered from the dualism: *unus invenit, alter fecit*. And if diligent engravers of the sixteenth century multiplied compositions by Bosch, the master himself never worked mechanically—he worked creatively.

In many of the surviving works by Bosch even the subjects are peculiar to him as, for instance, the abstruse *Temptations* or the allegories of the Last Things, others are common property as regards the subject-matter but are re-interpreted and interwoven with original motifs and a luxurious welter of ideas.

Two methods suggest themselves to clarify Bosch's manner. We can either, as Justi and Dollmayr attempted in masterly descriptions, concentrate on representations that in content and execution are peculiar to the master or else we can study Bosch's approach to a subject often successfully treated by his contemporaries and fellow countrymen, e.g. the familiar subject of the *Adoration of the Kings*. In this way Bosch's attitude to convention is revealed.

The subject of the Epiphany in itself was anything but suitable to bring the master's imagination to exploding point. We possess at least three versions by his hand:

[1] In the Vienna *Jahrbuch der Kunsthistorischen Sammlungen*.

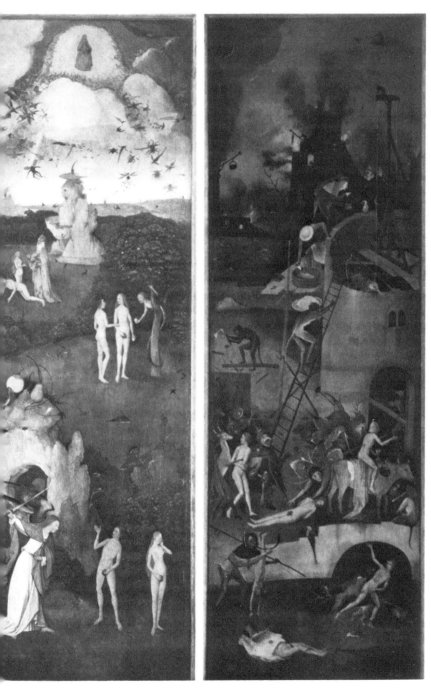

IV–V. Bosch: *Adam and Eve; Hell*. Wings of the 'Hay-Wain', Escorial

(*a*) The panel from the Lippmann Collection (now Metropolitan Museum, New York),

(*b*) the panel from the sale of the Earl of Ellenborough (now Johnson 147 Collection, Philadelphia),

(*c*) the celebrated, oft-copied triptych in the Prado. 148–150

Constrained by the commission Bosch curbed his instincts, particularly in the Madrid altarpiece, where the donor and donatrix with saints appear on the wings. All the more confidently, therefore, can we interpret the deviations from the norm as the exigencies of his temperament.

The biography of Bosch is not known exactly. The master, who died in 1516, seems to have been born around 1450. He is shown as a man well advanced in years on a portrait engraving which, however, must not be regarded as an absolutely reliable document. His name occurs in Hertogenbosch documents between 1493[1] and 1512.

This town, the centre of the master's activity, where in all probability despite his name 'van Aken'[2] he was born, lies within the boundaries of present-day Holland in Northern Brabant, far from Haarlem, the artistic centre of Holland proper. We know next to nothing of the art practised in this area and it seems hardly possible to find an historical basis for Bosch's art, whilst the tradition deriving from him is mainly in evidence at Antwerp (though, admittedly, that city was the centre of attraction at the beginning of the sixteenth century).

Of his known contemporaries the so-called Master of the Virgo inter 133 Virgines, whom I have attempted to locate at Delft, comes closest to him, but not really close. The costumes in his pictures afford some aid for the dating. The Prado triptych may have been done about 1490. An *Adoration of the Kings* has probably survived by every artist who worked between 1470 and 1500. There is thus a wide choice for comparative study.

The standpoint of the painter can be fixed from the proportions of the figures to the picture surface. The human figure is as far removed from Bosch's interest as from his eye. Its weight, cubic bulk and individual details are in themselves of indifference to him and he makes not the slightest attempt to produce the illusion of reality by a painstaking study of models. In his compositions the figure has value only as an expressive contour and as a link in the narrative chain.

*[1] As later research has established, it is in 1480/81 that Bosch appears for the first time in the registers of the Brotherhood of the Holy Virgin at Hertogenbosch (under the name 'Jeroen the painter').

*[2] Hertogenbosch citizens with the name 'Van Aken' can be traced back to 1399, as recently stressed again by L. von Baldass, *Hieronymus Bosch*, London 1960, p. 9.

The people stand like accessories in front of the landscape, not really within the landscape space, not surrounded by air. And yet he had a vision of that unity of figure and landscape that Pieter Bruegel was to realize. Bosch's large but geographically visualized landscapes have a very high horizon and seem to be surveyed from a tower, the figures on the other hand have their own much lower-lying horizon, are upright and seen without foreshortening. No proper illusion of depth can result from such an archaic division and dualism of perspective construction. And in fact the emphasis does seem to be on the surface decoration in Bosch's pictures, although breadth and distance in the landscape backgrounds are carefully expressed in line and colour. A vital factor for the illusion of space, the middle ground, is lacking.

The emotional content of the *Adoration of the Kings*, the dignified and humble reverence before the Christ Child, is merely incidental in Bosch's treatment. Instead of driving straight to the core of the theme, the subject under his hand bristles with adventurous and picturesque elements extracted from the bible story. His power of observation, subordinated as it is to an exuberant imagination, is concentrated less on the actual text than on the marginal trimmings. The Virgin with the Christ Child do not impress themselves on our minds. On the other hand the tumble-down hut, the Moorish king and the inquisitive shepherds are the motifs that he delights in elaborating. The court figures and the chorus are vivid and convincing but the protagonists seem insipid and indifferent. Dignity and holiness are expressed in beautifully developed forms but the terse and cursory language shows little imprint of the master's personality and seems strangely archaic. On the other hand abnormality and deformity stimulate Bosch to personal interpretation. With an aversion for architecture, symmetry and regularity he combines a diabolic delight in the apparent anarchy of organic form. Surprising form interests him, normal form leaves him cold.

As a psychologist Bosch is one-sided to the point of monomania. The very idea of the Passion of Christ evokes in his mind an orgy of mockery 155–157 and devilish spite and he cannot invent enough hideous monstrosities to pour down hatred and contempt on the adversaries of Our Lord, whereas the divine suffering seems vague or even ambiguous.

In his observation of human nature Bosch is certainly a precursor of Pieter Bruegel but his sense of reality is deflected, oppressed and haunted by visions, by the excrescences of an inhuman imagination that distorts the natural.

Like so many of the best masters of Germanic origin Bosch has all the

makings of an illustrator. In actual fact, however, as far as we know he never had occasion to do proper illustrations, but everywhere in his work the narrative overflows the boundaries of panel painting and is often unintelligible because the explanatory text is lacking.

Bosch has all the makings of a landscape painter. There is character and grandeur in his wide and barren plains. Perhaps he is more entitled than Patenier, a professional landscape painter, to be included among the pioneers and innovators in this field.

However progressive in his intellectual independence and robust inventiveness the master may be, his formal idiom and manner of painting are still of the fifteenth century. By studying his terse sharp lines in their archaic ductus and the glazed clarity of the thinly applied paint (in well-preserved originals) we can avoid confusing his works with those of his imitators.

Primitive even in the circle of his contemporaries, Bosch composes like a carver in relief or a medallist; his profiled figures are thin, almost transparent, everything is flattened onto the surface. The essentials are expressed in decoratively attractive silhouettes. The figures lack the leaden heaviness with which the fifteenth-century Netherlanders weighed them down by intensive study of nature and careful modelling. A rapid smooth-flowing line, precisely directed, gives an ethereal quality to his pictures.

Meagre limbs, thin sticks, branches, slender tree trunks all attract him; keen-edged, prickly, cactus-like forms infuse an uncanny life into the surface. Dots and lines in sharp staccato strokes, broad, pearly or ridgy, preferably light on a dark surface, produce a tingling sensation. In this way foliage is expressed in bright dots on dark surfaces. A harmonious cool colouring, glistening opal-like and transparent, particularly in the bright patches, does more to enhance the decorative charm than to increase the realistic effect.

The basic forms of the human figure, which is graceful and flexible in effect, are surely grasped but superficial intimations suffice him for the details. We can expect little reverence for nature from one who tries to poach on the Creator.

In his fantastic imagination Bosch defies the laws of nature, ignores the barriers between man and beast, between human works and the work of nature. Everything ever conceived in popular superstition and all the terror of Hell become visible in freaks and monsters. And he succeeds in giving these impossible creatures a certain credibility of appearance and movement.

Bosch is no portrait painter. He and Pieter Bruegel are among the few early Netherlandish painters by whom no portraits survive. Not the individual thing in itself but only individual abnormalities, excessive individuality, caricature have any meaning for him. The donor portraits 148–149 in the Prado are weak. The donatrix looks like St. Agnes's sister. A clear distinction is usually drawn between the saint and the donor portrait but here they flow into one another.

Bosch's human beings have thin, pale, elderly faces and generally participate in some sly feeble cunning. The pure and holy often have a foolish smile whilst evil lurks everywhere awaiting an opportunity to erupt.

Bosch's drapery folds seem flattened out, more linear than plastically conceived. The lines are not stiff or wide-sweeping, not crumpled or bunched up but rather finely designed with a well-controlled clarity of movement. At times widely arching lines predominate, as for instance in 147 the *Adoration of Kings*, Philadelphia, or again straight and angular ones 159 meet as in the *St. John on Patmos* in Berlin, I suspect that the curving drapery folds belong to an earlier, the straight ones to a later period. But owing to the lack of authentically dated pieces the chronological order of Bosch's work is still uncertain, despite recent research.

Our stock of Bosch paintings, even after a critical rejection of the many copies and imitations, remains considerably larger than Dollmayr assumed. Dollmayr rightly rejected some works from Justi's list, for instance the triptych at Valencia, but was wrong in discarding several others. A number of genuine works were unknown both to Justi and Dollmayr. Cohen's list in Thieme-Becker's *Künstlerlexikon* is fairly complete.[1] Lafond's richly illustrated book on Bosch is quite worthless because it lacks any critical approach.

In my attempt at classification I intend to ignore the chronology and arrange the material by subjects, because in this way the compositionally and stylistically related works can be put together, which facilitates the general survey.

I have already mentioned the three panels of the *Adoration of the Kings* —full-length figures staged against wide landscape backgrounds. Bosch liked to represent the Life of Christ—preferably the horror scenes of the Passion—in half-length figures which enabled him to give a maximum of expression in terrifying caricatures to the relatively large heads of the enemies of Christ and to the executioners.

[1] Friedländer himself published more complete lists in *Die Altniederländische Malerei*, V, 1927, pp. 143 ff. and XIV, 1937, pp. 100 ff.

The *Nativity of Christ* in half-length figures, Cologne museum, which was accepted by Justi, is probably only a copy of the mid-sixteenth century (like the corresponding generally rejected version in the Brussels gallery). Two small altar-wings from a *Nativity of Christ* on the Munich art market, not known to me, have passed to the Johnson Collection, Philadelphia. On one of the wings are royal horsemen—similar to those on the central panel of the *Hay-Wain* in the Escorial—the kings with their retinues; the other wing shows the shepherds. Of the Passion scenes with half-length figures the *Crowning with Thorns* in the Escorial is genuine[1]. Not one of the variations of this composition (Antwerp museum, formerly Kaufmann Collection, Berlin, and elsewhere) is an original. On the other hand *Christ carrying the Cross* in the Ghent museum is genuine; it is re- 156 markable for the densely packed mass of horrible hate-distorted heads with which, heedless of natural spatial effect, Bosch has filled the entire picture plane. *Christ before Pilate* in the Art Museum, Princeton, is similar in conception and composition.

Among the Passion scenes with full-length figures *Christ carrying the Cross* in the Escorial should be accepted—it is comparatively mild in expression and relief-like in treatment throughout. Further there is an *Ecce Homo* in the Staedel Institute, Frankfurt. Far more original in inven- tion is an *Ecce Homo*, arranged in two rows one above the other, in the 155 Johnson Collection, Philadelphia.

Several years ago I saw a *Crucifixion of Christ*, not mentioned anywhere, 146 on the Brussels art market, a composition with no personal characteristics.[2] The Rogier pattern still lingers particularly in the figure of Christ on the Cross. The subject did not permit the artist to give free rein to his inven- tive faculties. On the left next to the Cross the Virgin and St. John stand quietly together, on the right a youthful donor kneels, with St. Peter as his patron. The landscape is characteristic, with barren middle- ground and richly silhouetted background.

For Bosch a saint is first and foremost a being who is tempted, attacked and derided by devils. The famous oft-copied *Temptation of St. Anthony*, 153 an altarpiece with wings, is in Portugal. Single panels with St. Anthony can be seen in the Prado and in Berlin. In the perfectly preserved picture in Madrid the saint is seated huddled in the foreground gazing into space and lost in visions whilst the forces of Hell advance with cunningly contrived weapons of war. Here, admittedly, as in the similar Berlin

[1] In addition to this version, the *Crowning with Thorns* acquired by the National Gallery, 144 London, in 1934, has been accepted by Friedländer as autograph (in *Die Altniederländische Malerei*, XIV, 1937, p. 101).
[2] Now in the Royal Museum, Brussels.

picture, the devilish creatures are so small in size that the attack seems more like the odium of noxious insects than threatening.

159 Even St. John, who sits writing on Patmos and looks upwards to see the vision of an angel and the Virgin in the heavens above—even he is not spared. Like a spy from hell, unnoticed by the Evangelist, a small devil is pressed against the rock. This panel, on the reverse side of which the whole Passion of Christ is represented in monochrome, done in one grand sweep, is in the Kaiser Friedrich Museum, Berlin.[1]

One of the two badly damaged triptychs in the Vienna museum has St. Jerome on the central panel and SS Aegidius and Anthony on the wings. The second Vienna triptych depicts the *Martyrdom of St. Julia*.[2] The

154 Ghent museum has recently acquired a panel with *St. Jerome* lying full-length on the ground, strangely impressive in his act of penitence. Here even the fauna and flora seem insidious so that devilish spooks appear to be lurking everywhere.

158 The roundel with the *Prodigal Son*, in the collection of Dr. Figdor, Vienna,[3] is genre-like in conception; it has been pertinently described by Glück.[4]

Of the *Operations for the Stone* the version in the Prado is an original (not the one in Amsterdam). To our minds there is in such productions a contradiction between the humour of the action and the terse solemn archaism of the drawing.

There is quite a volume of literature on the three many-figured capital

152, 151, works by Bosch in the Escorial: the two triptychs, *Hay-Wain* and *Garden*
145 *of Earthly Delights*, and the table-top with the *Deadly Sins*.[5] Justi gave exhaustive descriptions of these compositions.[6] A replica of the *Hay-Wain* has turned up at Aranjuez[7] (the wings are in the Prado and the Escorial), the quality of which is hardly lower than the version preserved in its entirety

152, IV in the Escorial. Of the representations of the *Last Judgment* the triptych in
–V the Vienna Academy is still most entitled to be accepted as genuine.

Four narrow panels, now rather dulled, in the Venice Academy, said to have come from the Doges' Palace, representing the Blessed and the Condemned from a Last Judgment, are originals.[8]

*[1] Now in the Staatliche Museen, Berlin-Dahlem.
*[2] Both Viennese triptychs are now in the Palazzo Ducale, Venice.
*[3] Now in the Museum Boymans-van Beuningen, Rotterdam.
[4] *Jahrbuch der Preussischen Kunstsammlungen*, XXV.
*[5] The *Garden of Earthly Delights* and the table top with the *Deadly Sins* are now in the Prado, Madrid.
[6] *Jahrbuch der Preussischen Kunstsammlungen*, X.
*[7] Now in the Prado, Madrid.
[8] Two were published as School of Jerome Bosch by Dülberg, *Frühholländer in Italien*, Plates VIII, IX.

The *Garden of Earthly Delights* represents a culminating point. Here the insistent urge of the illustrator produced a heap of compositionally equal sections rather than a real composition.

In the images he creates Bosch remains a solitary figure in the fifteenth century. His conception of landscape seems to have borne fruit—in particular in Patenier and directly and indirectly also in others. Bosch was widely copied in the sixteenth century but the copyists were interested only in the subject-matter, in the entertainment, moralizing and horror values. The interest and the demand for these pictorial themes lasted until far into the sixteenth century, Jerome Cock in particular published prints after compositions by Bosch. And round about 1550 this publisher seems to have introduced Pieter Bruegel the elder to Bosch's art. Especially in his earlier period Bruegel sometimes appears to be an imitator and continuator of Bosch.

Until very recently there has been little understanding for the quality of original works by Bosch. What has survived is largely due to the taste of Philip II of Spain, who amassed in the Escorial everything by Bosch that he could lay hands on, similar to the way in which, at a later date, the Habsburg princes such as Rudolph II and Archduke Leopold Wilhelm sought the works of Pieter Bruegel.

GENERAL REMARKS ON THE

SIXTEENTH CENTURY

H ISTORIANS of art like to present the turn of the century as an Epoch and begin a new chapter even when describing Northern painting. The familiar contrast 'Quattrocento' and 'Cinquecento' in the South tempts us to make a similar incision in the North. The historian's passion for classification and superstitious belief in the mystery of numbers play their part in converting what was in fact a gradual transformation into a sudden change, whereby impartial observation becomes coloured.

Nevertheless it is permissible to emphasize some features as characteristic for the sixteenth as opposed to the fifteenth century—provided we remember that these traits emerged at intervals, here and there, and over a period extending well beyond and before 1500.

Not a single painter of the sixteenth century combined all the features of the new age in his work. We can enumerate the symptoms but are forced to admit that, of all artists who represent the sixteenth century for us, it is only by one or other aspect of his work that the individual one is stamped as a child of his age. Almost all the painters who began to work between 1490 and 1510 are in some way firmly rooted in tradition, a fact that is overlooked by historians who, whether from ignorance or in the interests of clarity, simplify the historical process. In certain fundamental points Quentin Massys is more archaic than Hugo van der Goes. And an account that places the Louvain master at the beginning of the new period but is forced to include the Ghent master in the old period falsifies the observed facts.

The creative power of Netherlandish art decreases considerably during the second half of the fifteenth century as can be seen particularly at Bruges. Apart from Hugo van der Goes and Geertgen we search in vain for courage and enterprise. Neither Memlinc's pleasant exploitation of inherited wealth nor the passive late-flowering art of David contain seeds for a new beginning.

(65)

The period around 1500 offers a confused picture in which simultaneous but widely diverging efforts can be observed in plenty. The character and general conditions can best be defined in negative terms.

Art at the beginning of the sixteenth century lacks confidence and assurance, is without roots and outside the law. Aim and content are no longer determined by the tradition of craftsmanship and ideas; a vacuum has arisen into which comes a wide and varied influx. Even in the past, art historians noted the appearance of Italian forms as an outwardly striking symptom and interpreted it as the real cause of a far-reaching change. The most naive theory, though admittedly hardly to be found in recent literature, presupposed everywhere a 'visit to Italy'; which in each case lured the artist away from the national Netherlandish manner and brought him into the orbit of Italian art.

Rogier visited Italy in 1450 but there is no evident effect of the foreign climate on his formal language. A century later Pieter Bruegel travelled through Italy without perceiving anything of Italian art. If Jan Gossaert or Scorel were transformed in Italy—for good or ill—this denotes exhaustion, lack of resistance, an inner void. The inability to keep up their end is by no means confined to the—greatly overestimated—relationship with Italy. We need only recall Dürer's effect on the Netherlands, first when his engravings and woodcuts arrived singly and then, in 1520, when he himself came and disseminated his prints in such profusion. The German artist was certainly not valued as a painter superior in every respect, he was probably even sharply criticized, but his inventions and richness of composition were seized upon and his prints extensively copied. Hunger reigned and nourishment had to be taken wherever it could be found.

Even in the heroic age of Netherlandish art, even in the first half of the fifteenth century, invention did not flow freely. The predominant role of Rogier van der Weyden can be explained by this general weakness. The strength of Netherlandish art lay more in the searching penetration to the details than in the general conception of the whole. In the sixteenth century it was on invention that a perverted ambition was concentrated. Desire and talent were fatally divided.

A long list of characteristics could be formulated for the new age, but even a tolerably complete survey of personalities and monuments evokes the uneasy feeling that the exceptions constitute a dangerous threat to the rules and that all generalizations are nothing more than half-truths. Nevertheless, in my opinion the sum-total of half-truths does to some

extent give an accurate overall pattern of the extraordinary medley of Netherlandish aims in the period between 1490 and 1520.

In the fifteenth century the painter worked modestly, in the spirit of the craftsman, but the artist of genius by his very nature—though not as his aim—produced personal and individual achievements. In the sixteenth century the manners of genius were aped by all. The small masters, who in the fifteenth century worked unassumingly according to the rules, became wild and undisciplined and strove for some bogus originality by exaggeration and ostentation. The craftsmanship began to disintegrate, for on the one hand careful and accurate methods were despised by the vainglorious artistry of the individual and on the other the instinct of gain favoured a more standardized and commercially profitable production with slipshod workmanship and mechanical repetition. On the technical side there was appreciable deterioration. But it was not until the period between 1530 and 1550 that the worst results of this decline were revealed. The general public now made greater claim than ever before and demanded what was new and fashionable rapidly and at little cost. The increasing export of art works to Spain, Germany, Sweden and Denmark, especially from Antwerp, brought the final depression in the quality of painting.

In place of the quiet, firmly defined form preference was now given to agitated, angular forms. The illusion of movement was sought in many small ways and turbulence produced by eccentric attitudes, violent distortions and postures. Incapable of giving new form to the old themes from within, the younger generation was usually content to rake and pile up the old with new trimmings and in a new guise.

Absorbed in the religious content, the artist's one aim and purport had been to evoke it in all simplicity, but this attitude was now replaced by a cold arty ambition (Jan Gossaert) or by an easy charm of manner (Joos van Cleve), by personal sentimentality (Quentin Massys) or by a delighted interest in accessories and stimuli, which were supplied in continually increasing doses (the 'Antwerp Mannerists'). Naturalness, the striking illusion for its own sake—not to serve a purpose—was now sought. The indifference to the content, which was re-interpreted, turned upside down, borders on the frivolous. Once art begins to lose its bearings, to interrupt the organic growth from native roots, to seek chance contacts rather than inner relationships, to be guided by ambitious aims rather than deep-seated impulses, stylistic changes proceed at a hitherto unknown pace. Nervous discontent compels a talented artist like Lucas van

Leyden to mirror the entire confusion of the age in his personal develop-
ment, and this, moreover, within a particularly brief span of life.

Architecture and décor seem to offer a suitable criterion for an
objective assessment of the contrast between the fifteenth and sixteenth
centuries. Almost exactly at the turn of the century the Netherlands pass
from national Gothic to Italian Renaissance. But even here the process,
on closer consideration, appears fairly complex. To begin with, the Gothic
style was not abandoned but disintegrated, became unrestrained and
degenerate. Not only Italian or would-be Italian Renaissance forms
replaced the Gothic ones but also half understood Romanesque motifs—
such as the chevrons in early paintings by Orley. The desire to emphasize
the remoteness of biblical and legendary scenes, to show off historical
knowledge and at the same time to add the spice of the exotic to the
representation, was responsible not only for the choice of Italian forms,
which were regarded as antique ones, but also for arbitrary inventions.

The delight in decoration runs riot, unhesitatingly mingles Gothic
with apparent Renaissance. We rarely find any understanding of
architectonic form, of proportions or functional qualities. Knowledge of
the Italian Renaissance was derived from doubtful sources and the
unassimilated elements were plastered on anywhere. The changing taste
in architecture and decoration must in no way be taken seriously. The
generally uninformed and superficial use of Italian motifs does not reveal
a stylistic ideal that could be regarded, as some writers have done, as the
essential driving power.

Almost all the characteristics that I have set out here as signs of disintegra-
tion could equally well be interpreted as the stirrings of a new creative
spirit. The longing for a great, free art emancipated from the Church
can be traced almost everywhere by optimistic seekers. Even in the
perfunctoriness of the technical treatment, in the broader, more com-
prehensive, coarser execution it is possible, bearing in mind the distant
aims of seventeenth-century art, to discern a beginning as well as an
end. The thick oily painting of an Engelbrechtsen, the broad and
fluent brushwork of Jan van Scorel, can be considered as promising seeds
on Dutch soil. And the moment forceful talents appeared they were able
to push forward successfully down paths that had seemed to lead astray
as, above all, Pieter Bruegel.

The new age, which tore down barriers everywhere, offered a wider
horizon, richer possibilities, knowledge and incentives, temptation and
opportunity, poison and nourishment. The dangers were more fatal for

the minor than for the medium talents, for the latter could find some protection against mannerist affectation in the direct and careful observation of nature. It took time for the Netherlandish sense of reality to find its bearings in the enlarged field, for the new possibilities to be exploited, for the new demands to be satisfied, and for the stimuli from the South to be assimilated. The critical transition period lasted almost a century.

QUENTIN MASSYS

QUENTIN MASSYS was born in 1466 and died in 1530, which makes him a generation younger than Hans Memlinc, a generation older than Bernaert van Orley. What we know of his work was done in full maturity and in old age. We can follow his work without coming upon serious gaps from about 1506 until almost 1530 and can discern the direction that he took. Everything prior to 1506 is obscure or only dimly illumined by hypotheses. It is of little consequence whether the master was born in Antwerp or, as now seems more probable, at Louvain. Even if we were certain that he had spent his youth and apprenticeship at Louvain and had absorbed nothing but Louvain art during his formative years it would not throw much light on his art. We know a little more about Louvain art around 1480 than about the contemporary art in Antwerp—but it is still precious little. The threads that have been spun from Dieric Bouts, the chief master at Louvain, who died in 1476, to Massys are tenuous indeed. Aelbert Bouts, Dieric's son, seems to have been head of a productive workshop at Louvain around 1480 and we think we can recognize the products. But we must not exclude the possibility that artists unknown today made a deeper impression on the young Massys than did the meagre Bouts tradition that we do know.

The only practicable way is to begin where the master's art is fully and richly developed.

By a fortunate coincidence the two accredited works, outstanding apart from their size, are dated or at least can be dated. These two works differ from one another in subject-matter; the sudden change of theme brought astounding variety and richness.

167–168 The altarpiece of *St. Anne* from Louvain, which is now in the Brussels gallery, is inscribed with the date: 1509;[1] the altarpiece with the *Lamenta-*
166 *tion over Christ* at Antwerp was set up in 1511. By making the plausible assumptions that Massys did not work simultaneously on both altarpieces, that the date 1509 marks the conclusion of work on the Brussels altarpiece and, finally, that a period of two years each is not excessive for completing the two sets of five large paintings, on these assumptions

*[1] Commissioned for the chapel of the Confraternity of St. Anne in the church of St. Peter's at Louvain in 1507, cf. Friedländer. *Die Altniederländische Malerei*, VII, 1929, p. 114.

we are entitled to regard the two works as fruits of the well-spent years 1508–1511. In 1508 Massys was 42 years old; he had been master at Antwerp since 1491, and had probably won fame and recognition for considerable achievements, so that great things were expected from him.

Much as we should like to be able to recognize the line of development by a comparison of the two works, there is little hope, in view of the small time interval and the widely differing subject-matter, of drawing reliable conclusions from such a comparison, particularly as the two altarpieces are not equally well preserved. The contrast, at first sight so striking, is due in part at least to the fact that whereas the Antwerp altarpiece is in perfect condition the Brussels one, as a result of vigorous 'cleaning', has lost much of its colour values and plastic quality.

The central panel of the Brussels altarpiece is tapestry-like with a 167 surprising absense of spatial illusion and centralized lighting. It is tempting to assume that for his large-scale compositions Massys turned to tapestry designers, who were the real representatives of monumental surface decoration in the Netherlands, that if he were accustomed to smaller-sized panels he would be driven to follow the tapestry compositions. At any rate, his *Holy Kindred* painting would make a masterly design for a wall-hanging. It is very possible that Massys did make designs for tapestries and that this type of work played a part in determining his style. One thing is certain: around 1500 in the Netherlands very few artists indeed were as qualified as he was to undertake such commissions. Much of his personal manner is reflected in the tapestries—and moreover in the finest ones—that have survived from about 1500.

The figures in the central panel of the *St. Anne* altarpiece in Brussels are of equal size, of equal compositional importance, have a community of feeling and are like in spirit. Since they are all of the same kin, this almost monotonous lack of contrast is well-suited to the subject. On the wings, where the dramatic incidents would permit a diversity in the emotional content, the general flavour remains unchanged. As opposed to the archaism and rigidity of the composition, the expressive quality, inspired throughout from the central creative impulse, has a sentimental appeal. A sensitivity that is almost too sweet, an elegance that tends to affection, certainly seems less appropriate for this virile and daring century than does the emphatic subjectivity with which these emotions are stamped.

The human beings with their spiritual sensibility, more feminine than masculine in character, of ladylike reserve, who shun vulgarity and coarseness, seem charged with the tension of a subdued grief. Intent on

preserving the stillness of the place, on maintaining their own dignity, they appear reserved with lightly parted lips and downcast eyes. Bodies, heads and hands are permeated by a restrained pathos. A repressed, not fully clear language echoes across to us, more like a song the words of which we do not understand but which from its melody suggests depths and thoughtfulness. The delicate creatures with their fine hands do not proclaim their inner excitement obtrusively and seem like half-transparent vessels which are for ever challenging us to guess at the contents. Admittedly, once we have examined Massys' entire production the secret loses something of its attraction in that the refined and sensitive spirituality appears everywhere, regardless of subject-matter—almost a mannerism. Massys somehow reminds one of a preacher who by force of habit adopts the pathos of his sermon for everyday language.

Almost prudishly modest, Massys drapes feet and ears, and loves to depict his holy children fully clothed. The human beings show signs of over-breeding with a slightly degenerate charm. The holy figures are fashioned with a conscious sense of beauty; no 'character heads' will be found in the *Holy Kindred*. Irregular or caricature-like forms as well as portrait features are reserved for the antagonists and executioners and for the mob, who are distinct from the ruling caste. Evil is represented as ugliness, all too clear, almost naked, painfully accurate, neatly and smoothly executed with deformations, disfigurements and distortions.

The costume is discreetly adapted to the refined humanity, an attire that does not in the least correspond to the dress worn in 1508 in the Netherlands. The desire to transport figures and actions away from the present by giving them exotic pieces of costume, in particular orientalizing headdresses, played some part, but the master's taste and his love of large areas of selected local colours, of flowing, as it were melodious, drapery folds played a still greater part in producing a freer interpretation of the cut of the garments. The simple guilelessness of the older artists is replaced by a suspicious attitude to nature. Working selectively and guided by a definite taste in what he accepts and what he rejects, Massys strives consciously towards the ideal, towards a refinement of vulgar reality by emphasis and contrast.

In the softer light and in the greater spaciousness of the cathedral the

166 Antwerp altarpiece must formerly have made a less irritating impression than it does today in the museum. It takes time to collect ourselves after the deep but not flawless impression. The tragedy of the Passion is expressed less movingly as a whole than in the individual heads and hands. In the even light of day the predominant impression is that of the

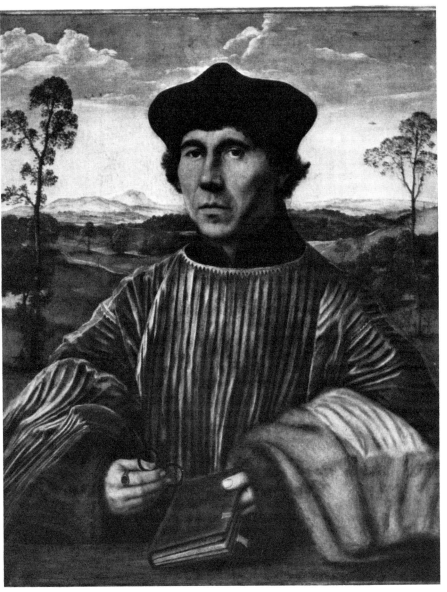

VI. QUENTIN MASSYS: *Portrait of a Canon*. Vaduz, Liechtenstein Collection

iridescent splendour of the broad areas of local colour. The symmetry of the almost inflexible groups contrasts distressingly with the realism of each detail. And the smooth silky glaze of the painting seems unsuitable for the large size. The eye searches in vain for an organization of parts to suit the dimensions, for strong contrasts of light and shade, for dominant accents.

We hesitate to trust our first impression and sense something of the chill breath of artistry in the consciously primitive archaic manner.

The ten chief figures, approximately equal in size, are all arranged, not without difficulty, at equal distances from the spectator, so that all the heads are of equal importance as if set by a stage manager who does not wish to offend any of the actors. The whole width is densely packed so that the middle ground is completely covered—eliminated. Everywhere the eye, which longs for a depth to correspond to the height and the width, comes up against the hedge of figures that tower over two-thirds of the picture. There is no connection and no transition from the figures to the landscape background, which is added to fill the free strip at the top. In the painting of the background with its multiple small parts no attention is paid to the proportions of the whole. The immense distance between the grounds is not expressed, at least not by pictorial means. Massys composes like a tapestry designer and paints like a miniaturist. In spite of the harrowing conflict resulting from the master's critical position at the threshold of two ages, the indefatigable care and sensitivity with which the forms are worked in detail over the wide surfaces arouses our astonishment and admiration.

In the two great altarpieces the personality of their author is expressed so eloquently and in such unforgettable accents that we cannot doubt, despite all possibilities of change, that we have grasped the immutable core of his art and can proceed with confidence to assemble the other surviving works by his hand. It may well be that not until fairly late, when he was at the height of his fame, did Massys dare to express his subjectivity clearly and with assurance, so that earlier works—and what an enthralling task it would be to trace them—will show his characteristic traits less clearly and we must be prepared to recognize in bud what we already know in maturity.

In the Brussels gallery are two *Madonnas*, one enthroned, a full-length 164 figure, the other in half-length, both of which were claimed decades ago by Ludwig Scheibler as works, comparatively early ones, by Massys. With full justification as I believe. The panels are heavy and warm in colour, filled with deep melancholy. The small Madonna, the one in

half-length, is arresting with her broad face dominated by dark wide-open eyes. What reminds us of Massys in the first place is the smooth surface, the subtle modelling which with superb skill gives a gentle swelling roundness to the bodies. The Children in both pictures resemble one another and their dull secretive air and the expression of helpless sadness in their eyes, familar in the eyes of animals, recurs in work of the maturer Massys style. The undulating drapery in the larger *Madonna* confirms the attribution to Massys.

These two *Madonnas* are a little earlier than the altarpiece of *St. Anne*, how much earlier it is difficult to say. To these can be added the *St. Christopher* in the Antwerp gallery; in the general effect it, too, is dark and is a little reminiscent of Dieric Bouts in the intensive blue and red patches. Though, it is true, the darkness could in this case be explained by the evening light.

W. Cohen's endeavour to trace the derivation of Quentin's art[1] is based on erroneous presuppositions. In the first place, the *Head of the Saviour* in the Antwerp gallery, which to Cohen's mind represents the connecting link between Massys and the Louvain studio of Dieric Bouts, is most certainly not a work by our master but only a particularly successful work by Aelbert Bouts and therefore does not come into consideration. Next we must reject all the conclusions that Cohen so cleverly drew from the Valladolid altarpiece. With a certainty that is unusual for him, C. Justi claimed the Spanish wings for Massys. But as I myself do not accept Massys' authorship I can ignore Cohen's conclusions of a Dutch influence.

Of Quentin's portraits, the one of a *Canon* belonging to Prince
VI Liechtenstein is, as far as I know, generally accepted. The portrait of
179 Aegidius at Longford Castle (probably done in 1517[2]) has been more frequently mentioned than studied. Its authenticity cannot be questioned. Whether its pendant, the second half of the diptych, the portrait of
178 Erasmus of Rotterdam, survives in the Roman version (in the Corsiniana,[3] formerly G. Stroganoff Collection) I cannot venture to decide. The master's most mature portrait, probably also his last, is the one at
172 Frankfurt which, after some extrordinary misconceptions, is now firmly and generally established. The man seems to address us with the air of a rhetorician or actor.

[1] *Studien zu Quinten Metsys*, Bonn, 1904.
*[2] The date 1517 is now established from the correspondence of Sir Thomas More, for whom Aegidius and Erasmus had their portraits painted by Massys.
*[3] In *Die Altniederländische Malerei*, VII, 1929, pp. 41 ff. discussing the portrait again, Friedländer expresses no doubt about the authenticity of this version.

In his passion for innovation the intelligent artist seeks to find a pictorial theme that embraces figure, movement, hands and head, and wishes to depict the individual in an action that is characteristic for him. The pictorial theme is not always clear but the interest is always directed to the intellectual qualities which strive to express themselves, and a spiritual relationship is deliberately established between the spectator and the person represented.

The *Portrait of a Man* at Northwick Park[1] is similar in composition to 173 the one belonging to Prince Liechtenstein. The indifference with which that excellent work is regarded is also shown to two more modest portraits, a man and a woman in the Oldenburg gallery. To this group I am adding 174–175 a relatively archaic *Portrait of a Man* in the Chicago Art Institute and one 176 of a younger man belonging to Lord Amherst (*Arundel Club*, 1909 No. 7, 'German School').[2] Who is represented in Lord Amherst's portrait? 'Portrait of Gonsalvo da Cordova' we read in the publication. The motto written in beautiful Roman lettering FIDELITER ET EXPEDITE, the singular huntsman's costume with the sleeves that appear to have been slashed with a sword, and the unusual moustache give an urgency to the problem of who the man can be. The supple posture, the elegant hand, the lightly parted lips, the look of suffering, the desire to speak, seem characteristic for Massys.

The best way to grasp the distinctiveness of Massys' pointed character studies is to compare them with portraits by Holbein, in which the healthy objectivity and inner calm seem classical next to the romantically insistent subjectivity and excitable pathos of the Antwerp master.

A few pictures with approximately life-sized figures, such as the half-length painting of *Christ* and its pendant, the *Mater Dolorosa*, in Antwerp (the corresponding panels in London are probably copies), or the half-length figure of *Mary Magdalen* in the same museum, the *Money Changer* 169, 177 in the Louvre (dated 1519?),[3] the *Madonna*, formerly Rattier Collection, now Louvre (dated 1529), a many-figured *Ecce Homo* privately owned in 170 Madrid,[4] and several other works by the master, take their place alongside the large altarpieces and confirm the impression they made, without enlarging the overall picture.

I feel it incumbent to put in a word for some small-sized paintings. Massys' art changes with the changing dimensions. In a new guise, seen from a new side, its nature is revealed anew and completes and supple-

*[1] Now in the National Gallery of Scotland, Edinburgh.
*[2] Present whereabouts unknown.
*[3] By Friedländer and other authorities the date inscribed on the painting is now read as '1514'.
*[4] Now in the Prado, Madrid.

ments our notion of it. The need to speak of the small pictures is the more urgent because they have been either overlooked or falsely judged, and not one is of any consequence for the popular idea of his art.

If the master's execution does not always appear to accord with the monumentality for which he strove, an easily achieved harmony can at least be expected in works of modest dimensions. And in fact small panels do exist of immaculate polish in which the supple drawing, the exquisitely sensitive movements vibrate in perfect unison with no trace of discord, and in which the remoteness from nature, the spatial structure and the arbitrary independence of the local colouring from natural lighting seem far less questionable or archaic than in the large pictures. One such small-figured work is the altarpiece with four panels in the Munich Pinakothek from which the over-painting has been removed and which has been successfully restored to its original condition. From the Boisserée collection some of the parts had passed to Nuremberg, others had been exhibited in the Pinakothek—the *Virgin on the Crescent*, the *Trinity*, *St. Sebastian* and *St. Roch*. To these may be added the two small panels with *St. John the Evangelist* and *St. Agnes* from the von Carstanjen Collection, at present in the Pinakothek.[1]

171

The *Standing Madonna* in the Lyons museum,[2] so frequently misunderstood, belongs to this group, also the *Madonna* in half-length formerly in the Aynard Collection.

The decision is more complicated in respect of a group of Passion scenes, some of which are of lesser quality and must be regarded as workshop productions. The group is self-contained and consists of a *Crucifixion* belonging to Prince Liechtenstein,[3] a *Crucifixion* in the National Gallery, London, a third very weak one in the Brussels gallery, two triptychs in the Harrach Gallery, Vienna, and the Musée Mayer van den Bergh, Antwerp. Further a *Lamentation over Christ* in the Louvre and finally the nude kneeling figures of female penitents in the Johnson Collection, Philadelphia, and a fragmentary *St. John the Evangelist* in the Padua museum.

Everything produced by Massys testifies to wide culture and conscious striving for refinement, testifies also to a personal taste that shrinks from the coarse and the common but seeks out the rare and the exquisite. The master would fain go beyond his native land to satisfy his aristocratic needs. If he absorbed anything of Southern art it was certainly Leonardo

*[1] Now in the Wallraf-Richartz Museum, Cologne.
*[2] A better version of this composition has come to light later. It is now in the collection of Count Antoine Seilern, London.
*[3] Now in the National Gallery of Canada, Ottawa.

da Vinci whom he felt as a kindred spirit. Perhaps he was familiar with pictures and drawings by Leonardo and schooled his own drawing and modelling on that great example. In one instance at least we can pin down a concrete relationship between the two masters. In the Poznan Museum, there is a large *Virgin* from the Raczynski Collection the inconsistency of which intrigues the critics. The Virgin in full-length is seated out-of-doors turning to one side, the Child is playing with the lamb. Leonardo's celebrated *Virgin and Child with St. Anne* is the model for the composition, but instead of sitting in St. Anne's lap the Virgin Mary is seated on high ground. Massys need not have known the picture that is now in the Louvre; perhaps he used a cartoon, a drawing or a copy of it (many such still exist today). In any case the relationship is instructive.

The picture from the Raczynski Collection has a competent and carefully detailed landscape, which looks purely Netherlandish, and comes up abruptly against the figure. The landscape does not seem to be by the same hand as the figures. The understandable idea has been expressed that it is by Patenier—but I do not find the attribution convincing.[1]

A—certainly inadequate—knowledge of the teachings and achievements of Leonardo seems to have informed Quentin's endeavours and to have supported his tendency to look for higher ideals away from home. It seems to us that in the elaborate complexity of movement, in the suppleness of the bodies and in the subtlety of the modelling we can perceive an ideal inspired by Leonardo.

[1] In *Die Altniederländische Malerei*, VII, 1929, p. 48, Friedländer regards the attribution of the landscape to Patenier more favourably.

JOACHIM DE PATENIER

I N van Mander's scanty account of Joachim de Patenier we find two statements that seem to be erroneous. The place of his birth is given as Dinant. But Guicciardini, who is more reliable, calls the painter 'Giovacchino di Pattenier di Bouines'. Whereas van Mander gives Bouvignes as the birthplace of Herri met de Bles, Guicciardini speaks of 'Henrico da Dinant'. Bouvignes and Dinant lie close together on opposite banks of the river Meuse.

According to van Mander, Patenier entered the Antwerp guild in 1535—which is incorrect. The correct date is 1515. The wrong date is not due to a slip of the pen. In his first edition van Mander wrote quite correctly 1515 but in the list of errata altered it to 1535 and repeated 1535 in his second edition. In 1535 a Patenier was in fact entered as master in the Antwerp guild, namely a Herri Patenier.

These strangely fluctuating dates encourage us to accept the hypothesis that Herri met de Bles is identical with Herri Patenier. On the one hand we find Joachim's birthplace confused with that of Herri met de Bles, on the other hand the date that is correct for Herri Patenier is applied to Joachim. Some person who could not distinguish between the two painters named Patenier may have supplied van Mander with the wrong date and perhaps at the same time given the wrong place. The deduction assumes some importance for Herri met de Bles, who, if he really was called Patenier, may have been a relation (perhaps a nephew—
186 Joachim does not seem to have had sons) of the older artist. Failing other dates it would be important to establish that Herri became master in Antwerp in 1535. In the engraved portrait the 'painter with the owl' looks about fifty. Judging by the costume the portrait can hardly have been done before 1560. So that Herri does not seem to have been born before 1510 and in 1535 would not have been older than twenty-five.

As regards Joachim, the question: Dinant or Bouvignes is of no consequence.

This master died in 1524. In 1521 Dürer made a silver-point drawing of him. Patenier's portrait engraved by Cort is obviously based on Dürer's drawing. The painter looks about forty-five. If he was born in

1475, Joachim, when he came to Antwerp in 1515, would have been about forty and prior to that must have worked elsewhere.

The three signed paintings by Patenier that are known to us (Karlsruhe, Antwerp, Vienna) have similar inscriptions: *opus Joachim D. Patinir* 184, 185 (Patinier).[1] The genuineness of the inscriptions is beyond doubt. A *Landscape with the Holy Family*, signed and dated 1520 (?) has recently appeared on the London art market. The Vienna panel with *The Baptism of Christ* seems to offer a good starting-point.

Patenier was a landscape painter, perhaps the first Netherlander to regard himself, and to be regarded, as a landscape painter, like Albrecht Altdorfer in Germany. Therein lies his fame. Dürer, who was on friendly terms with him, calls him the 'gut Landschaftsmaler' (the good landscape painter). How highly the specialist was valued is made abundantly clear by the fact that two of his greatest contemporaries, Quentin Massys and Joos van Cleve, collaborated with him: they painted the figures and he added the landscape.

At Middelburg, so van Mander writes in his vita of Joos, there was in the possession of Melchior Wijntgis a very beautiful *Madonna* by Joos for which Joachim Patenier painted a very beautiful landscape.

C. Justi made the pertinent observation that in the *Temptation of St. Anthony* in the Prado the landscape is by Patenier but the figures by 180 Quentin Massys. Van Mander's remark and the observation in Madrid force us, or at least permit us, to reckon with the possibility of such a collaboration also in other cases. We must in future beware of overlooking the possibility that the figures in Patenier's pictures were painted by other hands.

Landscape painting as an independent subject was late in appearing. We can regard on the one hand the painter's desire to depict and on the other hand the public's desire to see as mutually beneficial and inspiring factors. It was not sufficient for a painter to conceive the idea of painting a landscape and to be capable of doing so, someone also had to be there who was ready and willing to buy the picture. In our day natural landscape, whatever portion of it, from whatever corner of the world, whatever the season or time of day, is so unhesitatingly accepted as a fully valid and adequate pictorial subject that we find it difficult to conceive of conditions in which this was not the case.

Around 1520, in Patenier's day, conditions—conditions of a transition period—were roughly as follows: Netherlandish artists liked painting

[1] In addition two paintings by Patenier in the Prado are signed: *St. Jerome in a Landscape* and the *Temptation of St. Anthony*, even though in the latter case the figures are by Quentin Massys.

landscape and in their compositions gave increasing space, scope and importance to landscape. The public shared this liking. When people bought a *Holy Family*, a *St. Jerome* or some such edifying work they were delighted with the bit of landscape that was thrown in.

Though reduced to mere accessories, the figures were responsible not only for the title but also supplied the theme and the starting-point for the composition.

Patenier spins out the narrative in a leisurely way. The sequence in time that cannot be shown in one picture is smuggled in as a juxtaposition of scenes. The wider spacing of the episodes—possible because the landscape could be extended in depth and width and the structure varied whilst the figures could be made tiny and concealed—makes the juxtaposition seem less unnatural, less primitive than, for example, in Memlinc's panels with the *Passion of Christ* or the *Joys of the Virgin*, though in principle they were similarly composed.

The landscape, though predominant, does not form the content of the picture but only the setting.

Geographical and topographical interests, if not geographical historical knowledge, mingled with a genuine love of nature which, as yet only budding, unconscious of itself, put forward no definite claims but found incidental satisfaction.

The remoteness and strangeness of the events was expressed in the extraordinary and surprising aspect of the landscape. The more sensationally the surroundings differed from the familiar flatness the more natural and suitable they became as the background for sacred adventure.

The district of Dinant, the master's home, is rich in picturesque rock formations. Without doubt the impressions and the study of the surroundings promoted his understanding of the formation and texture of rock. But it would be wrong and unhistorical to believe that Patenier produced nothing but images of his native scenery. What he absorbed served only as material, as a means of expression, and it was the tendencies just indicated that determined the fashioning of this material.

The desire to build a deep stage on which many things could be enacted and to offer interesting sights to the eager sightseers resulted in mountain views and distant prospects. Patenier surveys the land from the mountain peaks. The naïve delight in the sheer quantity of the area surveyed, and therefore dominated, and the thrill of excitement at the monstrous shapes of nature, sensations that have survived today in the most banal of touristic pleasures, had their share in determining the beginnings of landscape art.

The painter's skill in conjuring miles of the countryside onto the small picture panel was admired. The interest in geography, stimulated by the great discoveries of the age, added to the delight in this convenient opportunity of getting to know foreign parts.

Patenier's geographical descriptions would have been sadly restricted had he kept to the laws of scientific perspective construction. Without the least hesitation he constructed his landscape from more than one point of view. One point of view was not sufficient for the whole as well as for the parts. All the horizontals, such as ground surfaces, water surface, paths are seen from above and the horizon is correspondingly high. On the other hand all verticals, upright and growing things such as rocks, trees, houses and people, are not shown from above at all but in approximately normal vision. A little of both ground plan and elevation is presented at the same time. In other words: we are seated in front of a deep stage on which the wings rise vertically above us whilst the stage floor, rising sharply as it recedes, permits a view from above.

The healthy Netherlandish sense of realism is less active in the whole than in the parts. In the details, such as the material texture of the rocks, a keen observation is at work, but the whole seems projected rather than perceived.

In more recent landscape painting it has become increasingly essential to be satisfied with such part of the landscape as happens to fall within a limited field of vision; in Patenier's day perspective dualism was a convention and a means of displaying nature with satisfactory clarity and in full detail.

Modern landscape painting is lyrical, Patenier's is epic. Love of nature had not yet crystallized out sufficiently clearly for everything, even the most secluded corners, to yield what modern sentimentality towards nature and art feels as 'atmosphere'. The lovers and buyers of Patenier's pictures were not satisfied with the effect as a whole, they wanted to read in the picture, they sought in it the leisure of a walk full of varied interest or a journey of discovery. If at every turn in the road they came upon adventure, discovered figures to interpret, relationships to trace, all the more satisfied did they feel.

Van Mander, in his life of Herri met de Bles, recounts already with a touch of irony how people would hunt for the owl in the painter's landscapes, how one would wager with another that he would not find it and how they idled away their time searching for the owl. 'Wondrously full of small details' is still praise from his lips.

What I have just indicated applies more to a fashion, a phase in

landscape painting, a tendency once predominant now odd, rather than to an individual achievement. Patenier was certainly not the first to enter this phase; he did not create a new category but he was its most distinguished representative who developed successfully and conspicuously, as a specialist, what others had practised incidentally. In the victorious progress of Netherlandish landscape painting no decisive step can be associated with his name. He found no new relationships to nature. If he was the first to regard himself as a professional landscape painter it was because things had reached the point where such a profession became possible. Jerome Bosch, who faced nature with greater subjectivity—and not with the limitations of a specialist—fashioned his landscapes sketchily, without emphasis, without display, but his point of view did not differ from that of Patenier. He was a little older than Patenier and in the link, if link there was, between the two masters he was certainly at the giving end.

The features just emphasized cannot serve to define Patenier's *oeuvre*, particularly since imitators exploited the successfully discovered formula. His individual manner must be sought by less generalized, more detailed observations.

184 The signed picture in Vienna, the *Baptism of Christ*, opens the way, but it is in Madrid that Patenier's art is most effectively revealed in its full scope, in four of his best pictures, including the two largest ones. To these

182 can be added a *St. Christopher* in the Escorial, but the unimportant though

185 genuinely signed pictures at Karlsruhe and Antwerp must serve as a warning not to count too heavily on the Spanish experience.

Love of nature and self-abandon, and all the other virtues of our landscape painters, did not suffice for Patenier, he required the wise economy and measured skill of the architect. The imaginative power that can set up a continent instinct with life is comparable to the creative talent of an architect. Patenier divides to rule and does so systematically. All the essential formations in his landscapes are presented parallel to the picture plane, receding layer by layer into the depth, each rising a little above the preceding one. They are so selected or rather so placed as to present expressive profiles. The terrain is divided into strips that run horizontally. It is not unusual for this system of parallel strips to be continued in the clouds in the sky. Sharply rising rocks and tree trunks, often with their roots in front, towering above the high-lying horizon, intersecting all the ground lines at right angles, heighten the illusion of space and help to divide the one scene into many scenes.

The general resources of perspective are used with assurance even

though the construction is inconsistent in that, as I have explained, a single viewpoint from above is not adhered to. Recession is achieved by careful diminution with many gradations in the size of familar things such as houses, trees, and figures. An exaggerated and schematic use is made of aerial perspective in separating two grounds, the warm tones of the foreground, in which the heavy green of late summer predominates, and the cool blue transparent background. The pictures are often painted in two abruptly contrasting colours.

To our eyes Patenier's compositions show over-abundant signs of human activity. A system of straight lines, like the linear network of a map, is imposed on the picturesque freedom and fortuitousness of the landscape. The confusion and endlessness of nature is controlled by a fixed system which, however, never becomes unpleasantly rigid. A lively fantasy supplies manifold variety within the framework, and the details are so vivid that we gain confidence in the realism of the whole. We are captivated by the illusion that emanates from the individual parts and led to believe in the potential existence of the whole.

The *Rest on the Flight into Egypt* in the Prado is a mature masterpiece. 181 From the plants in the foreground, studied with loving insight and botanical accuracy, to the dusky masses of foliage in the middle ground, from the fancifully constructed Romanesque temple buildings to the blue distance, everything is scrupulously worked out, abundant and rich. The principal figure, the Madonna in a light cloak, firmly outlined but with a softly flowing line, seems a little out of keeping with the whole.

A powerful mood is emitted from this panel; though descriptive and didactic, it seems imbued with poetry. And we gain a similar impression from the *Temptation of St. Anthony* in the Prado and from the *St. Christopher* 180, 182 in the Escorial. But we are not entitled to regard the uniformly sonorous accord of the all-embracing chiaroscuro of the foliage and the luminous distance as the general characteristic of Patenier's art but must rather be content to discern his more intellectual virtues. Patenier differs from his imitators in the clarity of his compositions with their relatively strong contrasts of dark and light patches, in the pleasant objectivity and accuracy of the details. Thanks to his feeling for organic growth he himself never succumbed to the danger of light-hearted massing and overcrowding of detail, an inherent danger with this kind of landscape painting.

Steep, naked, sharp-edged, jagged rocks shooting up singly or in groups, and comfortably rounded, dense, dark masses of foliage are as it were the expressive features in the face of Patenier's landscape. His compositions can be classified according as to whether foliage or rocks

predominate. In pictures of the Virgin the accent is on the tree, in representations of St. Jerome, and wherever the ascetic life of saints is portrayed, the expression is concentrated in the rocks. Patenier draws the grandeur of inhospitable mountain ranges into the devotional picture by exposing the contrast between the overwhelming power of the inanimate and the frailty of mankind. Man and the works of man seem lost. The buildings nestle in the crevices of the rocks and seek shelter there. Whereas in the *Baptism of Christ* in Vienna, the sudden alternations of water and rock produce an effect of vastness and desolation, all terrors of the mountains are piled on to the towering heights in the *St. Jerome* belonging to Mr. H. Oppenheimer, London,[1] which appears to be only the remaining half of a picture. The threatening mood is intensified by the heavy thunder clouds that cover one side of the sky and against which the jagged rocks stand off in bright relief.

Patenier's activity in Antwerp lasted barely ten years. According to the guild lists—in as far as they have been preserved and published—he had no pupils during this period. But even if not directly by teaching, he certainly influenced his contemporaries and compatriots in other ways. His modern style set a fashion which, in one way or another, was followed by almost everyone.

Seeing that Patenier, as van Mander relates and we observe, collaborated with other painters, his background landscape came to be considered as the background landscape *par excellence*. The model made the round of the workshops; imitation was made easy. If an artist of the standing of Quentin Massys collaborated with Patenier, then the lesser artists were certainly impelled to seek the aid of the landscape painter or to imitate what brought him so much success.

Quentin Massys is named as one of the guardians of Patenier's daughters, a proof of the friendship that must have existed between the two masters. In several of his landscapes Cornelis Massys, one of Quentin's sons, appears as a follower of Patenier. In a book on the Bruges Loan Exhibition of 1902 (Plate 67), I published the *St. Jerome* panel belonging 187 to Mr. Brabandere, Thourout[2]; a similar picture, also signed, is in the Amalienstift, Dessau.[3] Cornelis was presumably still young when Patenier died. The picture at Thourout is dated 1547.

Patenier collaborated with the Master of the Female Half-Lengths.

[1] Now in the National Gallery, London. According to Friedländer, *Die Altniederländische Malerei*, IX, 1931, p. 158, the picture is a replica of the left half of a painting in the Elberfeld Museum.

[2] Now in the Royal Museum, Antwerp.

[3] Later in the Dessau Museum.

Incidentally, in view of the difficulty that has arisen in locating this master, the fact provides a strong argument in favour of Antwerp. A picture of the *Virgin* in Copenhagen shows in the landscape the work of Patenier whilst the figures are by the anonymous master, an observation due to the keen eye of K. Madsen.

The case is not an isolated one. In the National Gallery, London, there is a *St. John on Patmos* in which I am also able to detect the hands of both masters. It seems to me that in the *Adoration of the Kings* by the Master of the Female Half-Lengths, in Munich,[1] the landscape was added by Patenier[2]. 190

Patenier's relationship to Joos van Cleve is far more complicated. Van Mander's remark is a perpetual challenge to search for a picture showing the collaboration of the two painters. C. Justi has drawn attention to a *Madonna in a Landscape* in the Brussels gallery in which the figure is by 201 Joos (that is by the Master of the Death of the Virgin)—this is certain— and the landscape possibly by Patenier. It is at least in the 'manner of Patenier'. Moreover the clumsy conspicuousness of the luggage of the Holy Family is almost in the nature of a signature. Admittedly, the wicker basket is a well-known requisite of David's atelier, but in Patenier's workshop the luggage is supplemented by travel bags slung over Joseph's staff lying on the ground. So far so good and we might even be tempted to identify the Brussels picture with the one Van Mander saw. But an obstacle arises in the fact that elsewhere, too, in Joos's compositions the landscape is similarly conceived and has the same constituents. I cannot venture to establish the boundary line. Perhaps Patenier often collaborated with Joos, yet it seems more probable that Joos successfully appropriated the landscape painter's tricks.

If we are ever on the alert to find figures by other hands in Patenier's compositions we may eventually gain some idea of Patenier's own figure style from what remains. A dry, hesitant style leaning heavily on Quentin's art recurs and can be found nowhere outside Patenier's landscapes. To mention only the comparatively large and informative figures the ones in the Vienna *Baptism of Christ*, the Madonna in the excellent painting in Madrid, the *St. Christopher* in the Escorial and the unusual figures of saints that take up most of the picture plane in the altarpiece— destroyed by fire—of the von Kaufmann Collection in Berlin, these figures are not inconsistent with one another.

Patenier certainly needed help in his figure drawing. Just as he obtained

[1] Later transferred to the Germanisches Museum, Nürnberg, now in the Regensburg museum.
[2] Friedländer later reached the conclusion that in the paintings of the Master of the Female Half-Lengths the landscapes were mostly his own work, done in imitation of Patenier's style (see Friedländer, *Die Altniederländische Malerei*, IX, 1931, p. 121, and XII, 1935, p. 27).

a study sheet with St. Christopher designs from Albrecht Dürer he may also have borrowed from Quentin Massys and other artists.

In his relatively archaic manner, which seems poised mid-way between Bosch and Massys, Patenier develops the figures relief-like in layers running parallel to the picture plane and likes to form the contours with long unbroken lines of little amplitude and sometimes haltingly; he arranges the drapery with understanding and taste, and in general is content to get round difficulties. The expression is always concentrated in the landscape, on which the master obviously dwells with greater pleasure and more freedom.

Patenier's stimulating influence made itself felt in the circle of Bruges artists. Far-reaching conclusions have been drawn from the fact that in 1515, in the same year as Patenier, a Gerard of Bruges—none other, as we believe, than Gerard David—became master at Antwerp. But far clearer than the landscape painter's link with David is his relationship
191–192 with the painter whom we call Adriaen Ysenbrandt. At least one joint work by Ysenbrandt and Patenier survives in a *Flight into Egypt* belonging to Mr. A. Thiem in San Remo.[1]

The following dates are of importance: even before 1500 David's landscape style was essentially established and thereafter evolved organically; Ysenbrandt became master at Bruges in 1510, Patenier went to Antwerp in 1515. I am inclined to view the situation as follows (always provided that the so-called 'Waagen Mostaert' is really identical with Ysenbrandt): prior to 1515 Patenier had spent a shorter or longer period at Bruges; in his relationship with the rather older Gerard David he was the one to be influenced, but Ysenbrandt, completely dominated though he was by David, sought now and again to profit from Patenier's art.

The moment we take Gerard David and Jerome Bosch into consideration Patenier's achievement appears limited. We cannot credit the first landscape painter with a single new discovery but we can discern in him a prophetic intuition of the value of this new field of art, which he cultivated with such devotion. Not only did Patenier make landscape predominant, he made it resound and—within the limits of descriptive landscape—imbued it with idyllic sentiment and pathos that touches our emotions.

*[1] Later in the Robert T. Francis Collection, New York.—In Friedländer's later view the landscape is only 'in the manner of Patenier', see *Die Altniederländische Malerei*, XI, 1933, p. 132.

JOOS VAN CLEVE

THERE are sound arguments to support the hypothesis that the Master of the Death of the Virgin is identical with Joos van Cleve. The personality was constructed entirely from stylistic criticism and has taken full shape. But from the name alone we can establish a few dates and with them the framework for a biography. Joos became master at Antwerp in 1511 and seems to have lived there until his death in 1540. Entries in the Antwerp lists for 1511, 1516, 1519, 1523, 1525, 1535, 1536 confirm his presence there; the long gap between 1525 and 1535 is striking, and the possibility that he was absent from Antwerp for a considerable time must be borne in mind.[1] C. Justi, in his clear-sighted and comprehensive way, studied the arguments in favour of the identification, first put forward by Firmenich-Richartz, but he did not reach a satisfactory conclusion.[2]

The arms of the dukes of Cleve which appear on a dog collar in the altarpiece of the *Adoration of the Kings* in the Naples museum provide us with an important piece of evidence. Whether Joos was born at Cleves or belonged to a family that had been settled for generations in Antwerp is immaterial, and in any case the arms could indicate his origin or his name, always provided that it is not an allusion to the donor of the altarpiece, a possibility that Justi did not overlook.

Quite recently an exact and careful replica of the triptych has come to light in the Emden Collection (sale in Berlin, later the property of Mr. van Gelder, Uccle near Brussels[3]). And here the coat of arms on the dog 196 collar has been duly copied. As it is improbable that both versions were done for the same patron we can with increased confidence link the coat of arms with the artist or the workshop. Moreover there is a second escutcheon in the Naples picture, a cross on light ground the lower part of which seems to terminate in an anchor.

Guicciardini relates that Joos van Cleve was such an excellent portraitist that he was called to Paris by the French king François I to paint portraits. His actual words are: *Gios di Cleves cittadino d'Anversa rarissimo*

*[1] The gap has been slightly narrowed down by the discovery that in 1528 Joos bought a house n Antwerp (cf. Friedländer, *Die Altniederländische Malerei*, IX, 1931, p. 23).
[2] In *Jahrbuch der preussichen Kunstsammlungen*, XVI, pp. 13 ff.
*[3] Now in the Institute of Arts, Detroit.

nel colorire, & tanto eccelente nel ritrarre dal naturale, che havendo il Re Francesco primo mandati qua huomini a posta, per condurre alla Corte qualche maestro egregio, costui fu l'eletto, & condotto in Francia ritrasse il Re, & la Regina, & altri Principi con somma laude & premi grandissimi. It has been suggested that the Antwerp historian committed the error of confusing Joos van Cleve with Jean Clouet; there has also been much speculation as to whether the entry did not refer to the younger Joos van Cleve (who has recently been almost obliterated by the art critics)[1]. But in my opinion portraits of the French king and of his wife exist which clearly reveal the style of the Master of the Death of the Virgin and this seems to me to confirm the statement of Guicciardini and to provide the best argument in favour of the identification.

There are a great many portraits of François I, most of which in contour and technique show the uninspired slickness and convention of the Clouet workshop. Several of the king's portraits, however, are conspicuous for greater breadth and more lively gestures and are based on the conception of a master with a different outlook. Here, as always when we are dealing with portraits of royalty, replicas, copies, variations exist, and as we are seaching for the author of the original model, the one painted from life, we must pay more attention to the composition than to the execution.

At Hampton Court there is a portrait of the king, of indifferent quality (with the old number 330), that is attributed to Joos van Cleve in the inventories. The same type recurs in a version—without hands formerly in the Doetsch Collection (Sale, London 1895, No. 184)—and in one of considerably superior workmanship in the Johnson Collection, Philadelphia. In the American picture the head, the hat, the left hand are similar to the Hampton Court version but the right hand is in a different position and the costume shows variations, in Philadelphia a carefully reproduced state robe of individual character. The portrait in the Johnson Collection could be an original by the Master of the Death of the Virgin; to prove our point it would be sufficient to establish that it goes back to an original by this artist.[2]

A series of portraits of Eleanor, wife of the French king, survive, all suggesting one prototype. Again we can distinguish between various versions which show deviations in the costume and in the hands. A good example, at one time in the Minutoli Collection, was acquired for the

[1] The so-called Joos van Cleve the Younger has been convincingly identified with Cornelis van Cleve ("Sotte Clef") by L. Burchard (in *Mélanges Hulin de Loo*, 1931, pp. 53 ff.). See also Friedländer, *Die Altniederländische Malerei*, IX, 1931, p. 21, and XIV, 1937, pp. 115 ff., and again in *Oud-Holland*, XL, 1943, pp. 7 f.

[2] In *Die Altniederländische Malerei*, IX, 1931, pp. 50 and 139, the Johnson version is accepted by Friedländer as an original work of Joos van Cleve.

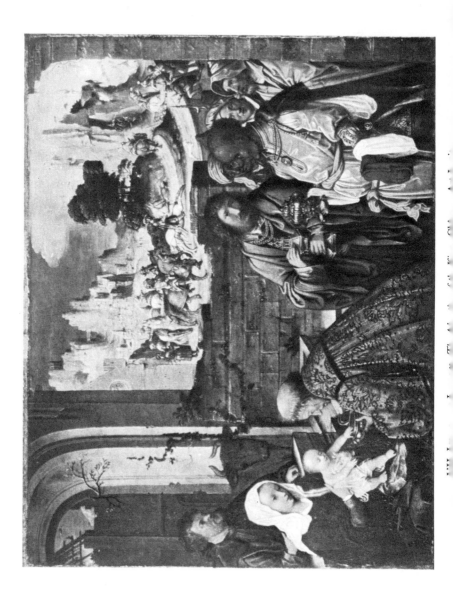

Kunsthistorisches Museum, Vienna. I do not doubt that this painting, 195
formerly erroneously ascribed to Jan Gossaert, if not an original by the
Master of the Death of the Virgin at least vouches for a lost original by
his hand.[1]

Incidentally the master seems to have specialized in royal portraits.
From his workshop came portraits of Emperor Maximilian (one bearing
the early date 1510) and also of Henry VIII (Hampton Court No. 563, 194
that must be dated about 1536, in old inventories under 'Jennet or Sotto
Cleve').

We are able to trace the master's work back a little further than 1511,
the date when he became free master at Antwerp. In addition to the
Emperor's portrait of 1510 (Musée Jacquemart-André, Paris), there are
two modest wings, *Adam and Eve*, dated 1507, in the Louvre—not in
perfect condition. I am inclined to accept these works as by our master
though they also recall Jan Joest of Haarlem, who worked at Kalkar
between 1504 and 1508. From this we could draw far-reaching conclu-
sions. We might assume that Joos van Cleve, before he went to Antwerp,
worked at Kalkar, perhaps in collaboration with the Haarlem master.
The fact that Barthel Bruyn, who was born in 1493, to judge from the
style of his early works, was a third member of the group lends itself to
further speculations. Joos van Cleve was presumably a little older than
Bruyn and younger than Jan Joest. It is almost certain that Bruyn was a
pupil of Jan Joest (presumably not at Kalkar but in Haarlem).

In 1515, the very year in which Barthel Bruyn, whose art was entirely
dependent on Jan Joest, began to work at Cologne, the brothers Hackenay
commisioned the two altarpieces with the *Death of the Virgin* from Joos
van Cleve. The smaller triptych in the Wallraf-Richartz Museum, 197–198
Cologne, is dated 1515, the larger one (Munich Pinakothek), must have
been done immediately after, seeing that the donor portraits are unchanged
(Nicasius Hackenay died as early as 1518).

A *Virgin and Child with St. Bernard*, bequeathed to the Louvre some
years ago, of good quality though it has attracted little attention, seems
considerably more archaic than the *Death of the Virgin* in Cologne. The
Descent from the Cross in the Dresden gallery, in part dependent on the
Master of Flémalle, is even more hesitant, almost the work of a beginner,
though, admittedly, it is not so evidently a work by Joos.

Among his earliest portraits is the one of a *Young Woman* in the Musée
Mayer van Bergh, Antwerp.

*[1] According to Friedländer (*Die Altniederländische Malerei*, IX, 1931, pp. 27 and 143) the Vienna
version is an exact replica by the master, equal in quality to the original, which is at Hampton
Court.

The *Death of the Virgin* provides the best starting-point for the period around 1515. The smaller *Adoration of the Kings* at Dresden may have been done a little earlier.

193 The *Portrait of a Woman* in Florence is dated 1520. Many other works can be fitted in here. The altarpiece with the *Lamentation over Christ* in the Staedel Institute, Frankfurt, dates from 1524. The traditional date is reliable. Not much later, in my opinion, is the large *Adoration of the Kings* at Dresden whilst the altarpiece, formerly at Genoa now in the Louvre,

202 with the *Lamentation over Christ* and, on the predella, the *Last Supper*, inspired by Leonardo, may date from about 1530. The self-portraits that have been detected in the two *Adorations* in Dresden and in the Louvre altarpiece assist us to fix these dates. A stay at Genoa, where at one time at least three altarpieces by the master stood—the *Crucifixion* in the Thiem Collection,[1] the *Adoration of the Kings* in S. Donato and the altarpiece now in the Louvre—is very probable.

Joos van Cleve remained quietly aloof from experimental or pioneer work. He practised his art efficiently and successfully with a workshop that tended to turn out rather factory-like products, and his relationship with his contemporaries was pleasantly harmonious. As he was directly or indirectly influenced by Leonardo he presumably considered himself progressive but his modernism is superficial. He did not lag behind and modified his mode of expression but the change does not touch the core of his art. Beginning and end lie close together, at least for a painter of this period.

160–163 Bernaert van Orley, perhaps less talented but more assiduous and restless, did not pause for long where Joos was content to linger. Successful not only in Antwerp but also at Cologne, Genoa, Paris, Joos saw no reason to make decisive changes. His attractive manner, never prickly, with few contrasts, and a readily accessible gay prettiness gave him easy success. His rosy creatures feel equally at home in bright interiors or park-like landscapes. As opposed to the proud aloofness which Quentin Massys, whose gold he often changes into baser coin, infuses into his holy persons, Joos makes his creatures sociable and companionable.

His adroit adoption and assimilation of the motifs of others is not perhaps the best testimony for deep-seated originality. The following survey may prove instructive:

After Jan van Eyck (*Madonna* in Frankfurt): Collection of Mr.
204 Spiridon, Paris.[2]

[*1] Now in the Metropolitan Museum of Art, New York.
[*2] Now in the Metropolitan Museum of Art, New York.

After Rogier van der Weyden (*Descent from the Cross*, Escorial): with landscape added, Johnson Collection, Philadelphia.

After the Master of Flémalle (*Descent from the Cross*, cf. the copy in Liverpool): the Dresden *Descent from the Cross*.

After Gerard David (*Madonna in Half-Length*): American art market.[1]

After Quentin Massys (*Salvator Mundi*): Louvre and elsewhere.

After the Master of the Morrison Triptych (an Angel in the Morrison triptych): In the *Madonna* at Ince Hall near Liverpool.[2] 200

After Albrecht Dürer (*St. Jerome*): Endless replicas showing more or less clearly the style of Joos.

After Leonardo (the group of embracing children, Christ and St. John): several replicas.

After Leonardo (*Madonna with the Cherries*): Several replicas, a good one at Schloss Meiningen.

Presumably there was a direct contact with the art of Leonardo, particularly if Joos really worked for a time in Paris. Leonardo, it is true, died in 1519 and we have good grounds for believing that the Antwerp master was not called to Paris until later but there was certainly still much talk at the French court about the Italian genius and there would be many of his works to show. There, too, was Andrea Solario, a Milanese artist of lesser stature, who comes astonishingly close to the Master of the Death of the Virgin.

In spite of his readiness to borrow motifs, the master's inventive powers were not indolent. His imagination, though not creative, was lively enough to push bodies adroitly around. A nimble mind was needed to create successfully from the same types and in the same spirit two compositions as widely divergent as the representations of the *Death of the Virgin* in Cologne and Munich. The slim figures are inordinately active. 197–198
Their flurry and commotion impairs the dignity of the scene. The excessive reduction of scale in the figures in the background makes the space appear wide and not clearly defined. A more profound effect is not achieved, particularly as the coldly gleaming, rather sugary colouring interspersed with strong red, so characteristic for the artist, seems unsuitable for the subject.

If anywhere, Joos is independent when depicting the mother joys of the Virgin Mary. Joseph shares her happiness like a benevolent grandpapa. The attractive *Madonnas* and *Holy Families* were a success. There are a

*1 Now in the Metropolitan Museum of Art, New York.
*2 Now at Lulworth Castle, Dorset.

large number of replicas, imitations and copies. The boldest conception
203 can be seen in the version in the Fitzwilliam Museum, Cambridge. The
Virgin smiles as she looks down on the Child asleep at her breast. This
sensuous, blissful smile does not come from Heaven and conceals no
secret; on the contrary, it is sure of general approval and of making an
immediate appeal. Where he is idyllic and sentimental, of gay, festive
mood the master readily attains an easy goal but the tearful Passion
scenes appear languid.

In the portraits, especially the early ones, the face is conspicuous as a
bright blob, with the hair, the hat and the clothing forming a dark frame.
The wide-open eyes look out piercingly dark from the bright disk, which
as a whole has little solidity. In later portraits the head is more powerfully
modelled. The schematic drawing of the profile line in three-quarter
view is interesting. The critical point is near the eye where the part
between eyelid and brows seems pushed out so that the line of the cheek
is interrupted and does not merge directly into the line of the forehead.
The upper eyelid runs approximately parallel with the lower one so that
where it terminates in the nose it has to be brought down steeply to the
strongly emphasized lachrymal gland. The later portraits are larger in
size than the earlier ones, they show fat, boneless, almost swollen forms
and dull expressions.

JAN PROVOST

ACCORDING to documents brought to light by James Weale, Jan Provost came from Mons, a town in the Southern Netherlands lying close to the present French frontier, not far from Valenciennes and Maubeuge. It would seem, so Hulin hints, that Weale found a trace of the master at Valenciennes.[1] But confirmation for this is still outstanding. Provost, who appears to have been born in 1462, and is thus not younger than Quentin Massys, attempted to gain a footing in Antwerp two years later than Quentin Massys, namely in 1493, in which year he is entered as master in the guild lists of the town ('Jan Provoost'). But in 1494 he became master at Bruges, where he remained until his death in 1529. It is certainly not his origin and schooling that justify us in reckoning him to the Bruges masters but rather his long and successful activity in the Flemish city.

When Provost settled at Bruges, Memlinc was the representative of the recognized school but for the younger generation, and certainly for the painters who had come via Antwerp, a representative of an out-moded and old-fashioned style. Gerard David belonged to the same generation as Provost. The newcomer had to establish himself successfully alongside David, whose art seemed relatively archaic and bound by ecclesiastic convention.

With Provost a worldly, turbulent spirit penetrates from the South to the musty cloistral calm of Bruges. Antwerp was the centre to which the younger talents flocked from every part of the Netherlands where, less oppressed by tradition than at Bruges, they could exchange ideas freely and promote rapid innovations. Provost seems to have kept up his relations with Antwerp. At least when Dürer was there in 1520 Provost was there too, made contact with the Nuremberg artist and accompanied him to Bruges on April 6th, 1521.

By a fortunate chance the *Last Judgement* painted by Provost in 1525, **207** for the Bruges Town Hall, has escaped destruction.[2] This panel was the

*[1] At Valenciennes before 1491, Provost married the widow of Simon Marmion, Jeanne de Quaronbe. He is said to have become a burgess of Valenciennes in 1498. See Friedländer, *Die Altniederländische Malerei*, IX, 1931, p. 74.

*[2] Parts of the picture, showing clerics in hell, were repainted by P. Pourbus in 1549/50. These repaintings were removed in 1956.

starting-point for research on Provost. It enabled us to detect the hand
of the master in several other panels. Although Provost did not put his
signature to any work, stylistic criticism has been able to resurrect his
personality successfully. The picture that gave us the first idea of the
artist's style was done during his last years and what could be added as
the first fruits of stylistic criticism belongs to the same, that is the last,
phase of his development. Our immediate task, therefore, seeing that the
long interval between 1493 and 1525 remains empty, is to search for
works belonging to earlier periods.

Hulin and I began by recognizing the *Madonna with the Angels, Prophets*
206 *and Sibyls* in St. Petersburg as a second work by Provost. The panel, more
than 6 ft. in height, came from the collection of King William of Holland
and was sold in 1850 as a Quentin Massys for 2000 fl. It was transferred
from wood to canvas, in the process of which it lost some of its freshness
and luminosity. Hulin connects it with a document of 1524 which con-
tains a reference to an altar panel painted by Provost for S. Donatian,
Bruges (for an altar dedicated to the prophet Daniel).

In conjunction with the *Last Judgement* at Bruges, the painting in St.
Petersburg is most informative. The evidence from the two works is
complementary and agrees. The compositions are pleasant, far removed
from the solemn monumentality of David, are gay and festive and light
in colour. The rather monotonous ideal types are fashioned with an eye
for sensuous qualities. The women, including the sibyls, are youthful with
well-rounded forms, large mouths with faintly smiling lips, the prophets
are strikingly youthful with long beards that often seem stuck on. The
general effect is agreeable and lively in form but shallow and empty in
spirit. In addition to the authenticated *Last Judgement* we have no less
than three other versions of the same subject by the master.

1. Weber Collection, Hamburg, now Kunsthalle, Hamburg.
2. Nieuwenhuys Sale, Brussels 1883, No. 1 (Aeken)—23 × 24¼ in., now
 in the Institute of Arts, Detroit, U.S.A.
3. Vicomte de Ruffo Collection, Brussels. Exhibited Bruges, 1902, No.
 169.

It was the task of painting the *Last Judgement* in particular that was
entrusted to our master because of all the Bruges painters of his generation
it was he who had imagination and, comparatively speaking, showed the
greatest boldness in his treatment of the nude. Whilst the pictures in
Hamburg and Detroit appear to be roughly contemporary versions, with
only slight deviations from the 1525 picture, the replica in the Vicomte

de Ruffo Collection is more archaic in structure, less personal in the types, dry, stiff and (if the attribution is correct) must be regarded as considerably earlier than Provost's *Last Judgement* of 1525.

To proceed direct to the de Ruffo panel is difficult and hardly permissible without intermediary stages. However little developed Provost's formal language appears to be in the hands and the female types of the de Ruffo panel and however far removed the disposition with the limited number of persons and the isolation of the figures seems from the closely intertwined groups in the other *Judgement* panels, the heads of the men with their black eyebrows and thick lips and the movements of the nude figures appear to some extent characteristic for Provost.

There is, however, another way which leads us to the earlier phases of the known Provost style. A *Lamentation over Christ* sold with the estate of G. Ferroni (March 1909, 'Memlinc') is certainly a work by our master. The picture is now in the von Back Collection in Szegedin.[1] Here in particular Mary Magdalen kneeling on the left is characteristic enough in type. To this archaic work various Passion panels can be linked one by one, becoming increasingly remote from the accustomed Provost style.

1. Sale Schevitch (Paris 1906, *Pietà* with St. Mary Magdalen and St. John).[2]
2. Madrid, Photo Laurent No. 2630, *Pietà*, similar in composition to the foregoing.
3. Paris, Kleinberger, *Pietà* with full-length figures.[3]
4. Madrid, private Collection, *Adoration of Kings*.

I think that with this group I have established something of Provost's early style (1490–1500). The expression of grief is strong but monotonous. The mouth is wide and straight. The eyes are deep-set, narrow and dark. The grouping is archaic with a relatively advanced treatment of the nude that heralds the softness and mellowness of the later style.

In his compositions Provost is more enterprising than reflective. Lavish groupings result in over-crowding, an unclear spatial effect, the jarring proximity of large and small figures and an uncertainty in the proportions —with stumpy figures next to inordinately long ones. In two altar wings that form a pair— *St. Catherine Disputing* (Rotterdam) and the *Martyrdom* of that saint in the Antwerp museum—from the artist's late and best-known period, the inadequacies have been frankly used to give a naive

*[1] Later (between 1930 and 1946) on the London art market.
*[2] The painting turned up again at a sale at Charpentier's, Paris, 1 June 1949 (lot 56).
*[3] Now in the Boveri Collection, Zurich.

and boldly grotesque effect, whereas simple tasks such as the Madonnas
205 at Cremona and Piacenza are boldly conceived and the soft prettiness of
the female heads does not fail to appeal.

I should like to add here a few small observations on superficial things
because, though they may not help us to make an attribution, they can
at least help to check attributions. Provost loved landscapes planned like
gardens (flower-pots, espaliers, flower beds); he avoided distant views
and wide vistas. He frequently gave the Virgin a ring on her finger, a
motif that, as far as I know, was not used by any other Netherlandish
artist of the period.

Attention should be paid to the shape of the hand, which, at any rate
in the late period, is a sure criterion for the artist. The fingers are long with
flexible joints, angular rather than arched, with the finger joints inclined
at an angle. On the inside of the hand the fingers are sharply divided
from the palm by a continuous straight line. Evidently the master prided
himself on an elegant, well-articulated hand.

The full mouth with slightly protruding lower lip and deep-set eyes
are the most reliable characteristics for Provost's fairly constant female
types.

Provost's personality, more imaginative than vigorous, is not easy to
grasp because in his anxiety to please he does not remain untouched by
the changing fashions that appear in Antwerp. He is stimulated in
particular by Quentin Massys, whose melodious drapery flow he strives
to imitate. In talent and taste he is at least the equal of Joos van Cleve
but he did not exploit his ability as efficiently as the Antwerp artist.

JAN GOSSAERT

THE masters who represent the sixteenth century for us differ considerably amongst themselves. A common background is now of less consequence than before. Each one, at least of the more talented artists, thrusts forward on his own initiative. More through the ability to combine and blend than as a result of creative power works are produced simultaneously on Netherlandish soil that have but little in common.

In the general atmosphere of unrest and discontent several assiduous painters are driven from one direction to another by changing fashions. The entity of personality is submerged in the profusion of new ideals and models that pour in from all sides. In the case of Orley, the art critic, assisted by only a small number of works authenticated by inscriptions, finds it difficult to get his bearings, in the case of Lucas van Leyden he has to make continual changes in rapid succession. To follow Jan Gossaert on his way is comparatively easy.

A substantial number of signed panels by his hand, some of them also dated, are easily accessible in the great galleries of London, Paris, Berlin, Munich and Vienna. Furthermore his language is loud, decided and, at bottom, unchanging, not easy to mistake. We are assisted by the fact that Gossaert never allowed his pupils to collaborate in his own work and that everything he produced, as a result of his ambition, his assiduity and his outstanding skill, possesses a quality that is hard to imitate.

What we know of Gossaert's life flows from van Mander's pen but it has unfortunately not been possible to add much to this information from other sources.

Gossaert came from Maubeuge in the Hainaut, now part of France. Hence his name Mabuse and the form of name he favoured for his signature at a later period: 'Joannes Malbodius'. The date of his birth is not known, he was probably born between 1470 and 1480 and was thus a contemporary of Dürer, a little younger than Quentin Massys, a little older than Lucas van Leyden.

An important clue has been found in the lists of the Antwerp St. Luke's Guild, in which for the year 1503 'Jennyn van Hennegouwe' is entered as master. It has been rightly assumed that this refers to Jan Gossaert,

98 JAN GOSSAERT

particularly as he wrote his name at least on two occasions in a similar
way (JENNINE and GENNIN). Mr. J. Masson of Amiens owns a circular
drawing[1] with the *Beheading of John the Baptist*, bearing the genuine in-
scription: GENNIN.GOSSART.DE.M. The name in a similar form is also
223 found on a panel with the *Adoration of the Kings* acquired by the National
Gallery, London, from the Carlisle Collection.

The next date is 1508. In that year Gossaert accompanied his patron
Philip of Burgundy to Rome. Philip went as ambassador to Italy. A
stay in the South in the service of a prince with wide humanistic interests
offered opportunities for the artist similar to those that were later offered
to the artist Jan van Scorel of Utrecht. Antiquity was the ideal, sculpture
and the nude figure the centre of interest. And an echo of it resounds
throughout his entire artistic production. If his conception seems sculp-
tural, this preference, if not produced, must at any rate have been
strengthened by the Roman impressions. His biographer van Nimwegen
says of Philip: *nihil magis eum Romae dilectabat, quam sacra illa vetustatis
monumenta, quae per celeberrimum pictorem Joannem Gossardum Malbodium
depingenda sibi curavit.*

I believe I am able to point out a drawing done by Gossaert in Rome in
1508 after an antique statue that was famous at the time, namely a
carefully finished pen drawing in the Venice Academy (Scuola Tedesca,
210 Photo Anderson) of the *Resting Apollo*, the so-called *Hermaphrodite*, which at
the beginning of the sixteenth century was in the courtyard of the Casa
Sassi. The statue, drawn also by Heemskerck, is now at Naples.[2]

In 1509 Gossaert returned from Italy but instead of settling again at
Antwerp followed royal patrons all over the place. According to the Ant-
werp guild lists he registered pupils in 1505 and 1507. His name does not
occur there again after 1507. Decisive for his manner was the patronage of
highly placed personalities, legitimate or semi-legitimate scions of the
Habsburg-Burgundian house. The 'exquisite' and virtuoso qualities of his
paintings are explained by the fact that the rich patrons rewarded ex-
ceptional achievements. Like Jan van Eyck, Gossaert worked mainly in
the services of princes, went everywhere and was equally little tied to the
guild of any particular town. Unless van Mander was misinformed as to
his character, Gossaert appears to have been arrogant and somewhat
dissolute.

*[1] Now in the Ecole des Beaux-Arts, Paris.
*[2] Three more drawings done by Gossaert after Roman monuments are now known: The
'Spinario (Print Room of the University, Leyden), the Colosseum (Print Room, Berlin-Dahlem),
and the Hercules, after the statue from the Forum Boarium, now in the Palazzo dei Conservatori,
Rome (Lord Wharton, London).

Gossaert's main patron apart from Philip of Burgundy was the latter's son Adolph of Burgundy, whose residence was at Middelburg in Zeeland and who retained the painter there at least for a time. Further Jan Carondelet, whose portrait he seems to have painted three times, King 219 Christian II of Denmark, who had married a sister of the emperor Charles V, finally the regent Margaret. Presumably, apart from Antwerp the most important centres of his activity were: Bruges, because it was almost certainly Carondelet's headquarters, Brussels and Malines, because of the Habsburg court, Utrecht, because Philip of Burgundy settled there, and without doubt Middelburg, because it was Adolph's residence. Gossaert's chief work, most emphatically admired by van Mander, was at Middelburg: a very large *Descent from the Cross* (unfortunately destroyed), commissioned by Maximilian of Burgundy. In 1520 Dürer saw this work and gave his opinion of it as follows: *nit so gut im Hauptstreichen als im Gemäl*, by which he probably meant that it was not so good in the invention as in the execution. The painter seems to have died at Middelburg in 1533 or 1534.[1]

The earliest accredited and dated work by Gossaert is unfortunately relatively late, namely 1516. It is the panel in the Berlin gallery with the life-size nude figures of *Neptune and Amphitrite*, fully signed, painted for 213 Philip of Burgundy and bearing this patron's name and device. Strangely enough Gossaert borrowed the composition from Dürer's famous engraving of *Adam and Eve*.

By 1516 the master was in full possession of his mature style. This dated panel gives us just as little information about his beginnings and the origins of his art as do the works dated 1517, the diptych with the portrait of Carondelet in the Louvre and the *Hercules* panel in the Cook 219–220 Collection, Richmond.[2] The only other dated works we have are an engraving of 1522, the Hercules panel of 1523 (preserved only in a copy, on the Vienna art market) and works dated 1526 and 1527; nothing more after 1527. Stylistic criticism must come to our aid and can do so . the more easily because several indubitable works by the master, though not inscribed with dates, were, to judge by their style, obviously done before 1516. Fortunately at least one of these works is signed, and owing to its outstanding importance and the eloquence of its language seems ideal as a point of departure. A few years ago this work was acquired by

<hr />

[1] 1532 is now established as the year of Gossaert's death by a document published by J. M. March (in *Boletin de la Sociedad Española de Excursiones*, LIII, 1949, p. 221). For details see also J. K. Steppe, in exhibition catalogue *Jan Gossaert, genoemd Mabuse*, Rotterdam and Bruges, 1965, pp. 33–8.

[2] Now in the Barber Institute, Birmingham.

223 the National Gallery, London, from Lord Carlisle and has since been easily accessible. Formerly, when it was at Castle Howard and at Naworth Castle, few art critics had been familiar with the stupendous achievement of this *Adoration of the Kings*. With a concealed but indisputable signature "IENNI. GOSSART. OG MABVS—" and in another place: "IENNIN GOS —" removing all doubt as to the authorship, the picture reveals its cold-hearted creator in quite a different relationship to tradition than van Mander's account would have led us to expect.[1]

Guicciardini and Vasari write: "Gossaert was the first (Vasari: *quasi il primo*) to bring the true method of representing nude figures and mythologies from Italy to the Netherlands." Van Mander read the eulogy and gladly used it in his vita of the master. Since then opinion everywhere has been guided accordingly, so that, depending on the writer's point of view, Gossaert is represented either as a great innovator or as the first mannerist and corrupter of art. Gossaert's relationship to Italian art is in so far rightly expressed in Vasari's sentence as Gossaert himself would have certainly recognized it as a just acknowledgement of his own intentions. Since we are not concerned with ambitions but with results, the accustomed ideas must be modified and altered. On two occasions we note that Gossaert, when he had to do nude figures, followed Dürer, once in the *Neptune* panel of 1516 and again in a wing of the triptych at Palermo. These observations are in contradiction to Vasari's phrase. Gossaert was not equal to the part allotted to him though it was certainly a role he would have liked to play. Without ability to compose freely he could not get very far with the 'true method'. He certainly found opportunity to appropriate Italian motifs. On occasion he would adorn the façade with foreign decorative elements but the foundation was too narrow to support the magnificent structure of a Netherlandish Renaissance. At bottom the master had assimilated nothing of Italian art beyond a preference for plastic form and a craving for nude bodies in violent movement. The moment it came to the crystallizing out of his forms he was dependent on the model, on ungainly reality.

223 In the Carlisle panel, in which the master strained his resources to the limit, he does not seem to have gone against tradition but he certainly did his utmost to surpass all previous achievements. From a superficial and uncritical examination it might appear that this ambitious goal had been attained. In the solidity of the painting, in the conscientiousness of the execution, in the characterization of the materials and in the rendering

*[1] Cf. Friedländer, *Jan Gossaert (Mabuse)*: *The Adoration of the Kings in the National Gallery.* (The Gallery Books, No. 19). London 1948.

of all still-life-like details Gossaert's work, it is true, is not inferior to anything in the fifteenth century, but it is not imbued with life, lacks the joyous abandon, the eager participation in the action without which, at bottom, no work can rise above the level of a virtuosity of craftsmanship. The *Adoration of the Kings* is shown as a court ceremony. There is a complete lack of dramatic movement, and relationships between the individual, stiffly parading figures are scarcely established. Gossaert's talent lacks dynamism. Self-conscious in expression, he is timid in composition, with only few ideas, and as a draughtsman he is sure of himself only when a life-model is continuously available, otherwise, particularly in fore-shortening, at any rate in his early period, he is unreliable. The fact that the two dogs in the foreground that seem so completely realistic are borrowed, and most adroitly borrowed, from engravings by Dürer and Schongauer is symptomatic and instructive.

The *Adoration of the Kings* probably dates from about 1506.[1] The master, who was so firmly linked to the Netherlandish tradition, later made a great show of his thirst for modernity. He was revolutionary in will rather than in talent. Right to the end his painting remained solid and firm. The enamel-like purity of the material, the light fluency of the brushwork, adhered to even when conflicting with the strenuously sought monumentality of the drawing, remained intact and that at a time when technique was disrupted on all sides. Of his predecessors Gossaert certainly admired van Eyck, and the study of Eyckian works had assuredly formed part of his training. He took the three principal figures God the Father, the Virgin and St. John, from the Ghent altarpiece and varied them skilfully. His adaptation, in half-lengths, is in the Prado; it is unsigned. The convincing attribution was made by Scheibler. A comparison with the original reveals the mannered undulations of Gossaert's formal style. Nevertheless it remains a masterpiece of archaizing composition. Gossaert has added an angel of his own invention but the difference in style is in no way obtrusive. The picture in Madrid is by no means a particularly early work. The Gothic elements in the ornamental frame, a goldsmith Gothic run wild, must not be put forward as a decisive argument that Gossaert painted the panel before his journey to Italy. It is true that after that journey he generally used Renaissance elements. But since his interest in architecture and ornament was determined not by feeling or inclination or taste but by calculating knowledge, he was able to use one or other form according to the inclination of the moment. On the whole he follows naturally the

*[1]For the date see p. 102, note 1

contemporary taste that proceeds from a rich painterly Gothic to a bare Renaissance style.

The Malvagna triptych in the museum at Palermo is of earlier date than the picture in the Prado and approximately contemporary with the *Adoration of the Kings* in the National Gallery. More modest in size than the Carlisle panel, it is pitched in a lower key and the masterly execution has produced a jewel of scintillating, sparkling brilliance. In the type of Madonna and in the rolling undulating play of the drapery, in the metallic-like fineness and precision of the Gothic ornament the personal style of the artist is revealed at a height that no imitator could hope to attain. But once again we catch the master borrowing. The group of Adam and Eve on the (left) wing is taken from Dürer's woodcut (from the *Little Passion*).[1] Around 1520 the triptych was copied more than once in the Netherlands. At that time it was presumably at Bruges. The painter known as Adriaen Ysenbrandt, a Bruges painter, used it at least three times (the central panel, translated into the rather languid manner of this David imitator, formerly Frau von Kaufmann Collection, Berlin,[2] and Baron de Rothschild Collection, Paris, the wing with Adam and Eve formerly Emden Collection, Hamburg[3]). Gossaert's triptych is said to have been at Messina about 1600. It so happens that Jan Carondelet, one of Gossaert's famous patrons, who was Chancellor of Flanders and certainly lived for a time at Bruges, was also Bishop of Palermo. It is therefore very tempting to assume that he owned the work at Bruges and later donated it to Sicily.

The *Agony in the Garden* in the Kaiser Friedrich Museum, Berlin, with the consistent treatment of the moonlight (the motif stimulated the artist to a veritable *tour de force*) and the curiously unsuccessful heads, is one of his earlier works. Whereas in those tasks that called for free compositional powers and the invention of figure types Gossaert failed to make the grade, from his youth on he was a striking portraitist and excelled in expressing imperious manhood, which was always greatly appreciated by his contemporaries. In the Carlisle panel the portrait or portrait-like heads are the best part and provide a good starting point for tracing other contemporary, i.e. early, single portraits. I regard, with varying degrees of certainty, a few male portraits from the period around 1510 as works by Gossaert. These include the clear-cut *Head of a Young Man* in the Cook

*[1] This fact led Friedländer (in *Die Altniederländische Malerei*, VIII, pp. 17 ff.) to date the Malvagna triptych and the National Gallery *Adoration c.* 1512, as Dürer's *Passion* bears the dates 1509–1511.

*[2] Now in the von Pannwitz Collection.

*[3] Sold with the E. Weinberger collection, Vienna, 22 October 1929.

Collection, Richmond[1] (with the painted stone frame that the master 216
favoured so greatly), the stern, tense *Head of an Old Man* in Baron von
Liphart's Collection at Ratshof[2] and a *Portrait of a Man* in the Copenhagen
gallery.

The *St. Luke painting the Virgin*, originally at Malines, now in the Prague
gallery, occupies an intermediary position. It probably dates from about 214
1515. Fortunately it is signed. Otherwise the question of its authorship
would be difficult, as van Mander mentions the panel erroneously under
the works of Orley. The bare, soberly composed picture shows the
Madonna and St. Luke in a magnificent stone prison. Space and cubic
volume are clearly articulated, exact and impeccable. Gossaert's later
works are increasingly dominated by constructive reasoning. If the passion
for rule, measure and theory became a danger even for Dürer, a master
of infinitely greater profundity, how much further away from the sources
of sound design must Gossaert have been led.

In those critical days when tradition had disintegrated in the North,
rationalism was an ever-present menace. The master was pre-occupied
by particular problems of form and particular difficulties. And in working
with arrogant pedantry to produce striking effects of perspective fore-
shortening and overlappings he loses the spiritual content. What was a
means to an end for a Leonardo da Vinci here became the end in itself.

Gossaert represented *Adam and Eve* several times. He welcomed the
task of depicting nude bodies in life-size. Van Mander mentions one
such work. An original is in the Berlin museum, another at Hampton 211
Court. Copies exist of the second composition, one of them also in Berlin,
another (purchased as an original) in Brussels. A third composition sur-
vives in an original drawing in the Albertina, Vienna. A fourth with com-
plicated postures, in bad taste, is at Schloss Schönhausen near Berlin.[3]

Just as Gossaert liked to make his figures as large as possible and
showed little feeling for the irrationalities of the landscape, he favoured
half-length figures for saints set against a neutral background and within
a narrow framework. He depicted St. Donatian—at Tournai—in this
way. On the back of the panel are the arms of Carondelet. I suspect that
with the Carondelet portrait [formerly] belonging to Mr. R. von Gut-
mann, Vienna,[4] it formed a diptych. There is a *St. Mary Magdalen* in half-

*[1] Now in the Van Beuningen Collection, Vierhouten.
*[2] Now in the Mauritshuis, The Hague. More recently the portrait has been attributed by
several scholars to 'Master Michiel' (Michiel Sittow).
*[3] Now at Jagdschloss Grunewald, Berlin. On Gossaert's *Adam and Eve* compositions cf. the
detailed study by H. Schwarz, in *Gazette des Beaux-Arts*, series 6, vol. XLII, 1953, pp. 145–82.
*[4] Now in the William Rockhill Gallery of Art, Kansas City, Missouri.

length in the Musée Mayer van den Bergh, Antwerp. A smaller *Magdalen* in half-length which was acquired a few years ago for the National Gallery, London, was certainly done much earlier and fascinates by the individualized naivety of its expression. This panel, despite the not quite perfect condition, takes its rightful place alongside the Palermo triptych. Gossaert's compositional ability fails him when he is called on to produce many-figured scenes. The excessive modelling of the details impairs the rhythm and impact of the whole. All the parts push forward ostentatiously.

The famous altarpiece at Middelburg was destroyed by fire. A *Descent from the Cross*, in my opinion a work by Gossaert, is exhibited as 'Orley' in the Hermitage, St. Petersburg (it came from the collection of King William of Holland).[1] This panel, which was transferred to canvas and has unfortunately lost much of its clarity and precision, may be identical with a picture by Gossaert that van Mander saw in the house of a Mr. Magnus of Haarlem.[2]

The master is more successful depicting figures in ceremonial array
215 than with dramatic scenes. His picture of *St. Luke* in the Vienna museum, which differs considerably from the altar panel of the same subject in Prague—perhaps inspired by a borrowed model (Joos van Cleve)—and probably dates from about 1518, is successful in composition.

For some reason or other an *Ecce Homo*, done by Gossaert about 1527, the original of which cannot be traced today, was frequently copied. The copyists (among them the Master of the Female Half-Lengths) generally added the honest inscription *Malbodius invenit*, but often it was *Malbodius pingebat*.

Of the mythological nudities, of which Gossaert was assuredly very proud—when he introduced such subjects he regarded himself as a learned connoisseur of antiquity and an enlightened son of a new age—I
213 have already mentioned the panels in Berlin and in the Cook Collection (1516 and 1517). Similarly conceived individual female nudes, on a smaller scale, are in Rovigo museum and in the Schloss Collection, Paris.[3]
212 The *Danae* in Munich, a carefully executed original of 1527, is sculpturesque in conception and makes a cold, metallic impression.

A large number of *Madonnas*, in particular Madonnas in half-length,

[1] In the 1958 Hermitage Catalogue of Western paintings the picture is listed as a work of Gossaert. The wings with *St. John* and *St. Peter* and, on the reverse, the *Annunciation*, have recently come to light again and are now in the Museum of Art, Toledo, Ohio. They are dated 1521.

[2] From documents published by J. Maréchal in *Académie Royale de Belgique, Classe des Beaux-Arts, Memoires*, XIII, No. 2, Brussels, 1963, pp. 11–15, it is now clear that the altarpiece was originally in the Salamanca Chapel of the Augustinian Church at Bruges, where it remained at least until 1795.

[3] Now in the Royal Museum, Brussels.

survive. A few, with complicated postures and skilful drawing enjoyed much popularity and were frequently copied. The emotional coldness, which alienates us, offended no one. Amongst Gossaert's Madonnas is a very fine original which forms one half of the Carondelet triptych in the 219–220 Louvre (1517); of approximately the same date and scarcely inferior in quality is a panel in the E. Simon Collection, Berlin (from the Kaufmann Collection).[1]

An unusual number of mediocre copies, the original of which has not been traced, exist of a pretentious composition in which the Christ Child is attempting to disentangle Himself from His mother's veil. Most of these copies dating from about 1550 are similar in style. Could they have been done by Paulus van Aalst, of whom van Mander states that he was exceptionally good at copying works by Jan van Mabuse? The son of Pieter Coeck could well be responsible for the effeminate style.

Another almost equally popular type is a *Virgin and Child* in which the hair of the Madonna is parted in a striking way. Several good replicas come close to Gossaert, even in the execution, as for instance the panel at Longford Castle and the one formerly in the R. Kann Collection.[2] There is something portrait-like in the appearance of the Mother and the Child and in this connection van Mander's passage has been recalled in which he relates that Gossaert was supposed to have painted the wife and son of his patron, the Marquis de Vere (Adolph of Burgundy), as the Virgin with the Christ Child. The partly accredited portrait of the Marquise (in the Gardner Museum, Boston) does not at any rate preclude this possibility.

An almost forgotten Madonna panel by Gossaert was sold with the Beurnonville Collection and is now in the Max Wassermann Collection, Paris.[3]

The number of portraits is considerable. Clear in form, often with considerable movement in the hands, self-assured in expression, in a narrow frame and often powerfully modelled against a neutral ground, these works are more impressive than the master's free inventions. The modelling is brilliant, achieved not so much by deep shadows as by keenly observed reflexes, and skilful, at times almost exaggerated drawing of intersecting parts and foreshortening. Examples are easy to find in the large galleries, in particular in the National Gallery, London, in the Louvre, in Berlin, Vienna, Antwerp.

*[1] Later in the Huck Collection, Berlin.
*[2] Now in the Metropolitan Museum of Art, New York.
*[3] The collection has been divided among the heirs of Mr. Wassermann.

Gossaert solved the rather unusual problem of a group portrait of
221 children when he painted the three Danish royal children in one panel.
Three versions of this picture, more or less equal in quality, survive in
England—at Hampton Court, Wilton House, and Longford Castle. The
master must also have painted Christian of Denmark, the father of these
children. Jacob Binck's engraved portrait of this king, judging by its
style, is based on Gossaert.[1]

Gossaert was not so closely connected with the Habsburg regent as was
162 his rival Orley but the link with the Danish king, who was married to
Isabella of Austria, is sufficient evidence that Gossaert's services were
appreciated at court. Orley was more readily available and had to replace
(inadequately as we believe) the most capable of the Netherlandish
portrait painters around 1525.

Justi's attempts to trace portraits of members of the Habsburg family by
Gossaert were not successful. Recently I saw a portrait on the Italian art
market[2] that looks like a portrait by our master and seems to represent a
sister of Charles V. The similarity with the best authenticated portrait
of the Danish queen (in the collection of Count Tarnowski) is very striking
—but it could equally well represent her sister Mary of Hungary, whose
known portraits date from a much later period.

Gossaert develops his manner of drawing, in deliberate contrast to
Netherlandish tradition, to a full, rounded breadth of form, a spirited,
undulating ductus with clear and precise demarcations. His highest aim
is to achieve the striking illusion of physical form. Sensitivity, light, air,
material texture, charm of colour—all are sacrificed. Gossaert seeks out
difficulties and emphasizes them. He treats us to amazing aspects, not
justified by the content, merely to be different from the others and to show
off his art. Not infrequently his figures appear rigid in eccentric poses,
because his analytical approach and adherence to the model impede the
flow of movement.

No one could have been worse equipped to convey visions, dreams or
spook. His fanatical devotion to physical form spoilt him as interpreter
of Christian spirituality and in this negative sense he was truly 'modern',
for he only believed what he saw and he only saw what he could actually
touch.

[1] The original drawing by Gossaert has come to light again and is now in the F. Lugt Collection, Paris. Cf. Friedländer's paper on the portraits of the Danish king (in *Annuaire des Musées Royaux de Beaux-Arts de Belgique*, I, 1938), where Jacob Binck too is rejected as the engraver, although there is in fact also an engraved portrait of Christian II by Binck.

[2] Later in the August van Berg Collection, Portland, Oregon.

JAN JOEST

A SINGLE work, however significant, is not, generally speaking, sufficient to illuminate its author's personality from all sides. Characteristic qualities must recur in other works if our conception of the author is to be confirmed and completed.

Jan Joest is everywhere named in connection with the wings of the Kalkar altarpiece, but since the proposal to identify him with the Master of the Death of the Virgin was—quite rightly—rejected, no further attempt has been made to insert him correctly in the historical chain. In 1904, when the wings were exhibited at Düsseldorf, comment on the isolated altar work was limited to conventional words of praise.

Kalkar documents have supplied us with the information that Jan Joosten carried out the great task of painting the two wings with twenty pictures, five on each side, between 1505 and 1508. As far as we can gather from the payment entries, the painter seems to have come from outside to do the work at Kalkar and to have departed after he had completed his task. On the other hand the painter's name was found in a Kalkar list of soldiers for the year 1480. It was, so one assumes, on the strength of this earlier association with Kalkar that the master received the commission in 1505. Perhaps he was a native of the town.

It so happens that the name of a painter, Jan Joest, has been found in a far more celebrated art centre than Kalkar ever was, namely Haarlem. And the identification of the Haarlem artist with the Kalkar one has been everywhere accepted.

In 1510, i.e. after the years at Kalkar, Jan Joest purchased a house in the Dutch town;[1] in 1515 he executed a commission for the church of St. Bavo; in 1519 he was buried in that church. The Haarlem and the Kalkar dates agree. But prior to 1505 there is no trace of Jan Joest at Haarlem. From which town he had come to Kalkar must remain an open question.[2]

There is an altarpiece in the cathedral of Palencia to which, as to so many noteworthy monuments in Spain, C. Justi has drawn attention.[3] In the church records the painter's name is given as Juan de Holanda.

[1] In 1512 he painted the high altar of the abbey church of St. Ludger at Werden (J. H. Schmidt, *Kalkar*, 1950, p. 63).
[2] Friedländer (*Die Altniederländische Malerei*, XIV, 1937, p. 114) thinks it probable that Joest was born at Wesel, as according to a newly-found document he was in that town as early as 1474.
[3] *Miszellaneen aus drei Jahrhunderten Spanischen Kunstlebens*, I, p. 329.

(107)

Justi, who describes the altarpiece, raises the question of the identity of this Dutch Jan, he suggests Jan Mostaert. But Jan Mostaert, whose art is now familiar to us, no longer comes into the picture. For anyone who has seen the Kalkar altar wings one glance at the Palencia panels is sufficient to reveal the similarity of style. And even those who do not trust this impression will be forced to admit that the probabilities are all in favour of the identification.

Jan Joosten of Kalkar is probably none other than Jan Joest of Haarlem; the name Juan de Holanda would therefore be applicable to him. That a Jan of Holland should have produced work at Palencia related in style to the Kalkar altar wings and not be identical with Jan Joest is all the more improbable because relations between Spain and Holland were comparatively rare. The identification provides welcome confirmation of the Kalkar records and of the connection between the Kalkar and the Haarlem records.

225–227 The altarpiece at Palencia—always according to Justi—was 'commissioned in 1505 in Brussels' by Juan de Fonseca. Strangely enough the commissions for Kalkar and Palencia came at the same time. This gives rise to difficulties, but they are not by any means insuperable. Before he went to Kalkar Jan Joest could have been living in Brussels or he could have been called to Brussels to receive the commission from the Spaniard, who was there on a diplomatic mission. If the inscription, which I am unable to check, really reads 'Commissioned 1505' it is not easy to believe that Jan Joest before he went to Kalkar found time to execute the commission. And the idea that he worked at the Palencia panels during his years at Kalkar is an awkward one. Perhaps he postponed the execution of the work until after the Kalkar period. Or perhaps the inscription means that the altarpiece was completed in 1505 and would thus have been finished before the Kalkar work. Incidentally in Justi's introduction to the Baedeker of Spain the date of the altarpiece is given as 1507.

Only a calculating scholar, but never an unbiassed observer, could be reminded of Geertgen when looking at the Kalkar wings. The Haarlem tradition, the continuing effects of Geertgen's influence, are apparent in the work of Jan Mostaert but not in that of Jan Joest. The stylistic phase is a different one, the source of this art is not known—which is not surprising considering the scarcity of surviving Dutch monuments of the fifteenth century. But this does not entitle us to regard the master as an original genius. Nevertheless Jan Joest is well to the fore amongst the painters who are looking for new ideas. We are at the beginning of the sixteenth

century but the nearest stylistic parallel is to be found in the work of Joos van Cleve, who became master at Antwerp in 1511, and in the earliest works of Barthel Bruyn, who was only twelve years old in 1505. Eisenmann in particular emphasized the affinity with the Master of the Death of the Virgin and he was even tempted to amalgamate the two artists; the relationship to Bruyn was cleverly detected by Firmenich-Richartz.

We are approximately in the artistic phase of Hans Holbein the elder, but the broader, more painterly approach of the Netherlandish artist contrasts with the more linear style of the South German master. What they have in common is the easy unconcern with which they loosen the ties of traditional stylistic severity, the abrupt juxtaposition of realistic portrait-like heads and empty, mask-like ideal heads. The impulse to express powerful movement fizzles out without producing a more dramatically intensified composition. The construction of the figures is uncertain although the succulent, glowing colour, the sense of reality in the rendering of unimportant details and the charm of changing effects of light successfully conceal the innate weakness.

The conception is comfortably bourgeois, at times even humorous, rather than dignified or representative in the spirit of the Church. Comical 'nursery' motifs and caricature, which are introduced wherever opportunity arises, supply evidence enough that for this ancestor of Dutch portrait, landscape and genre painting religious painting was an uncongenial task to which he had perforce to resign himself.

The badly foreshortened figures of the Apostles with their stuck-on beards are just as unconvincing as the tender-hearted figure of Our Lord, whereas the incidental figures, with eyes slit open and strongly sensuous mouths, are striking in their individual realism. The hands are conspicuously large with long, bony, flexible fingers. The children, women and youthful men often have upturned noses which produces a comic, impudent or vulgar impression.

The Palencia picture is divided in an unusual way into eight panels, eight representations, with three each on the right and on the left, two in the centre one above the other. The main panel, the lower central one, is twice as large as the others both in size and in the scale of the figures. The scenes are separated by a powerfully moulded Gothic framework. The dominant composition in the centre, a group of St. John the Evangelist standing at the back of and supporting the mourning figure of 225 the kneeling Virgin, shows a simplicity, nobility and tenderness beyond anything achieved in the Kalkar work. To the right kneels the donor

Juan de Fonseca. The smaller panels from the top left downwards represent:

 1. *The young Jesus disputing in the Temple.* An interior with bold perspective construction, consistent treatment of the lighting, surprising chiaroscuro.

226 2. *The Flight into Egypt.*

 3. *The Presentation in the Temple.* This scene is also represented in the Kalkar altar work.

 4. (Top centre) *Christ carrying the Cross.*

 5. (Top right) *The Crucifixion.*

 6. *The Lamentation over Christ.*

227 7. *The Entombment.*

Judging by the style, the Palencia altarpiece seems a little older than the Kalkar work. I am therefore inclined to believe that it was completed in 1505, before Jan Joest went to Kalkar. The composition in the great majority of the Palencia panels is calmer, less diffuse than in the Kalkar ones, the types are more dignified, the execution more uniform.

There is at Sigmaringen a painting by Jan Joest, stylistically close to the Palencia altarpiece, which is strikingly original in composition—a
228 *Lamentation over Christ.*[1] In the centre is the Virgin Mary with the Body of Christ, holding her Son in the manner of God the Father in early representations of the Trinity, to the left St. John supporting the weight, to the right the Magdalen holding the left arm of the Saviour. The scene appears soft and painterly against a dark landscape in the middle ground. Under No. 72 (formerly Weyer Collection 149) of the Sigmaringen catalogue the picture is described, on Scheibler's and Eisenmann's authority, as an early work by Bruyn.

We find a clue that leads to Jan Joest in the von Kaufmann Collection, Berlin. This collection once included the well-known Bruyn panel dated 1516, a *Nativity* with brilliantly executed lighting.[2] A comparison with the *Nativity* at Kalkar, where the kneeling figure of the Virgin is similarly shown, reveals that in 1516 Bruyn (he was then 24 years old) was slavishly dependent on Jan Joest.

Bruyn's composition is derivative. It is also to be found elsewhere. There was a second *Nativity* in the von Kaufmann Collection, rather inferior in execution, which has nothing whatever to do with Bruyn but repeats all essential motifs of the Bruyn panel, in particular the group

*[1] Now in the Wallraf-Richartz Museum, Cologne.
*[2] Now in the Staedel Institute, Frankfurt.

of kneeling angels standing head to head behind and a little to the side of the crib. I am convinced from stylistic grounds that the two versions go back to a picture by Jan Joest that can no longer be traced today. In 1508, when Jan Joest left Kalkar probably proceeding direct to Haarlem (he was certainly in Haarlem by 1510), Barthel Bruyn was only fifteen years of age. He was most likely trained in the Dutch town between 1510 and 1515. The name Bruyn occurs in 1490 on a Haarlem document. The painter Bruyn who worked there for the church of St. Bavo in 1490 may have been Barthel's father.

In the museum at Valenciennes there is a panel with a fairly exact copy by the so-called Master of Frankfurt of the picture we know from the von Kaufmann Collection.[1] The Master of Frankfurt was older than Bruyn, and was probably active at Antwerp as early as 1500. His lack of independence and his tendency to borrow compositions can be observed also in other cases. Without having been actually a pupil of Jan Joest he may have made use of the model. It is not by any means out of the question that Jan Joest, directly or indirectly, exerted an influence on the Southern Netherlands. For was he not, if the Palencia inscription is genuine, in Brussels in 1505?

Joos van Cleve has been confused with Jan Joest and the stylistic affinity between the Cleve master and Bruyn has been emphasized repeatedly. The relationship can best be sorted out by assuming that Bruyn and Joos van Cleve were pupils of Jan Joest and regarding what they had in common as derived from the common teacher. Joos was a little older than Bruyn. He begins as Master in 1511 but may have started to work a few years earlier, perhaps in 1507; Bruyn did not begin until 1515. Joos, always provided he really did work in Jan Joest's workshop, may well have been at Kalkar around 1506. This connection is not improbable, considering how close Cleve is to Kalkar.

There is in the von Bissing Collection, Munich, a small *Nativity* which, without being a replica of the model we have reconstructed, has many features in common with it, e.g. the hands of the Virgin and the position of the Child; in quality it far surpasses any of the panels compared here including the ones by Bruyn and the Frankfurt master. This panel is certainly an original, in my opinion it could well be an original by Jan Joest. The well-preserved parts, in particular the flying angels at the top, are quite masterly. The heads of St. Joseph and of the Virgin are not in perfect condition and probably for that reason seem a little strange.

Jan's art, the force of which has not been properly appreciated, had

[1] Exhibited Paris 1904, Exposition des Primitifs Français, No. 115, Photo Giraudon.

manifold and wide repercussions. The centre probably lay within the boundaries of Holland even though the master's origins are obscure. The influence of Jan, who worked at Kalkar, perhaps in Brussels, at Haarlem and for Palencia, spread to Antwerp (Master of Frankfurt, Joos van Cleve) and to Cologne (Barthel Bruyn).

The threads that bind his art to the older Dutch art are not visible. But if we are ever bold enough to attempt a reconstruction of the evolution of Dutch art, of the growth of the characteristics which in the seventeenth century emerge so triumphantly as specifically Dutch, then Jan Joest will find his place as an essential link between Geertgen and Jan van Scorel.

JAN MOSTAERT

IN as far as we rely on van Mander's account we enjoy the advantage of a fairly informative biography of Jan Mostaert. It was at Haarlem in particular that van Mander pursued his investigations with such zeal, where in many of the houses he was shown pictures by 'old Masters' and where he came upon a living tradition relating to Mostaert. As long as that painter's activity remained attached to Haarlem, van Mander's account is reliable. In his Life of Ouwater van Mander refers to an honest old man, the painter Aelbert Simonsz, who in 1604 claimed to have been, some sixty years previously, that is in 1544, a pupil of Jan Mostaert at the time about seventy years of age. In his biography of Mostaert van Mander says that the painter died at a ripe old age about 1555 or 1556. Two documents published by Van der Willigen,[1] which have been much neglected of late, confirm these dates. As early as 1500 Mostaert received a commission for a painting at Haarlem, which means that at that time he was already working there as master.[2] He left the city 'where he had been living until then' at an advanced age. Probably most of van Mander's information came from the lips of Mostaert's pupil Simonsz—that is from a good source. In his valuable contribution to the life of Geertgen, this witness makes the assertion that Mostaert (although he was born as early as c. 1475[3]) never met Geertgen, from which we can deduce that he would certainly have known Geertgen if the latter had lived long enough. It would thus seem that not only was Mostaert born in Haarlem, not only did he live and teach there towards the end of his life (about 1546) but he was also trained there. He must therefore have been closely linked to the Haarlem art tradition. This is supported by the information that when still very young he was a pupil of Jacob of Haarlem, who executed the 'Zakkedragers' (corn carriers) altarpiece for the great church there. We have no further information about this Jacob[4] unless we venture to assume

[1] *Les Artistes de Haarlem* (1870).
*[2] Mostaert is mentioned as a painter in Haarlem records as early as 1498 (see Thierry de Bye Dolleman, in *Jaarboek voor het Centraal Bureau voor Genealogie*, XVII, 1963, pp. 1 ff.).
*[3] Thanks to the research of M. Thierry de Bye Dolleman, loc. cit, we can now give the date of Mostaert's birth more precisely as c. 1472/1473.
*[4] Jacob of Haarlem has been tentatively identified with the so-called Master of the Brunswick Diptych (cf. p. 53, note 3), a follower of Geertgen (see Exhibition catalogue *Middeleeuwse Kunst der Noordelijke Nederlanden*, Amsterdam, 1958, pp. 55 f.).

that he is identical with an anonymous painter who stands, stylistically, between Geertgen and Mostaert.

Van Mander speaks very highly of the refined habits and the courtesy of Mostaert who, he says, was the descendant of an old and noble family. A period of activity at court interrupts like an episode the long years of his Haarlem activity.[1] For eighteen years, so van Mander maintains, probably on information received from old Simonsz, Mostaert was painter to the Regent Margaret, staying wherever that regent held her court. Unfortunately no documentary confirmation for this report has been forthcoming and the master's name does not occur on any of the lists of pictures belonging to Margaret. The daughter of the emperor Maximilian was regent of the Netherlands from 1506 to 1529 (the year of her death). Van Orley was her court painter between 1518 and 1529, Jacopo de' Barbari between 1510 and 1515. The only document from the court that seems to refer to Mostaert is somewhat obscure. A payment was made in 1521 *'a ung painctre qui a présenté a Madame une paincture de feu Notre Seigneur de Savoye faict en vif, nommé Jehan Masturd: XX philippus'*. The man portrayed can only be Philibert of Savoy, Margaret's husband, who had died before 1504. If we are to take the text literally it would mean that prior to 1504, when he was still very young, Mostaert had been in contact with Margaret's husband. The fact that seventeen years after the death of Philibert he should sell to that prince's widow a portrait of the prince painted from life is hard to explain and scarcely tallies with the information that he had been eighteen years in her service.

Van Mander describes a whole series of works by Mostaert that he had seen at Haarlem and The Hague. The majority was shown to him in the house of Niclaes Suyker, Mayor of Haarlem. Suyker was a grandson of Mostaert and, one presumes, was able to give accurate accounts of his ancestor and to confirm or supplement Simonsz's statements.

Art critics have succeeded in reconstructing step by step the work of a master whose identity with Jan Mostaert, first advocated by G. Glück, became more and more apparent the more pictures came to light. There are many passages by van Mander that apply to the work of this painter who, once his personality began to take shape, became known as the 'Master of the Herald'. In the work of this anonymous master we come upon a link with Haarlem: in rather an inferior triptych, namely, which at least follows his style, Geertgen's Haarlem *Lamentation of Christ* is copied.

*[1] The earliest record of Jan Mostaert's connection with Haarlem is a recently discovered document referring to the purchase by him of half a house in Haarlem in 1498 (see catalogue of the exhibition *Le Siècle de Bruegel*, Brussels, 1963, p. 163).

Distinguished personalities, who according to van Mander were anxious to have their portraits painted by Margaret's court painter, are not infrequently seen in the reconstructed *oeuvre*. We find members of leading Dutch families, the Alkemades, the Bronckhorsts, and the Wassenaers. The *Portrait of a Lady* in the Würzburg museum represents 233, 235 Justina van Wassenaer—as Grete Ring has shown.[1] The portrait of the lady's husband, Jan van Wassenaer, survives in copies at least. Courtly, ceremonial dignity is characteristic for all portraits by the presumptive Mostaert.

Van Mander mentions among Mostaert's pictures in the house of the Haarlem Mayor a portrait of the countess Jacobaea. The lady in question is Jacqueline of Bavaria, who was ruler of Holland, not, as might be expected, in Mostaert's day but a century earlier. The master copied an older portrait, probably for a Dutch town hall where the display of a series of portraits of the lords of the land was intended. We are familiar with Jacqueline's features not only from a copy in the Portrait Codex of Arras but from what is probably an original drawing in Frankfurt and which we can tentatively attribute to Jan van Eyck. In the gallery of Copenhagen there is a painting of this royal lady which is close in style to the works of the presumptive Jan Mostaert.

Furthermore: the strangest item in van Mander's list of pictures can be traced in the *oeuvre* of our master, namely 'a West Indian landscape with many nude people, a fantastic cliff and exotic houses and huts'. In a 241 Dutch private collection E. Weiss[2] found a picture that would fit this description and it reveals the style that we have ample grounds for regarding as the style of Jan Mostaert. The surviving picture[3] may not be identical with the one van Mander saw and which he considered unfinished but just as it is quite conceivable that Jan Mostaert painted more than one West Indian landscape so it is unlikely that round about 1520 anyone else should have hit upon such an unusual subject. A self-portrait of Jan Mostaert is described in detail by van Mander. A distinguishing feature, an unusual addition, are the small figures in the background: Christ as Judge in the Heavens, the painter as a nude kneeling figure, a devil with the book of sins and an interceding angel. Neither this self-portrait nor indeed any other portrait with such secondary motifs has been found, but the custom of enlivening the background landscapes of the portraits, especially the skies, with small but significant figures is a

[1] *Repertorium f. Kunstwissenschaft*, XXXIII, p. 418.
[2] *Zeitschrift f. bildende Kunst* 1909/10, p. 215.
*[3] Now in the Frans Hals Museum, Haarlem.

striking characteristic of our master. The most popular of these narrative additions was the representation of the sibyl pointing out the visionary figure of the Madonna in the heavens to the emperor Augustus. This background scene occurs in the portrait of an elderly bald-headed gentleman in the Copenhagen gallery, in the portrait of a man in the Brussels gallery, in which a whole assortment of little figures and animals has been added, and in a rather rubbed portrait of a woman in the depot of the Berlin museum. A scene from the legend of St. Hubert has been inserted in the

234 landscape in the *Portrait of a Young Man* in the Liverpool gallery.

Jan Mostaert worked for many decades with unvarying conscientiousness. Between 1500 and 1553 he passed through changing phases of taste but deep down he remained untouched by new demands. At bottom his variegated colour and hesitant manner remained at the level of 1500. A comparison in particular with Jacob Cornelisz of Amsterdam or with the two Leyden painters Engelbrechtsen and Lucas van Leyden reveals his basic conservatism.

Consideration for the wishes of noble patrons, who demanded neat, exact and complete rendering of the costume details and accurate heraldry, lends a trivial, pedantic touch to his work. Whilst his contemporaries in Leyden and Amsterdam considered themselves progressive with their use of a vigorous impasto or broad blot-like technique, Jan Mostaert held fast to a careful smooth execution and never sacrificed local colours in the interests of harmony or chiaroscuro, or to achieve in his compositions a fully co-ordinate whole.

The master's chief work, the triptych with the *Descent from the Cross* in

237 the central panel, executed for the Haarlem juror Albert von Adrichem, which passed from the d'Oultremont Collection to the Brussels gallery, though a staggering achievement, reveals his poverty of spirit far more obviously than do the more modest works, and for all its magnificence and for all its ostentation it remains painfully dull and empty. In the composition of the central panel the master's inability to escape the memory of Rogier's Escorial panel, which he knew either in the original or from one of the many imitations, provokes a most dangerous comparison. The overall solemnity of effect is lacking. The eye seeks for a point of anchorage in the even, monotonous daylight, in the dense proximity of compositionally equal figures and is everywhere held up by the irritating virtuosity of the realism in trivial details, especially in the materials. Nevertheless Mostaert's perseverance and conscientiousness bring about a veritable *tour de force*. If, as I cannot help suspecting, in this his main work the master was striving to compete with Quentin Massys to

emulate not only his compositional principles but also his conception, then we must note that he replaced the deep emotional pathos with an at times indifferent, at times over-sweet emotionalism and instead of the solemn melodious flow of Quentin's drapery produced a monotonous, weak undulation.

The master's manner of treating materials, avoiding all sharp angularity, and using schematic, sinuous lines is ever his most salient feature. His large, empty, globular 'lathe-turned' male heads with low receding foreheads and shallow-set eyes are represented full face or in profile. Attempts at foreshortening are unsuccessful. In expressing dignity he never quite avoids a 'bigwig' pomposity.

Mostaert's unsubstantial and rather exquisite art is better suited to the smaller panel in which he can excel with neat precision and has no need to puff up his talent. The dainty little *Adoration of the Kings* in the Rijks- 239 museum, Amsterdam, is an enchanting example. Such pictures with their multiple divisions and fine articulation are gay and animated in effect. In the National Gallery, London, there is a very small and therefore little noticed work by Mostaert, a *Head of St. John the Baptist with Angels*, which positively sparkles.

A prevailing weakness in the execution of the torso, with long limbs to which are attached hands with shrivelled palms and comparatively long fingers, is a characteristic feature of the master's style. A thin, feathery vegetation almost invariably covers the mountains and ruins in the landscape backgrounds that are always heavily charged with over-minutely executed details. The foliage of the trees in the middle-ground often appears spherically shaped. A comparison with contemporaries such as Orley or Lucas van Leyden would entitle us to expect in Mostaert's production which lasted over a period of six decades, changes so fundamental as to make a link between beginning and end almost imperceptible. Whilst the fairly long sequence of known works by Mostaert may reach neither to the beginning nor to the end, it almost certainly covers a long period of time. We may attempt a rough chronological classification of the pictures but nowhere do we find any changes of direction. The uniformity of style remains essentially intact.

The panel with the *Tree of Jesse* (Stroganoff Collection, Rome, $22\frac{7}{8} \times$ 240 $34\frac{1}{4}$ in.)[1] is the most archaic work that I feel justified in attributing to Mostaert. This panel may date from c. 1500. It is decorative in design,

[1] Illustrated, amongst others, in Dülberg, *Frühholländer in Italien*, with the attribution 'School of Geertgen'. *Now in the Rijksmuseum, Amsterdam, where the painting is ascribed to Geertgen. This attribution, accepted by several scholars, has recently been rejected by K. G. Boon (in *Oud-Holland*, LXXXI, 1966, pp. 61 ff.), who supports Friedländer's view with cogent arguments.

iridescent and truly dazzling in the foppish costume display. The echo of Geertgen is not surprising.

The Alkemade triptych may have originated about a decade later. It is now in the Provinzialmuseum, Bonn (formerly Wesendonck Collection; Düsseldorf Exhibition, 1904, Pl. 59).

To judge from the costumes, several portraits may be dated about 1520. The portrait of Jan van Wassenaer in the Louvre (or at any rate the original) must have been done between 1516 and 1523.

A small panel with *Christ before Pilate*, not mentioned anywhere, passed from the Collection of Sir John Ramsden to the London art market.[1]

Another—hitherto unknown—slightly later picture by the Master, an *Ecce Homo*, is at Northwick Park.[2]

The large many-figured *Crucifixion*, a busy turbulent scene, in the Johnson Collection, Philadelphia, also came from the Northwick Park Collection, which formerly contained many more Early Netherlandish rarities than it does today. I am inclined to regard this work as rather late, circa 1530. The comparatively free and asymmetrical arrangement, the deliberate attempt at dramatic effect, the gradation in the scale of the figures which produces an unexpected feeling of depth, all this suggests a later date of origin. Massys's influence, so predominant in the Oultremont altarpiece, is no longer perceptible.

I regard as one of the later works the large *Landscape with St. Christopher* in the Musée Mayer van den Bergh, Antwerp, a picture that may be identical with a work van Mander saw in the house of Jan Claesz at The Hague and which he describes as follows: 'a St. Christopher in a landscape, a large picture.' In the construction of the landscape the master seems to stand about half-way between Patenier and Pieter Bruegel. The clumsy head of the saint is not successful in the foreshortening.

A few works that we can attribute to our master on stylistic grounds bring us at least close to the court of the Habsburg regent. There is a portrait of a man in the Prado[3] which, though perhaps only a copy, does show characteristic features of Mostaert's style, particularly in the lines of the drapery and in the landscape motifs. And this portrait represents Philibert of Savoy, Margaret's husband who died prematurely. The costume, it is true, which seems to fit a period around 1520 rather than 1504, raises an awkward problem.

An apparently delicately executed portrait in the Mostaert style, known to me only from the photogravure in the catalogue of the Lepke

*[1] Later in the G. Tillmann Collection, Amsterdam.
*[2] Sold in 1965 after the death of Captain E. G. Spencer Churchill.
*[3] Now in the Museo de Santa Cruz, Toledo.

sale (12 Dec. 1888 No. 51, 'Holbein') seems to represent King Ferdinand, Margaret's nephew, as a youth of 20 years. The likeness is by no means striking.

Finally an echo of Mostaert's style can be found in an altar panel in the Copenhagen museum, which was donated by Christian II of Denmark and his wife Isabel (circa 1518). And Isabel was Margaret's niece.[1]

The Copenhagen panel is similar in arrangement and in the compositional idea to the Alkemade triptych. The royal donors in front take up the entire width of the picture whilst the traditional figures of the Last Judgement—Christ as Judge, St. Michael, the elect and the damned— though less accessory-like than in the altarpiece in the von Wesendonck Collection, are certainly of little consequence and seem to have been given makeshift accommodation.

It was Grete Ring who succeeded in proving that a picture fully described in the inventory of the regent's art collections, but without artist's name, was a work by Mostaert.[2] The description fits a *Christis as* 238 *Man of Sorrows* in the Museo Civico, Verona, a picture that I had attributed to our painter many years ago. There was a replica of equal quality in the S. Wedells Collection, Hamburg[3] (formerly belonging to M. Colnaghi, London) which like the version in Verona could be identical with the work formerly belonging to Margaret.

In addition to these representations of the suffering Redeemer in half-length with a ring of angels on a red ground, Jan Mostaert also represented several times the rather plaintive *Man of Sorrows* without the characteristic addition of small figures. To the version in the Willett Collection that was in Bruges in 1902 (No. 338, photo Bruckmann[4]), I can add one with only slight differences in composition, in the Provincial Museum in Burgos. A third was once in the Lanfranconi Collection (Sale 1895, No. 46), a fourth belonged to Mr. von Stolk, The Hague, a fifth has recently appeared on the Amsterdam art market.

Compositions with life-size figures did not seem to occur in the *oeuvre* of the master. Formerly this rather disturbed me because van Mander mentions two works with half-length figures in life-size, and in view of the master's obvious preference for small figures I could not quite believe that he would have attempted them.

Recently, however, I saw a panel by Mostaert—which turned up on

*1 According to E. Moltke (in *Nationalmuseets Arbejdsmarkt*, 1955, pp. 87 f.) the Copenhagen painting, which has also been attributed to Jacob Cornelisz van Oostsanen, was produced before March 1515.

² *Monatshefte für Kunstwissenschaft*, VII, 1914. *3 Now in the Kunsthalle, Hamburg.

*4 Now in the National Gallery, London.

the London art market—with half-length figures in life-size, that actually corresponds in subject-matter to a work mentioned by van Mander, namely an *Ecce Homo*—in not quite perfect condition. Unfortunately it is by no means identical with the picture described. At any rate the myrmidon who holds Christ has no 'plastered' head.

Dr. Oertel's Collection in Munich contains a fairly large panel by our
236 master with full-length figures of *Abraham and Hagar,* in half-size.[1] This subject, too, is mentioned in van Mander's list but the pictures cannot be identical because van Mander speaks of half-lengths.

Even though the text of the Haarlem document stating that Mostaert left his native town, where he had been living until then, at an advanced age seems to indicate that his art, purely Dutch, grew and thrived on Haarlem soil, yet the character of his art refutes this and confirms van Mander's information that he worked for the court in the West.

242–245 In comparison to Cornelis Engelbrechtsen and Jacob Cornelisz, approximately contemporary Dutch artists, Mostaert seems less robust and less bourgeois, and exacting aristocratic standards appreciably modified his style. We can accept Mostaert as follower and pupil in the second generation of Geertgen but never as his direct successor.

*[1] Now in the Schloss Rohoncz Collection (Baron Thyssen), Lugano-Castagnola.

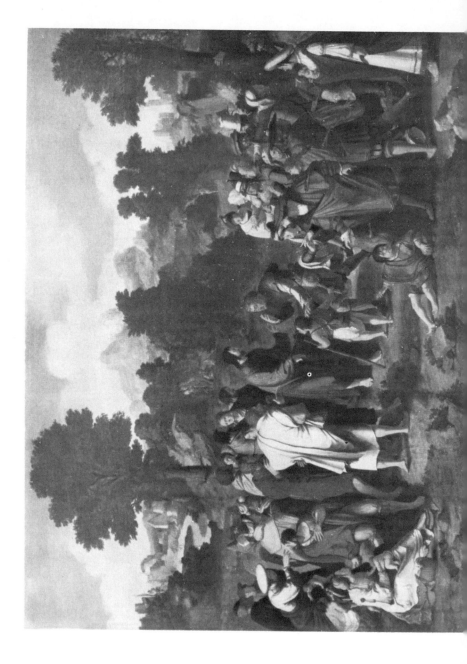

LUCAS VAN LEYDEN

THE name Lucas van Leyden has an authoritative ring but evokes no specific idea in our minds. He enjoys full and genuine popularity only with collectors and connoisseurs of engravings, who value very highly the precious prints, good impressions of which are rare. Everywhere, especially in Italy, paintings wrongly attributed to him sully his name and confuse our conception of his art. And where indeed could a painting be found with sufficiently salient features and sharply enough defined in character to be capable of upholding his honour! A long uninterrupted sequence of engravings authenticated by signatures and often inscribed with the date reveal the draughtsman. If, armed with this knowledge, the critic then cautiously approaches the paintings, van Mander's account will come to his aid.

Carel van Mander, who around 1600 collected with honest enthusiasm the material for his unfortunately rather meagre *Lives of the Painters*, waxes almost eloquent when he comes to speak of Lucas. In his desire to do justice to the memory of the esteemed engraver he made eager and successful enquiries from the descendants of the master at Leyden, and, we may take it, picked up every scrap of the available tradition.

Lucas, so van Mander tells us, was born in 1494 as the son of the able painter Huig Jacobsz, from whom he received his first instruction. He had a weak constitution, was small in stature and from early boyhood on tireless in his devotion to art. He worked in his native town until his premature end. The biographer knows of only one journey that his hero made, through the Netherlands in 1527 in the company of Jan Gossaert.[1] From Dürer's Diary of his Netherlandish journey we know that Lucas was in Antwerp in 1521. The Dutch painter died as early as 1533.

Among the engravings an important print, *Mohammed and the Monk* 246 *Sergius*, is dated 1508. Lucas van Leyden was in his fifteenth year when he did this engraving, which is in some respects a full achievement and was not surpassed by subsequent works. The precocity is so extraordinary and unusual that it has served over and again as a basis for an attack against the traditional date of his birth. But all attempts to upset the date have

*[1] Van Mander does not give the actual date of the journey. He only says that Lucas made the journey when he was 33. This has to be kept in mind in view of the controversy over the year of Lucas's birth (see p. 122, note 1).

proved futile. If van Mander says that Lucas was born in 1494 at the end of May or the beginning of June then the careful accuracy testifies to the exactness of the information. Everthing else that he tells us in his account is, as far as we can check it, accurate. What we know of the circumstances of the master's life, apart from van Mander's vita—and it is little enough —confirms his statements. The unusually early maturity of the engraver was admired as a miracle in the circles from which van Mander drew his knowledge and the narrator cannot sufficiently extol the deeds of the infant prodigy. However strongly experience recoils from the idea, we must for better or for worse accept the date and fit the abnormality into the picture that we are building of our master.[1]

It would seem, moreover, that the print of 1508 is not even the oldest of the engravings; there are several undated works, such as the print of the *Raising of Lazarus,* which are probably even earlier. Admittedly we are assuming that the young master, still in his boyhood, made exceptionally rapid progress and that it was a matter not of years but of months or even weeks for him to wipe out mistakes and to overcome imperfections. His father was allegedly a painter and no more of an engraver than was Cornelis Engelbrechtsen, who is mentioned as second teacher. It has not been possible to bridge the gap between Netherlandish engravers around 1500, about whom we know very little, and the highly developed early works by Lucas, and it is hardly likely that it ever will be possible. In all probability the appearance as it were out of the blue of the engraver Lucas is due to more than a mere gap in our knowledge: he was a genius even if only on the technical side. We can now proceed to examine the engravings in the order in which they were produced with the comfortable knowledge that we have reliable documentary evidence of his development, and trust that despite all changes the master's individuality will ultimately be revealed. But a spectacle of organic growth is unfortunately not for us. The path he pursues runs at sixes and sevens, now towards one goal now towards another and by no means always upwards. The master does not seem to be surely guided by his personal power of design but rather to seek models in nature and in the art of others which like will-o'-the-wisps seem to determine the zig-zag course of the distracted draughtsman.

Tradition afforded just as little support for Lucas as for his contemporaries. In this dangerous crisis of art the Dutch artist seeks salvation in

*[1] Despite the attempt by E. Pelinck (in *Oud-Holland,* LXIV, 1949, pp. 193 ff.) to move the date of birth back to 1489 and to show that van Mander's date 1494 may have been due to a misunderstanding, Friedländer in *Lucas van Leyden* (edited by F. Winkler and published posthumously in 1963) still favours 1494 as the year of Lucas's birth.

the natural world. From the inexhaustible wealth of nature he enriches his art precipitately, superficially, startlingly, but not consistently, accumulating rather than constructing.

The engraver's ambition, his urge to conquer new ground for the burin, seems positively insatiable. Ever new problems arise, are solved and, apparently, cast aside. As a result of the craftsman's dangerously unlimited skill as an engraver, effort, success and satiety are almost simultaneous.

In the print of 1508 the scene from Mohammed's life is depicted with 246 ingenuously drastic gestures, postures and movements. The prophet has fallen asleep as he sits, the murdered monk lies on the ground, seen in powerful foreshortening, the soldier slips noiselessly between the dead and the sleeping man, exchanging his bloody sword for the clean one of the prophet. The figures are successfully combined in a group. Behind lies a deep hilly landscape the aerial perspective of which is surprisingly well expressed considering the rigidity of the burin. There is no lack of other prints to share in this achievement. But—and this is the astonishing part—Lucas never made further progress along these lines. In not a few of the earliest scenes the spatial depth is exploited to accommodate an animated countryside with bold foreshortenings, compact groupings and a rich variety of landscape elements. Under the assured hand of this engraver the burin runs easily and smoothly acquires the ability to conjure up soft and delicate tones, air and light and a silvery sheen. Despite the amazing mastery of these early prints, round about 1510 Lucas did engravings which apparently show no interest in foreshortening, grouping, spatial depth or dense and delicate strokes, in which the figures seem extraordinarily stiff and stand awkwardly side by side and the view of the landscape is obstructed.

With the famous large *Ecce Homo* of 1510 Lucas achieves his greatest 248 triumph in the rendering of architecture. The wide market-place of complicated shape surrounded by a great variety of buildings, is represented in impeccable perspective and with brilliant clarity of design. Once again the novelty seems to have inspired the master. Christ, shown to the people who are in front of the tribune, is himself indistinctly seen in the middle ground. The gesticulating multitudes fill the wide space in front, and seem, not inaptly, to hold the centre of the stage. But Lucas, as we can also observe elsewhere, did not always follow the content of the narrative but allowed himself to be diverted by thirst for novelty and interest in genre motifs. He enjoyed filling the stage with all kinds of people and in the place of the oft-enacted scene he presented a seemingly new form of rich spectacle.

For the Dutch master the Bible was more a book of stories than an edifying work. At least he took pleasure in drawing inspiration for his art from the anecdotic content of the biblical tale, and his love of spinning yarns often led him to the Old Testament, which had formerly been very rarely drawn upon and then only in relationship to the New. The remoteness and exotic nature of the adventures narrated are expressed superficially and naively by grotesque costume. The Passion series, whilst retaining their traditional spiritual content, were to be transformed from within and inspired with new life. The two series by Lucas that have come down to us are among his most feeble productions. In the earlier one, with the compositions in the round, the master seeks to stimulate interest by a rather clumsy brutality, in the later one he follows Dürer closely, thereby challenging a comparison that goes against him.

A few idyllic prints of his early period, in particular some *Madonnas*, seem permeated by a weary melancholy shown rather awkwardly in the inclination of the head and in the expression of the face. The charm of mood disappears in the course of his further development and is not replaced by a clearer or more differentiated interpretation of spiritual emotion. Altogether Lucas is more physiognomist than a psychologist. He fashions a whole gallery of unusual male heads with over-steep profile lines, projecting chins, curiously modelled noses. The large *Adoration of the Kings* seems to be built around such character heads. At times the rather caricature-like representation goes straight to the heart of the subject as in the print in which David, a robust youth, plays his harp for a rather moody Saul. The accessory figures are generally interesting but the heroes if not exactly devoid of nobility are at least indifferent.

Rooted in a bourgeois milieu, serving neither court nor church, seeking out oddities in everyday life, Lucas also had a natural interest in the wide and diffuse field that we call genre. There can be no doubt that he was in the forefront of the precursors and innovators in this field, not so much because in several prints and in two or three paintings he created the incunabula for this category but rather because his whole narrative is interwoven with genre features and genre motifs.

The master's formal language is in a perpetual state of flux. The figures in his early period are haggard with angular limbs and blunt extremities. Later they tend to be round with swelling contours. The movement, at first rather stilted and hesitant, gradually acquires a greater freedom.

Lucas died young, but from the point of view of what he achieved not prematurely. His later works draw less from the observation of nature than do his early ones.

If around 1520 even Dürer's art had not been without danger for him, around 1530 Marcantonio's manner was to prove disastrous. The Dutch master, who had previously ever preferred the unexpected to the norm, who, if he lacked any talent, lacked a sense of beauty, was bound more inevitably than the majority of his contemporaries to be led astray when he followed the lure of the Southern ideals of form. Northern art was the victim of an extraordinary fatality: the same Marcantonio who had once copied Dürer and had borrowed a landscape motif from a print by Lucas van Leyden, who had certainly been disturbed by the matchless skill of the Dutch engraver, finally emerged as victor, if not thanks to his own ability then at least as representative of a great power advancing to the North—the art of Raphael.

Most of Lucas's paintings are undated. In spite of this we are able to link the pictures historically by comparing them with the unbroken chain of engravings. More than one picture, it is true, perished in the icono-clastic storms, but our stock is far greater than the compilatory literature would lead us to suspect, and is quite sufficient to give a clear idea of the master's manner of painting—once all false attributions have been carefully removed.

The painter does not emerge with the early maturity of the engraver. The paintings that must be regarded as the earliest, such as the *Game of Chess* in the Berlin museum, the slightly later *Beheading of John the Baptist* 251 in the Johnson Collection, Philadelphia, are laboriously painted with intractable colours and multiple brush strokes and seem definitely the work of a beginner. The Berlin genre picture dates from about 1510, the *Beheading of the Baptist* from around 1512. Paintings executed in the succeeding years, e.g. *St. Jerome* in Berlin and the *Virgin enthroned with Angels* in the same gallery or the *Card Game* at Wilton House, are done 250 with greater ease, are blond in colour and flowing, rather glazed in the painting.

We are very well acquainted with the art of Cornelis Engelbrechtsen, 245 who is regarded as Lucas's teacher, but we hesitate to designate specifically what the pupil owed to the teacher. For it is not impossible that in their relationship Lucas gave as well as received. Cornelis died in 1533, the same year as his illustrious pupil.

In the period between 1517 and 1531 Lucas produced pictures that vary considerably among themselves, and certainly show no trace of organic evolution. A small *Portrait of a Man* in a Dutch private collection[1]

*[1] Now in the Schloss Rohoncz Collection (Baron Thyssen), Lugano-Castagnola. The date is now read by Friedländer and other critics as 1511.

(The Hague, formerly in the Zeiss Collection, Berlin) dated 1517 gives a definite effect of chiaroscuro. The considerably more important *Portrait of a Man* in the Fry Collection, Bristol,[1] may date from about 1520. The imposing altarpiece with the *Last Judgement* in Leyden seems to date from about 1526, the sole work by the painter that has remained in his native town.[2] The condition of the triptych is by no means as bad as is usually stated. The rather ostentatious Renaissance design centres round the representation of nude bodies in movement. This is the period above all others when Lucas oscillates between two extremes. Local colours are often suppressed in favour of a dominant dull, earthy tone. Sometimes it even seems as if the draughtsman were neglecting the specific task of the painter as for instance in the carefully executed detail in the diptych of 1522 with the *Virgin, a Donor*, and the *Annunciation* (Munich, Pinakothek). At other times the interest is concentrated on a broad painterly treatment with strong patchy effects of light.

Lucas often found occasion to adopt in his paintings the rather chatty compositional style that he used with so much complacency in his engravings, as e.g. in the *Sermon* (Rijksmuseum, Amsterdam), in the *Moses striking Water from a Rock* at Nürnberg[3] or in the triptych in the Hermitage St. Petersburg, allegedly from the year 1531. The picture with the elaborate but rather confused composition showing Moses striking water out of the rock, dated 1527, painted on canvas and, like the majority of canvas pictures of the period, now dull and dark. came to the Nürnberg museum from Rome. Landscape and figures are firmly linked. The hero does not stand out clearly from the surroundings. The action is obscure. The last known painting by the master is in some respects also his most significant work. Though generally speaking the brush was less adaptable to his aims and moods than the burin—at the end of his meteor-like career, when there was scarcely anything left for Lucas the engraver to try, he marshalled all his forces once more in a painting. The subject of the *Healing of the Blind Man* is spread broadly over the central panel and the two wings of the triptych in St. Petersburg. Christ performs the miraculous cure in a wooded countryside, surrounded by a dense excited throng. The movements of the figures and even more the strong spotlight effect of the illumination bring life to the scene. This truly Dutch interest

The following margin references appear alongside the text: 254–260, 261, 252, 249, VIII

*[1] Now in the National Gallery, London.

*[2] August 6, 1526, has been established as the actual date of the commission. The triptych was intended as a memorial for the Leyden alderman and councillor Claes Dircksz van Swieten (not as an altarpiece) and was already at its place near the font in St. Peter's Church, Leyden, before the end of 1527.

*[3] Now in the Museum of Fine Arts, Boston, Mass.

which is even more definite in the approximately contemporary paintings by Jan van Scorel, can be regarded as foreshadowing Rembrandt. A comparison between this *Healing of the Blind Man* and Rembrandt's *Hundred Guilder print* is not without interest.

Whether Lucas, who had certainly no further expectations to take with him to the grave as an engraver, would have progressed any further as a painter had not death put an end to his work is something that we may reasonably doubt. His ambition and his keen eye were certainly turned boldly into the distance but his foundation was not firm enough to assure a steadily increasing success. The people of Holland had first to liberate themselves and to define their political boundaries before their sense of realism could acquire the necessary restraint to develop a natural stylistic assurance. Without forcing the facts we can interpret the genius of Rembrandt as the fulfilment of many an aim that flickers dimly in the endeavour of his Leyden ancestor.

JAN VAN SCOREL

THE opinions of the sixteenth century are unanimous on Jan van Scorel and proclaim his fame loudly and—the reasons for this fame. On the other hand, the judgment in more recent literature is full of doubt and criticism, because the value of his achievements, admired by his contemporaries, has now become questionable. So unbounded is our admiration for Netherlandish painting that Scorel's determined and conscious turning away from tradition seems at first sight to be a dangerous uprooting. In quite recent times, it is true, there is a dawning tendency to recognize the positive side of the Rome pilgrim's achievement—as we can see in Grete Ring's article.[1] The growing scientific spirit widens our susceptibilities in all directions. Increasing insight throws ever greater light on the necessity of change, and every result demands recognition. It may well be that behind this objectivity lurks the subjectivity of modern taste for which Scorel's mannerism has lost its horror. When the Obervellach altarpiece first became known, some forty years ago, this work, painted before the *Fall of Man*, was immediately placed far higher than all Scorel's later achievements. And since few people were able to examine this out-of-the-way triptych the bias in its favour was retained in the compilatory literature. The motive for Grete Ring's criticism of the early work was the desire to get rid of the foolish idea that on Italian soil the master had exchanged inherited values of priceless worth for a phantom. In reality, the style of the Obervellach altarpiece is discordant and on the verge of disintegration. One can sense the inner void and the readiness to receive fresh ideals.

Jan van Scorel was born on August 1, 1495, in the village of Schoorel near Alkmaar. His first teacher was Willem Cornelisz (more correctly Cornelis Willemsz), an unknown Haarlem painter,[2] and later he went to Amsterdam to Jacob Cornelisz. Restlessness and dissatisfaction with mere craftsmanship drove him to Jan Gossaert, who at that time—c. 1515—was at Utrecht and was looked upon, thanks to his Italian experience, as the great innovator. Subsequently, Scorel was lured southwards by his

242-244

[1] *Kunstchronik*, 17 May, 1918.

*[2] It is due to Professor J. Bruyn that we now have some idea of the art of Cornelis Willemsz (see D. P. R. A. Bouvy, in *Schilderkunst, Kerkelijke Kunst*, I, Bussum, 1965, p. 52, fig. V, A and B, and J. G. van Gelder, in *Simiolus*, I, 1967, p. 6, n. 10). Before he went to Cornelis Willemsz he may have been apprenticed to Cornelis Buys at Alkmaar, cf. Friedländer, *Die Altniederländische Malerei*, XII, 1935, p. 119.

love of travelling and his thirst for new experience and knowledge, to Speyer 'where a cleric was skilled in architecture and perspective', to Strasbourg, Basle and Nürnberg, where he may well have found under-standing for his rationalistic ambitions in Dürer, then to Carinthia, where in 1520—according to the inscription—he completed the Obervellach 264 altarpiece.

In that same year, the year of Raphael's death, he probably crossed into Italy and stayed for some time at Venice. From there he made a journey to the Holy Land, not merely as a pious pilgrim but also as a mentally alert traveller eager to see the places where Christ's feet had trodden. This painter's desire to interpret the biblical scene more 'correctly' than had been possible for his predecessors by expressing time and place of the action in the costume, landscape and architecture could not, of course, lead to results that would satisfy our modern historical sense. Nevertheless, the endeavour played its part in forming his style, in drawing him away from commonplace reality and in any case, aided by memories of his travels, he was able to offer his contem-poraries plausible novelty. The town of Jerusalem, painted in the land-scape backgrounds of his religious pictures after studies from nature, was viewed with awe and curiosity. 266

In Scorel's imagination, it is true, the Southern sun was blended with Northern mists, the East with the West, biblical history with Roman antiquity, the sacred figures of the gospels with the universally valid beauty of antique statues, oriental materials cut to antique patterns.

Scorel returned to Venice from the East, visited several other Italian towns and finally reached Rome where, under the brief rule of Hadrian VI, from January 9, 1522 to September 14, 1523—a breathing space in the Roman High Renaissance—he enjoyed a favoured position as a com-patriot of the Utrecht-born pope, and was placed 'over het heel Belvider'. Scorel was still in Rome on May 26, 1524, as is evident from a letter with that date. However he returned to his Northern home shortly after and settled at Utrecht where, held in high esteem, he remained until his death on December 6, 1562, with only brief interruptions to work at Haarlem and Delft. Short as his stay in Rome was, it made a decisive and lasting impression on his entire production. As a result of his Dutch tem-perament when he tried to become a Roman he became a Venetian.

Since the master's chief religious works, which once stood at Utrecht, Haarlem, Gouda and Delft, have all perished, we are forced to establish our views of his art on panels laboriously collected in critical research. A large altarpiece stands, unnoticed, in the main church at Breda. 267–268

The determination to make radical changes, the ambitious thirst for originality, the pleasure in surprising inventions form the mainspring of his endeavour; the course was set by his interest in antiquarian accuracy and his enthusiasm for antique sculpture. The human body is freed from the fetters of many-layered costumes, is shown in the nude or in flowing drapery which, moulded on the human form, seems to expose rather than veil the organism beneath. With statuary as his model the painter strives to find uniform and impressive movements, in easy contraposto, that can dominate the position, steps and gestures of each figure.

The religious pictures are endowed with dignity and monumentality by a regular formation of the healthy muscular forms, a stately carriage, pathos of attitude and a 'beauty' in the heads that is derived from the art of others. The reverent attitude of mind, that pieced everything together, bit by bit, with loving care and, despite the overall unnaturalness, forced illusion on the details, is completely abandoned in favour of the picture conceived as a whole and the correctness of the proportions. Scorel treats the details perfunctorily. He expresses himself rather in the movements of the body than in the features of the face. His heads, little individualized, often appear mask-like.

Jan Gossaert, who had looked around in Rome some fifteen years before Scorel and had then returned to the Netherlands as teacher and guide to the new aims, was primarily gifted as a draughtsman, goldsmith and sculptor. Scorel viewed space peopled with statues with the eye of a painter. In his scrupulous regard for all formal factors Gossaert remained tied to the Netherlandish tradition, Scorel in step with the Italian High Renaissance style, concentrated on the picture as a whole. Gossaert is painfully exact, analytical and pedantic, Scorel hasty, fluent and dynamic. For Gossaert light is a means to an end, the end being the illusion of three-dimensional form, whereas Scorel builds up his picture in light and shade, which are the essential elements; his shadows are deep, cover wide areas, often ruthlessly dominating the form. Classic profiles not infrequently stand out effectively as flat discs against the light background. Gossaert came from Maubeuge, was Latin or at least half-Latin, whereas Scorel was Dutch with a sensitive eye for light and tone values. His acute inventiveness proceeds from light contrasts, he accentuates and suppresses and composes with light. The golden shimmer of his misty backgrounds anticipates the intentions of Aelbert Cuyp; the all-enshrouding darkness of his interiors can be regarded as the germ of Rembrandtesque chiaroscuro. Scorel, who observed what was far off rather than what was close, whose ideals were colourless stone figures and reliefs, was indifferent and

arbitrary in his treatment of local colour. His palette, which contains broken colours, is harmonious and blond though sometimes rent by an excessive contrast of light and shade.

Scorel developed his manner of painting to suit the purpose of his design, independently and consistently. The colour is soft, broadly applied in large patches, his pigment is transparent and enamel-like but not excessively smooth. He expresses the swift-gliding mobility of shadows with a stippling brush, illumines and spotlights the forms. In places the light chews up the line and softens it.

Despite all novelty, grandeur and ideality this master's devotional pictures remain bare, like an egg that has been drained dry; the content, namely the religious feeling, has escaped. Presumably the Jerusalem pilgrim, favourite of the pope, Utrecht canon was an orthodox believer whose art was reverently dedicated to God. But general outlook and creed do not suffice; the profanation, externalization and inner emptiness of the religious picture was a necessary result of his way of seeing and his manner of composing. Scorel transformed the devotional picture into a history piece in the grand 'manner'.

Recently two works by Scorel have come to light, accredited from a reference by van Mander. First the *Presentation in the Temple*, acquired by 265 Gustav Glück for the Vienna gallery, and secondly a fragment discovered by Grete Ring at Valenciennes. The *Presentation* is evidently identical with the picture once owned by Geert Schoterbosch at Haarlem which was admired by van Mander for its magnificent architecture. The fragment with the *Martyrdom of St. Lawrence* certainly formed part of the altarpiece of this saint at Marchiennes in the Artois, mentioned in the same source.[1]

The two panels provide a welcome addition to our knowledge. Though, admittedly, there is no lack of altar panels to show the master's compositional style, types and general conception, in view of the tremendous prestige that he enjoyed as an artist and in view of the heavy demands on

*[1] The fragment with the *Martyrdom of St. Lawrence*, which until the First World War was in the Museum of Valenciennes, has since disappeared. In his most important article on late works by Scorel in France and Flanders (referred to on p. 128, note 2) Professor van Gelder has published an old copy of the complete composition which he identified in the Museum of Poznan. The *Martyrdom of St. Lawrence* was one of three altarpieces by Scorel which, according to van Mander, were in the Abbey Church of Marchiennes. Among these three altarpieces, which were commissioned by Jacques Coëne, abbot of Marchiennes 1501–1542, the largest, with two pairs of movable wings, was dedicated to St. Stephen and St. James. It was painted about 1541. Except for one static wing and the central panel with the *Stoning of St. Stephen*, this altarpiece has been reconstituted at the Museum of Douai by its curator, M. J. Guillouet, who published it in *Oud-Holland*, LXXIX/2, 1964, pp. 89–98. A drawing of the *Stoning of St. Stephen* in the F. Lugt Collection, Paris, is, according to van Gelder, the design for the lost painting. The third altarpiece by Scorel at Marchiennes mentioned by van Mander was a triptych with *St. Ursula and the 11,000 Virgins*, the right wing of which has recently been found by M. Guillouet (see van Gelder, in *Simiolus*, op. cit., p. 22).

his workshop we must from the outset reckon with copies, imitations and the collaboration of pupils. Only the best works can give an idea of Scorel's manner of painting and personal handwriting. These do not include, for example the *Crucifixion* in the Bonn museum, which owing to its problematic inscription 'Schoorle 1530' is often quoted in the literature, 275 but they do include the *Magdalen* in Amsterdam. The positive and special qualities of his style are better illustrated in the *Magdalen* than in any other of his compositions. The general effect of sunniness and humidity in the picture is striking, and dominates both the plastic volume and the local colours. The Magdalen was frequently portrayed by his contemporaries and fellow-countrymen but generally within a narrow framework, scarcely ever, as here, in a wide landscape setting. The gradation of the tone values, the aerial perspective, the lights flashing in dots and strips, the cast shadows are all observed for their own sake and rendered with brilliance and transparent luminosity. The deep cast shadows in the drapery sometimes swamp the individual folds. Bright patches gleam out, e.g. in the tree trunk on the right but without defining the cylindrical form of the trunk. The areas of shadow are not sharply edged but soft against the sky. The texture of hair and drapery is characterized with sensitive perception. The extensive use of glazes is adapted to characterize the material, thin in places, particularly in the flesh where the drawing shines through, and in places oily and with impasto. Light, air and landscape are used as the chief expressive factors and confer ideality and festive distinction on the attractive woman.

All Scorel's characteristics become virtues in his portraits. The nature of the task brings him back to the particular. The emancipation from tradition, which was a danger for his religious painting, is an advantage here because the subdued, limited and monotonous gravity, a rudiment of the donor portrait, is lifted and a study of human nature introduced. Scorel's portraits differ from one another in carriage, posture and movement of the hands. The self-confident free personality of the sixteenth century is portrayed with deep insight into the human mind. Scorel had seen the world, was versed in languages, and, moreover, a musician and a poet. He does not seek out physical facts with minute detail and completeness but rather surveys the whole and grasps the essential features by selecting a certain turn of the head, carriage of the body, movement of the hand to suit the temperament of the sitter and a lighting that gives surprising emphasis to the structure of the head. He expresses the inner life of the individual with keen insight. Scorel's beings are communicative, open their hearts to us with eloquence.

The richness and variety of his portraiture is revealed in the long series of *Jerusalem Pilgrims* in the Utrecht Museum, although the panels have suffered considerably and are disfigured by extensive retouching. This great achievement of Dutch portraiture, which we are able to date—two groups shortly after 1525, one soon after 1535 and one after 1541—this vigorous root of the guild group-portrait, that flourished so luxuriantly in the seventeenth century, represents the starting-point and standard of judgment. A thorough study of the surviving parts is highly instructive.

The portrait frieze in the Haarlem museum, which shows twelve Jerusalem pilgrims, is better preserved than the Utrecht groups. Fairly 269 early, to judge by the style not later than the twenties, and obviously by the same hand as the Utrecht groups, that is by Scorel, this work gives so much variety to the turn of the heads, the direction of the eyes and the individual expressions that it should form the basis for our assessment of the master's portrait painting. Here if anywhere the keen unbiassed power of observation of the Netherlander combines with the dignity and freedom of the Italian High Renaissance. Though they are closer together the men are encompassed by air and each figure stands out fully modelled, thanks mainly to the consistent treatment of the lighting. The members of the company are depicted with a confident glance, a strongly expressive mouth-line, with a natural reverence, varied according to the character and temperament of the individual.

The heads are given in half-profile and for the most part are so strongly illumined that the far side of the face is profiled as a light patch against the dark background, but powerfully articulated by broad shadows along the bridge of the nose and on the cheeks. In some parts the shadows are sharply delineated, in others they terminate in softly blurred edges, everywhere lightly poised on the forms.

Generally speaking the pathos in the individual portraits, mainly achieved by the lighting, is less marked than in the group portraits, where the chiaroscuro, whilst holding the members together, also gives emphasis and variety to the monotonous chain of figures.

Of the well-known and often quoted single portraits the one of Agatha van Schoonhoven in Rome, in particular, is an instructive example (by 274 way of exception signed, and dated 1529). The young roguish, lovingly devoted woman is portrayed with an astonishing concentration on the essentials, with a directness that recalls Frans Hals.

Outstanding among several portraits that have only recently come to light is the *Portrait of a Jerusalem Pilgrim* which passed from a private

273 collection in Trier to the Nürnberg collector R. Chillingworth.[1] To judge by the costume and the hat with the broad brim, the portrait must date from shortly after 1520. Eyes and eloquent gesture point with restrained yearning into the distance so that the background landscape with its outlandish buildings seems more than a superficial addition. The *Portrait*
272 *of a Man* in the Berlin museum achieves even greater harmony and delicacy of expression, in this instance one of solicitous devotion; on the reverse is a statuesque figure of *Lucretia*. We have here one half of a diptych the other half of which was a panel with the Virgin. Lucretia, to be sure, is a strange adjunct to a Madonna.

 Other portraits just as certainly by Scorel are at Turin, in the collec-
281, 282 tion of the Earl of Pembroke,[2] privately owned at Wiesbaden,[2] on the Berlin art market; further there is a *Portrait of a Child* at Bergamo and one
271 at Rotterdam, the former a mischievous boy, the latter a well-behaved model schoolboy, and the *Man with the Dog*,[2] where empty arrogance is drastically expressed, in Cologne.

 Scorel's art made a powerful impression throughout Holland and can be traced in three strong currents in Amsterdam. In the portraits of Dirk Jacobsz, who was a son of his old teacher Jacob Cornelisz, we find a willing acceptance of the Utrecht master's influence. Marten van
277–278 Heemskerck's excited extravagances have their origin in Scorel as has the immaculate perfection to which the portrait painting of Anthony Mor aspired. In their earlier works these two pupils are so close to their master that the attribution of certain paintings oscillates from one to another.
276 The *Family Group* in Cassel, for all its daring an intimate depiction of
279–280 domestic happiness, and the *Portraits of Pieter Bicker and his Wife* belonging to Baron Schimmelpenninck[3] (dated 1529?), seem to transcend Scorel's limits in their exuberant vitality. But we must credit the master with great versatility as a portraitist. And taking everything into consideration I should prefer to regard him as the author rather than Heemskerck with his arbitrary bravura and superficial greatness, just as I am inclined to credit him, rather than Anthony Mor, with the group portrait of the five *Jerusalem Pilgrims* in Utrecht.

[1] Now in the Museum of the Cranbrook Academy of Arts, Bloomfield Hills, Michigan.

[2] These portraits are now attributed by Friedländer and other scholars to Jan Cornelisz Vermeyen, an artist whose *œuvre* has been assembled only quite recently. That from Wiesbaden, a portrait of Erard de la Marck, Bishop of Liège, is now in the Rijksmuseum, Amsterdam.

[3] They are now in the Rijksmuseum, Amsterdam. The completely different character of a portrait by Scorel, also dated 1529, which came to light only after 1935, led Friedländer later to express even greater doubts as to Scorel's authorship, and to consider the attribution to Heemskerck rather favourably. See Friedländer, *Die Altniederländische Malerei*, XIV, 1937, p. 129.

PIETER BRUEGEL

IN every one of Jan van Eyck's works, more, in every part of any work, in every head, every hand, his greatness can be demonstrated. His masterly observation and interpretation is concentrated in each detail and it is in this mastery that his historical importance lies.

In our eagerness to reveal Pieter Bruegel's greatness we should like to line up everything by the master we can lay our hands on—with the uneasy feeling that with every work of his that has perished something of his title to fame has perished too. But our desire to proclaim his worth is all the more intense because not many art lovers have a full idea of the extent and richness of his creative power. The master does not seem to occupy his rightful place in the public mind. It is to be feared that even to mention Jan van Eyck and Bruegel in one breath may sound provocative.

There is more than one painter named Bruegel, Brueghel or Breughel. But the family produced only one great master. And he was the eldest, the founder of the dynasty, Pieter, nicknamed 'Peasant-Bruegel'.

The second Pieter Brueghel was nothing but an imitator and copyist who lived on his father's heritage, whilst Jan, the other son, though more independent, was yet a painter of lesser stature. The elder master spelt his name (with but few exceptions): Bruegel, the sons preferred the spelling Brueghel.

Bruegel is the name of a place. There are two villages of that name, either possible as the birth-place of the painter; both lie east of Antwerp, the one not far from Hertogenbosch, the other further south in the province of Limburg.

The name 'Peeter Brueghels' appears in the Antwerp guild list of 1551. At that time the painter became free master. He died in Brussels in 1569. With the aid of van Mander's account, and a variety of combinations, attempts have been made to complete his biography. Bruegel is alleged to have been a pupil of Pieter Coeck van Alost in Antwerp and to have married his teacher's daughter Maria, whom he had carried in his arms when she was a child. So van Mander relates. Maria, Coeck's daughter, cannot have been born before 1540 or (since she married in 1563) after 1545. If we accept the story that Bruegel carried the child in his arms when he was an apprentice, then the years of his apprenticeship must

have been roughly between 1540 and 1545. If he entered Coeck's work-shop at the customary age, then the year of his birth must lie somewhere between 1528 and 1530.

Bruegel's portrait has survived in engravings and they show him with a dignified and patrician air. If he were born in 1530 he would have been only thirty-nine when he died in 1569. He looks a little older. We will therefore have to push the year of his birth back as far as possible, even further than 1525. Moreover, all conclusions based on his apprenticeship with Coeck are doubtful because van Mander's information cannot be confirmed in any way. Bruegel is not entered as a pupil in the Antwerp guild lists. Perhaps the lists have not come down to us complete. Stylistic criticism brings no manner of confirmation. From the erudite art of Coeck we can span no bridge to Bruegel.[1] From a study of Bruegel's beginnings, or what seem to us beginnings, we might even be tempted to believe that he was never trained by a professional panel painter, least of all by Coeck. Perhaps van Mander only heard that Bruegel had married Coeck's daughter and added the rest himself. But if Bruegel did not serve his apprenticeship with Coeck, and not even in Antwerp, then many possibilities open up and the artist who appears in Antwerp in 1551 could have previously worked as master elsewhere.

Bruegel's relationship to Jerome Bosch is as close as his link with Pieter Coeck is slight. The master of Hertogenbosch, though not Bruegel's master, is certainly his ancestor, in fact his only ancestor with whom he has any affinity—at any rate as far as we can tell from our knowledge of the older art. Bosch died in 1516. At that time Bruegel, even if he was already alive, would scarcely have been old enough to be anyone's pupil. But in view of the fact that the village where he may have been born is not far from Hertogenbosch we can quite well imagine that his first impressions were formed on Bosch's art, that he was apprenticed to a follower of Bosch, and that the affinity is based on a community of race and stock. On the other hand the relationship between the two masters could be explained in a different and more superficial way. During his first years in Antwerp Bruegel worked for the print publisher Jerome Cock. This publisher had had compositions by Bosch reproduced as prints. As a shrewd businessman he may have recognized Bruegel's talent as a designer of didactic and entertaining popular prints and have

[1] Connections between the art of Bruegel and Coeck have been shown to exist by several scholars and last by F. Grossmann, in *Festschrift Kurt Badt zum siebzigsten Geburtstag*, Berlin, 1961, pp. 135 ff., where earlier literature on the subject is also listed, and by G. Marlier, *La Renaissance flamande, Pierre Coeck d'Alost*, Brussels, 1966, *passim*.

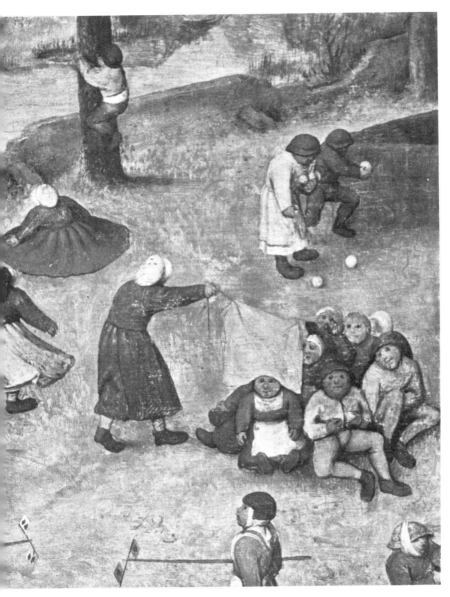

IX. PIETER BRUEGEL: *Children's Games*. Detail. Vienna, Kunsthistorisches Museum

referred him to the example of the great artist then dead, whose composi-
tions he had disseminated so profitably.

Jerome Cock could also have been directly responsible for the direction
his print designer's art took. There has recently come to the Berlin print
room a drawing by Cock with the remarkably early date 1541, a *Land-
scape with St. Jerome*, which, like his etchings, is similar in conception
to Bruegel's landscapes. The drawing, however, is not signed 'Jerome'
but only 'Cock' and could thus be the work of Matthys Cock his brother,
of whom van Mander speaks in very emphatic terms.

The period during which Bruegel became master in Antwerp was a
critical one in the history of Netherlandish art. Painters such as Floris
and Coxie were beginning to dominate the scene. Everything that seems
genuine and fruitful to us today was then merely an undercurrent.
Bruegel does not appear to have been regarded as a great artist by his
contemporaries. His art lacked the grand style, lacked Roman erudition,
in a word everything that made the craftsman painter an artist—the
conception 'artist' only came up at that time. For the older generation
Bruegel's art lacked the careful finish and enamel-like technique, whilst
the younger generation may have frowningly wondered why Bruegel's
visit to Italy had so entirely failed to improve his taste.

Bruegel did visit Italy. Not only does van Mander say: "he travelled
to France and thence to Italy". On certain engravings and drawings
dated 1553 the name of the place is given as *Romae*.

During his lifetime Bruegel's art appealed mainly to the man in the
street and more through the content than through the form. He instructed
the people, delighted and entertained them, a public that enjoyed robust
humour and caricature. With rather unskilled prints after his drawings he
satisfied an uninformed longing for pictures and he drew inspiration from
the eternal sources of popular imagination whilst on a higher level, and
on the surface, Netherlandish painting was being paralysed by Roman-
izing culture.

Bruegel, like so many painters of Germanic origin, was at bottom a
draughtsman and illustrator. He began as a designer for engravings and
trained himself to become an easy and witty story-teller before he began to
paint pictures. In a good as well as in a bad sense the training left its mark
on the design and technique of his paintings. In 1551 he became master,
but the first signed and dated picture known to us is from the year 1558.[1]

* [1] A *Landscape with the Parable of the Sower*, now in the Timken Art Gallery, San Diego, California,
and first mentioned by Friedländer (in *Pantheon*, 1931, p. 58), bears the date 1557 and recently a
Landscape with Christ appearing to the Apostles at the Sea of Tiberias, signed and dated 1553, and

It is possible to separate the period of the drawings: before 1558, from the period of the paintings: 1558 to 1569, the year of his death.

There is one—not quite certain—exception, a picture signed 'Bruegel' and dated 1556. This is the *Operation for the Stone* which was sold with the von Gerhard Collection, Berlin, in 1911.[1] The panel is 29 by 40 inches. Inside a village barber's shop the operation is being performed in varying ways on the heads of the patients. What is related here at length, in a rather wild and clumsy genre manner, was given a symbolic twist by Bosch in his more pointed way (cf. his picture in the Prado). In spite of the evident weaknesses, the signature—P. Bruegel 1556—which is exact in style and spelling, seems to confirm the authenticity of the picture. The large number of surviving copies of the master's pictures do not generally agree with the originals in the style of the signature and in the date. This isolated painting is too slight and too uncertain as a basis for our ideas of Bruegel's painting around 1556.

Bruegel begins as an imitator of Bosch, begins as a draughtsman and —presumably stimulated by the brothers Matthys and Jerome Cock— as a landscape artist. On his journey—c. 1553—he, as a Netherlander, is absorbed by the novelty of Alpine scenery. In Italy he is impressed by landscape and topography but not, as far as we can see, by the art of the Italian High Renaissance.

From 1558 on Bruegel considers himself a painter and overcomes progressively the habits of the illustrator. Paintings, like picture-sheets, overcrowded in content and form, such as the *Proverbs* in Berlin, and the IX *Children's Games* in Vienna, are dated 1559 and 1560; the simple genre pieces, with few large figures and readily intelligible themes, with a uniform spatial composition and pictorially conceived design, such as the 287, 290 *Peasant Wedding* and the *Peasant Dance* in Vienna seem to round off his lifework and to be the goal of his aims. Bruegel's art becomes increasingly free of the influence of Bosch. The contrast, which is a contrast of generations, becomes more pronounced the more Bruegel succeeds in establishing his own easy-going, even humorous interpretation of reality in opposition to the allegorizing and moralizing tendency dictated by the taste of the time and by the publisher.

Much of Bruegel's work has undoubtedly perished, particularly his water colour paintings on fine canvas. Still more would have been destroyed had not Habsburg princes shown an early taste for the peasant

accepted by Friedländer as an original work of the master, has been published by Ch. de Tolnay in *The Burlington Magazine*, XCVII, 1955, pp. 239 ff.

*[1] Later in the Tomcsányi Collection, Budapest. See also p. 139 note 5.

painter. Just as Philip II loved Bosch's inventions with their significance and mystery, so Rudolph II and Archduke Leopold Wilhelm delighted in Bruegel's work. It is to this interest, remarkable as a historical and psychological phenomenon, that we owe the preservation of a substantial part of Bruegel's *oeuvre*. Netherlandish robustness, directness and honesty acted as a counterfoil to the religious discipline and to the rigours of Spanish court etiquette. Bruegel's pictures may have, to some extent, replaced the court jester.

Almost half the surviving works by the master—if we take the quality into consideration more than half—are in the Vienna museum. In Vienna, there are fifteen pictures by his hand in the gallery, and one privately owned,[1] four in Brussels,[2] one in Berlin,[3] one in the Louvre, none in England, as far as I can see (I do not believe that the Northwick Park picture is genuine),[4] one privately owned in Hungary,[5] one in Copenhagen,[6] two in Munich, two in Naples, two privately owned in Antwerp, one in the Prado, one in the Darmstadt museum, one in the Lobkowitz collection at Raudnitz,[7] one in Montpellier[8]—that makes in all thirty-four originals.[9] I regard all the rest as doubtful.

283-293

The Vienna collections give a full picture of Bruegel's art. There we find landscapes, biblical subjects and genre-like pieces. The categories cannot be clearly segregated. A biblical content is infused into the landscape and all human activities are conceived as genre. Innumerable figures, a whole world, adventure, picturesque scenes, gaiety and edification, an endless spectacle unfolds, entertaining for the simple observer, a miracle for one who is following the course of Netherlandish art.

Convention and tradition are overcome. Nothing remains of the mood of the early Netherlandish devotional panel which was fashioned bit by

*[1] This picture, *The Adoration of the Kings*, is now in the National Gallery, London.
*[2] In addition to the four paintings in the Royal Museum, there is now one in a private collection in Brussels.
*[3] The Berlin museum now owns two paintings by Bruegel.
*[4] The Northwick Park picture, which Friedländer admitted to the list of autograph works in *Die Altniederländische Malerei*, XIV, 1937, p. 60, is now in the Musée Municipal, Brussels. From the 1937 list three are now in England; to these must be added two undoubted originals, now in the collection of Count Antoine Seilern, London, which have come to light since 1937.
*[5] There is now one painting by Bruegel in the Museum of Fine Arts, Budapest. The *Operation for the Stone*, the authenticity of which appeared highly doubtful to Friedländer in 1937, was last heard of in the Tomcsányi Collection, Budapest.
*[6] Two according to Friedländer's list of 1937.
*[7] This picture is now in the National Gallery, Prague.
*[8] No longer regarded as a work of Bruegel by Friedländer or any other authority.
*[9] Friedländer's list of 1937 contains fifty paintings. It is made up of the works referred to in the text and in the preceding notes and of ten more, which are now in Rome (one), Holland (three), Switzerland (two), and U.S.A. (four); it should, however, be added, that several of the works accepted by Friedländer as autograph have been doubted by other scholars.

bit from the model; nothing is left of the lingering observation in which figures and groups were isolated and observed details of nature pieced together in wondrous manner. Nor do Italian compositional laws prevail. Bruegel is free of Romanist ambitions, more so than any other painter of his day, he seems to be consciously opposed to the aims of his contemporaries and compatriots.

There was in Bruegel, in addition to his delight in direct observation of nature, in addition to his bent for story-telling, also defiant craving for novelty. Suspicious of every formula, of all ceremonial, estranged from the old gods, inimical to the new ones, the master liked nothing better than to peer ever closer into what was sacred, until the human and commonplace core was exposed, or to move ever farther away from greatness until it became insignificant and void. He was for ever seeking a new angle, a new side, a wider vantage point.

The master's eloquence was continually in flux. He never repeated himself. Compelled by the overflowing richness of his own ideas he had no time to work out the details. Everything drove him to haste, the manner of his illustration, the fire of his personality, the perpetual urge to show something new. He became an impressionist as a result of his own temperament and produced a style that satisfied the rhythm of his own nature.

His ability to grasp movement is obvious, his inventive imagination is so rich that amongst a thousand figures no two appear in the same attitude. Compared with Bruegel's people, the creatures produced by those artists who have on occasion been mentioned as his predecessors— such as Lucas van Leyden, Pieter Aertsen, Hemessen and even Bosch— seem, for all their would-be animation, feeble, monotonous, rigid, posing.

If we do compare Bruegel's eye with the photographic lens then we must not forget to add that Bruegel always seized the critical moment in the movement whereas it is just this moment that the camera rarely captures and then only by chance. No observation, however keen, however patient, could give this ability; it was the result of a brilliantly intuitive understanding of the functioning of the human body.

When representing the human form, older artists started with the straight and upright figure, with a fundamental idea based more on knowledge than on observation. Attempts were made, more or less successfully with the aid of particular studies from nature, to enrich the norm by a displacement, a foreshortening, an inclination, a turn. Bruegel, on the other hand, never seems to apply foreshortening to an ideal figure, but begins with the action, and from one particular angle seizes the ever-

changing contour as a whole. Therein lies the secret of the manifold
variety of movement, of his ability to make the activity and motive power
of his people convincing.

Working in the spirit of the Italian Renaissance, the Netherlandish
artists of the sixteenth century started out with the nude figure. Clothing
was arranged on the framework of the body, revealing or concealing, and
subordinated to it. For Bruegel no such dualism exists. Body and dress
casually associated, are seen as an entity.

Bruegel's figures generally appear squat, seen from above in fore-
shortening, broad and clumsy yet agile, coiled together, in endless
diversity of outlines not one of which in any way recalls the academical
basis: the erect nude figure, the proud beauty of the upright body.

He is a pioneer in the boldness with which he overlooks the details, in
the way he visualizes the relationship of the parts to one another. He
abandons the traditional Netherlandish detailed and exhaustive drawing,
modelling and characterization of texture. His origins as a draughtsman,
his black and white graphic phase, may have fostered this indifference to
detail. The vital thing is his eye for the whole. The forms are firmly
contoured. The master is not even afraid to give a linear emphasis to the
outlines so as to enhance the expression. This solidity in the drawing
combined with a primitive and positive use of local colours lends his
pictures a superficial archaism and a popular robustness. By weakening
the modelling he intensifies the effect of the silhouette. Bruegel does not
introduce original motifs into traditional compositional schemata but
aims rather at an overall originality in the design of the pictorial theme.

In the art of the fifteenth century if the human beings are large the
landscape is small. The human being is in the centre of interest, in the fore-
ground. Everything else is purely accessory, a mere filling for the space
and the ground. Landscape remains of lesser importance even when at the
beginning of the sixteenth century, it commences to form the content
of a new art category. Bruegel reverses the relationship, and here too he
proceeds to the limit. Like a pantheist who delights in ever new visions, he
seems to mock at the anthropocentric outlook. He gives to the landscape
what he takes away from man. Whilst reducing the human being to ant-
like unimportance he swells the landscape to gigantic stature. There is
width and depth in his landscapes which, despite some fantastic details,
are organically constructed after nature, or rather in the spirit of nature.
When he crossed the Alps on his journey to Italy Bruegel may have been
so deeply impressed with their grandeur that his eye rejected the normal
standards. Carel van Mander does not express himself at all badly when

he remarks "at that time the master swallowed the mountains and rocks of the Alps and later spat them out in his pictures."

Admittedly, the landscape painters of the sixteenth century who worked as specialists in this field—Bruegel was certainly no specialist—loved the picturesque richness of the high mountains but they fashioned greatness with poverty of spirit. Their piled-up masses and exaggerations lack the impetuosity of Bruegel's creations. Their steep and jagged rocks extend and rise monotonously parallel to the picture plane, whereas Bruegel drives his formations diagonally into the depths and opens up astonishing vistas.

In as far as Patenier and his followers were able at all to express mood in landscape they were absorbed in the idyllic spirit of mid-summer. Bruegel, on the other hand, perceives the spirit of every season and in his pictures expresses the turbulence of early spring as well as the steely clarity of winter. Landscape for him is more than just something to be looked at. Nature reveals herself to him in all her changing relationship to humanity, now harsh and inhospitable, now richly bountiful, but always dominant and all-embracing.

Genre motifs had begun to twine round the stem of religious art even in the Middle Ages. Painters in the fifteenth century were already solving specifically genre problems and at the beginning of the sixteenth century there were already specialists in the field of genre painting. But it was long before the true spirit of genre emerged freely. Peasant Bruegel was the first successfully to eliminate the lingering echo of religious devotion, the expression of solemn gravity in the heads and gestures. He was the first to observe the daily round of human activity with unprejudiced honesty, with humour but without mockery or distortion and without bias. Even in Bosch's art mankind, if not striving towards Heaven, is at least heading for Hell.

The reader who has followed these remarks may well ask what exactly was left for the painters of the seventeenth century to achieve since their predecessor had penetrated victoriously so far.

Bruegel, compared with, say, Brouwer, is more a draughtsman than a painter. In his ever-present endeavour to outline the action, to seize and define the passing movement, he lays no great weight on the subtleties of line or colour. He is more interested in the physical than in the psychological side, in the type rather than in the individual. The comical, sly peasant heads with large round eyes are not individualized as portraits. But as Bruegel avoids large-scale figures the generalized emptiness of the heads does not disturb us unduly. And the irresistible momentum of the

whole leaves the onlooker no time to criticize the details. Bruegel's interest did not lie in a penetrating study of human individuality. He is almost the only great Netherlandish artist whose *oeuvre* does not include portraiture.

Despite all imperfections—the newly conquered territory was too vast for the conquerer to dominate it completely—Bruegel is one of the great ones in the historic sequence. And to place him alongside Jan van Eyck and Rembrandt is to emphasize what is essential in the course of Netherlandish painting.

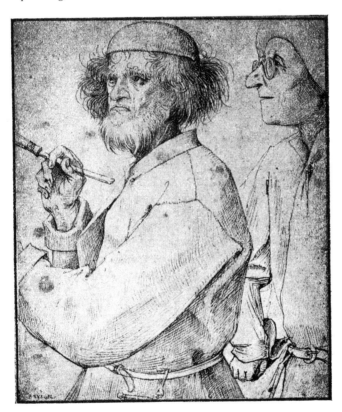

PIETER BRUEGEL: The Painter and the Connoisseur. Drawing, about 1568.
Vienna, Albertina

THE PLATES

THE FIFTEENTH CENTURY

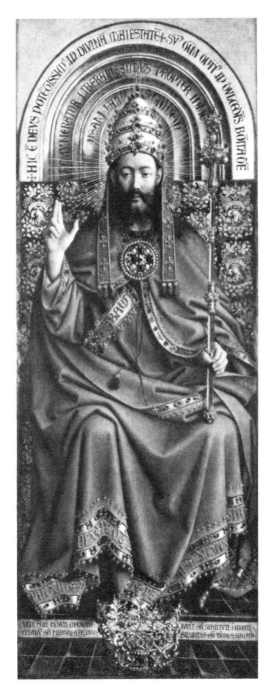

1. VAN EYCK: *God the Father*. Detail from the Ghent altarpiece (plate 2)

2. Van Eyck: *The Ghent altarpiece* (open). Ghent, St. Bavo

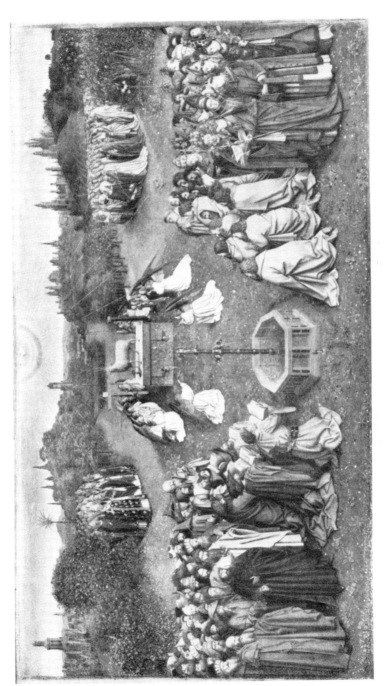

3. Van Eyck: *The Adoration of the Lamb.* Detail from plate 2

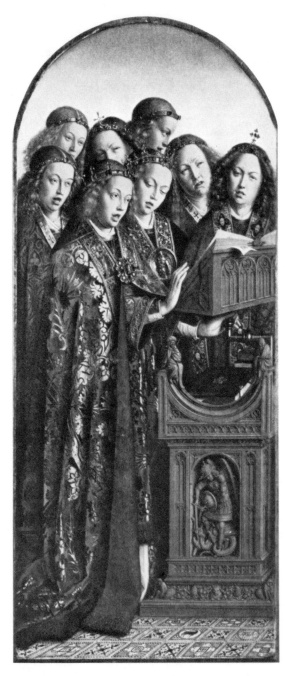

4. Van Eyck: *Singing Angels*. Detail from plate 2

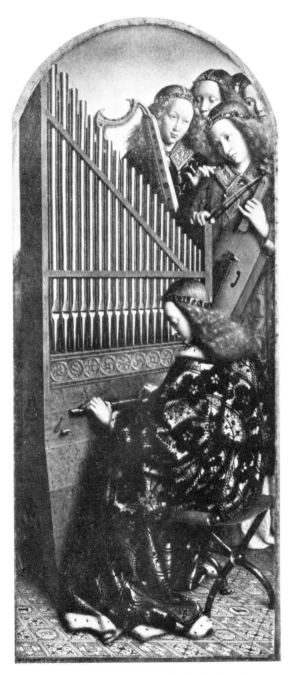

5. VAN EYCK: *Angels making Music*. Detail from plate 2

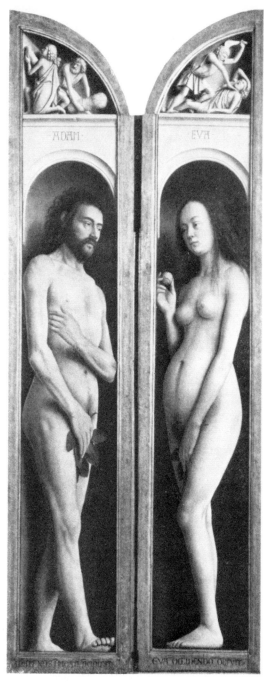

6. Van Eyck: *Adam and Eve*. Detail from plate 2

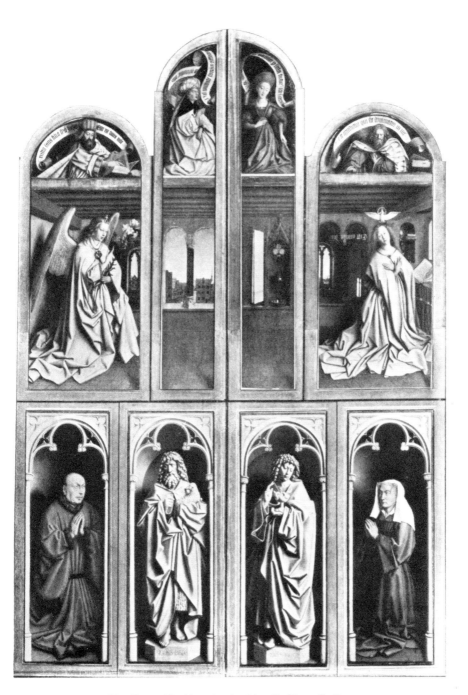

7. VAN EYCK: *The Ghent altarpiece* (closed). Ghent, St. Bavo

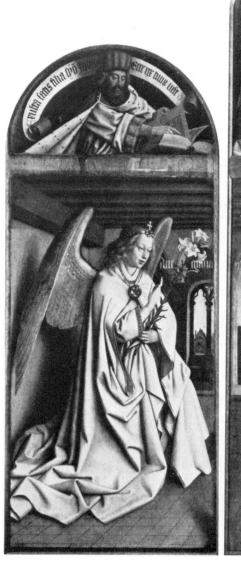

8a. VAN EYCK: *The Angel of the Annunciation.* In the lunette: *The Prophet Zechariah.*
Detail from plate 7

8b. VAN EYCK: *The Virgin Annunciate*. In the lunette: *The Prophet Micah*.
Detail from plate 7

9. VAN EYCK: *St. John the Baptist and St. John the Evangelist*. Detail from plate 7

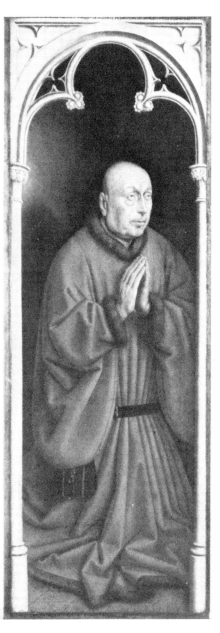
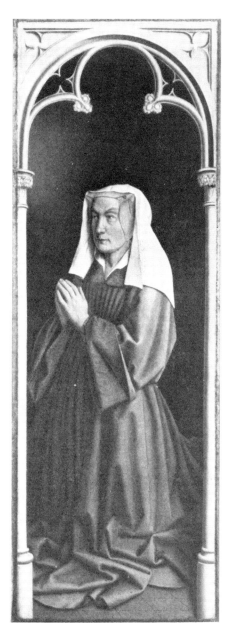

10. VAN EYCK: *Jodocus Vyd* and *Isabella Borluut*. Detail from plate 7

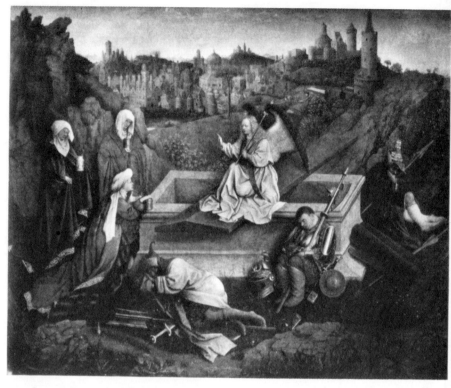

11. Jan van Eyck: *The Three Marys at the Sepulchre*. Rotterdam, Museum Boymans-Van Beuningen

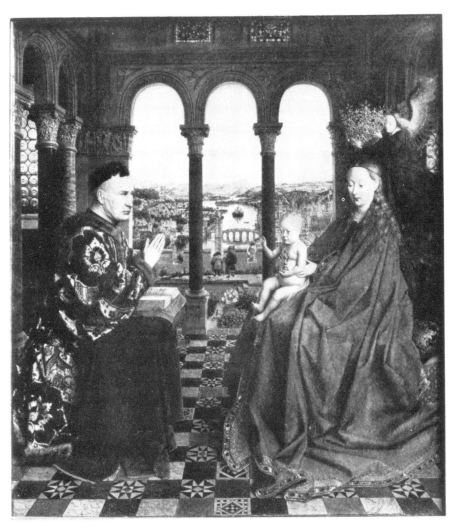

12. JAN VAN EYCK: *Virgin and Child with the Chancellor Rolin*. Paris, Louvre

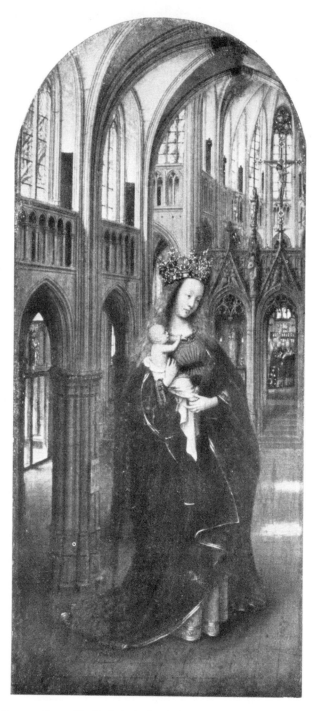

13. Jan van Eyck: *The Virgin in the Church*. Berlin-Dahlem, Staatliche Museen

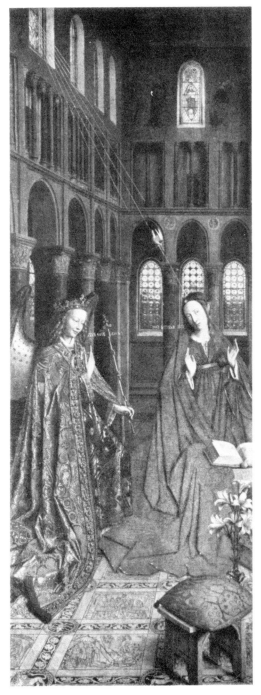

14. JAN VAN EYCK: *The Annunciation.*
Washington, National Gallery of Art (Mellon Collection)

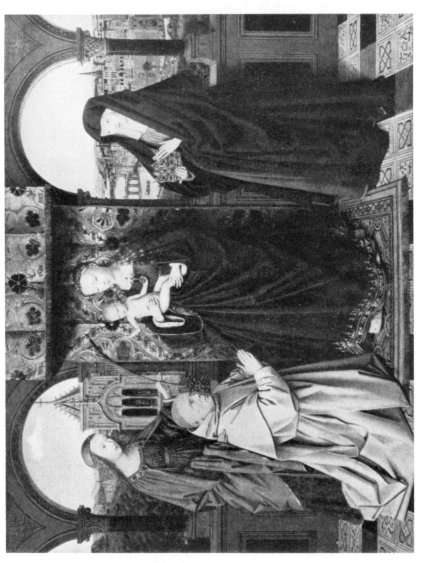

15. JAN VAN EYCK: *Virgin and Child with St. Barbara, St. Elizabeth of Hungary and a Carthusian.* New York, Frick Collection

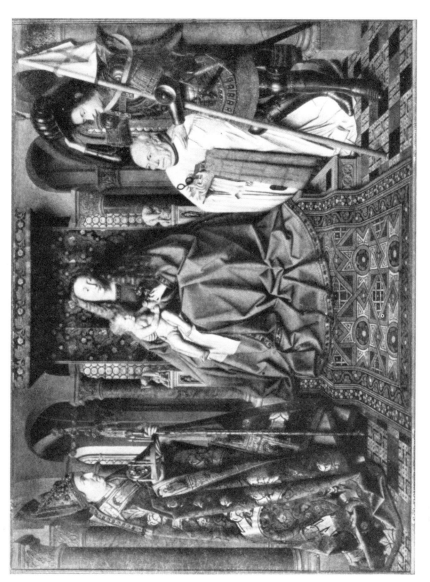

16. JAN VAN EYCK: *Virgin and Child with St. Donatian, St. George and Canon van der Paele.* Bruges, Museum

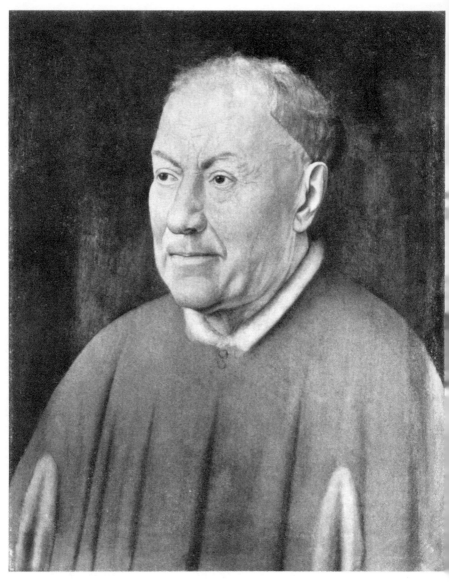

17. Jan van Eyck: *'Cardinal Niccolò Albergati'*. Vienna, Kunsthistorisches Museum

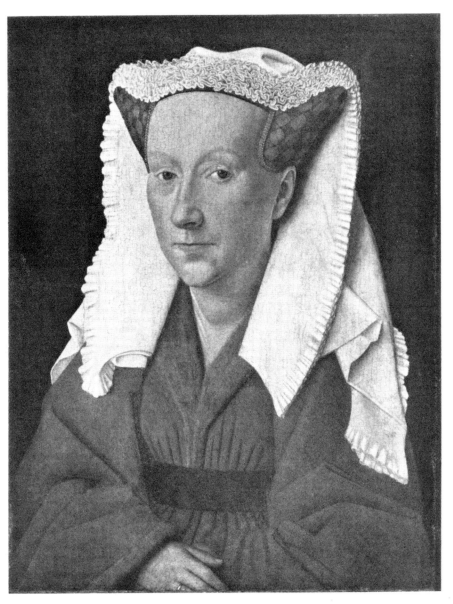

18. Jan van Eyck: *Margaret, the Painter's Wife*. Bruges, Museum

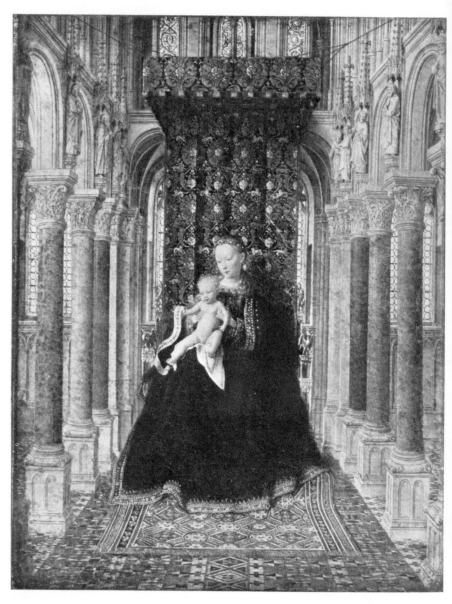

19. JAN VAN EYCK: *Virgin and Child*. Centre panel of a triptych. Dresden, Gallery

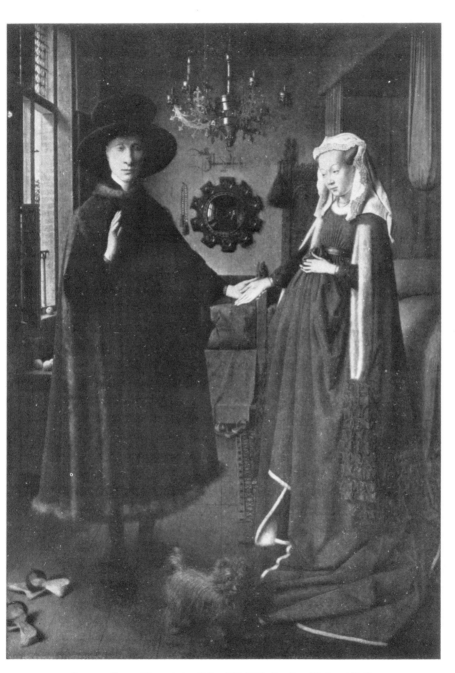

20. JAN VAN EYCK: *Giovanni Arnolfini and his Wife*. London, National Gallery

21. JAN VAN EYCK: *St. Barbara*. Brush drawing. Antwerp, Museum

e uentic matus mer uocauic me dns
nomine mco. et posuit os men siait
gladium acutum sub tegumento
manus sue protexit me posuit me

22. Turin Book of Hours: *The Birth of St. John the Baptist.* Miniature. Turin, Museo Civico

23. Turin Book of Hours: *The Voyage of St. Julian.* Miniature, destroyed by fire

24. Jan van Eyck: *The Stigmatization of St. Francis.*
Philadelphia, John G. Johnson Collection

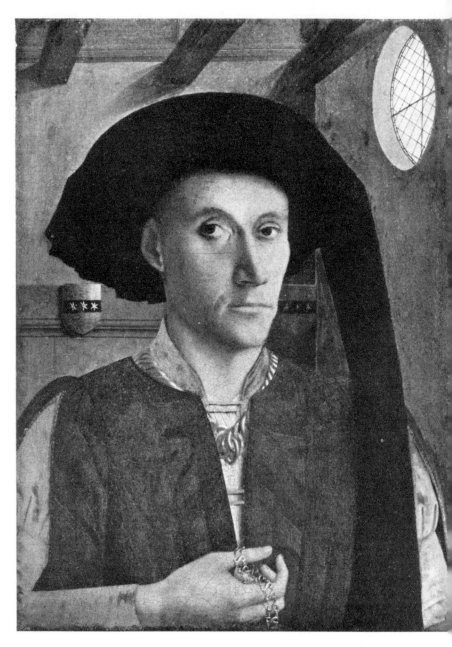

25. PETRUS CHRISTUS: *Edward Grimston*. London, National Gallery
On loan from the Earl of Verulam

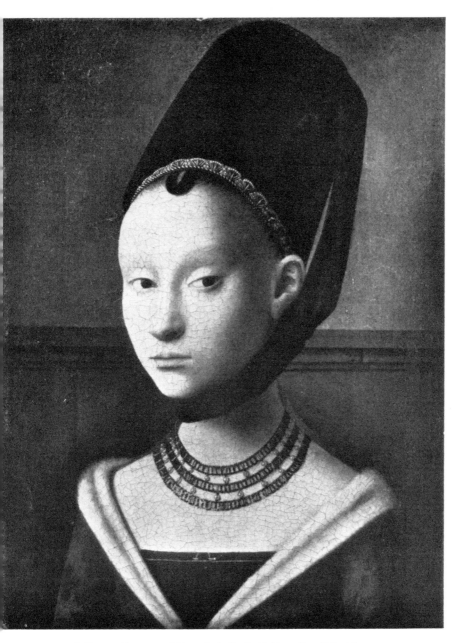

26. PETRUS CHRISTUS: *A Young Lady*. Berlin-Dahlem, Staatliche Museen

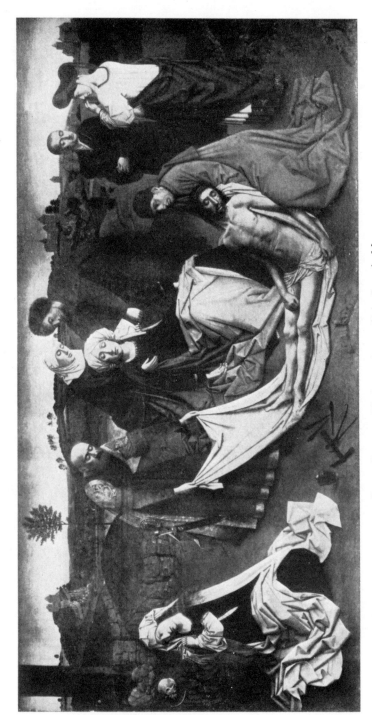

27. Petrus Christus: *The Lamentation over Christ.* Brussels, Museum

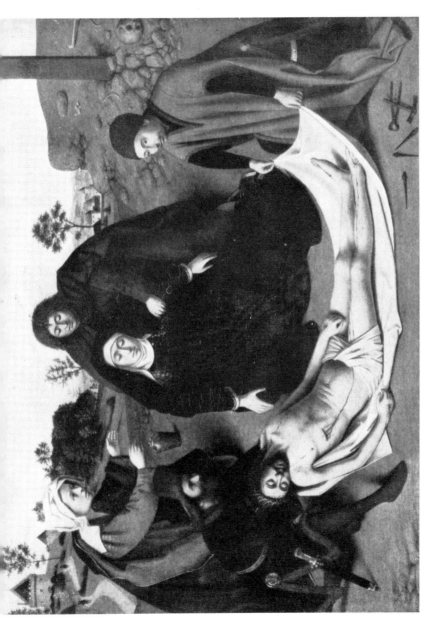

28. Petrus Christus: *The Lamentation over Christ.* New York, Metropolitan Museum of Art

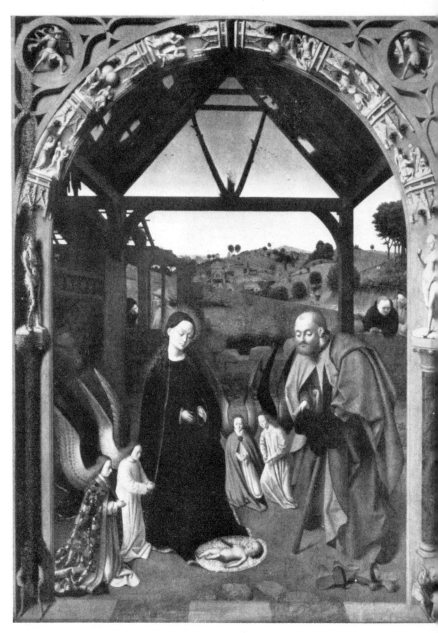

29. PETRUS CHRISTUS: *The Nativity*. Washington, National Gallery of Art (Mellon Collection)

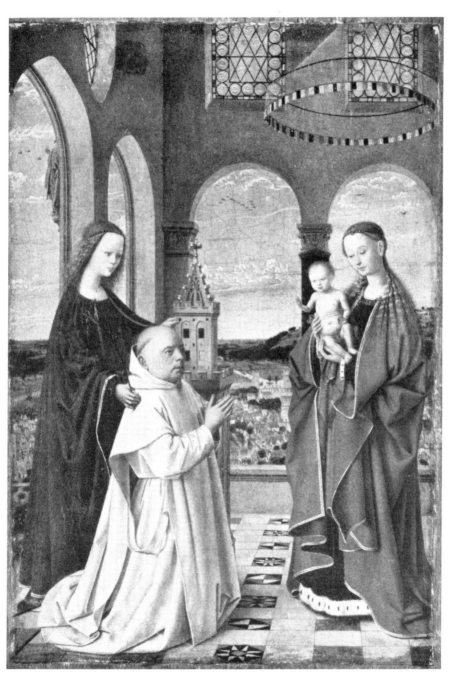

PETRUS CHRISTUS: *Virgin and Child with St. Barbara and a Carthusian.* Berlin-Dahlem, Staatliche Museen

31. PETRUS CHRISTUS: *A Carthusian*. New York, Metropolitan Museum of Art

32. Petrus Christus: *St. Eligius weighing the Wedding Rings of a Bridal Couple.*
New York, Robert Lehman Collection

33. Master of Flémalle: *The Annunciation.* On the wings: *St. Joseph and two Donors.* Known as the Inghelbrecht altarpiece. New York, Metropolitan Museum of Art

34. Master of Flémalle: *The Betrothal of the Virgin*. Madrid, Prado

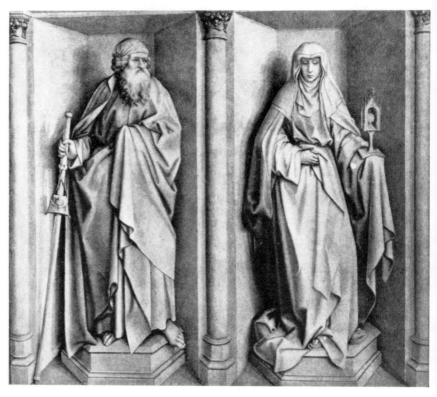

35. MASTER OF FLÉMALLE: *St. James the Greater and St. Clare*. Reverse of plate 34

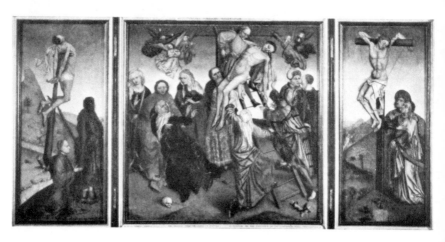

36. COPY AFTER THE MASTER OF FLÉMALLE: *The Descent from the Cross*. Liverpool, Walker Art Gallery

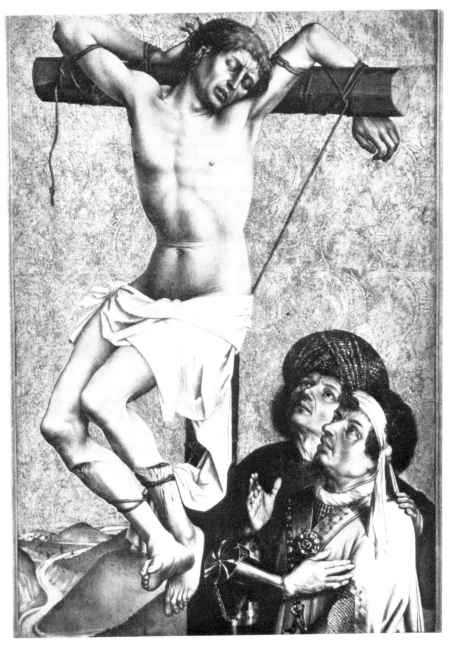

37. MASTER OF FLÉMALLE: *Thief on the Cross*. Frankfurt, Staedel Institute

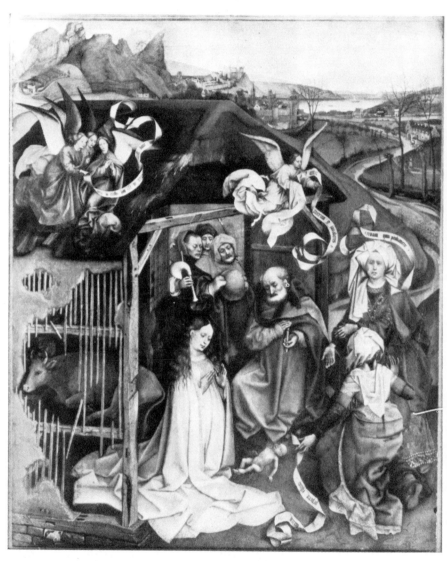

38. MASTER OF FLÉMALLE: *The Nativity*. Dijon, Museum

39. MASTER OF FLÉMALLE: *The Holy Trinity*. Frankfurt, Staedel Institute

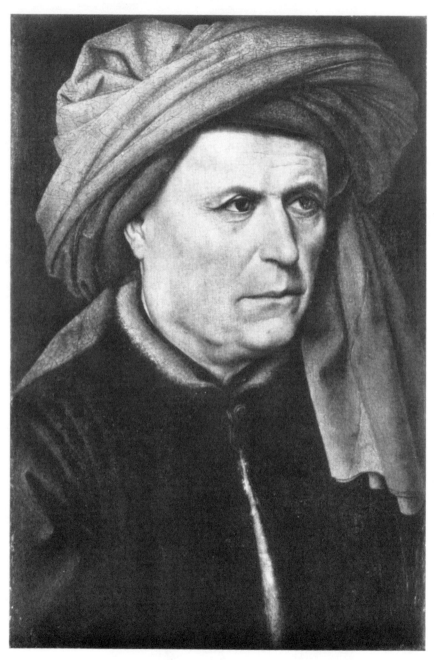

40. Master of Flémalle: *A Man*. London, National Gallery

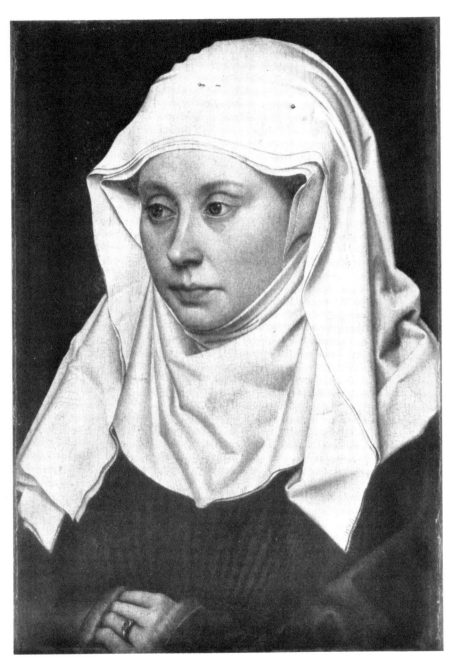

41. MASTER OF FLÉMALLE: *A Woman*. London, National Gallery

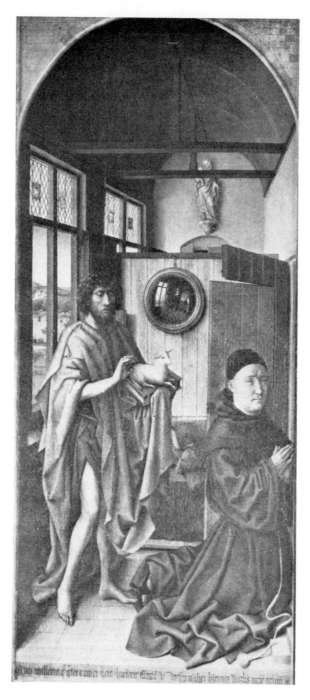

42. MASTER OF FLÉMALLE: *St. John the Baptist and Heinrich Werl*. Madrid, Prado

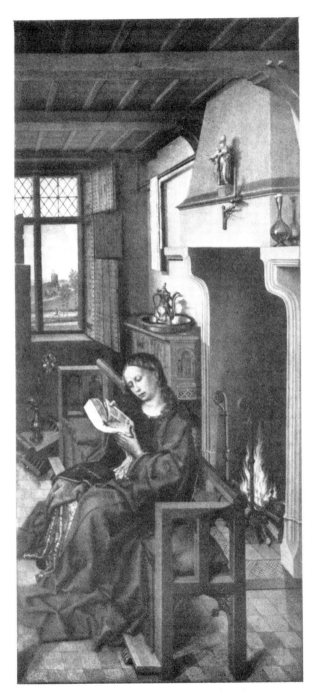

43. MASTER OF FLÉMALLE: *St. Barbara*. Madrid, Prado

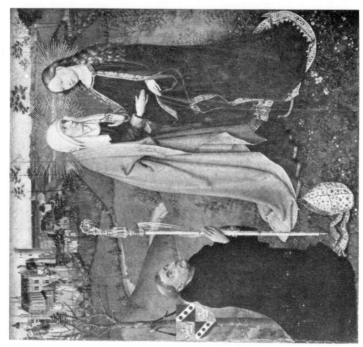

45. Jaques Daret: *The Visitation, with a Donor.*
Berlin-Dahlem, Staatliche Museen

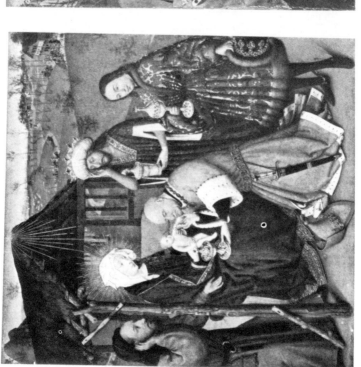

44. Jaques Daret: *The Adoration of the Kings.*
Berlin-Dahlem, Staatliche Museen

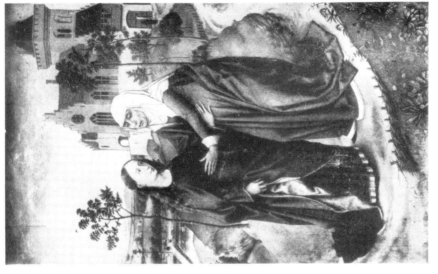

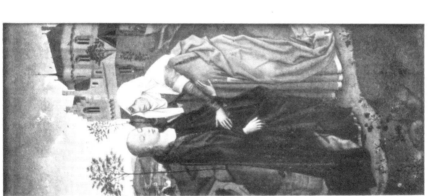

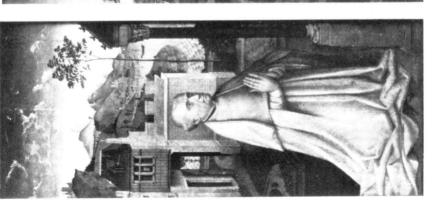

46. ROGIER VAN DER WEYDEN: *The Visitation and a Donor*. Turin, Pinacoteca

47. ROGIER VAN DER WEYDEN: *The Visitation*. Leipzig, Museum

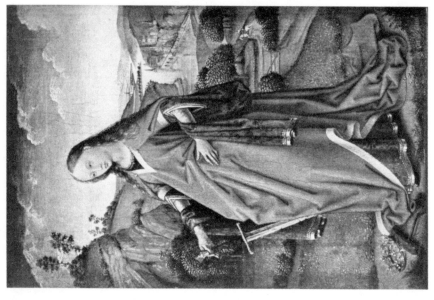

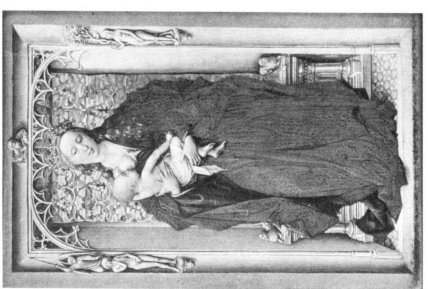

48. ROGIER VAN DER WEYDEN: *Virgin and Child*; *St. Catherine*. Vienna, Kunsthistorisches Museum

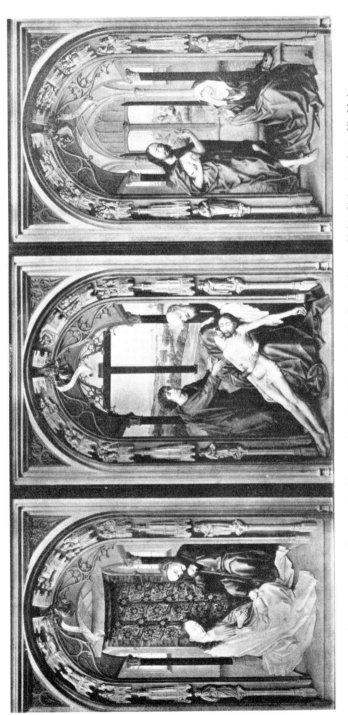

49. ROGIER VAN DER WEYDEN (workshop replica): *The Holy Family; The Lamentation over Christ; Christ appearing to His Mother.* Known as the Miraflores altarpiece. Berlin-Dahlem, Staatliche Museen

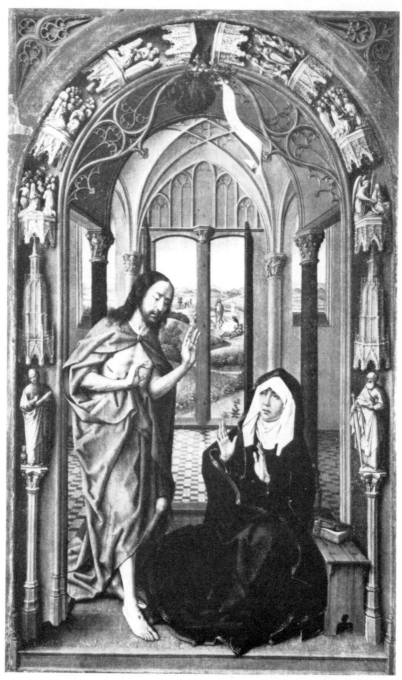

50. Rogier van der Weyden: *Christ appearing to His Mother*. New York, Metropolitan Museum of Art

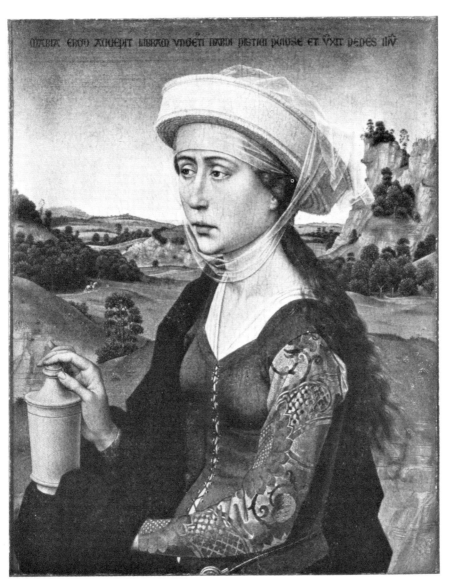

51. Rogier van der Weyden: *St. Mary Magdalen*. Wing of the Braque triptych. Paris, Louvre

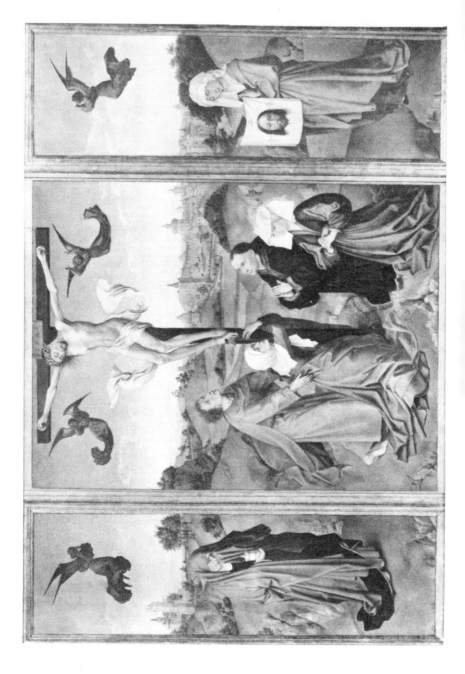

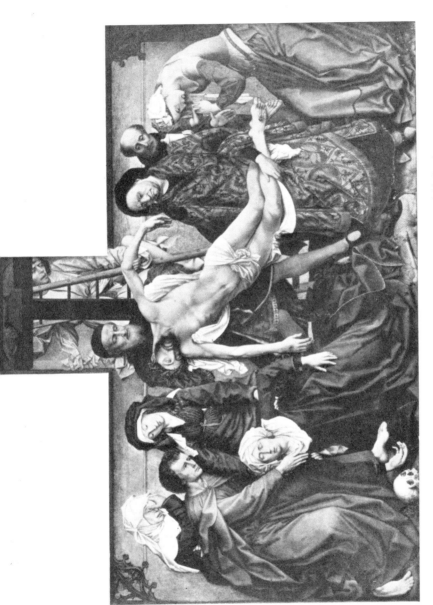

53. Rogier van der Weyden: *The Descent from the Cross.* Madrid, Prado

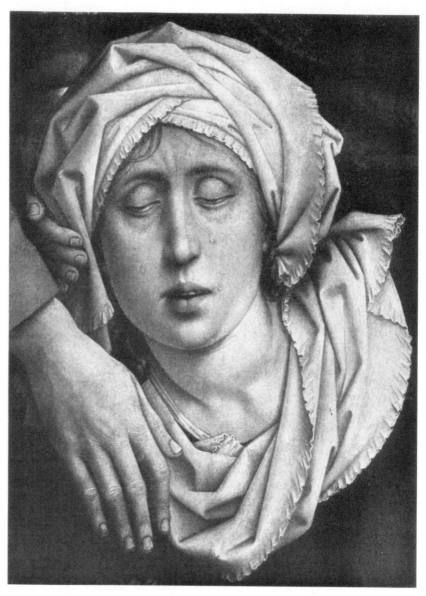

54. *The Virgin*. Detail from plate 53

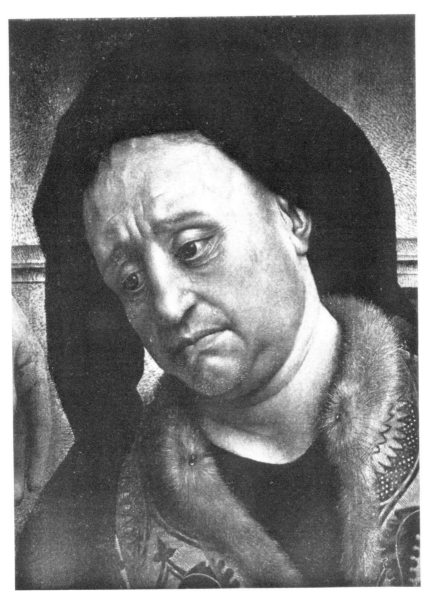

55. *Nicodemus*. Detail from plate 53

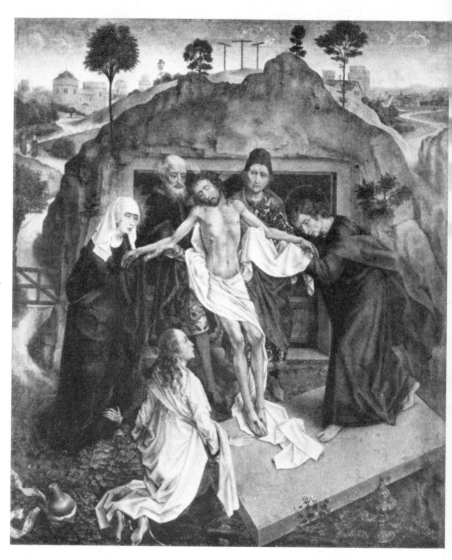

56. ROGIER VAN DER WEYDEN: *The Entombment*. Florence, Uffizi

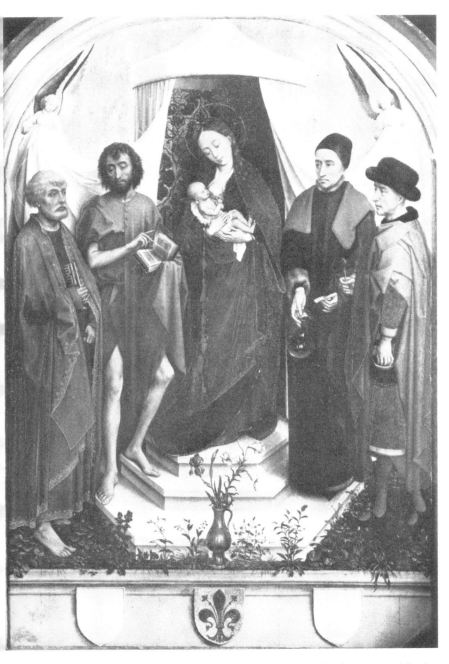

57. Rogier van der Weyden: *Virgin and Child with Saints Peter, John the Baptist, Cosmas and Damian.*
Frankfurt, Staedel Institute

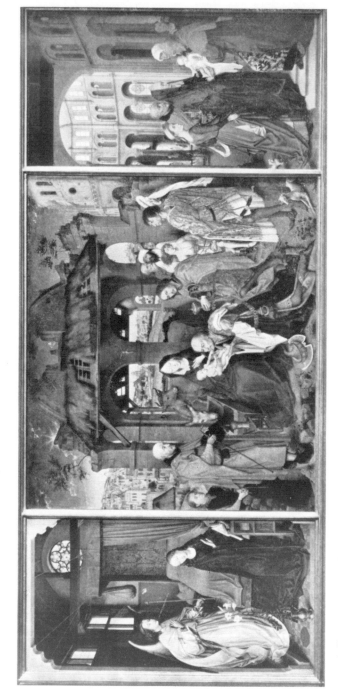

58. ROGIER VAN DER WEYDEN: *The Annunciation; The Adoration of the Kings; The Presentation in the Temple.* Known as the Columba altarpiece. Munich, Alte Pinakothek

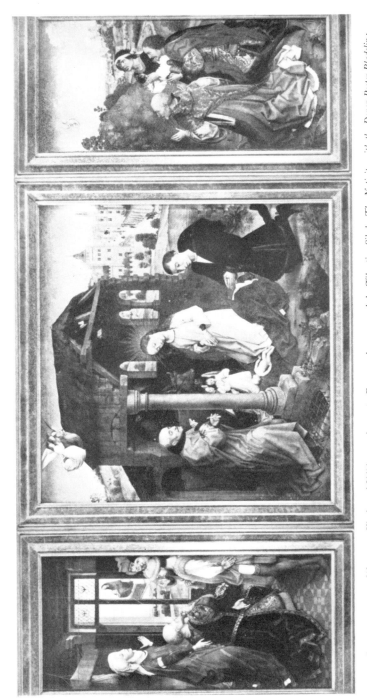

59. ROGIER VAN DER WEYDEN: *Virgin and Child appearing to the Emperor Augustus and the Tiburtine Sibyl; The Nativity with the Donor Peeter Bladelin; The Star of Bethlehem appearing to the Kings.* Berlin-Dahlem, Staatliche Museen

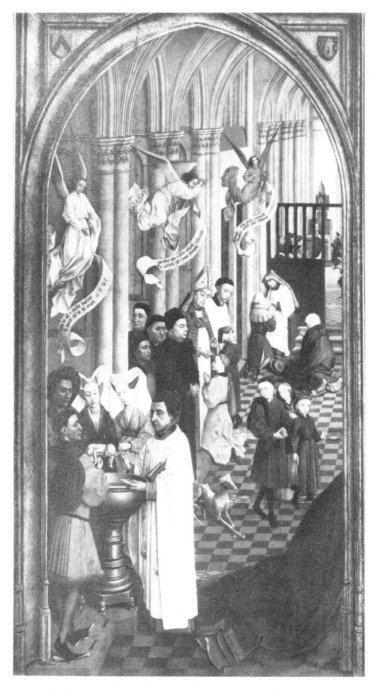

60. ROGIER VAN DER WEYDEN: *Baptism, Confirmation and Confession.*
From the altarpiece of the Sacraments. Antwerp, Museum

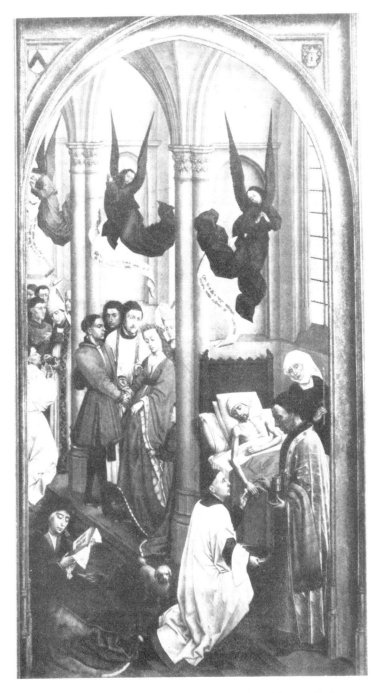

61. Rogier van der Weyden: *Marriage, Ordination and Extreme Unction.*
From the altarpiece of the Sacraments. Antwerp, Museum

62. Rogier van der Weyden: *The Last Judgement*. Beaune, Hôtel-Dieu

63. *Damned Souls.* Detail from plate 62

64. *The Last Judgement*. Detail from plate 62

65. ROGIER VAN DER WEYDEN: *St. Luke painting the Virgin*. Boston, Museum of Fine Arts

66. Rogier van der Weyden: *Virgin and Child*. Caen, Museum

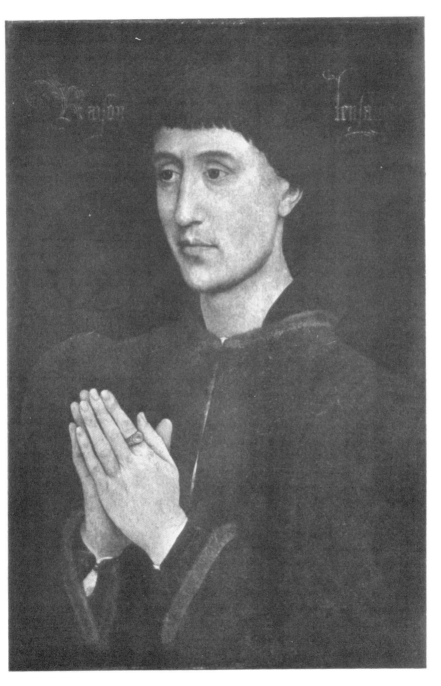

67. ROGIER VAN DER WEYDEN: *Laurent Froimont*. Brussels, Museum

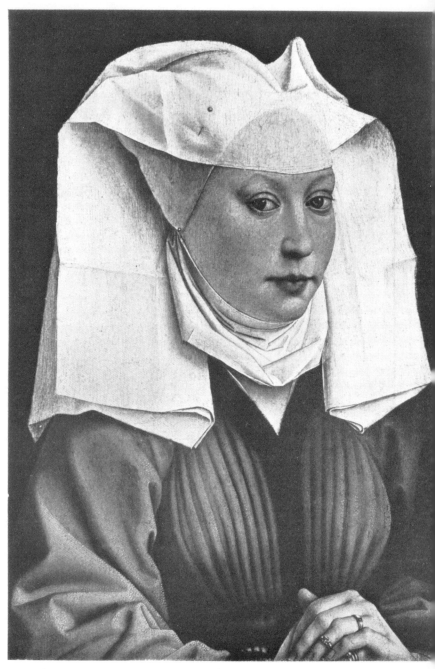

68. Rogier van der Weyden: *A Young Woman*. Berlin-Dahlem, Staatliche Museen

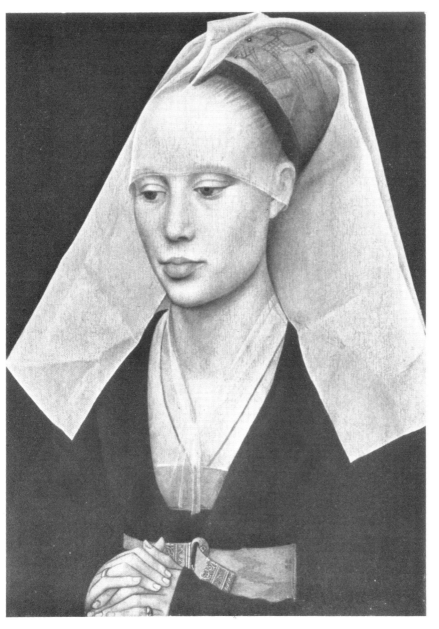

69. Rogier van der Weyden: *A Lady*. Washington, National Gallery of Art (Mellon Collection)

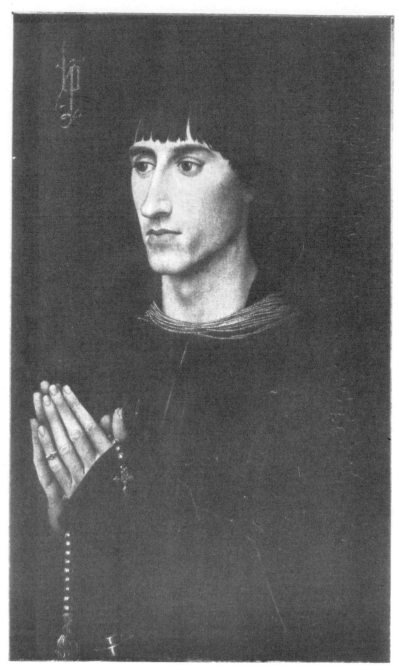

70. ROGIER VAN DER WEYDEN: *Philippe de Croy*. Antwerp, Museum

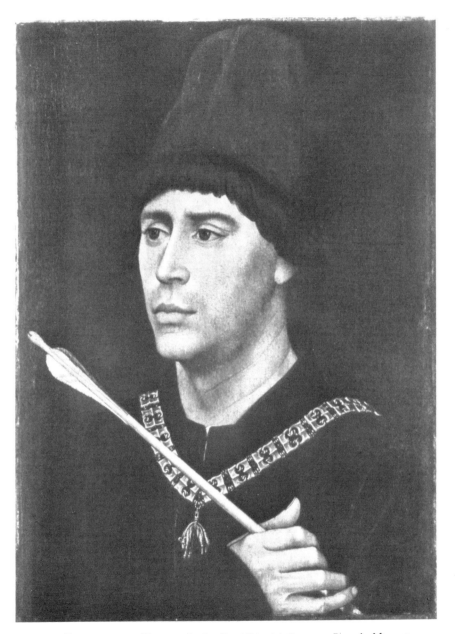

71. ROGIER VAN DER WEYDEN: *Antoine, Grand Bâtard de Bourgogne*. Brussels, Museum

72. DIERIC BOUTS: *The Annunciation.* Madrid, Prado

73. DIERIC BOUTS: *The Visitation.* Madrid, Prado

75. DIERIC BOUTS: *The Adoration of the Kings*. Madrid, Prado

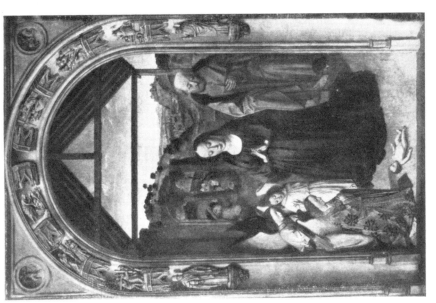

74. DIERIC BOUTS: *The Nativity*. Madrid, Prado

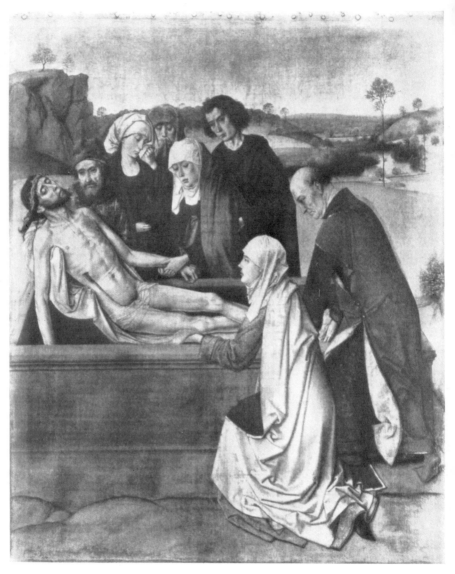

76. Dieric Bouts: *The Entombment*. London, National Gallery

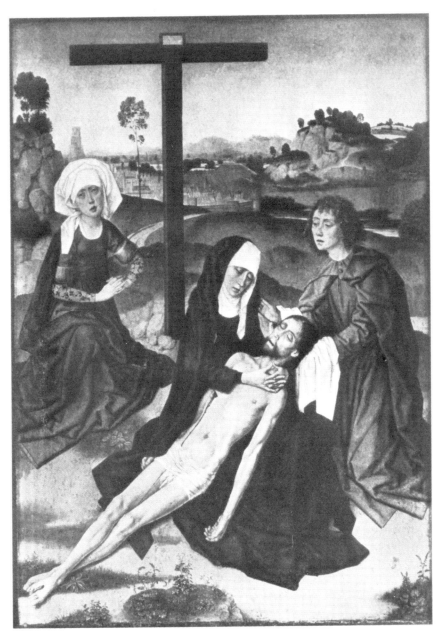

77. DIERIC BOUTS: *The Lamentation over Christ*. Paris, Louvre

78. DIERIC BOUTS: *The Justice of Emperor Otto*. Brussels, Museum

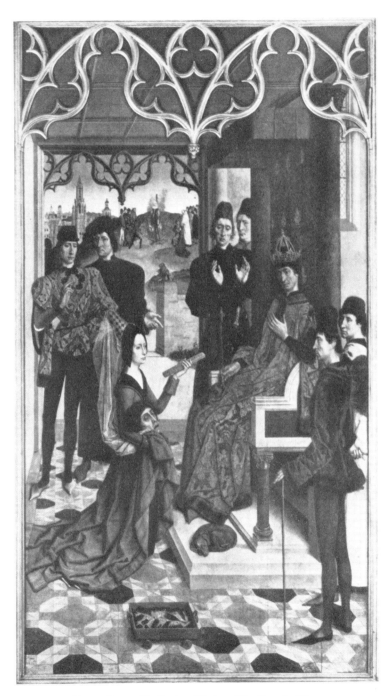

79. Dieric Bouts: *The Justice of Emperor Otto*. Brussels, Museum

80. DIERIC BOUTS: *St. John the Baptist*; *The Adoration of the Kings*; *St. Christopher*. Altarpiece known as the 'Pearl of Brabant' Munich, Alte Pinakothek

81. Dieric Bouts: *The Altarpiece of the Sacrament.* Louvain, S. Pierre

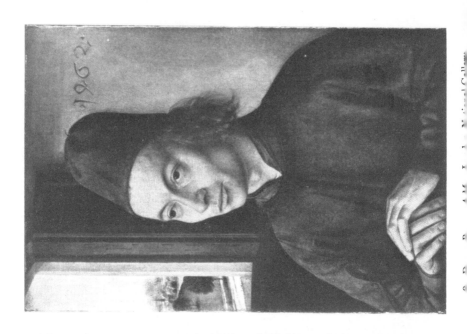

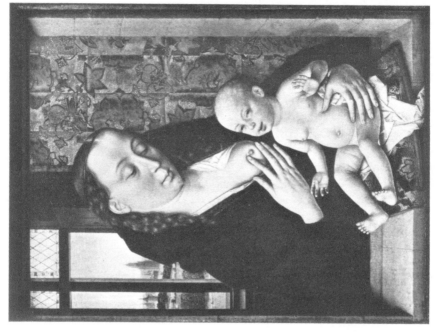

8a. Dirrc Bouts, *Virgin and Child*, London, National Gallery.
8b. Dirrc Bouts, *A Man*, London, National Gallery.

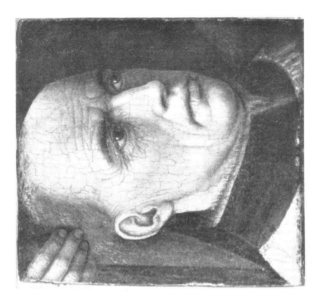

85. AELBERT VAN OUWATER: *Head of a Donor*. Fragment.
New York, Metropolitan Museum of Art

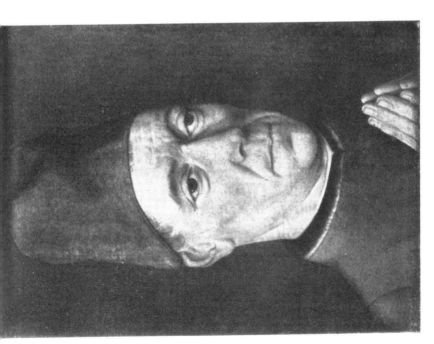

84. DIERIC BOUTS: *A Man*. New York, Metropolitan Museum of Art

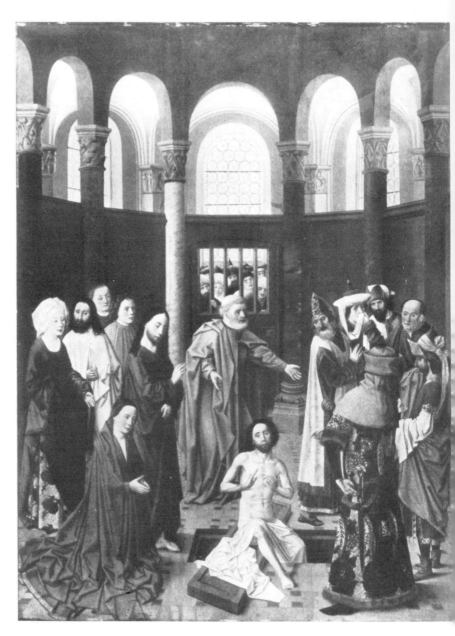

86. AELBERT VAN OUWATER: *The Raising of Lazarus*. Berlin-Dahlem, Staatliche Museen

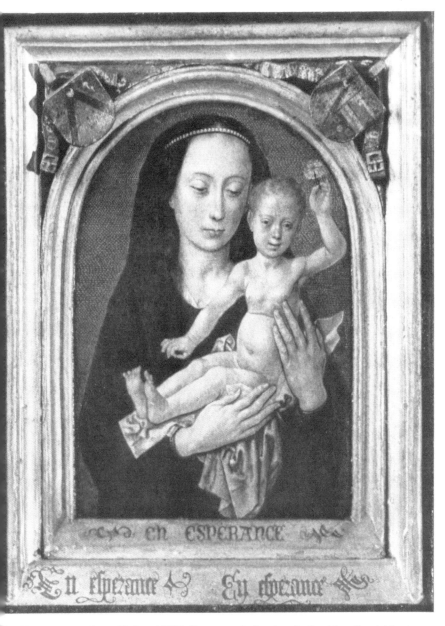

37. Hugo van der Goes: *Virgin and Child*. Centre panel of a triptych. Frankfurt, Staedel Institute

89. *The Three Kings on the Way to Bethlehem*. Detail from plate 91

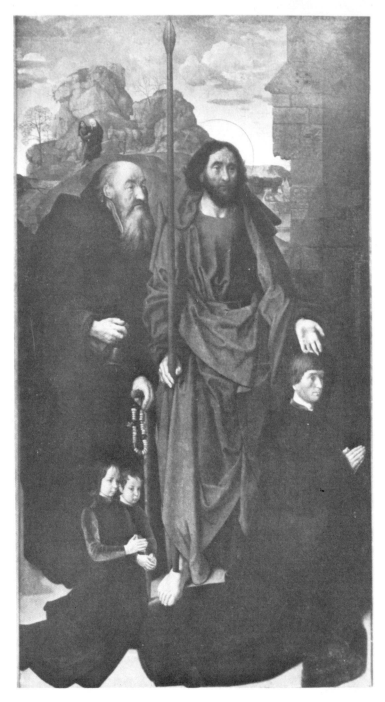

90. HUGO VAN DER GOES: *Tommaso Portinari with his Sons and Saints Anthony and Thomas.*
Left wing of the Portinari altarpiece. Florence, Uffizi

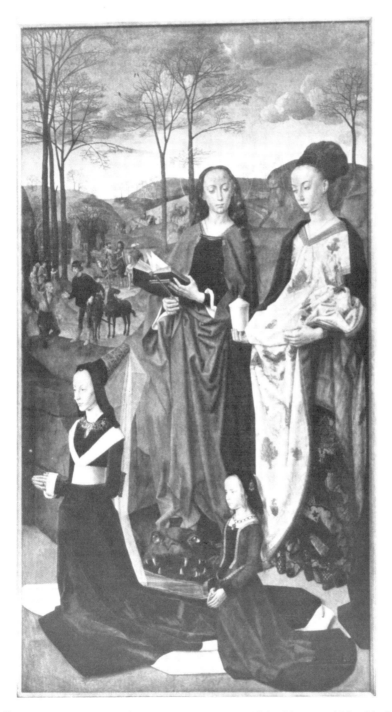

91. Hugo van der Goes: *Maria Portinari with her Daughter and Saints Margaret and Mary Magdalen.*
Right wing of the Portinari altarpiece. Florence, Uffizi

92. *Landscape*. Detail from plate 91

93. *The Shepherds*. Detail from plate 88

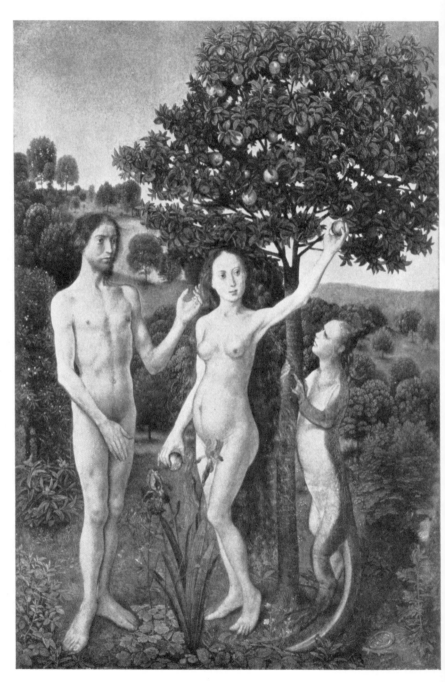

94. Hugo van der Goes: *The Fall of Man*. Vienna, Kunsthistorisches Museum

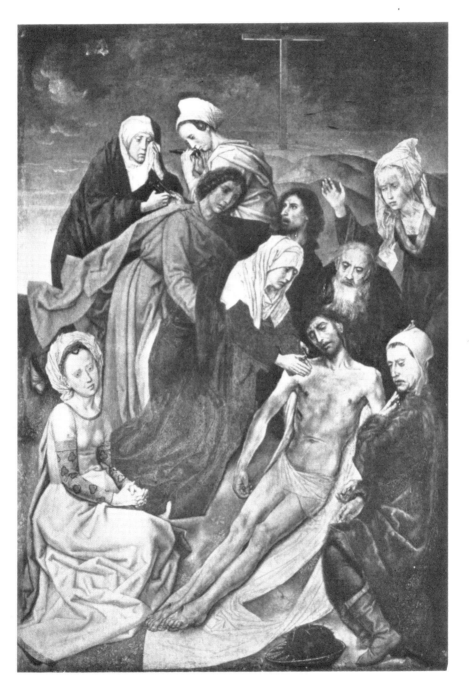

95. Hugo van der Goes: *The Lamentation over Christ*. Vienna, Kunsthistorisches Museum

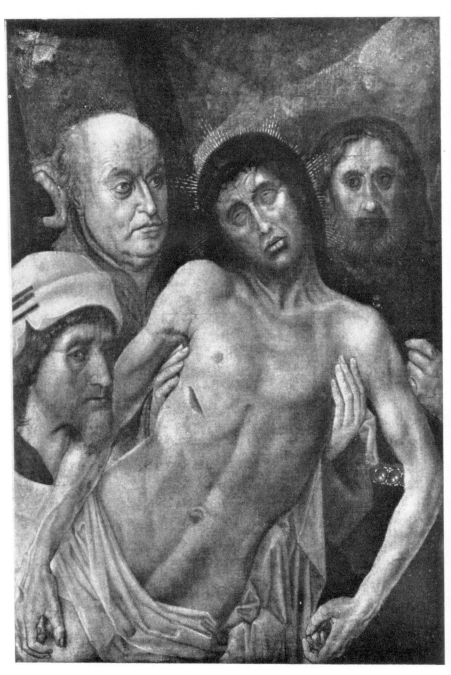

96. Hugo van der Goes: *The Descent from the Cross.* Paris, Wildenstein & Co.

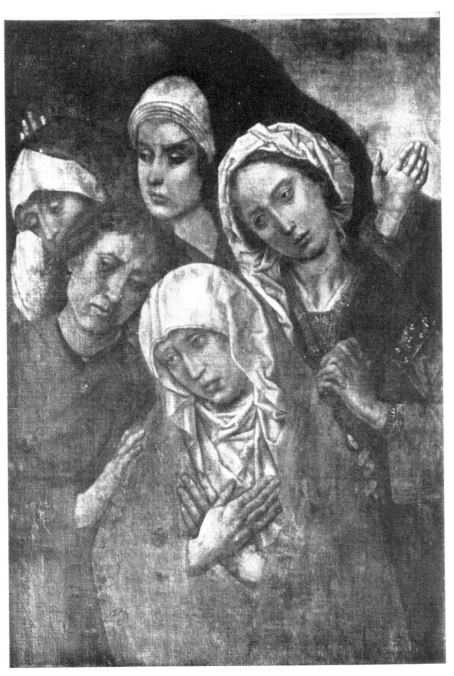

97. HUGO VAN DER GOES: *The Holy Women*. Berlin-Dahlem, Staatliche Museen

98. Hugo van der Goes: *The Adoration of the Shepherds*. Berlin-Dahlem, Staatliche Museen

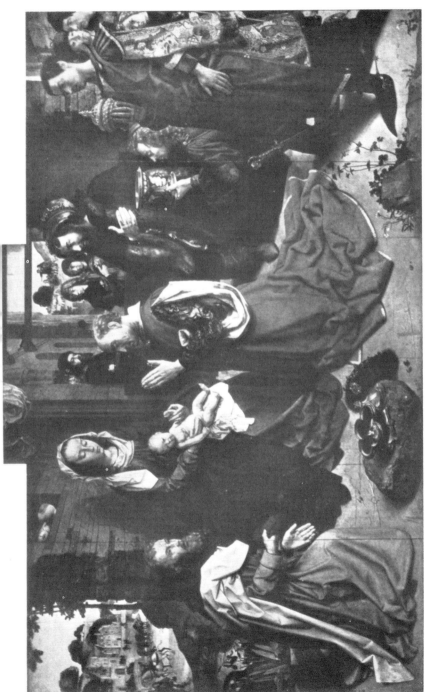

99. HUGO VAN DER GOES: *The Adoration of the Kings*, Known as the Monforte altarpiece. Berlin-Dahlem, Staatliche Museen

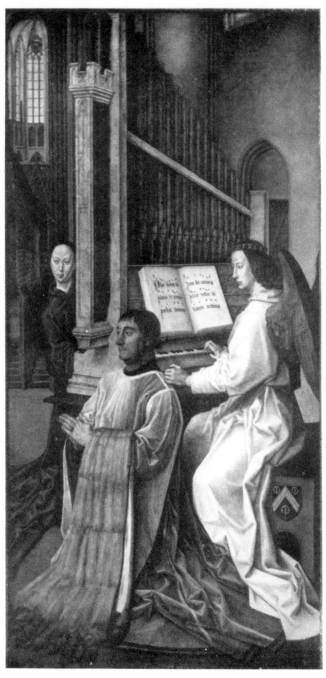

100. Hugo van der Goes: *Sir Edward Bonkil and two Angels*. Edinburgh, National Gallery of Scotland
On loan from Palace of Holyroodhouse.
Reproduced by gracious permission of Her Majesty The Queen

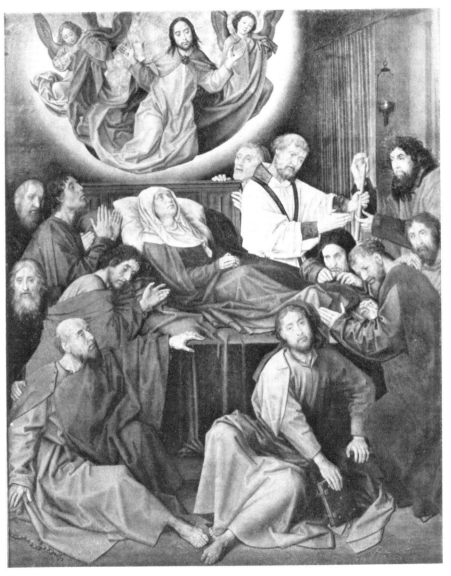

101. Hugo van der Goes: *The Death of the Virgin*. Bruges, Museum

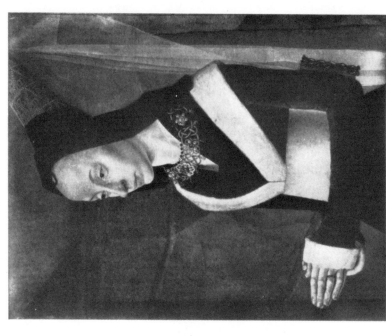

103. HUGO VAN DER GOES: *Maria Portinari*. Detail from plate 91

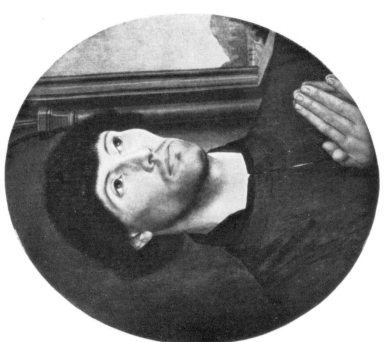

102. HUGO VAN DER GOES: *A Man*. New York, Metropolitan Museum of Art

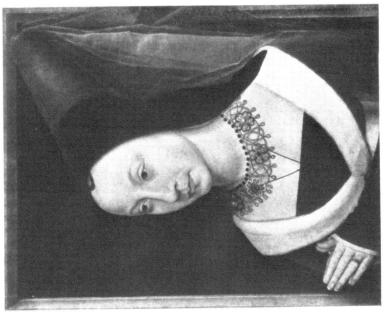

105. MEMLINC: *Maria Portinari*. New York,
Metropolitan Museum of Art

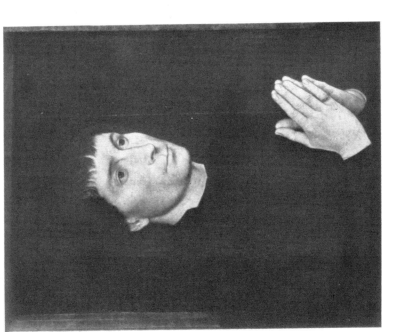

104. MEMLINC: *Tommaso Portinari*. New York,
Metropolitan Museum of Art

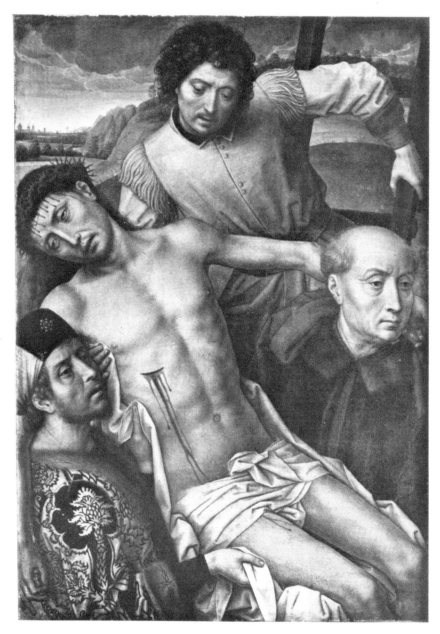

106. MEMLING: *The Descent from the Cross*. Granada, Capilla Real

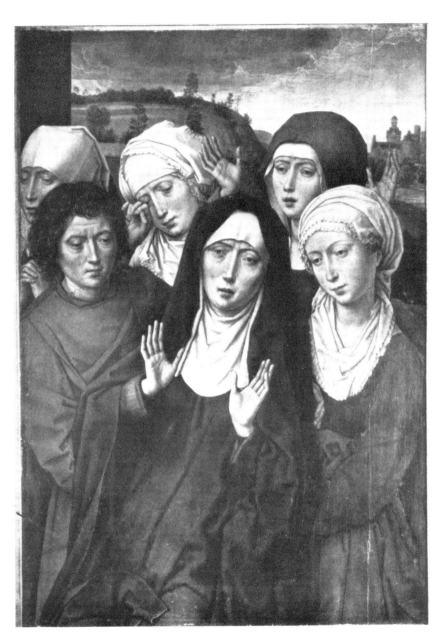

107. MEMLINC: *The Holy Women*. Granada, Capilla Real

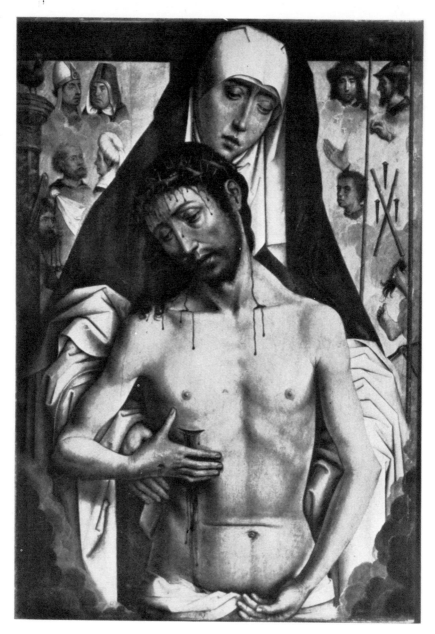

108. MEMLING: *Pietà*. Granada, Capilla Real

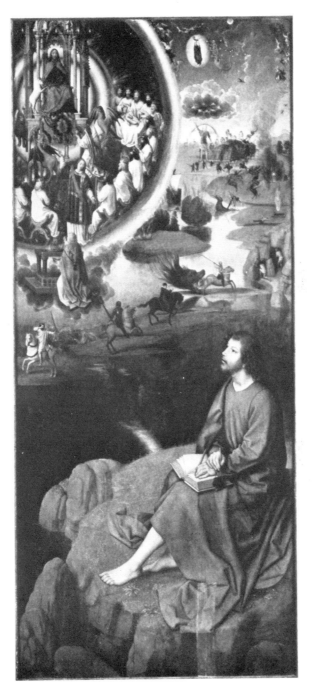

109. MEMLINC: *St. John on Patmos contemplating the Apocalyptic Vision.*
Bruges, Memlinc Museum, St. John's Hospital

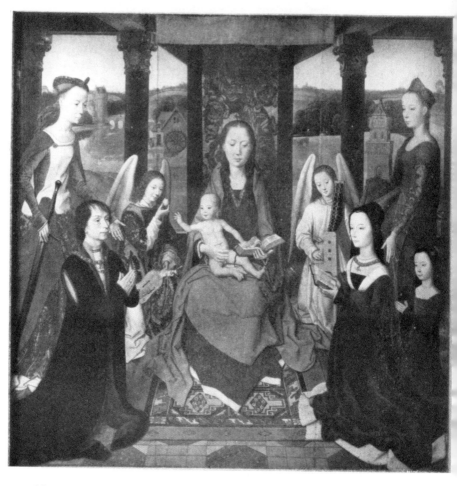

110. MEMLINC: *Virgin and Child with Angels, Saints and Donors*. Centre panel of the 'Donne Triptych'.
London, National Gallery

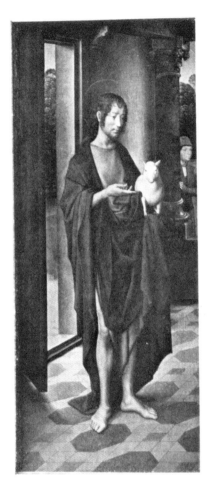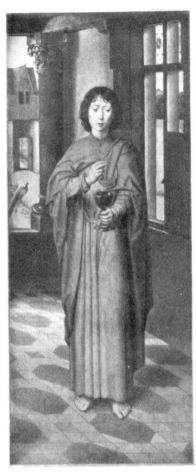

111. Memling: *St. John the Baptist and St. John the Evangelist*. Wings of the 'Donne Triptych'. London, National Gallery

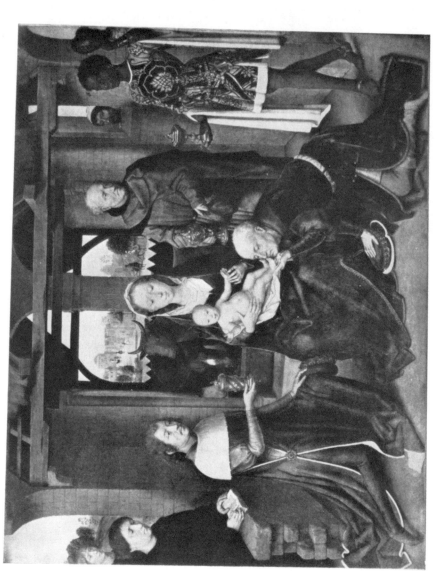

112. MEMLING: *The Adoration of the Kings*. Centre panel of the Floreins altarpiece. Bruges, Memling Museum, St. John's Hospital

113. MEMLING: *The Passion of Christ.* Turin, Pinacoteca

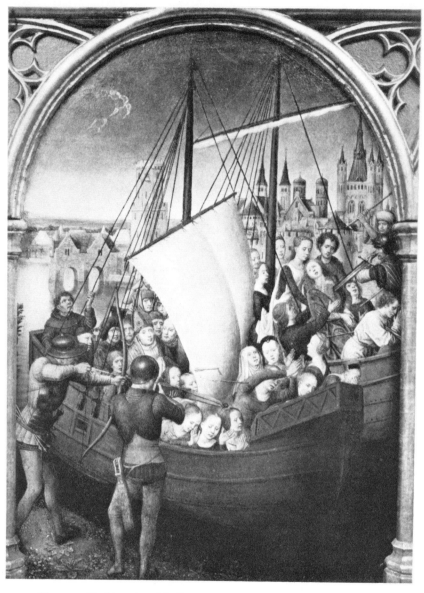

114. MEMLINC: *The Martyrdom of St. Ursula's Companions.* From the Shrine of St. Ursula.
Bruges, Memlinc Museum, St. John's Hospital

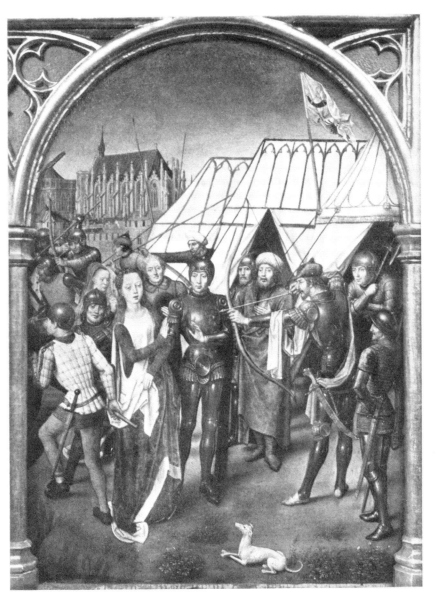

115. MEMLINC: *The Death of St. Ursula.* From the Shrine of St. Ursula. Bruges, Memlinc Museum, St. John's Hospital

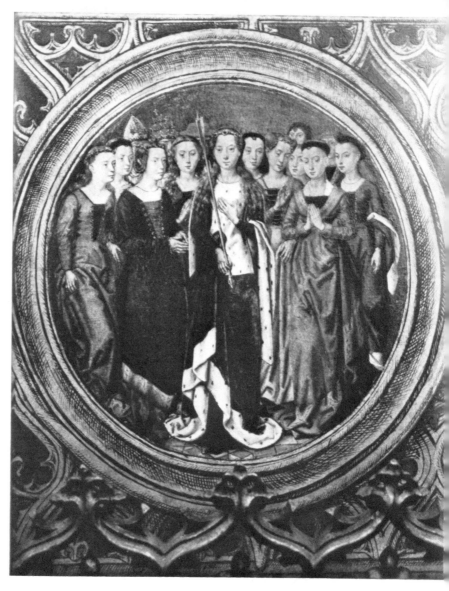

116. MEMLINC: *St. Ursula in Glory with eleven Virgins*. From the Shrine of St. Ursula. Bruges, Memlinc Museum, St. John's Hospital

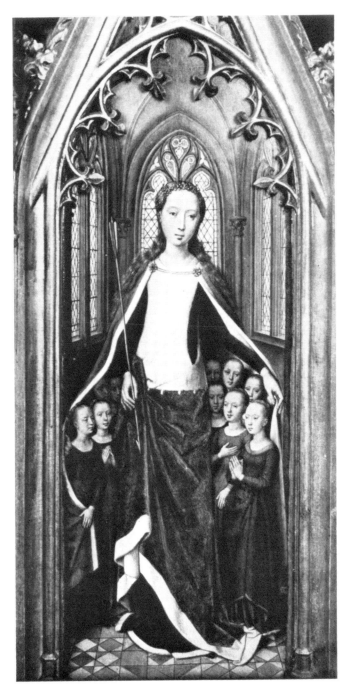

117. MEMLINC: *St. Ursula sheltering ten Virgins.* From the Shrine of St. Ursula. Bruges, Memlinc Museum, St. John's Hospital

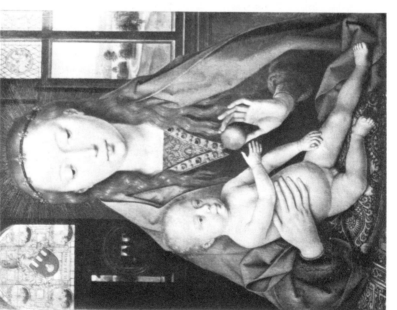

119. MEMLINC: *Martin van Nieuwenhove*. Bruges, Memlinc Museum, St. John's Hospital

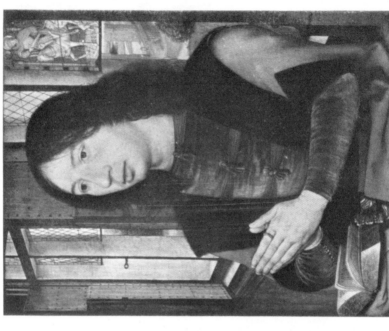

118. MEMLINC: *Virgin and Child*. Bruges, Memlinc Museum, St. John's Hospital

120. MEMLINC: *Man holding a Medal*. Antwerp, Museum

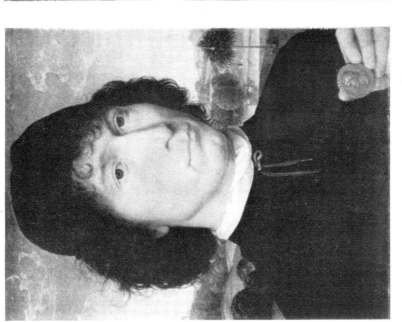

121. MEMLINC: *Young Man*. New York, Robert Lehman Collection

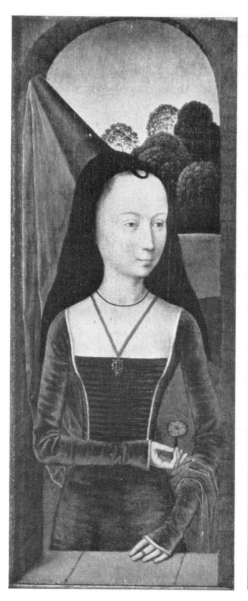

122. MEMLINC: *Lady with a Pink*. New York,
Metropolitan Museum of Art

123. MEMLINC: *Two Horses*. Rotterdam,
Museum Boymans-van Beuningen

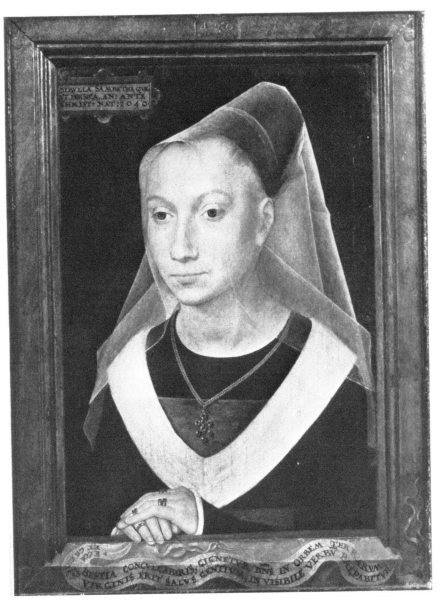

124. MEMLINC: *Maria Moreel*. Bruges, Memlinc Museum, St. John's Hospital

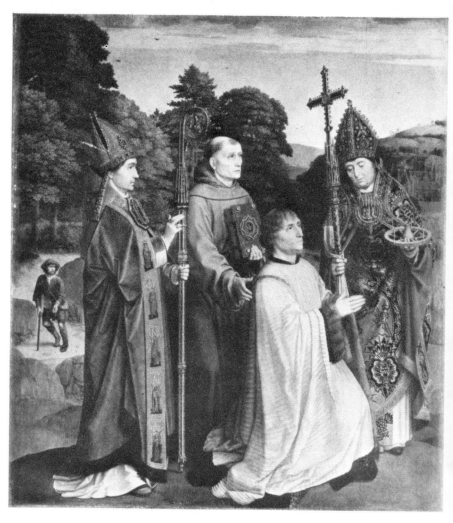

125. GERARD DAVID: *Canon de Salviatis with Saints Donatian, Bernardino and Martin.*
London, National Gallery

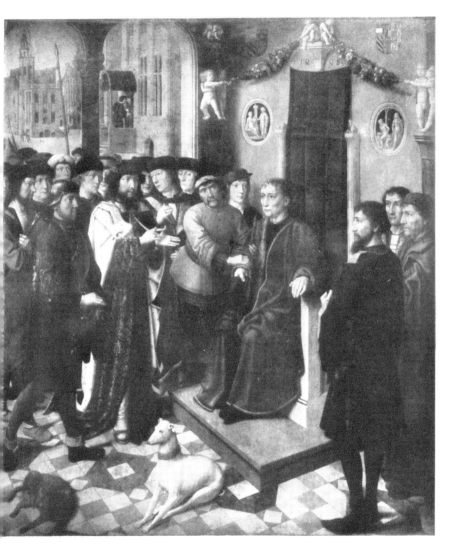

126. GERARD DAVID: *The Verdict of Cambyses*. Bruges, Museum

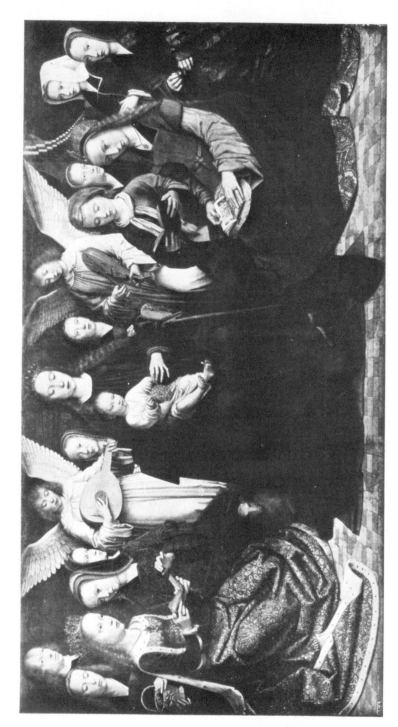

127. GERARD DAVID: *Virgin and Child with Angels and female Saints.* Rouen, Museum

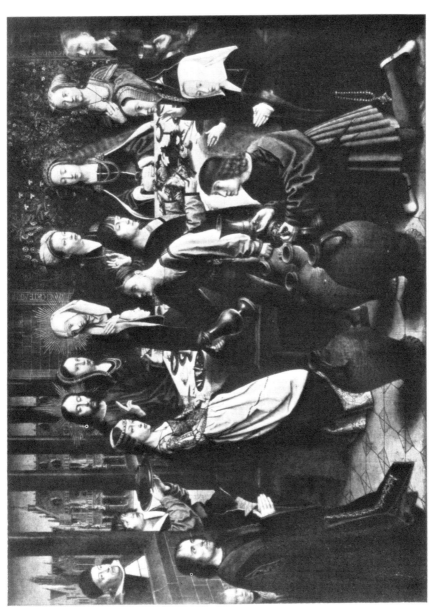

128. Gerard David: *The Marriage of Cana, with the Donor Jean de Sedano and his Family.* Paris, Louvre

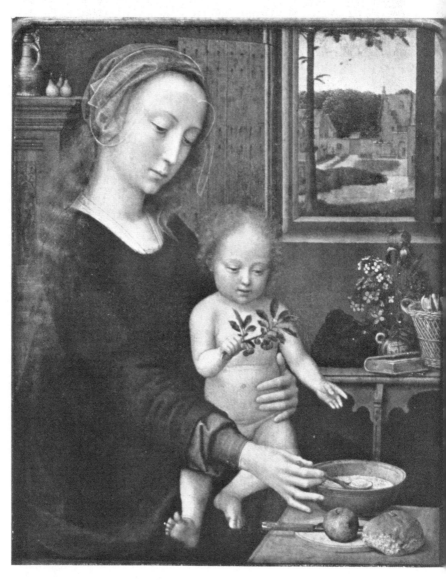

129. GERARD DAVID: *Virgin and Child*. Von Pannwitz Collection

130. GERARD DAVID: *Two Landscapes*. Amsterdam, Rijksmuseum

191. GERARD DAVID. *The Baptism of Christ*. Bruges. Museum: *on the wings, The Donor, Jean de Trompes, and his family, with St. John the Evangelist*

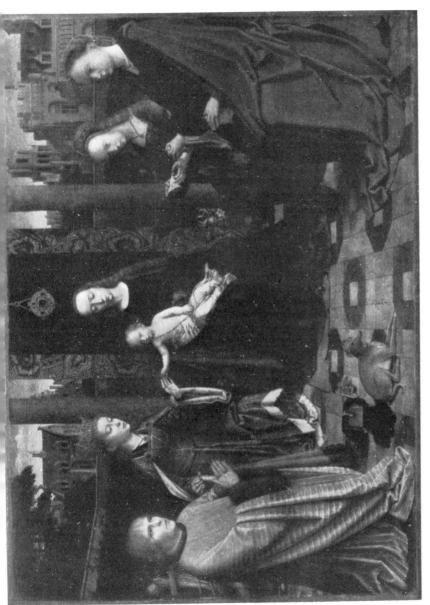

132. GERARD DAVID: *Virgin and Child with Saints Barbara, Mary Magdalen, Catherine and the Donor Richardus de Capella*. London, National Gallery

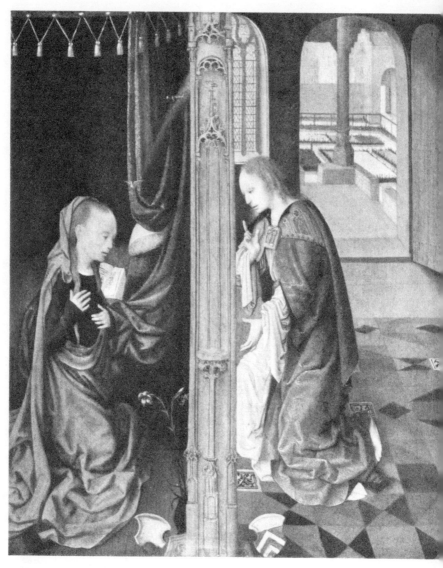

133. MASTER OF THE VIRGO INTER VIRGINES: *The Annunciation.* Rotterdam, Museum Boymans-van Beunir

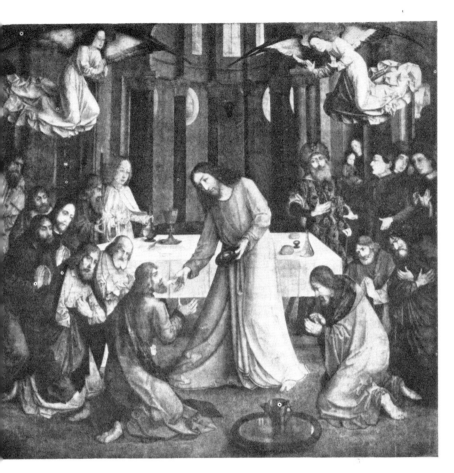

134. Justus van Gent: *The Last Supper*. Urbino, Palazzo Ducale

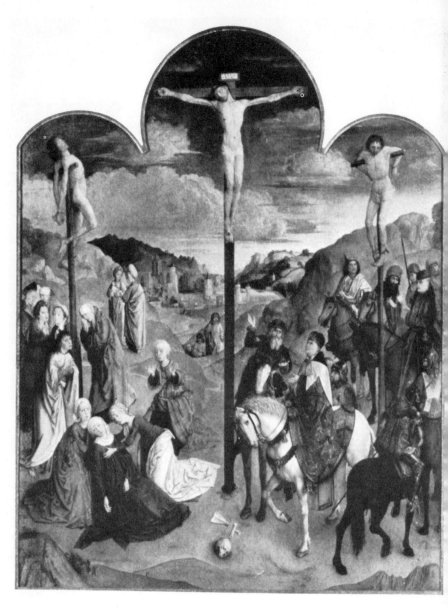

135. Justus van Gent: *The Crucifixion*. Ghent, St. Bavo

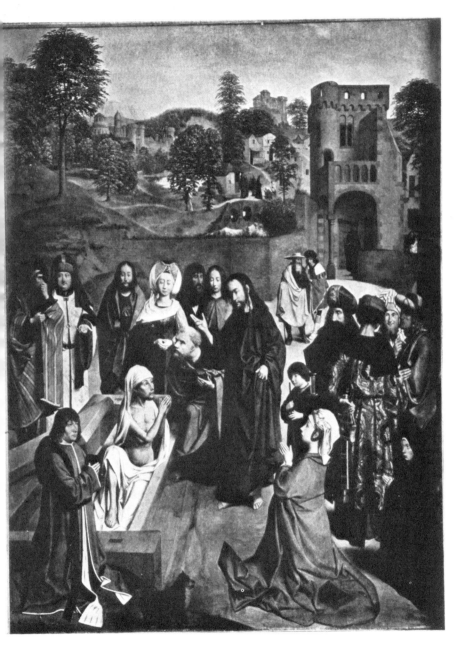

136. Geertgen tot Sint Jans: *The Raising of Lazarus*. Paris, Louvre

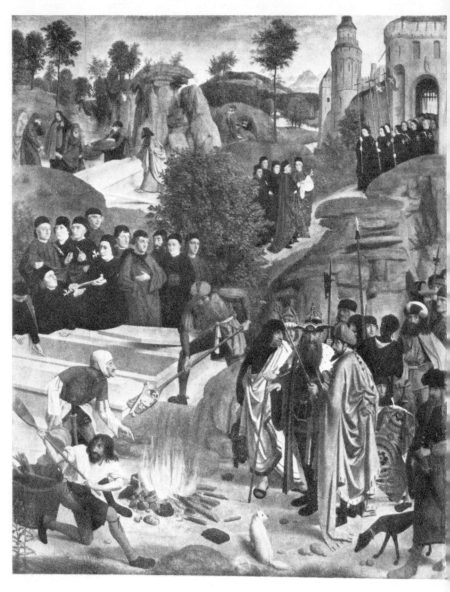

137. Geertgen tot Sint Jans: *The Burning of the Bones of St. John.* Vienna, Kunsthistorisches Museum

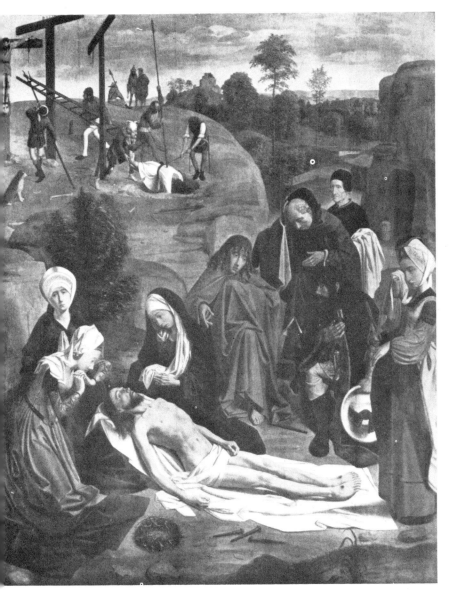

138. Geertgen tot Sint Jans: *The Lamentation over Christ*. Vienna, Kunsthistorisches Museum

140. GEERTGEN TOT SINT JANS: *Virgin and Child.*
Rotterdam, Museum Boymans-van Beuningen

139. GEERTGEN TOT SINT JANS: *The Nativity, at Night.*
London, National Gallery

142. GEERTGEN TOT SINT JANS: *St. John the Baptist in the Wilderness.* Berlin-Dahlem, Staatliche Museen

141. GEERTGEN TOT SINT JANS: *The Adoration of the Kings.* Cleveland, Museum of Art (Gift of Hanna Fund)

143. GEERTGEN TOT SINT JANS: *Christ as Man of Sorrows*. Utrecht, Archiepiscopal Museum

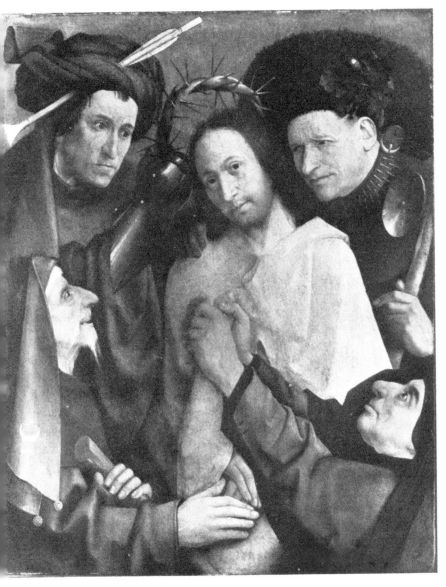

144. BOSCH: *The Crowning with Thorns*. London, National Gallery

145. BOSCH: *Table top with the Seven Deadly Sins*. Madrid, Prado

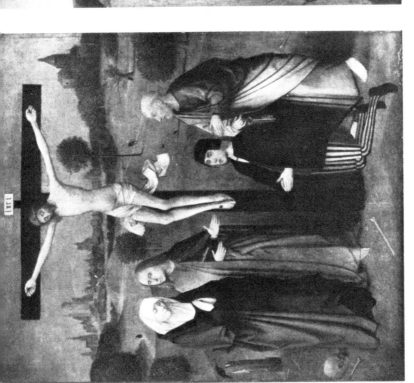

147. BOSCH: *The Adoration of the Kings.* Philadelphia,
John G. Johnson Collection

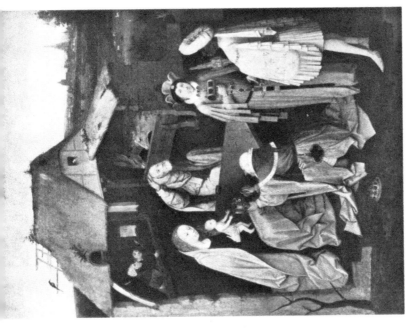

146. BOSCH: *The Crucifixion, with the Virgin, St. John, St. Peter and a Donor.*
Brussels, Museum

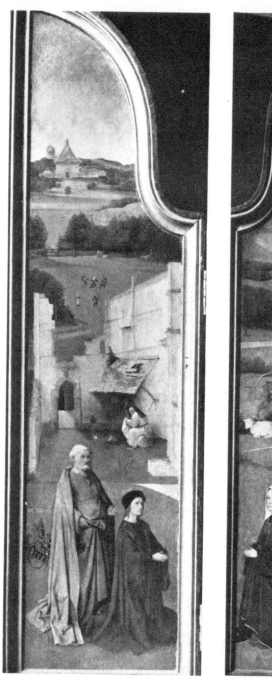
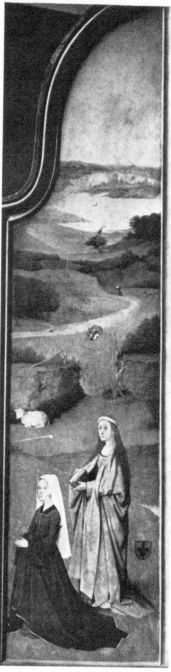

148-149. BOSCH: *St. Peter with a Donor; St. Agnes with the Donor's Wife.* Wings of plate 150.
Madrid, Prado

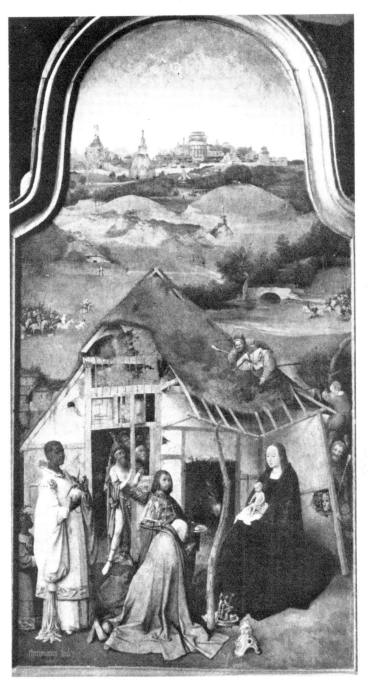

150. BOSCH: *The Adoration of the Kings*. Madrid, Prado

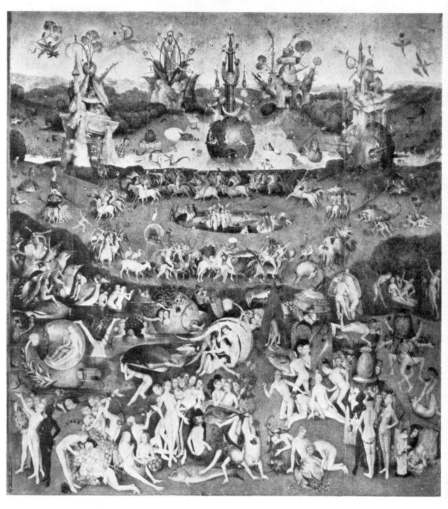

151. Bosch: *The Garden of Earthly Delights*. Centre panel of a triptych. Madrid, Prado

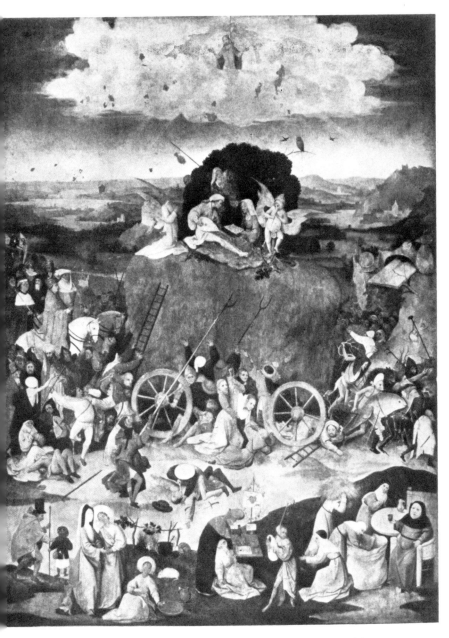

152. Bosch: *The Hay-Wain*. Centre panel of a triptych. Escorial

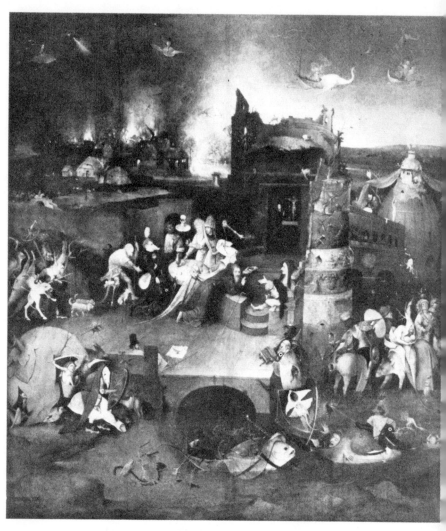

153. BOSCH: *The Temptation of St. Anthony*. Lisbon, Museum

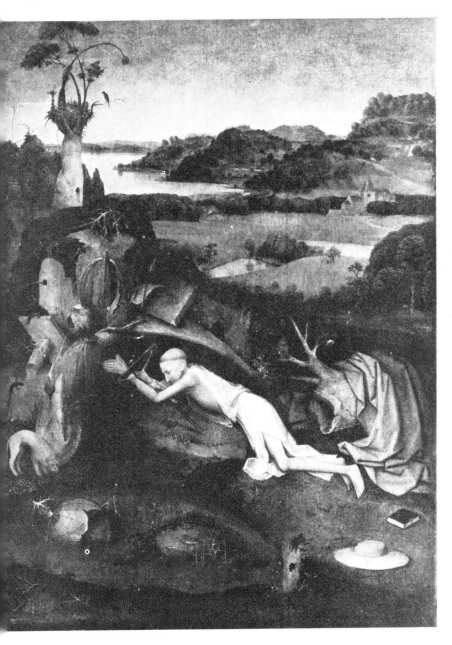

154. Bosch: *St. Jerome in Penitence*. Ghent, Museum

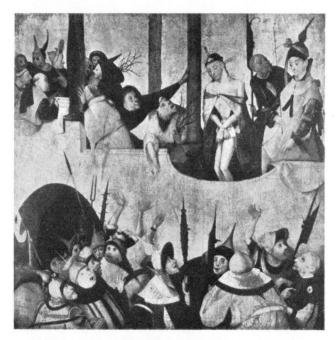

155. Bosch: *Ecce homo*. Philadelphia, John G. Johnson Collection

156. Bosch: *Christ carrying the Cross*. Ghent, Museum

157. BOSCH: *The Mocking of Christ.* Escorial

158. BOSCH: *The Prodigal Son.* Rotterdam,
Museum Boymans-van Beuningen

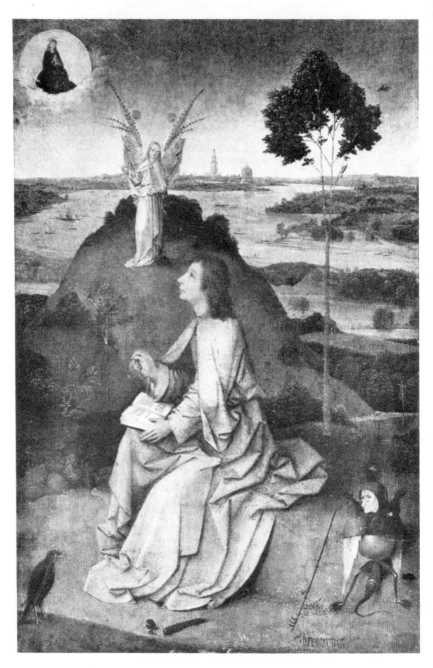

159. Bosch: *St. John on Patmos*. Berlin-Dahlem, Staatliche Museen

THE SIXTEENTH CENTURY

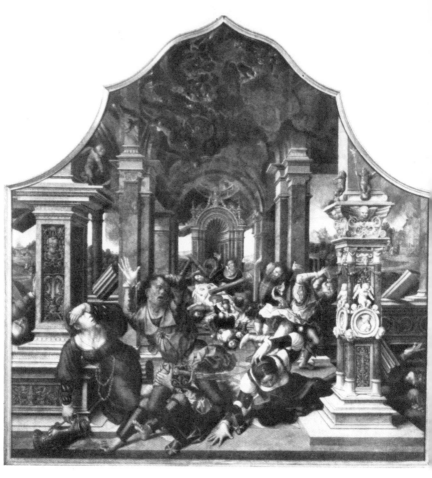

160. BERNAERT VAN ORLEY: *The Ruin of the Children of Job*. Brussels, Museum

1. Bernaert van Orley: *The Poor Lazarus at the Door of the Rich Man; The Death of the Rich Man and his Torments in Hell.* Wings of the Job altarpiece. Brussels, Museum

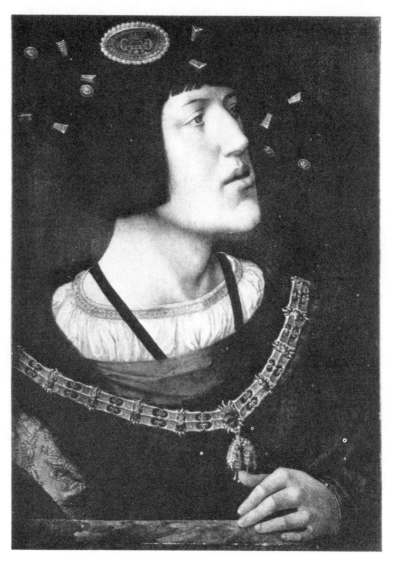

162. Bernaert van Orley: *Charles V.* Budapest, Museum

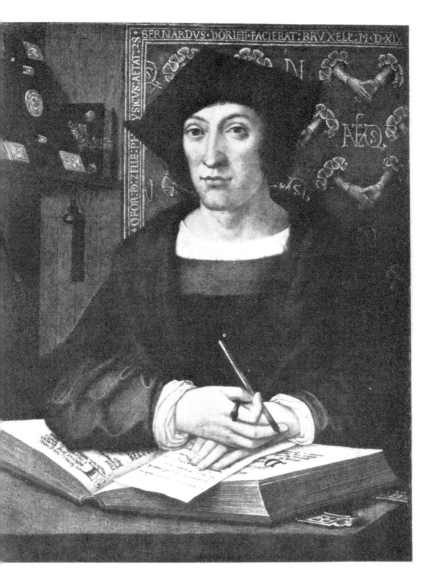

163. Bernaert van Orley. *Dr. Georg van Zelle*. Brussels, Museum

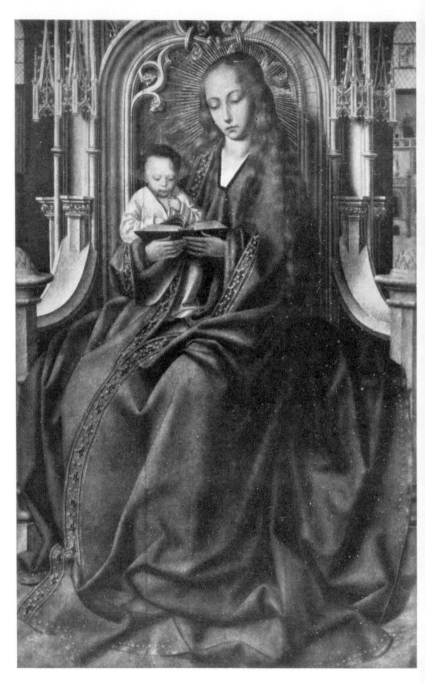

164. QUENTIN MASSYS: *Virgin and Child*. Brussels, Museum

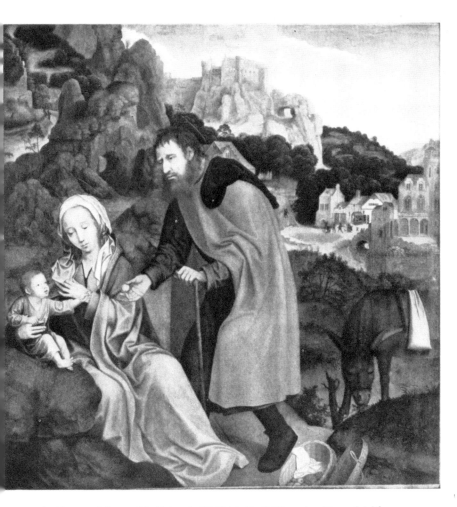

165. QUENTIN MASSYS: *The Rest on the Flight into Egypt.* Worcester, Mass., Art Museum

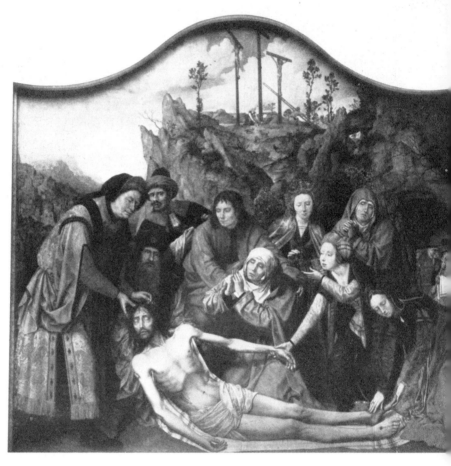

166. QUENTIN MASSYS: *The Entombment*. Antwerp, Museum

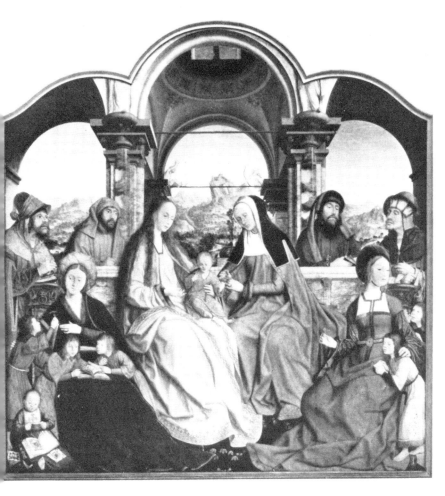

57. QUENTIN MASSYS: *The Holy Kindred*. Centre panel of the St. Anne altarpiece. Brussels, Museum

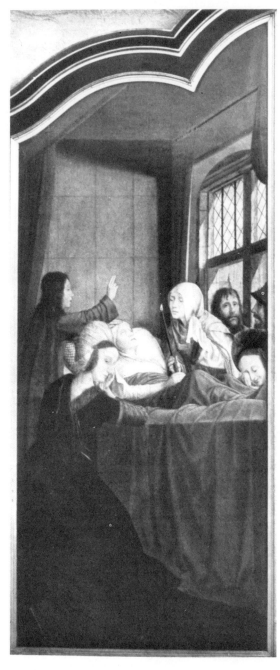

168. QUENTIN MASSYS: *The Death of the Virgin.*
Right wing of the St. Anne altarpiece. Brussels, Museum

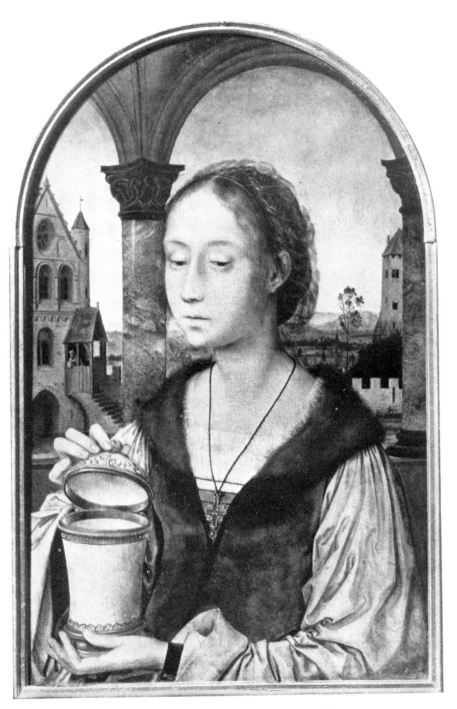

169. QUENTIN MASSYS: *St. Mary Magdalen*. Antwerp, Museum

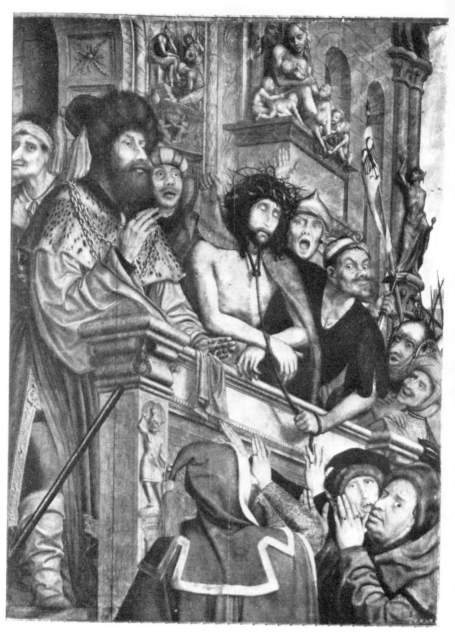

170. QUENTIN MASSYS: *Christ presented to the People*. Madrid, Prado

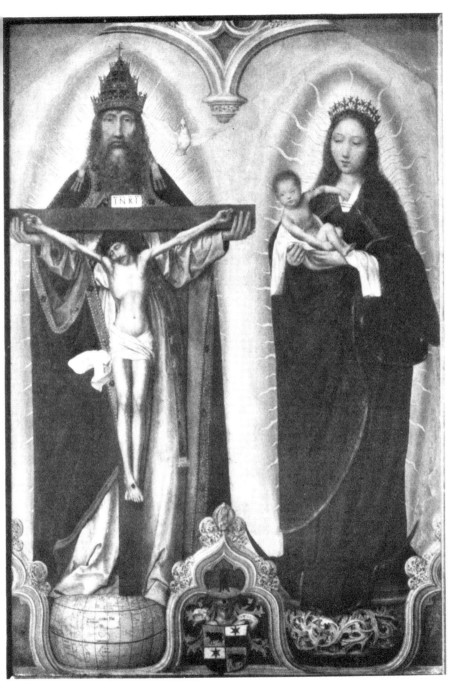

171. QUENTIN MASSYS: *The Holy Trinity and Virgin and Child*. Centre panel of an altarpiece.
Munich, Alte Pinakothek

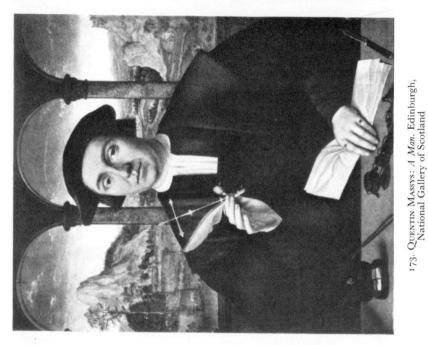

173. Quentin Massys: *A Man*. Edinburgh,
National Gallery of Scotland

172. Quentin Massys: *A Man*. Frankfurt,
Staedel Institute

174–175. QUENTIN MASSYS: *A Man and his Wife.* Oldenburg, Museum

176. Quentin Massys: *A Man with a Pink*. Chicago, Art Institute

177. QUENTIN MASSYS: *A Money Changer and his Wife*. Paris, Louvre

178. QUENTIN MASSYS: *Erasmus of Rotterdam*. Rome, Galleria Corsini

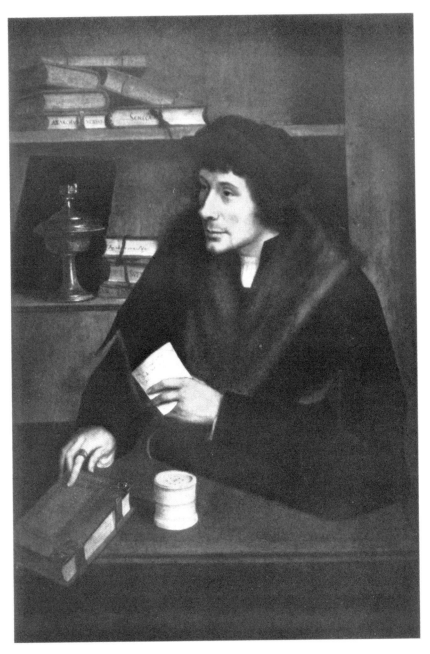

179. QUENTIN MASSYS: *Petrus Aegidius*. Longford Castle, Earl of Radnor

180. QUENTIN MASSYS and PATENIER: *The Temptation of St. Anthony.* Madrid, Prado

181. Patenier: *The Rest on the Flight into Egypt.* Madrid, Prado

183. Patenier: *Charon crossing the Styx*. Madrid, Prado

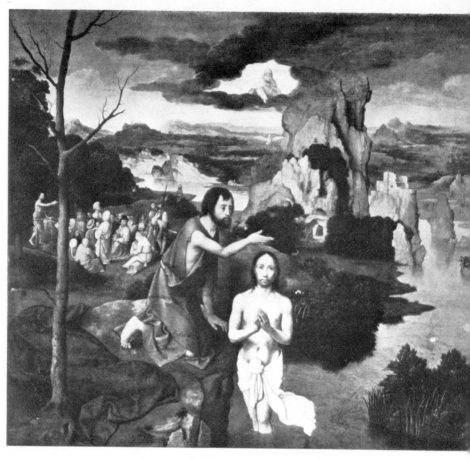

184. PATENIER: *The Baptism of Christ*. Vienna, Kunsthistorisches Museum

185. Patenier: *The Flight into Egypt.* Antwerp, Museum

186. Herri met de Bles: *The Flight into Egypt.* London, Hallsborough Gallery

187. CORNELIS MASSYS: *St. Jerome in the Wilderness*. Antwerp, Museum

188. CORNELIS MASSYS: *The Virgin and St. Joseph arriving at the Inn in Bethlehem.*
Berlin-Dahlem, Staatliche Museen

189. Master of the Female Half-Lengths: *Three Ladies making Music*. Vienna, Harrach Collection

190. MASTER OF THE FEMALE HALF-LENGTHS: *The Adoration of the Kings*. Regensburg, Museum

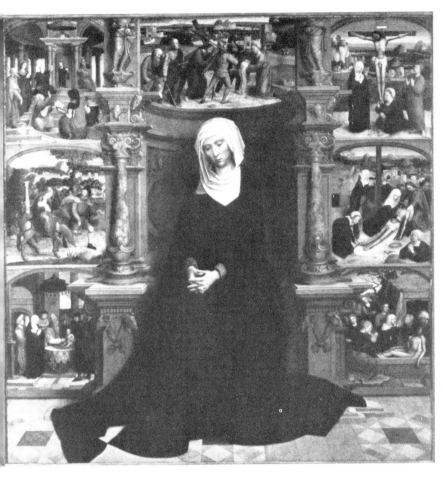

191. YSENBRANDT: *The Seven Sorrows of the Virgins*. Bruges, Notre-Dame

193. JOOS VAN CLEVE: *Woman with a Rosary*. Florence, Uffizi

192. YSENBRANDT: *The Gold-Weigher*. New York,
Metropolitan Museum of Art

195. Joos van Cleve: *Queen Eleanor of France.*
Vienna, Kunsthistorisches Museum

194. Joos van Cleve: *Henry VIII.* Hampton Court Palace.
Reproduced by gracious permission of Her Majesty The Queen

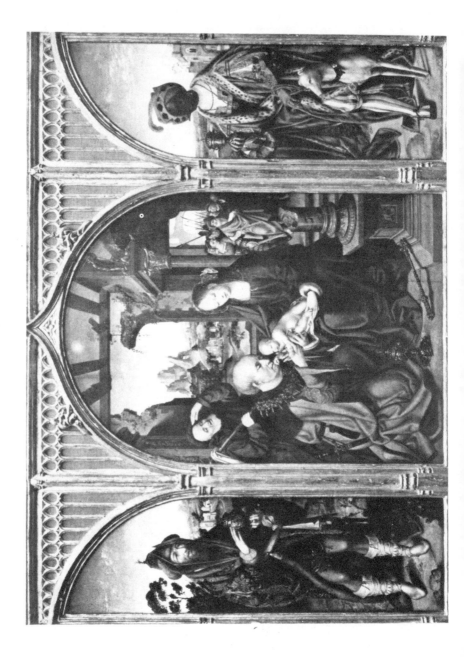

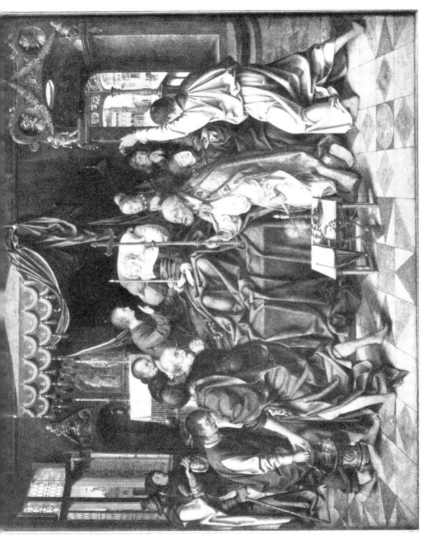

197. Joos van Cleve: *The Death of the Virgin*. Centre panel of a triptych. Munich, Alte Pinakothek

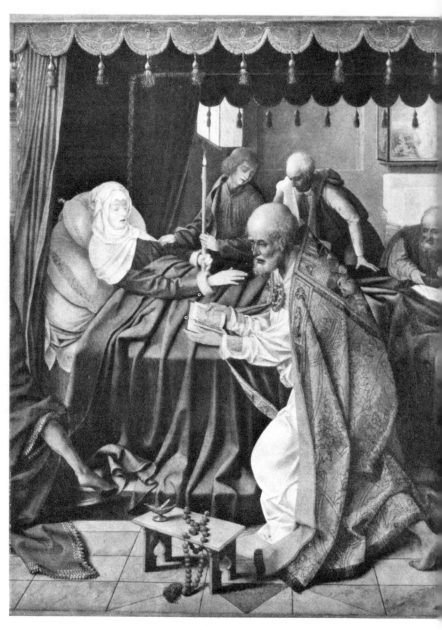

198. Joos van Cleve: *The Death of the Virgin* (detail). Centre panel of a triptych.
Cologne, Wallraf-Richartz Museum

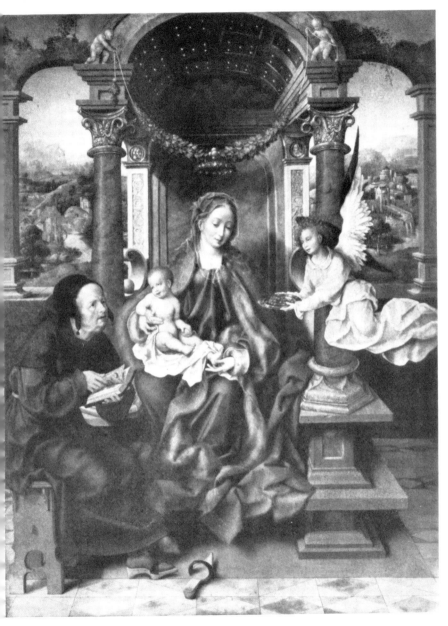

199. Joos van Cleve: *The Holy Family*. Vienna, Kunsthistorisches Museum

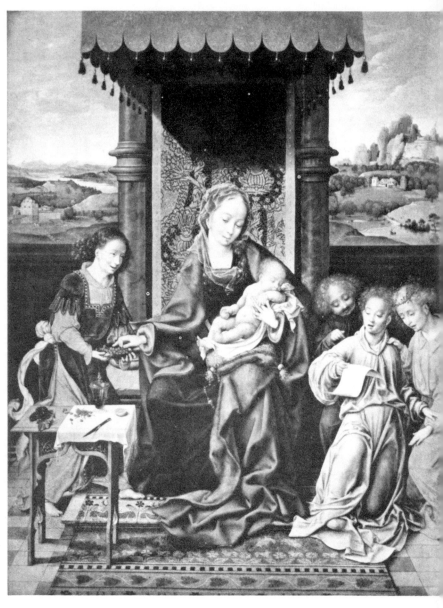

200. Joos van Cleve: *Virgin and Child with Angels*. Lulworth Castle, Colonel J. Weld

201. JOOS VAN CLEVE: *The Rest on the Flight into Egypt*. Brussels, Museum

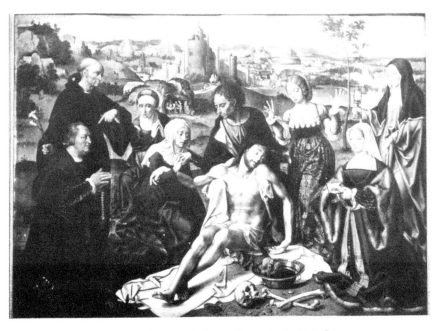

202. JOOS VAN CLEVE: *The Lamentation over Christ*. Paris, Louvre

203. Joos van Cleve: *Virgin and Child*. Cambridge, Fitzwilliam Museum

204. Joos van Cleve: *The Holy Family*. New York, Metropolitan Museum of Art

205. PROVOST: *Virgin and Child*. Piacenza, Museo Civico

206. PROVOST: *Virgin and Child with Angels, Prophets and Sibyls.* Leningrad, Hermitage

207. PROVOST: *The Last Judgement.* Bruges, Museum

208. PROVOST: *Death and the Miser.* Bruges, Museum

209. PROVOST: *The Angel appearing to Abraham.* Formerly Paris, Comte Durrieu

210. Gossaert: *Resting Apollo* ('*Hermaphrodite*'). Drawing. Venice, Academy

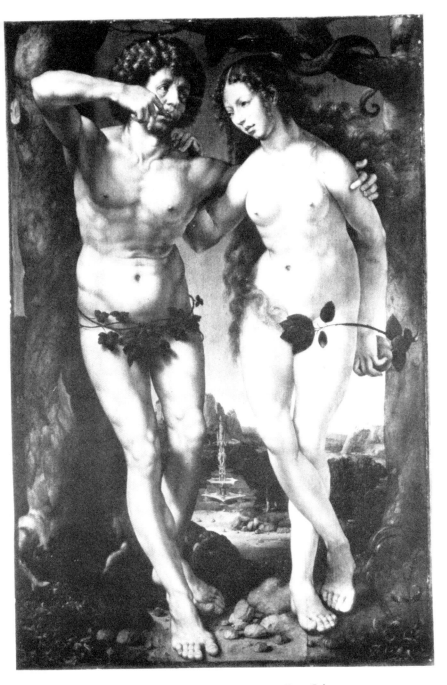

211. GOSSAERT: *Adam and Eve*. Hampton Court Palace.
Reproduced by gracious permission of Her Majesty the Queen

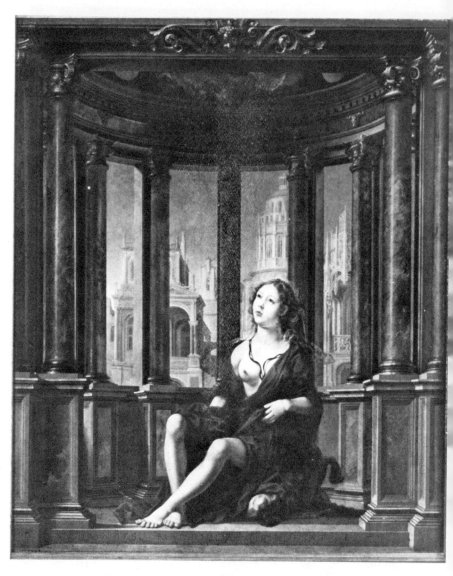

212. GOSSAERT: *Danae*. Munich, Alte Pinakothek

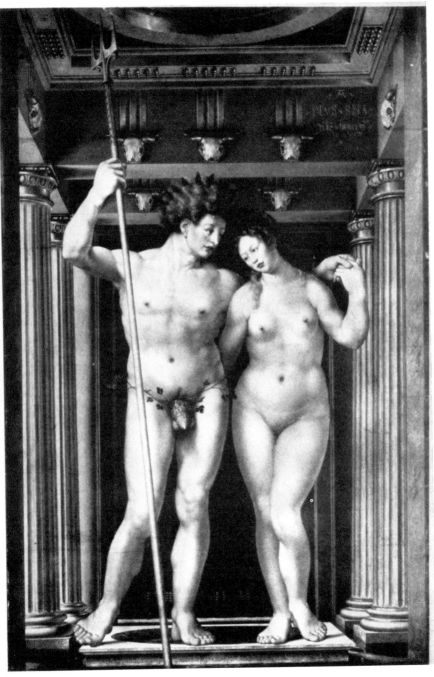

213. GOSSAERT: *Neptune and Amphitrite*. Berlin-Dahlem, Staatliche Museen

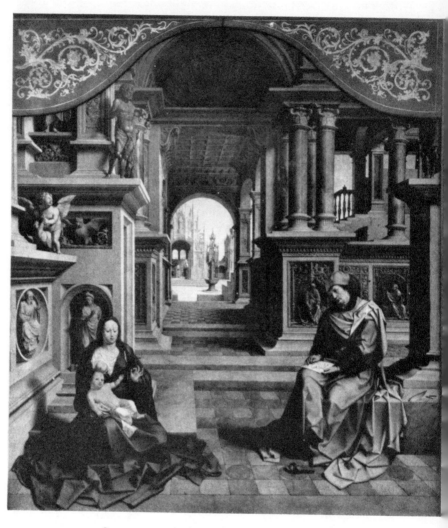

214. GOSSAERT: *St. Luke painting the Virgin*. Prague, National Gallery

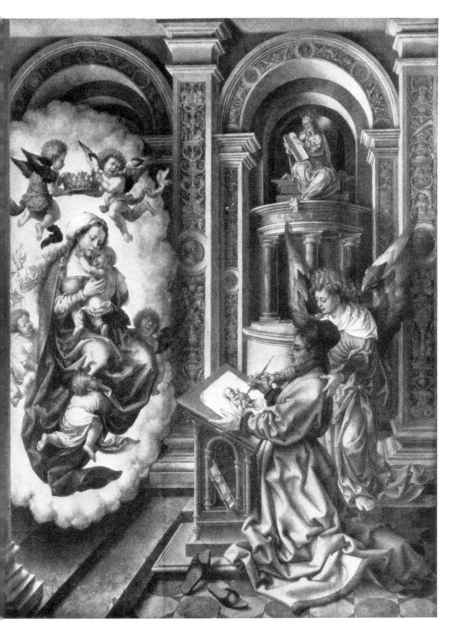

215. GOSSAERT: *St. Luke painting the Virgin.* Vienna, Kunsthistorisches Museum

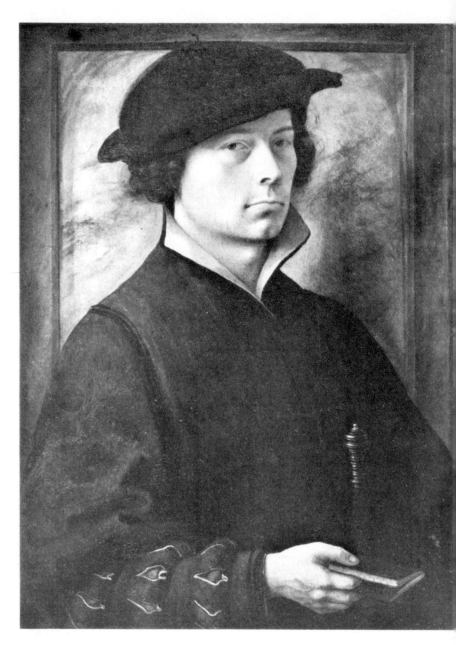

216. GOSSAERT: *A Man*. Vierhouten, Van Beuningen Collection

217–218. GOSSAERT: *A Donor and his Wife*. Brussels, Museum

219–220. GOSSAERT: *Virgin and Child adored by Jean Carondelet*. Paris, Louvre

221. Gossaert: *The Children of Christian II of Denmark.* Hampton Court Palace.
Reproduced by gracious permission of Her Majesty the Queen

222. GOSSAERT: *Virgin and Child with Angels*. Centre panel of the Malvagna triptych. Palermo, Museu

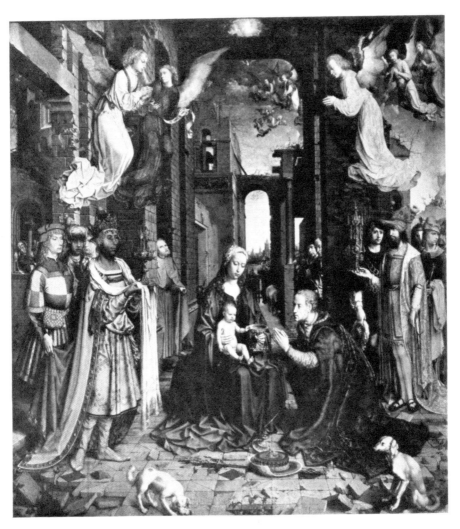

223. GOSSAERT: *The Adoration of the Kings*. London, National Gallery

224. GOSSAERT: *The Agony in the Garden*. Berlin-Dahlem, Staatliche Museen

225. JAN JOEST: *The Virgin and St. John the Evangelist, with the Donor Juan de Fonseca.*
Palencia, Cathedral

227. JAN JOEST: *The Entombment*. Palencia, Cathedral

226. JAN JOEST: *The Flight into Egypt*. Palencia, Cathedral

229. JAN JOEST: *The Baptism of Christ*. Kalkar,
Church of St. Nicholas

228. JAN JOEST: *The Lamentation over Christ*. Cologne,
Wallraf-Richartz Museum

230. MASTER OF FRANKFURT: *The Holy Kindred*. Frankfurt, Staedel Institute

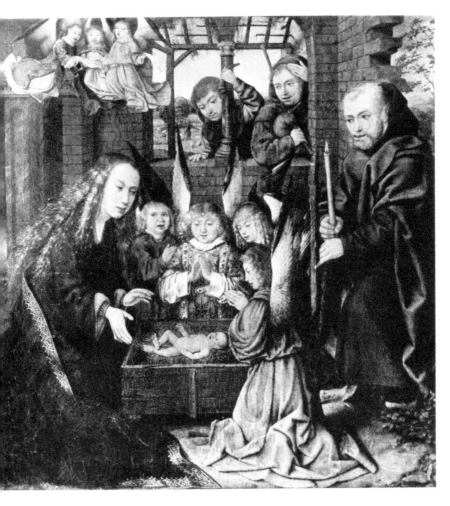

231. MASTER OF FRANKFURT: *The Nativity* (detail). Valenciennes, Museum

232. MASTER OF FRANKFURT: *The Artist and his Wife*. Rome, Baron van der Elst Collection

233. JAN MOSTAERT: *Joost van Bronckhorst*. Paris, Petit Palais

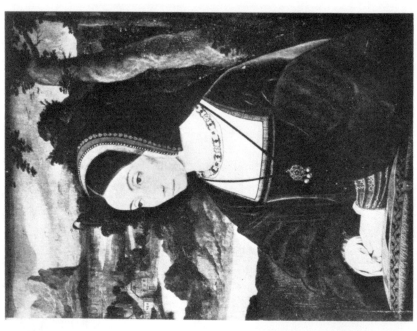

235. Jan Mostaert: *Justina van Wassenaer.* Würzburg,

234. Jan Mostaert: *A Man.* Liverpool,

236. Jan Mostaert: *Abraham and Hagar.* Lugano-Castagnola, Schloss Rohoncz Collection, Thyssen Bequest

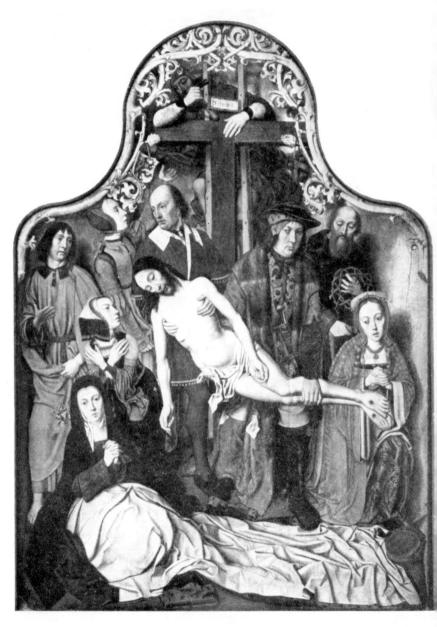

237. JAN MOSTAERT: *The Descent from the Cross*. Centre panel of a triptych. Brussels, Museum

238. JAN MOSTAERT: *The Man of Sorrows*. Verona, Museum

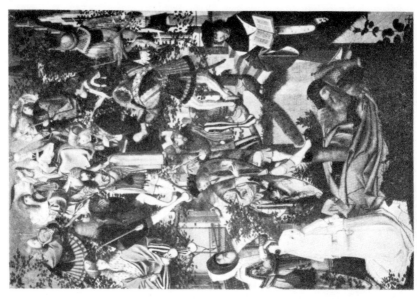

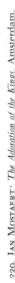 229. IAN MOSTAERT: *The Tree of Jesse.* (Also attributed to

228. IAN MOSTAERT: *The Adoration of the Kings.* Amsterdam

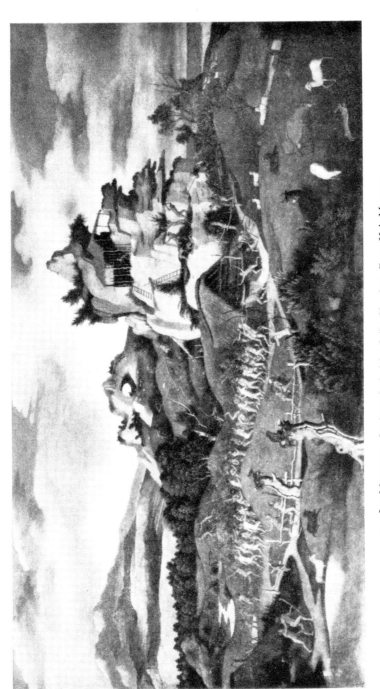

241. JAN MOSTAERT: *Landscape in the West Indies*. Haarlem, Frans Hals Museum

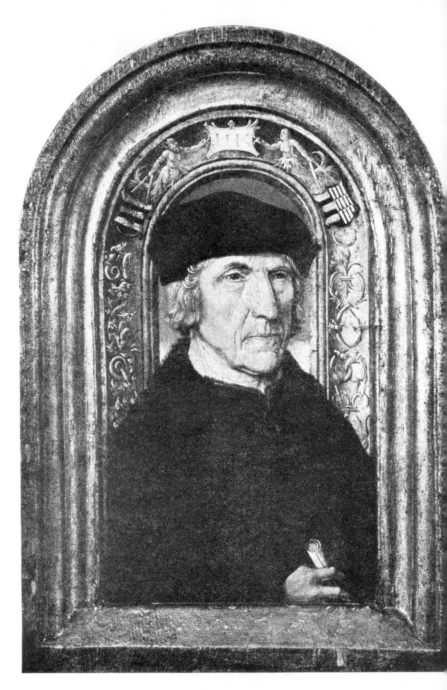

242. Jacob Cornelisz. van Oostsaanen: *Jacob Pijnssen*. Enschede, Rijksmuseum Twenthe

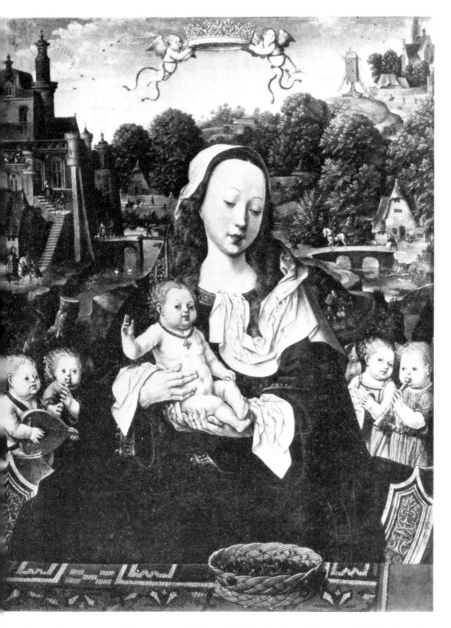

243. Jacob Cornelisz. van Oostsaanen: *Virgin and Child with Angels*. Centre panel of a triptych. Berlin-Dahlem, Staatliche Museen

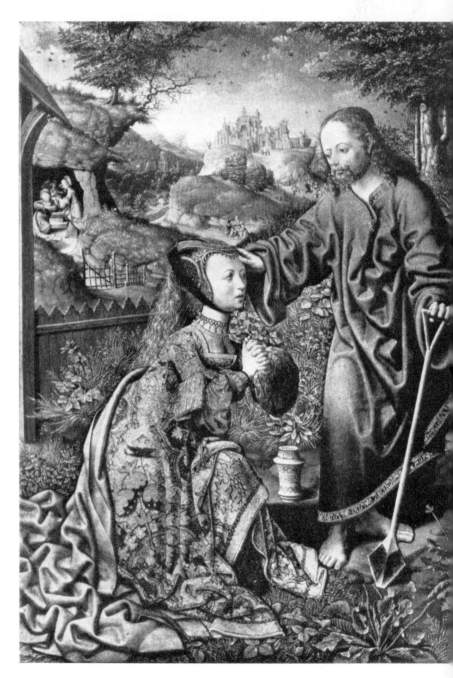

244. Jacob Cornelisz. van Oostsaanen: *Noli me tangere*. Cassel, Museum

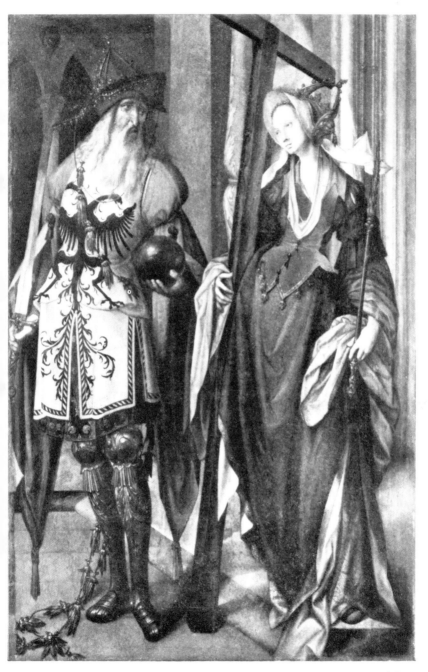

245. CORNELIS ENGELBRECHTSEN: *St. Constantine and St. Helena*. Munich, Alte Pinakothek

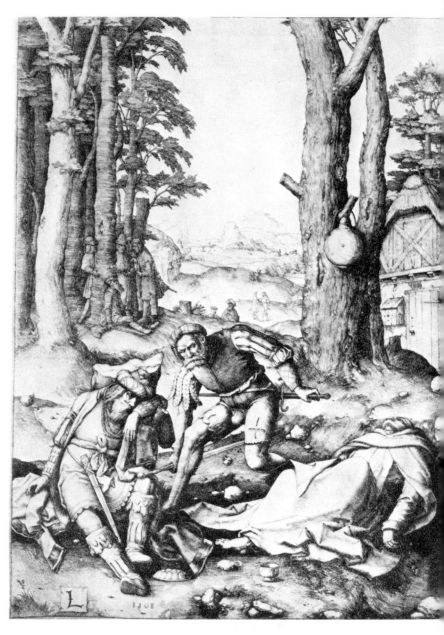

246. LUCAS VAN LEYDEN: *Mohammed and the Monk*. Engraving

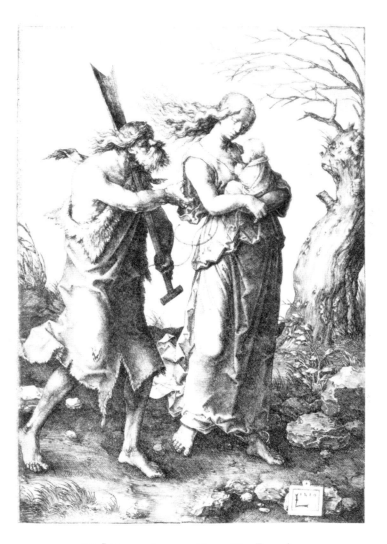

247. Lucas van Leyden: *Adam and Eve*. Engraving

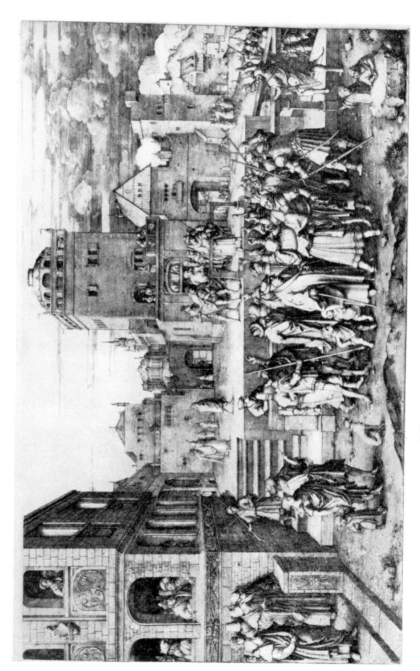

248. Lucas van Leyden: *Ecce homo*. Engraving

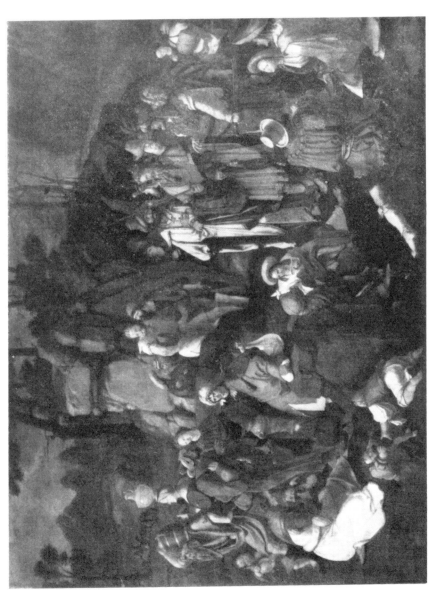

249. LUCAS VAN LEYDEN: *Moses striking Water from the Rock.* Boston, Museum of Fine Arts

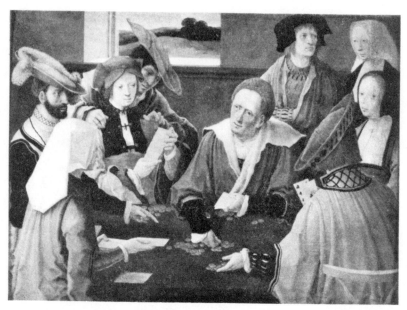

250. LUCAS VAN LEYDEN: *The Card Players*. Wilton House, Earl of Pembroke

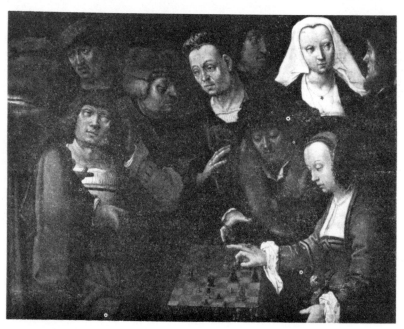

251. LUCAS VAN LEYDEN: *The Chess Players*. Berlin-Dahlem, Staatliche Museen

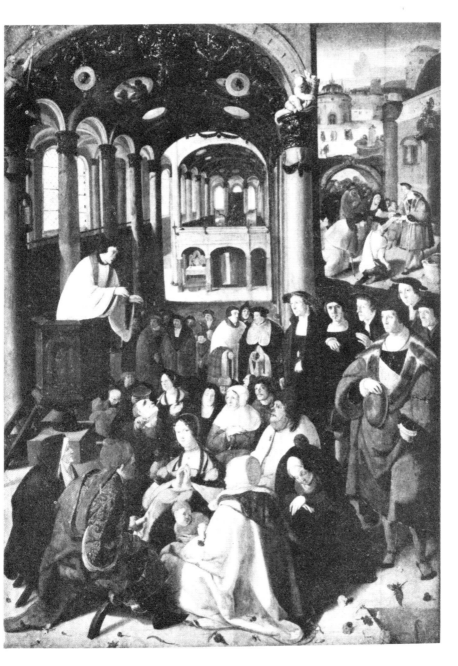

252. LUCAS VAN LEYDEN: *The Sermon*. Amsterdam, Rijksmuseum

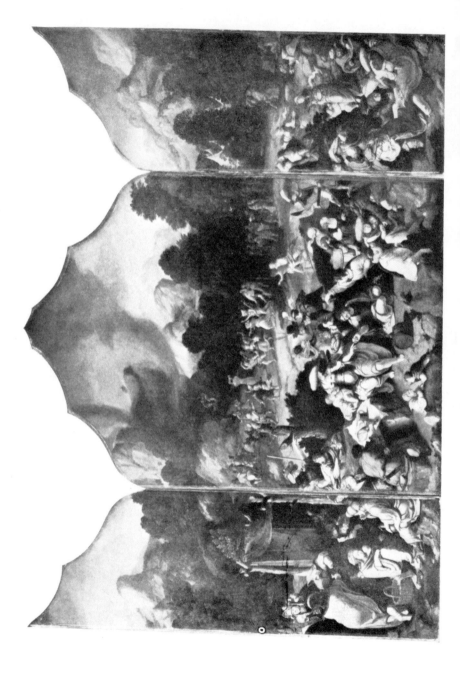

254. LUCAS VAN LEYDEN: *The Last Judgement*. Leyden, Lakenhal Museum

255. *Angels*. Detail from plate 254

256. *The Damned in Hell*. Detail from plate 254

257–258. *Saints Peter and Paul.* Reverse of the wings of plate 254

259. *Landscape.* Detail from plate 257

260. *Landscape.* Detail from plate 258

261. LUCAS VAN LEYDEN: *Virgin and Child with St. Mary Magdalen and a Donor.*
Munich, Alte Pinakothek

262. LUCAS VAN LEYDEN: *Susanna before the Judge.* Formerly Bremen, Kunsthalle

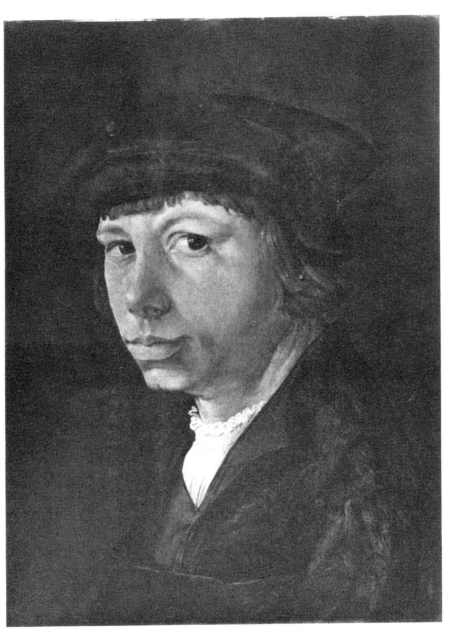

263. Lucas van Leyden: *Self-Portrait*. Brunswick, Herzog Anton Ulrich Museum

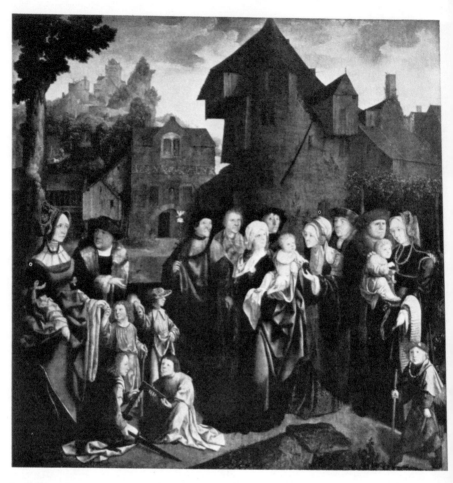

264. Jan van Scorel: *The Holy Kindred*. Centre panel of an altarpiece. Obervellach (Carinthia), Chur

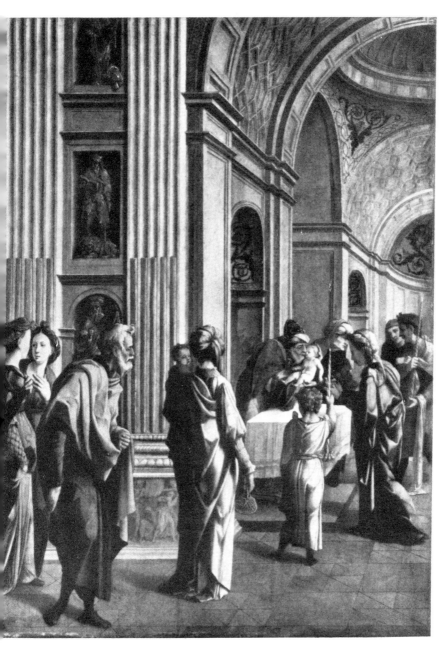

265. JAN VAN SCOREL: *The Presentation in the Temple*. Vienna, Kunsthistorisches Museum

266. JAN VAN SCOREL: *Christ's Entry into Jerusalem.* Centre panel of the Lochorst altarpiece. Utrecht, Centraal Museum

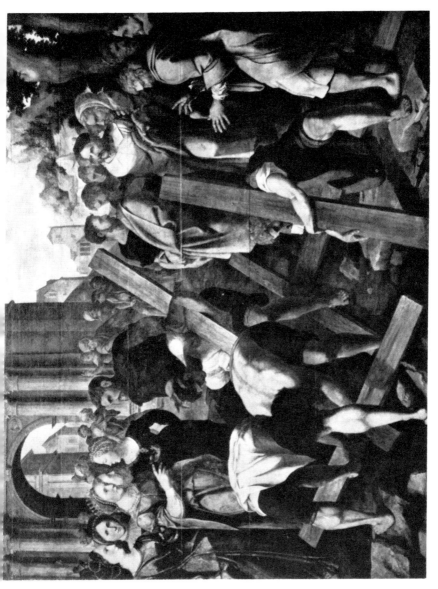

267. JAN VAN SCOREL: *The Invention of the Cross*. Centre panel of an altarpiece. Breda, Church

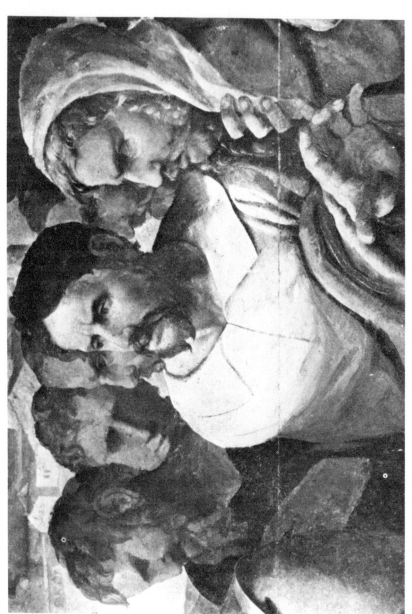

268. *Six Heads*. Detail from plate 267

269. JAN VAN SCOREL: *Twelve Jerusalem Pilgrims*. Haarlem, Frans Hals Museum

269.

270.

271. Jan van Scorel: *A Schoolboy*. Rotterdam, Museum Boymans-van Beuningen

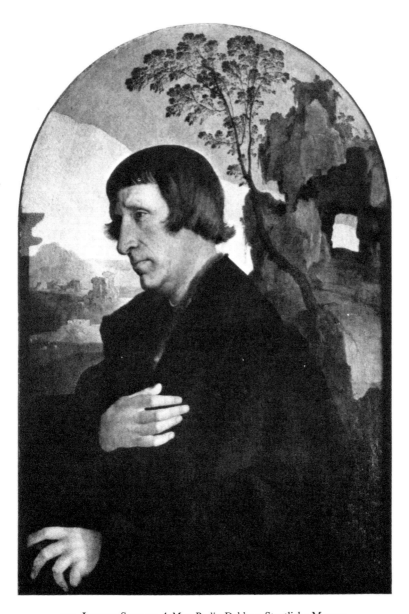

272. JAN VAN SCOREL: *A Man*. Berlin-Dahlem, Staatliche Museen

273. Jan van Scorel: *A Jerusalem Pilgrim*. Bloomfield Hills (Mich.), Cranbrook Academy of Art

274. JAN VAN SCOREL: *Agatha von Schoonhoven*. Rome, Galleria Doria

275. JAN VAN SCOREL: St. Mary Magdalen. Amsterdam, Rijksmuseum

276. Maerten van Heemskerck: *Family Group.* Cassel, Museum

277–278. Maerten van Heemskerck: *St. Luke painting the Virgin.* Haarlem,
Frans Hals Museum

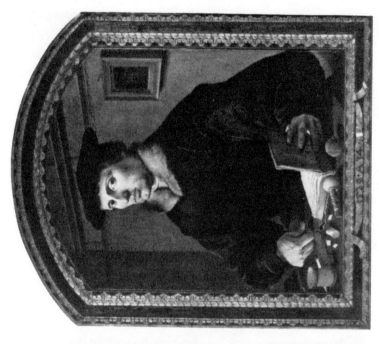

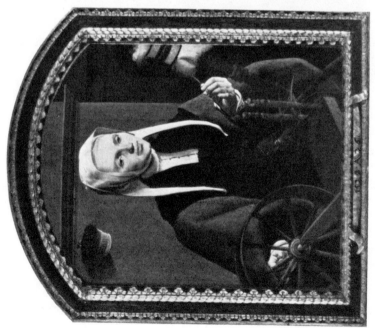

279–280. Maerten van Heemskerck: *Pieter Bicker and his Wife.* Amsterdam, Rijksmuseum

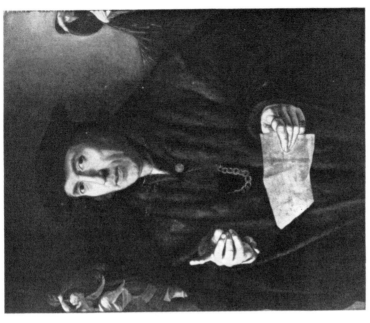

282. VERMEYEN: *A Man*. Wilton House, Earl of Pembroke

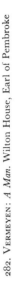

281. VERMEYEN: *Erard de la Marck*. Amsterdam, Rijksmusuem

282. PIETER BRUEGEL · *The Triumph of Death* Madrid Prado

284. *The Death Cart.* Detail from plate 283

285. Pieter Bruegel: *The Return of the Herd.* Vienna, Kunsthistorisches Museum

286. Pieter Bruegel: *The Hunters in the Snow*. Vienna, Kunsthistorisches Museum

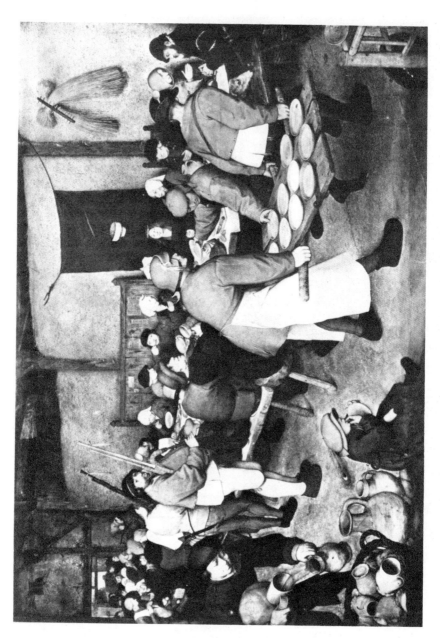

287. PIETER BRUEGEL: *The Peasant Wedding.* Vienna, Kunsthistorisches Museum

288. Pieter Bruegel: *The Suicide of Saul.* Detail. Vienna, Kunsthistorisches Museum

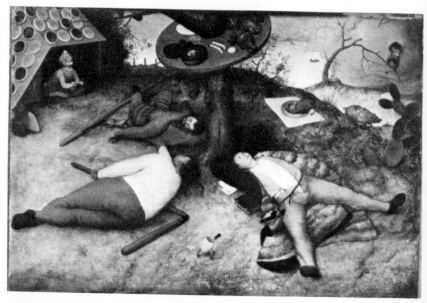

289. PIETER BRUEGEL: *The Land of Cockaigne*. Munich, Alte Pinakothek

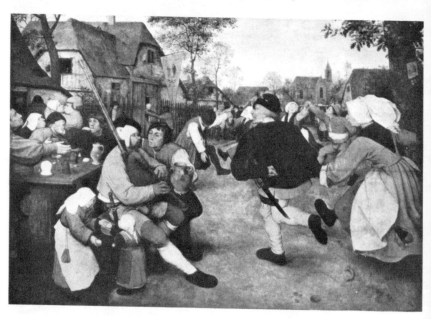

290. PIETER BRUEGEL: *The Peasant Dance*. Vienna, Kunsthistorisches Museum

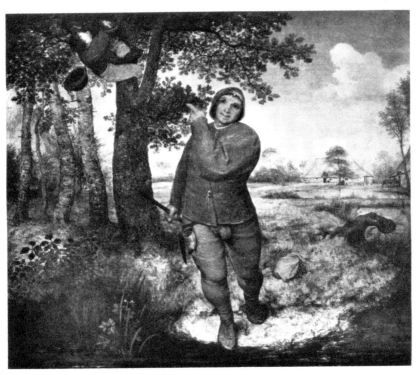

291. PIETER BRUEGEL: *The Birdnester*. Vienna, Kunsthistorisches Museum

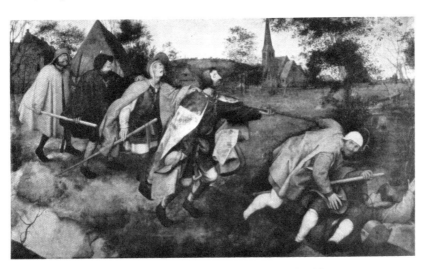

292. PIETER BRUEGEL: *The Parable of the Blind*. Naples, Museum

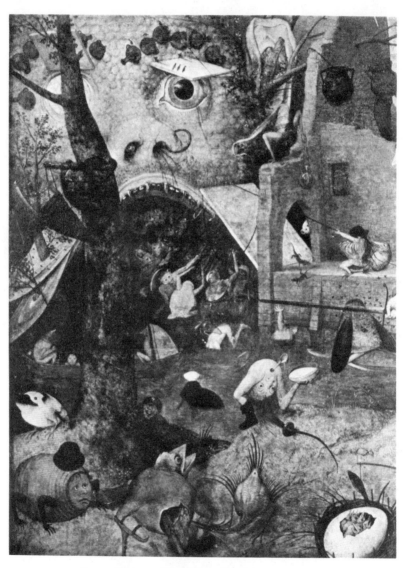

293. PIETER BRUEGEL: *Head of Satan.* Detail from the *Dulle Griet.*
Antwerp, Museum Mayer van den Bergh

LIST OF PLATES

HUBERT VAN EYCK (died 1426)
JAN VAN EYCK (died 1441)
1–10. The Ghent altarpiece. *Ghent, St. Bavo*

JAN VAN EYCK
11. The Three Maries at the Sepulchre. *Rotterdam*
12. Virgin and Child with the Chancellor Rolin. *Paris*
13. Virgin in the Church. *Berlin–Dahlem*
14. Annunciation. *Washington*
15. Virgin and Child with St. Barbara, St. Elizabeth of Hungary and a Carthusian. *New York, Frick Collection*
16. Virgin and Child with St. Donatian, St. George and Canon van der Paele. *Bruges*
17. 'Cardinal Niccolò Albergati.' *Vienna*
18. Margaret, the painter's wife. *Bruges*
19. Virgin and Child. *Dresden*
20. Giovanni Arnolfini and his wife. *London*
21. St. Barbara. *Antwerp*
24. The Stigmatization of St. Francis. *Philadelphia*

TURIN BOOK OF HOURS
22. Birth of St. John the Baptist. *Turin*
23. The Voyage of St. Julian. *Destroyed*

PETRUS CHRISTUS (died 1472 or 1473)
25. Edward Grimston. *London*
26. Young Lady. *Berlin–Dahlem*
27. Lamentation over Christ. *Brussels*
28. Lamentation over Christ. *New York*
29. Nativity. *Washington*
30. Virgin and Child with St. Barbara and a Carthusian. *Berlin–Dahlem*
31. A Carthusian. *New York*
32. St. Eligius. *New York, Robert Lehman*

MASTER OF FLÉMALLE
(? ROBERT CAMPIN 1378?–1444)
33. Annunciation, St. Joseph and donors. (Inghelbrecht altarpiece.) *New York*
34. Betrothal of the Virgin. *Madrid*
35. St. James and St. Clare. *Madrid*
36. Descent from the Cross (copy). *Liverpool*
37. Thief on the Cross. *Frankfurt*
38. Nativity. *Dijon*
39. Holy Trinity. *Frankfurt*
40–41. A man and a woman. *London*
42. St. John the Baptist and Heinrich Werl. *Madrid*
43. St. Barbara. *Madrid*

JAQUES DARET (1404–after 1468)
44. Adoration of the Kings. *Berlin–Dahlem*
45. Visitation. *Berlin–Dahlem*

ROGIER VAN DER WEYDEN
(1399?–1464)
46. Visitation and donor. *Turin*
47. Visitation. *Leipzig*
48. Virgin and Child; St. Catherine. *Vienna*
49. Holy Family; Lamentation over Christ; Christ appearing to His Mother. (Miraflores altarpiece.) *Berlin–Dahlem*
50. Christ appearing to His Mother. *New York*
51. Mary Magdalen. *Paris*
52. Christ on the Cross; Mary Magdalen; St. Veronica. *Vienna*
53–55. Descent from the Cross. *Madrid*
56. Entombment. *Florence*
57. Virgin and Child with Saints. *Frankfurt*
58. Annunciation; Adoration of the Kings; Presentation in the Temple. (Columba altarpiece.) *Munich*
59. Virgin and Child appearing to Augustus and the Sibyl; Nativity with Peeter Bladelin; Star of Bethlehem appearing to the Kings. *Berlin–Dahlem*
60. Baptism, Confirmation and Confession. *Antwerp*
61. Marriage, Ordination and Extreme Unction. *Antwerp*
62–64. Last Judgement. *Beaune, Hôtel-Dieu*
65. St. Luke painting the Virgin. *Boston*
66. Virgin and Child. *Caen*
67. Laurent Froimont. *Brussels*
68. Young woman. *Berlin–Dahlem*
69. A lady. *Washington*
70. Philippe de Croy. *Antwerp*
71. Antoine de Bourgogne. *Brussels*

DIERIC BOUTS (died 1475)
72. Annunciation, *Madrid*
73. Visitation. *Madrid*
74. Nativity. *Madrid*
75. Adoration of the Kings. *Madrid*
76. Entombment. *London*
77. Lamentation over Christ. *Paris*
78–79. Justice of Emperor Otto. *Brussels*
80. St. John the Baptist; Adoration of the Kings; St. Christopher. ('Pearl of Brabant.') *Munich*
81. Altarpiece of the Sacrament. *Louvain, S. Pierre*

(403)

82. Virgin and Child. *London*
83. A man. *London*
84. A man. *New York*

AELBERT VAN OUWATER
(active 1430–1460)

85. Head of a donor. *New York*
86. Raising of Lazarus. *Berlin–Dahlem*

HUGO VAN DER GOES (died 1482)

87. Virgin and Child. *Frankfurt*
88–93. The Portinari altarpiece. *Florence*
94. Fall of Man. *Vienna*
95. Lamentation over Christ. *Vienna*
96. Descent from the Cross. *Paris, Wildenstein & Co.*
97. The Holy Women. *Berlin–Dahlem*
98. Adoration of the Shepherds. *Berlin–Dahlem*
99. Adoration of the Kings. (Monforte altarpiece.) *Berlin–Dahlem*
100. Sir Edward Bonkil and two Angels. *Edinburgh, Holyroodhouse*
101. Death of the Virgin. *Bruges*
102. A man. *New York*
103. Detail from 91

HANS MEMLINC (1433?–1494)

104–105. Tommaso and Maria Portinari. *New York*
106. Descent from the Cross. *Granada*
107. The Holy Women. *Granada*
108. Pietà. *Granada*
109. St. John on Patmos. *Bruges*
110–111. Virgin and Child with Angels, Saints and donors; St. John the Baptist; St. John the Evangelist. *London*
112. Adoration of the Kings (Floreins altarpiece.) *Bruges*
113. Passion of Christ. *Turin*
114–115. Legend of St. Ursula. *Bruges*
116. St. Ursula with eleven Virgins. *Bruges*
117. St. Ursula sheltering ten Virgins. *Bruges*
118–119. Virgin and Child adored by Martin Nieuwenhove. *Bruges*
120. Man holding a medal. *Antwerp*
121. Young man. *New York, Robert Lehman*
122. Lady with a pink. *New York*
123. Two horses. *Rotterdam*
124. Maria Moreel. *Bruges*

GERARD DAVID (1460?–1523)

125. Canon de Salviatis with three Saints. *London*
126. Verdict of Cambyses. *Bruges*
127. Virgin and Child with Angels and Saints. *Rouen*
128. Marriage of Cana. *Paris*
129. Virgin and Child. *Von Pannwitz Collection*
130. Two landscapes. *Amsterdam*
131. Baptism of Christ. *Bruges*
132. Virgin and Child with three Saints and donor. *London*

MASTER OF THE VIRGO INTER
VIRGINES

133. Annunciation. *Rotterdam*

JUSTUS VAN GENT (active 1460–c.1480)

134. Last Supper. *Urbino*
135. Crucifixion. *Ghent, St. Bavo*

GEERTGEN TOT SINT JANS
(c.1455/65–c.1485/95?)

136. Raising of Lazarus. *Paris*
137. Burning of the bones of St. John. *Vienna*
138. Lamentation over Christ. *Vienna*
139. Nativity. *London*
140. Virgin and Child. *Rotterdam*
141. Adoration of the Kings. *Cleveland*
142. St. John in the Wilderness. *Berlin–Dahlem*
143. Christ as Man of Sorrows. *Utrecht*

JEROME BOSCH (died 1516)

144. Crowning with Thorns. *London*
145. Table top with Deadly Sins. *Madrid*
146. Crucifixion. *Brussels*
147. Adoration of the Kings. *Philadelphia*
148–150. Adoration of the Kings. *Madrid*
151. Garden of Earthly Delights. *Madrid*
152. Hay-Wain. *Escorial*
153. Temptation of St. Anthony. *Lisbon*
154. St. Jerome in Penitence. *Ghent*
155. Ecce homo. *Philadelphia*
156. Christ carrying the Cross. *Ghent*
157. Mocking of Christ. *Escorial*
158. Prodigal Son. *Rotterdam*
159. St. John on Patmos. *Berlin–Dahlem*

BERNAERT VAN ORLEY (c. 1488–1541)

160–161. Ruin of the Children of Job. *Brussels*
162. Charles V. *Budapest*
163. Dr. Georg van Zelle. *Brussels*

QUENTIN MASSYS (1465/6–1530)

164. Virgin and Child. *Brussels*
165. Rest on the Flight into Egypt. *Worcester, Mass.*
166. Entombment. *Antwerp*
167–168. Holy Kindred. *Brussels*
169. Mary Magdalen. *Antwerp*
170. Christ presented to the people. *Madrid*
171. Holy Trinity and Virgin and Child. *Munich*
172. A man. *Frankfurt*
173. A man. *Edinburgh*
174–175. A man and his wife. *Oldenburg*
176. Man with a pink. *Chicago*
177. Money-Changer and his wife. *Paris*
178. Erasmus of Rotterdam. *Rome, Galleria Nazionale, Palazzo Corsini*
179. Petrus Aegidius. *Longford Castle, Earl of Radnor*
180. Temptation of St. Anthony. *Madrid*

JOACHIM DE PATENIER (died 1524)
180. Temptation of St. Anthony. *Madrid*
181. Rest on the Flight into Egypt. *Madrid*
182. St. Christopher. *Escorial*
183. Charon crossing the Styx. *Madrid*
184. Baptism of Christ. *Vienna*
185. Flight into Egypt. *Antwerp*

HERRI MET DE BLES
186. Flight into Egypt. *London, Hallsborough Gallery*

CORNELIS MASSYS
(before 1508?–after 1580)
187. St. Jerome in the Wilderness. *Antwerp*
188. The Virgin and St. Joseph arriving in Bethlehem. *Berlin–Dahlem*

MASTER OF THE FEMALE HALF-LENGTHS
189. Three ladies making music. *Vienna, Harrach Collection*
190. Adoration of the Kings. *Regensburg, Museum*

ADRIAEN YSENBRANDT (died 1551)
191. Seven Sorrows of the Virgin. *Bruges, Notre-Dame*
192. Gold-weigher. *New York*

JOOS VAN CLEVE (died 1540–1)
193. Woman with rosary. *Florence*
194. Henry VIII. *Hampton Court*
195. Eleanor of France. *Vienna*
196. Adoration of the Kings. *Detroit*
197. Death of the Virgin. *Munich*
198. Death of the Virgin (detail). *Cologne*
199. Holy Family. *Vienna*
200. Virgin and Child with Angels. *Lulworth Castle, Col. J. Weld*
201. Rest on the Flight into Egypt. *Brussels*
202. Lamentation over Christ. *Paris*
203. Virgin and Child. *Cambridge*
204. Holy Family. *New York*

JAN PROVOST (c.1465?–1529)
205. Virgin and Child. *Piacenza, Museo*
206. Virgin and Child. *Leningrad*
207. Last Judgement. *Bruges*
208. Death and the Miser. *Bruges*
209. Angel appearing to Abraham. *Formerly Paris, Comte Durrieu*

JAN GOSSAERT (died 1532)
210. Resting Apollo ('Hermaphrodite'). Drawing. *Venice, Academy*
211. Adam and Eve. *Hampton Court*
212. Danae. *Munich*
213. Neptune and Amphitrite. *Berlin–Dahlem*
214. St. Luke painting the Virgin. *Prague*
215. St. Luke painting the Virgin. *Vienna*

216. A man. *Vierhouten, Van Beuningen*
217–218. Donor and his wife. *Brussels*
219–220. Virgin and Child adored by Jan Carondelet. *Paris*
221. Three children of Christian II of Denmark. *Hampton Court*
222. Virgin and Child. *Palermo*
223. Adoration of the Kings. *London*
224. Agony in the Garden. *Berlin–Dahlem*

JAN JOEST (died 1519)
225. Virgin and St. John. *Palencia*
226. Flight into Egypt. *Palencia*
227. Entombment. *Palencia*
228. Lamentation. *Cologne*
229. Baptism of Christ. *Kalkar*

MASTER OF FRANKFURT
230. Holy Kindred. *Frankfurt*
231. Nativity. *Valenciennes*
232. Artist and his wife. *Rome, Baron van der Elst*

JAN MOSTAERT (c. 1472/3–1555/6)
233. Joost van Bronckhorst. *Paris, Petit Palais*
234. A man. *Liverpool*
235. Justina van Wassenaer. *Würzburg*
236. Abraham and Hagar. *Lugano-Castagnola, Castle Rohoncz Collection*
237. Descent from the Cross. *Brussels*
238. Man of Sorrows. *Verona*
239. Adoration of the Kings. *Amsterdam*
240. Tree of Jesse. (Also attributed to Geertgen tot Sint Jans.) *Amsterdam*
241. Landscape in the West Indies. *Haarlem*

JACOB CORNELISZ. VAN OOSTSAANEN (c.1470–1533)
242. Jacob Pijnssen. *Enschede*
243. Virgin and Child. *Berlin–Dahlem*
244. Noli me tangere. *Cassel*

CORNELIS ENGELBRECHTSZ.
(1468?–1533)
245. St. Constantine and St. Helena. *Munich*

LUCAS VAN LEYDEN (1494–1533)
246. Mohammed and the monk. *Engraving*
247. Adam and Eve. *Engraving*
248. Ecce homo. *Engraving*
249. Moses striking water from the rock. *Boston*
250. Card Players. *Wilton House, Earl of Pembroke*
251. Chess players. *Berlin–Dahlem*
252. Sermon. *Amsterdam*
253. Worship of the golden calf. *Amsterdam*
254–260. Last Judgement. *Leyden, Lakenhal*
261. Virgin and Child with Mary Magdalen. *Munich*
262. Susanna before the judge. *Formerly Bremen, Kunsthalle*
263. Self-portrait. *Brunswick*

JAN VAN SCOREL (1495–1562)
264. Holy Kindred. *Obervellach*
265. Presentation in the Temple. *Vienna*
266. Christ's Entry into Jerusalem. *Utrecht*
267–268. Invention of the Cross. *Breda*
269. Twelve Jerusalem pilgrims. *Haarlem*
270. Five Jerusalem pilgrims. *Utrecht*
271. Schoolboy. *Rotterdam*
272. A man. *Berlin–Dahlem*
273. Jerusalem pilgrim. *Bloomfield Hills, Mich.*
274. Agatha van Schoonhoven. *Rome, Galleria Doria*
275. Mary Magdalen. *Amsterdam*

MAERTEN VAN HEEMSKERCK
(1498–1574)
276. Family Group. *Cassel*
277–278. St. Luke painting the Virgin. *Haarlem*

279–280. Pieter Bicker and his wife. *Amsterdam*

JAN VERMEYEN (c. 1500–1559)
281. Erard de la Marck. *Amsterdam*
282. A man. *Wilton House, Earl of Pembroke*

PIETER BRUEGEL (1525/30–1569)
283–284. Triumph of Death. *Madrid*
285. Return of the Herd. *Vienna*
286. Hunters in the Snow. *Vienna*
287. Peasant Wedding. *Vienna*
288. Suicide of Saul. *Vienna*
289. Land of Cockaigne. *Munich*
290. Peasant Dance. *Vienna*
291. Birdnester. *Vienna*
292. Parable of the Blind. *Naples*
293. Dulle Griet (detail). *Antwerp, Museum Mayer van den Bergh*

COLOUR PLATES

I. Rogier van der Weyden: Portrait of a Lady (before cleaning). *London*
II. Rogier van der Weyden: Descent from the Cross. *Madrid*
III. Memlinc: Annunciation to the Shepherds. Detail from the 'Seven Joys of Mary'. *Munich*
IV-V. Bosch: Adam and Eve; Hell. Wings of the 'Hay-Wain'. *Escorial*
VI. Massys: Portrait of a Canon. *Vaduz, Liechtenstein Collection*
VII. Lucas van Leyden: Adoration of the Kings. *Chicago*
VIII. Lucas van Leyden: Healing of the Blind Man. *Leningrad*
IX. Pieter Bruegel: Children's Games (detail). *Vienna*

INDEX OF PLACES

AMSTERDAM, Rijksmuseum
David, 130; Mostaert, 239–40; Lucas, 252, 253; Scorel, 275; Heemskerck, 279–80; Vermeyen, 281

ANTWERP, Musée Royal
Van Eyck, 21; Rogier, 60–1, 70; Memlinc, 120; Massys, 166, 169; Patenier, 185; Cornelis Massys, 187

ANTWERP, Museum Mayer van den Bergh
Bruegel, 293

BEAUNE, Hôtel-Dieu
Rogier, 62–4

BERLIN-DAHLEM, Staatliche Museen
Van Eyck, 13; Christus, 26, 30; Daret, 44, 45; Rogier, 49, 59, 68; Ouwater, 86; Goes, 97, 98, 99; Geertgen, 142; Bosch, 159; Cornelis Massys, 188; Gossaert, 213, 224; Oostsaanen, 243; Lucas, 251; Scorel, 272

BLOOMFIELD HILLS (Mich.), Cranbrook Academy
Scorel, 273

BOSTON, Museum of Fine Arts
Rogier, 65; Lucas, 249

BREDA, Church
Scorel, 267–8

BREMEN, Kunsthalle (formerly)
Lucas, 262

BRUGES, Museum
Van Eyck, 16, 18; Goes, 101; David, 126, 131; Provost, 207, 208

BRUGES, St. John's Hospital
Memlinc, 109, 112, 114–17, 118, 119, 124

BRUGES, Notre-Dame
Ysenbrandt, 191

BRUNSWICK, Herzog Anton Ulrich Museum
Lucas, 263

BRUSSELS, Musées Royaux
Christus, 27; Rogier, 67, 71; Bouts, 78–9; Bosch, 146; Orley, 160, 161, 163; Massys, 164, 167, 168; Joos van Cleve, 201; Gossaert, 217–18; Mostaert, 237

BUDAPEST, Museum
Orley, 162

CAEN, Museum
Rogier, 66

CAMBRIDGE, Fitzwilliam Museum
Joos van Cleve, 203

CASSEL, Museum
Oostsaanen, 244; Heemskerck, 276

CHICAGO, Art Institute
Lucas, VII; Massys, 176

CLEVELAND, Museum of Art
Geertgen, 141

COLOGNE, Wallraf-Richartz Museum
Joos van Cleve, 198; Joest, 228

DETROIT, Institute of Arts
Joos van Cleve, 196

DIJON, Museum
Master of Flémalle, 38

DRESDEN, Gallery
Van Eyck, 19

EDINBURGH, National Gallery of Scotland
Goes, 100 (on loan from Palace of Holyroodhouse); Massys, 173

ENSCHEDE, Rijksmuseum Twenthe
Oostsaanen, 242

ESCORIAL
Bosch, IV, V, 152, 157; Patenier, 182

FLORENCE, Uffizi
Rogier, 56; Goes, 88–93, 103; Joos van
Cleve, 193

FRANKFURT, Staedel Institute
Master of Flémalle, 37, 39; Rogier, 57;
Goes, 87; Massys, 172; Master of Frank-
furt, 230

GHENT, St. Bavo
Van Eyck, 1–10; Justus van Gent, 135

GHENT, Museum
Bosch, 154, 156

GRANADA, Capilla Real
Memlinc, 106–8

HAARLEM, Frans Hals Museum
Mostaert, 241; Scorel, 269; Heemskerck,
277–8

HAMPTON COURT, Palace
Joos van Cleve, 194; Gossaert, 211, 221

KALKAR, St. Nicholas
Joest, 229

LEIPZIG, Museum
Rogier, 47

LENINGRAD, Hermitage
Lucas, VIII; Provost, 206

LEYDEN, Lakenhal
Lucas, 254–60

LISBON, Museum
Bosch, 153

LIVERPOOL, Walker Art Gallery
Master of Flémalle (copy), 36; Mostaert,
234

LONDON, Hallsborough Gallery
Herri Met de Bles, 186

LONDON, National Gallery
Rogier, I; Van Eyck, 20; Christus, 25;
Master of Flémalle, 40, 41; Bouts, 76, 82,
83; Memlinc, 110–11; David, 125, 132;
Geertgen, 139; Bosch, 144; Gossaert, 223

LONGFORD CASTLE, Earl of Radnor
Massys, 179

LOUVAIN, S. Pierre
Bouts, 81

LUGANO, Castle Rohoncz Collection
Mostaert, 236

LULWORTH MANOR, Col. J. Weld
Collection
Joos van Cleeve, 200

MADRID, Prado
Master of Flémalle, 34, 35, 42, 43; Rogier,
II, 53–5; Bouts, 72–5; Bosch, 145, 148–51;
Massys, 170, 180; Patenier, 181, 183;
Bruegel, 283–4

MUNICH, Alte Pinakothek
Memlinc, III; Rogier, 58; Bouts, 80;
Massys, 171; Joos van Cleve, 197;
Gossaert, 212; Engelbrechtsz., 245; Lucas,
261; Bruegel, 289

NAPLES, Museum
Bruegel, 292

NEW YORK, Metropolitan Museum
Christus, 28, 31; Master of Flémalle, 33;
Rogier, 50; Bouts, 84; Ouwater, 85; Goes,
102, Memlinc, 104, 105, 122; Ysenbrandt,
192; Joos van Cleve, 204

NEW YORK, Frick Collection
Van Eyck, 15

NEW YORK, Robert Lehman
Collection
Christus, 32; Memlinc, 121

OBERVELLACH, Church
Scorel, 264

OLDENBURG, Museum
Massys, 174–5

PALENCIA, Cathedral
Joest, 225–7

PALERMO, Museum
Gossaert, 222

PARIS, Louvre
Van Eyck, 12; Rogier, 51; Bouts, 77; David, 128; Geertgen, 136; Massys, 177; Joos van Cleve, 202; Gossaert, 219–20

PARIS, Petit Palais
Mostaert, 233

PARIS, Wildenstein & Co.
Goes, 96

PARIS, Comte Durrieu (formerly)
Provost, 209

PHILADELPHIA, John G. Johnson Art Collection
Van Eyck, 24; Bosch, 147, 155

PIACENZA, Museo Civico
Provost, 205

PRAGUE, National Gallery
Gossaert, 214

REGENSBURG, Museum
Master of the Female Half-Lengths, 190

ROME, Galleria Nazionale, Palazzo Corsini
Massys, 178; Scorel, 271

ROME, Galleria Doria
Scorel, 274

ROME, Baron van der Elst Collection
Master of Frankfurt, 232

ROTTERDAM, Museum Boymans-Van Beuningen
Van Eyck, 11; Memlinc, 123; Master of Virgo inter Virgines, 133; Geertgen, 140; Bosch, 158; Scorel, 271

ROUEN, Museum
David, 127

TURIN, Museo Civico
Book of Hours, 22, (23)

TURIN, Pinacoteca
Rogier, 46; Memlinc, 113

URBINO, Palazzo Ducale
Justus van Gent, 134

UTRECHT, Archiepiscopal Museum
Geertgen, 143

UTRECHT, Centraal Museum
Scorel, 266, 270

VADUZ, Liechtenstein Collection
Massys, VI

VALENCIENNES, Museum
Master of Frankfurt, 231

VENICE, Academy
Gossaert, 210

VERONA, Museum
Mostaert, 238

VIENNA, Kunsthistorisches Museum
Van Eyck, 17; Rogier, 48, 52; Goes, 94, 95; Geertgen, 137, 138; Patenier, 184; Joos van Cleve, 195, 199; Gossaert, 215; Scorel, 265; Bruegel, IX, 285–8, 290–1

VIENNA, Harrach Collection
Master of the Female Half-Lengths, 189

VIERHOUTEN, Van Beuningen Collection
Gossaert, 216

WASHINGTON, National Gallery of Art
Van Eyck, 14; Christus, 29; Rogier, 69

WILTON HOUSE, Earl of Pembroke
Lucas, 250; Vermeyen, 282

WORCESTER, Mass., Art Museum
Massys, 165

WÜRZBURG, Martin von Wagner Museum
Mostaert, 235

Von Pannwitz Collection (formerly)
David, 129

ACKNOWLEDGEMENTS

Plates 100, 194, 211 and 221 are reproduced by gracious permission of Her Majesty the Queen.

Plate VI is reproduced by gracious permission of His Serene Highness The Prince of Liechtenstein.

We wish to express our sincere gratitude to the following private owners and museum authorities for permission to reproduce paintings in their collections and for supplying photographs:

The late Mr. D. G. van Beuningen; the late Captain E. G. Spencer Churchill; His Excellency Baron van der Elst; Mr. Robert Lehman; Mme von Pannwitz; the Earl of Pembroke; the late Earl of Radnor; the Earl of Verulam; Mrs. Weld Blundell.

Rijksmuseum, Amsterdam; Musée Royal, Antwerp; Staatliche Museen, Berlin-Dahlem; Museum of Fine Arts, Boston; College van Kerkvoogden, Breda; Memlinc Museum, St. John's Hospital, Bruges; Herzog Anton Ulrich Museum, Brunswick; Fitzwilliam Museum, Cambridge; Museum, Cassel; Devonshire Collection, Chatsworth; Art Institute, Chicago; Museum of Art, Cleveland; Wallraf-Richartz Museum, Cologne; Institute of Arts, Detroit; Rijksmuseum Twenthe, Enschede; Staedel Institute, Frankfurt; Frans Hals Museum, Haarlem; Lakenhal, Leydon; Walker Art Gallery, Liverpool; National Gallery, London; Castle Rohoncz Collection, Lugano-Castagnola; Prado, Madrid; Alte Pinakothek, Munich; Metropolitan Museum, New York; Frick Collection, New York; Museum, Oldenburg; John G. Johnson Art Collection, Philadelphia; Museum Boymans-Van Beuningen, Rotterdam; Centraal Museum, Utrecht; Kunsthistorisches Museum, Vienna; National Gallery of Art, Washington, D.C.; Art Museum, Worcester, Mass.; and Martin von Wagner Museum, Würzburg.

Further photographs have been supplied by A.C.L., Brussels; De Spaarnestad, Haarlem; Alinari, Florence; Archives Photographiques, Paris; Bulloz, Paris; Giraudon, Paris; and Anderson, Rome.